Reinventing the Company
in the Digital Age

BBVA

Preface

1
Francisco González
Chairman & CEO
BBVA

The Impact of the Technological Revolution

1

Taking a broader perspective, the authors included in this first section discuss the ways in which the technological revolution is rendering company and industry-wide structures obsolete, regardless of their success up to now. Business models must be rethought for a new setting that requires closer customer involvement, enhanced agility, and ongoing innovation.

Customers and Markets

85
Infographics

95
**Reinventing Marketing
in the Digital Era
George S. Day**
Wharton Business School

109
**The Rise of the New Multinationals
Esteban García-Canal**
Universidad de Oviedo
Mauro F. Guillén
The Lauder Institute, Wharton School

133
**Business Models for the
Companies of the Future
Joan E. Ricart**
IESE Business School

The second part of the book focuses on two central concerns for companies: their customers, and the markets in which they operate.
The changes we are seeing in customers —their requirements, and the technologies used to relate to them—are bringing about a radical transformation in sales and marketing functions.

2

In addition, market structures are changing in two key ways. First, business is shifting towards emerging areas, which are becoming major markets and global competitors. Secondly, the ways in which companies create value are also changing. This means that business models must be redefined to adapt to new supply opportunities and new requirements in terms of demand and competition.

People, Talent and Culture

147
Infographics

157
If It's Innovation You Want, Think About Job Quality
Chris Warhurst
Sally Wright
University of Warwick

175
Diversity and Tribal Thinking in the Collaborative Organization
Celia de Anca
Salvador Aragón
IE Business School

195
A Gender Power Shift in the Making
Alison Maitland
London Cass Business School

217
Implications of the Revolution in Work and Family
Stewart D. Friedman
The Wharton School,
University of Pennsylvania

The transformation of companies in step with technological and societal change is a task that has to be planned and carried out by people.
The concept underpinning this section of the book is that job quality must be enhanced in order to encourage innovation. However, making better use of high-quality resources calls for changes in working practices and culture. Collaboration becomes the driving force for the digital era—co-creating, co-working, sharing, co-designing, and co-thinking—in a diversity rich framework that fosters creativity.

One key factor of diversity is gender diversity. We must make the most of the inexorable shift towards different power relations among the genders, which is shaping new leadership styles and the rise of "soft power." We also need diversity in professional and personal values and aspirations. Governments and—all the more so—companies should create a flexible work framework that accepts and encourages greater empowerment for individuals.

Workplaces and Cyberworkplaces

239
Infographics

247
New Ways of Working in the Company of the Future
Peter Thomson
Henley Business School

263
A Single Building and a Multifaceted Town: BBVA, Madrid, a Workplace for the Future
Herzog & de Meuron
Architects

293
New Workplaces for BBVA: Promoting a Culture of Collaborative Work
The BBVA New Headquarters Team
Various Authors

The need to generate higher quality, smarter, collaborative, flexible work, which brings enhanced satisfaction and a better work-life balance, has led to a revolution in working practices and management, embracing technology to develop new physical and/or virtual workplaces in keeping with these new demands.

This section of the book looks at these concepts, and then explores them in more depth with reference to the specific example of BBVA's new corporate headquarters, in terms of both urban and architectural development: technology and the design of the working environment are employed to drive the shift towards a far more flexible and open collaborative working culture that encourages collective intelligence and nurtures innovation.

4

Leadership, Strategy and Management

335
Infographics

347
Governance and Managing Change in the Company of the 21st Century
William M. Klepper
Columbia Business School

375
The Organization of the Future: A New Model for a Faster-Moving World
John P. Kotter
Harvard University

395
Open Innovation: Striving for Innovation Success in the 21st Century
Henry Chesbrough
Haas School of Business, University of California at Berkeley

411
Sustainability and the Company of the Future
Carol A. Adams
Monash University

431
Transforming an Analog Company into a Digital Company: The Case of BBVA
Francisco González
Chairman & CEO BBVA

If we are to adapt the company to a radically changed environment in which production functions, distribution channels, customers, markets and human resources are all different, we must also change the way we manage and lead our business. The leadership of the company must form a vision and strategy for change and provide a flexible, transparent framework: this way the entire organization can align itself with change, and the process can be properly directed.
New structures must be created to support and encourage change while keeping the organization fully operational while the shift is under way.

This transformation process requires opening up the company to a wide range of stakeholders and to the community at large, with a twofold goal: first, to set in motion an ongoing process of open innovation; secondly, to meet society's demand for values, good practice, respect for the environment, and sustainability. The complexity of the process and the need for strong but open and inclusive leadership to bring it to completion is illustrated by the case study of BBVA, whose transformation is taking place in three closely interrelated domains: technology, corporate culture, and organizational structure.

5

Reinventing the Company in the Digital Age

Francisco González
Chairman & CEO BBVA

This book, *Reinventing the Company in the Digital Age*, is the latest addition to BBVA's annual series dedicated to analyzing the key issues of our time. As before, we have sought out the world's leading experts and asked them to use a straightforward, accessible approach that permits open access to the latest knowledge for the non-specialist general public. This year we have been fortunate to count on over twenty renowned authors, at the top in their respective fields, who augment the more than 130 authors who had already contributed their articles to our books; without their insights our project would never have taken off in such a positive way. Once again I should like to acknowledge them all and, in particular, those new additions to our community.

BBVA began this series to coincide with the launch of the Frontiers of Knowledge Prizes awarded by the BBVA Foundation in 2008. As the first few books received such an excellent reception we looked for a way to make them more widely accessible, and in 2011 we created OpenMind (www.bbvaopenmind.com), our online knowledge sharing community.

OpenMind—which contains all our six books so far—is going from strength to strength and has become a lively space for the discovery and dissemination of ideas. It has enhanced its content beyond our books to include posts, interviews, videos, and infographics to further widen its audience, in conjunction with its main objective of sharing knowledge to build a better future. In 2014, some 500,000 users will visit our web, read, comment, debate around and/or download our content, all of which is accessible both in English and Spanish.

As always, the principal idea underpinning our series of books is the desire to understand and help people understand the powerful forces that are influencing our world. In last year's book, *Change: 19 Essays on How the Internet Is Changing Our Lives*, we looked at probably the most significant change agent of our times. This year's book touches on some of the same subjects: technological and social change,

Big Data, innovation and new habits, and people's preferences. However, *Reinventing the Company in the Digital Age* goes much deeper into how this information technology driven revolution is influencing the very foundation of how the great majority of us work and do business. This is tantamount to discussing how the digital revolution is shaping the future of the economy, society, and our daily lives.

It almost goes without saying that the digital era has unleashed a far-reaching tsunami that we are still trying to understand and come to terms with. Almost on a daily basis the rules of the game for doing business are changing and we strive to adjust to the fast-moving, constantly changing landscape. This has had a colossal impact in the workplace, and nowhere more so than in the so-called traditional sectors: to succeed in this new era big organizations that up to now have been profitable and perfectly able to lead their industry for decades are confronted with the need for radical change.

The challenges companies face nowadays are very complex, closely intertwined, continually evolving. In order to make them more accessible, we have chosen to break them down into sections with five broad titles:

– The Impact of the Technological Revolution
– Customers and Markets
– People, Talent and Culture
– Workplaces and Cyberworkplaces
– Leadership, Strategy and Management

And so it is not by chance that we have chosen this subject: first, it is a central issue for the future of all societies and individuals; and secondly, BBVA has pioneered the efforts of banks to rise to the challenge of the digital age by undertaking a radical transformation project. For the last seven years, we have completely rebuilt our technological

platform and maintained a relentless innovation program, not only in products, but in processes, ways of working, organizational structures, corporate culture…

Perhaps the principal showcase for the dramatic change is the groundbreaking headquarters that we will be moving into in 2015; we see this as a means of making the BBVA team more capable of serving the needs of digital customers.

This year we have launched our Digital Banking Unit, which we see as a powerful tool to accelerate change, getting us closer to our aim of becoming the best—and first—knowledge bank for the digital age.

In accordance with our vision ("BBVA, working for a better future for people"), we want to share in this book our transformational experience and present the reader with the analysis and news of leading experts in this field. And we do that in the hope that it will help our readers to navigate these changes and broaden the horizon of their opportunities.

The Impact of the Technological Revolution

Key Challenges of Big Data Faced by Companies (2013)

Challenges:

① Finding out how to create value using Big Data
② Framing a strategy
③ Acquiring the necessary skills
④ Integrating multiple information sources
⑤ Infrastructure/architecture
⑥ Governance risks and issues
⑦ Financing initiatives
⑧ Understanding what Big Data means to us
⑨ Internal or leadership issues
⑩ Other challenges

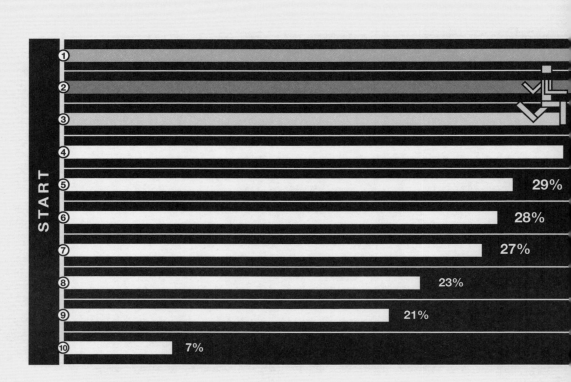

Podium

 First Second Third

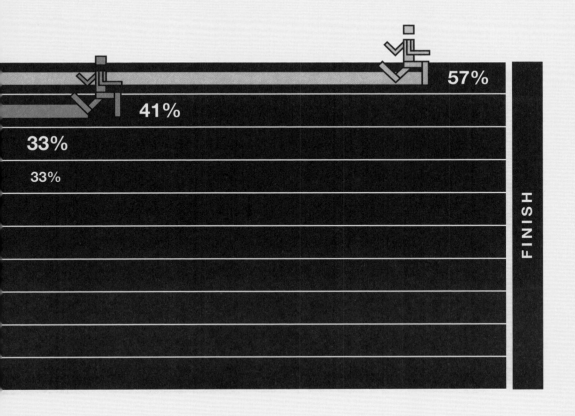

57%
41%
33%
33%

FINISH

Source: Gartner

Organizations Which Have Invested, or Intend to Do So in the Next 24 Months, in Facing the Challenge of Big Data (2013)

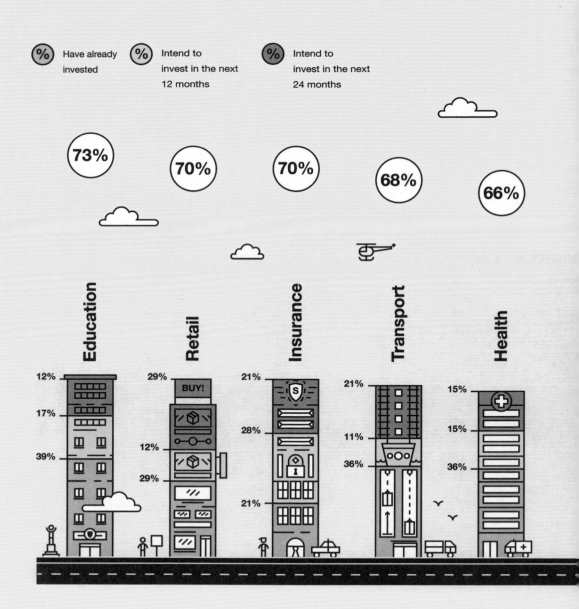

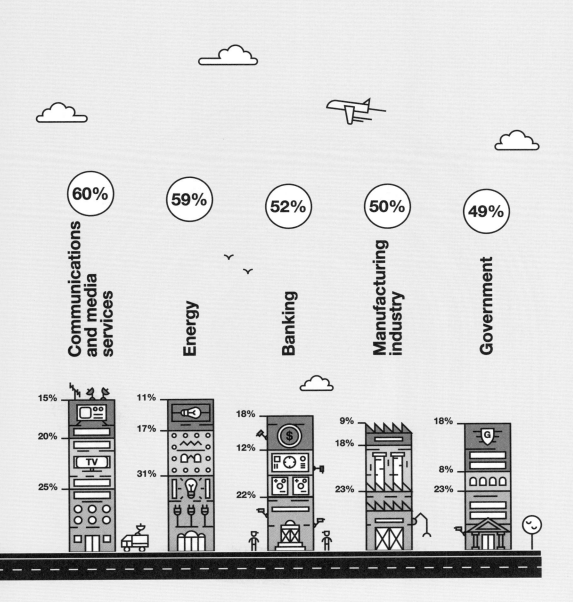
Source: Gartner

Global IP Traffic Forecast (2014)

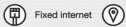 Fixed internet 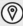 IP under management 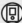 Mobile data

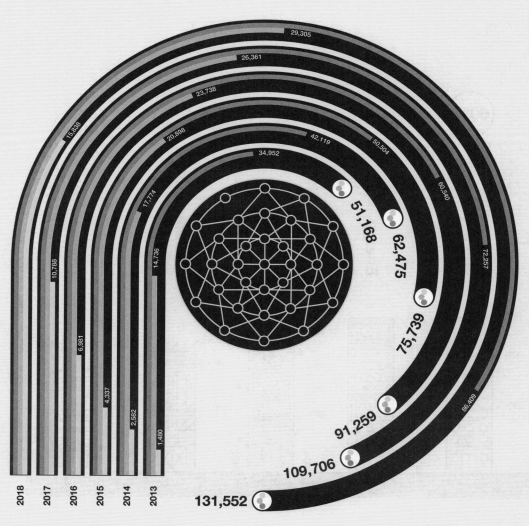

Amounts in millions of petabytes

Source: Cisco, VNI

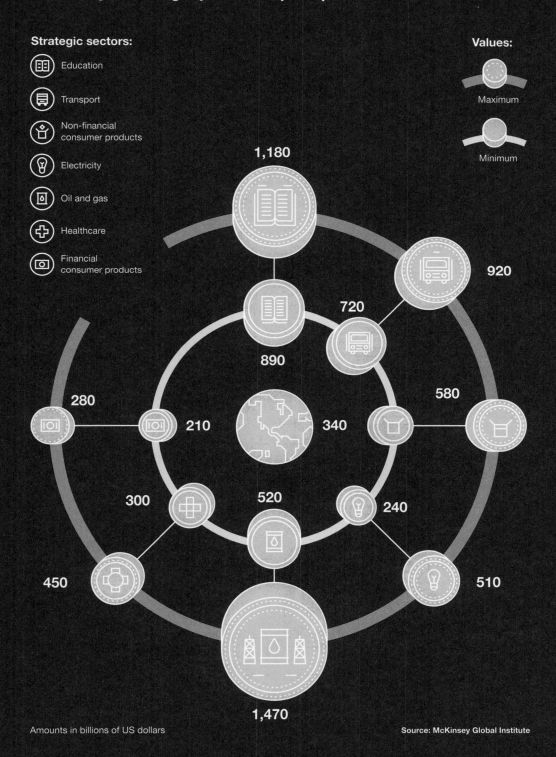

Forecast B2C Sales Growth in China and the US (2011-2016)

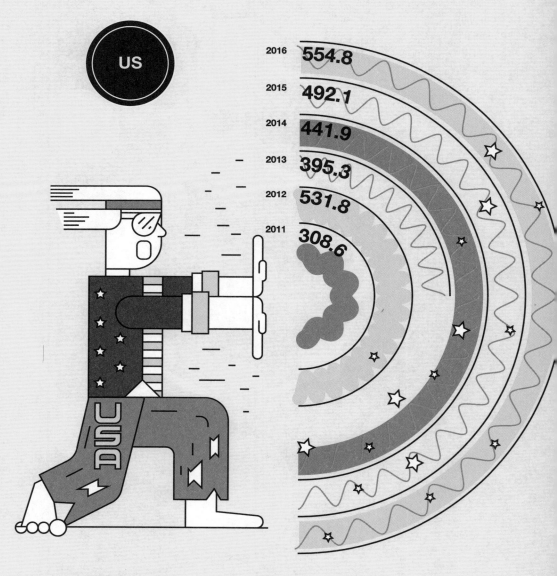

Amounts in billions of US dollars

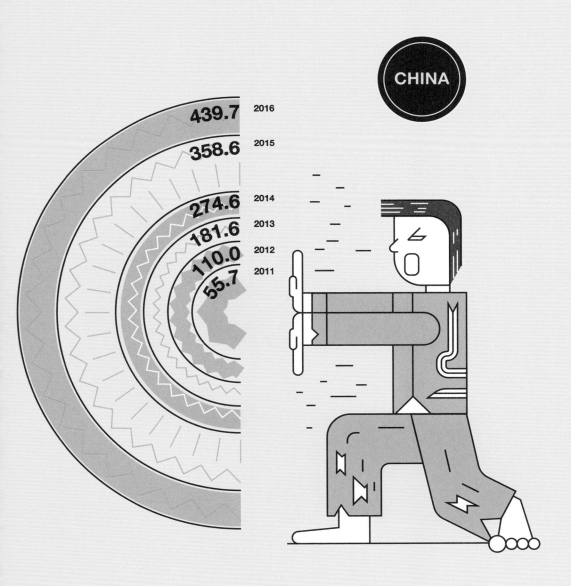

From Deconstruction to Big Data: How Technology is Reshaping the Corporation

Philip Evans

Evans affirms that we are undergoing a re-acceleration of technological change despite the global recession and that something sudden and dramatic is happening. One important aspect of this is how Big Data is reshaping business, and transforming internal organization and industry architecture. He goes on to explain that two information technology drivers are reshaping internal organization: business strategy and the structures of industries. The first is deconstruction of value chains: the breakup of vertically-integrated businesses, as standards and interoperability replace managed interfaces. And the second is polarization of the economies of mass, meaning that in some activities, economies of scale and experience are evaporating, while in others they are intensifying. He doesn't consider Big Data as an isolated or unique phenomenon, but rather as an example of a wider and deeper set of trends reshaping the business world. In his article he describes how the broad logic of deconstruction and polarization of scale can be applied to the specific case of Big Data and the corporation, and finds that these apparently contradictory strategies are mutually complementary.

Philip Evans
Boston Consulting Group

Philip Evans is a Senior Partner with the Boston Consulting Group and BCG Fellow. He founded BCG's Media and Internet practices.
He was educated at Cambridge University, was a Harkness Fellow at Harvard, and obtained an MBA from the Harvard Business School. He is a Director of the Oxford Internet Institute. He is author of many publications, including "Strategy and the New Economics of Information" which won a McKinsey Prize, awarded annually for the best contributions to the *Harvard Business Review*. His book *Blown to Bits: How the New Economics of Information Transforms Strategy* (1999) was a global best-seller.

Key Features for the Company of the Future:

Organize the Business Along Its Potential Fault Lines
The most important enablers of "disruption" are standards and interoperability, which break prevailing value chains. The correct response is to organize around that contingency, loosely coupling successive value-added steps and defining organizational units by their distinct competitive economics. Increasingly this means substituting a more functional organizational structure. This gives managers a clear line-of-sight on the threats they face, and gives senior managers the option to redraw business boundaries and make incursions into the business models of others.

Devolve Key Activities to Autonomous Communities
Within such a loosely-coupled, functional structure, some activities emerge as better done by communities of autonomous individuals. These can be users, independent experts, or enthusiasts, most frequently one's own customers. They can also be communities within the corporation itself: engineers and front-line staff coming together autonomously to swarm over glitches and innovate on features and interfaces. This requires a different mode of management: curatorial rather than hierarchical, enabling rather than directing.

Build Shared Infrastructure
Both within the corporation and across its boundaries many functions are scaling beyond traditional business unit boundaries, possibly beyond corporate boundaries. In particular data and the distributed commodity computing performed on large data sets, become infrastructure: a resource shared across the company. Private and public cloud computing, and industry-wide data sets built as commons, will be essential to new services in many industries. With personal data, where data rights are crucial, this may require that data repositories be mandated as trustees to protect integrity and privacy.

From Deconstruction to Big Data: How Technology is Reshaping the Corporation

Businesspeople everywhere grasp that something sudden and dramatic is happening. Here are five salient observations.

- The number of transistors on an integrated circuit still doubles every two years. Storage density doubles every 13 months. The amount of data transmittable through an optical fiber doubles every nine months.

- Broadband internet access in the G-20 is growing from 800 million (of which 50% mobile) in 2010, to 2.7 billion (of which 80% mobile) in 2015.[1] The number of cellphones in the world is now equal to the number of people. 1-2 billion more people in the world have a cellphone than have a bank account—or a toilet.[2] Smartphone sales reached one billion units in 2013 (up 66% over 2012). Smartphones are the fastest-adopted technology ever.

- Facebook has 1.3 billion active users. 64% visit the site daily (spending an average of 20 minutes). 4.5 billion "likes" are posted daily.[3] Half

a trillion photographs are uploaded to the web each year, and one hundred hours of video to YouTube every minute.

– The number of IP-enabled sensors will exceed 50 billion by 2020.[4] RFID tags now cost as little as 5 cents. Estimates vary, but the range of projections is for the total number of sensors in the world to reach one to ten *trillion* between 2017 and 2025.

– 90% of the world's stock of data was generated in the past two years.[5] 99% of that is now digitized, and over half IP-enabled, meaning that technically it can be uploaded and shared over the internet. Half of the world's knowledge is potentially a single document.

Most of this is really sudden: a re-acceleration of technological change that seems to have occurred in the last decade, after the lull of the dot-com bust, and despite the global recession. It is deeply disorienting: people speak of "disruptive technologies" meaning change which incumbents—by definition—cannot deal with. Managers in established companies crave something more specific than the proposition that they are destined to be "disrupted" by some kids in Silicon Valley. But with the current pace of change it would be a rash person who claimed to be able to forecast the fate of specific businesses or corporations: Apple, for example, has been declared "dead" by commentators in the press 64 times since April, 1995.[6] At the time of writing it is the world's most valuable corporation.

90% of the world's stock of data was generated in the past two years. 99% of that is now digitized, and over half IP-enabled

To cope with this degree of fluidity and uncertainty, the strategist needs to return to first principles. We cannot assume that traditional bases of competitive advantage will last. We cannot presume that hard-earned "excellence," built within the current business model, is the right skill-set for the future. We do not know who our future competitors will be. Indeed the boundaries of the business and the industry cannot be taken for granted. We need to step back and rethink the connection between technology and business strategy.

I believe that the general principle is as follows. Two large phenomena, both driven by information technology, are reshaping internal organization, business strategy and the structures of industries. The first is *deconstruction* of value chains: the break-up of vertically-integrated businesses, as standards and interoperability replace managed interfaces. And the second is *polarization of*

the economies of mass, meaning that in some activities, economies of scale and experience are evaporating, while in others they are intensifying. "Negative" polarization, where economies of scale and experience have weakened, leads to the fragmentation of activities, often to the limiting case of individuals in communities replacing corporations as the principal actors. "Positive" polarization, where they have strengthened, leads to the concentration of activities, often to the limiting cases of utilities, co-ops or monopoly. The combined consequence of these trends is to substitute "horizontal" organization for "vertical," both within the corporation and across industries. The transposition of the industrial matrix.

Deconstruction of value chains and polarization of the economies of mass are reshaping internal organization and the structures of industries

This does not render the traditional corporation obsolete, but it does often mean that corporations need to redefine their role and reshape their business definitions. They need to establish collaborative relationships with communities, especially user communities, where individuals or small proprietorships are more flexible, better-informed about end-use, or can innovate more cheaply. Conversely they need to establish collaborative relations with other institutions, perhaps competitors, to achieve economies of scale and experience that would otherwise be inaccessible. On both sides, strategy becomes a matter of collaboration as well as competition.

Internally corporations need to do much the same thing. Innovation and small-scale experimentation are best done in loose groups where individuals and small teams enjoy a high measure of autonomy. Conversely scale- and experience- sensitive functions need to be centralized across businesses, driving the overall organization to a more functional structure. The internal architecture of the corporation becomes a set of platforms, each supporting activities at smaller scale and with faster cycle times. One platform can be stacked on top of another. And the architecture of an "industry" can be exactly the same, some companies serving as platforms for others, some serving as platforms for end-user communities. The pattern is fractal.

These trends are quite general, and account for numerous industry disruptions. But they apply in particular to Big Data. "Big Data" means much more than vastly larger data sets and exotic software. It requires treating data as infrastructure: centralized, secure, massively-scaled, built as a general resource not for any specific end-use. It also requires treating the processes of inference as "super-structure": iterative, tactical, granular, modular, decentralized. Put the two together internally and you are replacing product- or market-based organization with a functional one. Put the two together externally and you have a fundamental challenge—a disruption—to many traditional business models.

Thus, Big Data is not an isolated or unique phenomenon: it is an exemplar of a wider and deeper set of trends reshaping the business world. Achieving the potential of Big Data is a challenge not only to process and capabilities, but also to organization and strategy. It is an issue for the CEO.

In this chapter I plan to survey the broad logic of deconstruction and polarization of scale, and then apply it to the specific case of Big Data. I hope that by stepping back in this fashion we can see its longer-term strategic and organizational significance.

Deconstruction

Activities can be vertically integrated for two possible reasons: the *technical* need to coordinate a complex or ambiguous interface, and/or the *moral* need to align the interests of the two parties, without contracts and lawyers. Technology weakens both rationales: as economists would put it, technology lowers transaction costs.

The fundamental technical drivers, of course, are the "Big Exponentials": the falling costs of computing, storage, and communication. The first-order consequence is that both parties to a transaction have access to far more (and more timely) information about each other, and about alternatives. Search, comparison, benchmarking, qualification, price discovery, negotiation, and auditing all become orders-of-magnitude cheaper and more comprehensive. In the context of this explosion in reach, the logic for standards becomes compelling: simplifying interfaces, setting mutual expectations, promoting interoperability, and nurturing the network effect. By commoditizing interfaces, standards reduce, often eliminate, the need for technical coordination.

The moral argument is a bit less obvious. Information asymmetries inhibit transactions ("what does the seller know about this used car that I don't know?") Technology generally increases the information symmetry between transactors. So technology can reduce the economic inefficiencies stemming from rationally defensive behavior by the less-informed party. When the repair history of a car can be read from a data socket under the dashboard, buyer and seller can close a deal with much greater ease.

Further, electronic technologies can put transactors in front of a virtual audience. The rating systems curated by Amazon, Etsy, and Yelp give each product or seller a cumulating "reputation" which is a surety for trust. Amazon encourage customers to rate not just the products, but the raters, awarding stars and badges to their most frequent and consistently constructive contributors. The more broadly visible and persistent the reputation, the more an individual can be trusted to act to preserve it; the higher the trust, the lower the need to negotiate, monitor, see for oneself, write and enforce a contract. Reciprocity is

social capital established between two parties: it "hard wires" trust because it requires the investment of multiple transactions between those parties for the mutual trust to be established. Reputation, in contrast, is portable within a community: trust earned in one context can be relied on in another. Reputation "soft wires" trust. Technology enables a wholesale switch from reciprocity to reputation, embeds reputation in data, and allows reputation to scale beyond the traditional limits of geography or institution.

> Electronic technologies can put transactors in front of a virtual audience. The rating systems curated by Amazon, Etsy, and Yelp give each product or seller a cumulating "reputation" which is a surety for trust

Transaction costs serve as a sort of "set-up" cost for a transaction. So, lower transaction costs reduce the threshold transaction size, making it possible to execute smaller, more granular transactions (eBay started as a mart for Pez dispensers). And this feeds on itself: the smaller the transaction, the less the gain from opportunistic acts relative to the reputational risk of being caught taking advantage of a counterparty. People and companies have, therefore, stronger reasons to avoid opportunistic behavior; *other* people have, therefore, stronger reasons for trusting them. Transactions throw off data, data sustains trust, trust enables transactions: a virtuous circle.

Visibility lowers transaction costs by another mechanism increasingly relevant to Big Data: it creates a "negative cost" to transactions, derived from the value of the information generated as a byproduct: the "data exhaust." As long as the parties that are the subject of the data are indifferent to its ancillary uses (an important caveat!), this beneficial offset lowers the *net* cost of transacting. When this positive value is sufficiently high, it can warrant providing the underlying service for free, just to capture the transactional data. This, of course, is the model of many internet services, notably search and social networking. Freeness in turn eliminates another tranche of transaction costs that would otherwise be necessary to maintain accounts, invoice, and collect. (Half the cost of the phone system, for example, is *billing*.) Whether the transactors are (or should be) indifferent is a different question. Just as transparency can *create* trust, so transparency can *require* trust: trust in the entity collecting and using the data.

Exactly how this logic plays out varies, of course, from one domain to another. But the themes are as predictable and recombinant as the ingredients in a Chinese menu: standards, interoperability, information symmetry, reputation-based trust, "free"; all in the context of cheap global connectivity. The pervasiveness of the Big Exponentials, and their relentless downward pressure on transaction costs, result in the universal weakening, and frequent melting, of the informational glue that holds value chains together. This is *deconstruction*.

Polarization of Economies of Mass

Businesses in a traditionally structured industry compete on similar, vertically-integrated value chains comprising a bundle of heterogeneous, roughly sequential activities: sourcing, machining, assembly, distribution, advertising, etc. Advantage in one element might well be offset by disadvantage in another. Many activities exhibit increasing returns to scale and/or experience (which I lump together as "mass"), but many do not. There might even be activities with negative returns to mass: where bigger simply means loss of flexibility and more overhead. This is why, *averaged across all the components of the value chain*, we have typically seen only gently increasing returns for a business as a whole. Therefore, in a maturing industry, multiple competitors could survive, their profitability positively (but not overwhelmingly) correlated with market share.

But deconstruction, by ungluing different value-chain steps and allowing them to evolve independently, undermines the "averaged" pattern of gently positive returns to mass. Instead, each step evolves according to its own laws.

Where economies of mass are *negative* the activity will fragment, perhaps into a population of small proprietorships, such as the developer and producer communities that flourish on such platforms as iOS, Alibaba, and Valve. In the limiting case, autonomous individuals come together in communities for the purpose of "peer production" of information goods. Users of the good or service are often those most motivated and best positioned to make improvements for their own purposes, and if the contribution in question is information, sharing their improvements is costless to the sharer. Contributions can be in such small increments that non-financial motivations—whether fun, altruism, reputation, or applause—can suffice. Maybe it is merely because people are willing to donate their labor, maybe because tasks can now be cost-effectively broken down into smaller pieces, maybe because hierarchical management in some circumstances is merely overhead, maybe because there is some ineffable and emergent phenomenon of collective intelligence: *it works*. Hence Wikipedia, hence Linux, hence the body of reader reviews on Amazon: coherent intellectual edifices built from thousands of autonomous and unpaid contributions.

Deconstruction, by ungluing different value-chain steps and allowing them to evolve independently, undermines the "averaged" pattern of gently positive returns to mass

What is new here is not the possibility of productive communities (they are, after all, a tribal mode of coordination that antedates both markets and hierarchical organization), but rather the new ability of communities to *scale*.

With scale comes complexity, emergent structure, and the gravitational pull of the network effect. For certain kinds of production, globally scaled communities not only get stuff done, but are economically advantaged over traditional corporate hierarchies and markets in doing so.

Where economies of mass are strongly *positive*, the reverse logic applies: the activity concentrates and may indeed become a monopoly. Sometimes the economies of scale were always present but locked inaccessibly within the value chains of competing corporations. Sometimes, as with fiber optic networks, genomic science, cloud computing—and of course Big Data—the scale economies have emerged in consequence of new technologies.

Deconstructing Data

So how does this logic affect "data"? The short answer is that digitization—which is largely complete—permits deconstruction, and we are now entering the era of polarization. Economies of mass—both scale and experience—are polarizing in favor of the very large: that is "Big Data." But they are also polarizing in favor of the very small, as teams and individuals become the vehicles to extract "Big Insight."

Data was the by-product of other activities. It was analog and short-lived: generated and consumed on the spot, or passed along value chains like (indeed *as*) *kanban* tickets on a Toyota assembly line. Most often it was then discarded, or if retained, filtered and formatted in rigid schemas such as accounting, for narrow and predetermined purposes.

Data, like all information, has a fixed cost of creation or collection, so even prior to digitization it was amenable to economies of scale through the amortization of that fixed cost. And the logic of statistical inference has *always* dictated that larger data sets yield superior insight, whether in the number of patterns or discriminations that can be inferred at a given level of confidence, or in the confidence with which a given conclusion can be drawn. But until recently these scale and experience economies have not predominated because of constraints in collection, storage, transmission, processing, and analytical technique. We worked with smaller datasets because we could not cost-effectively gather all the data, array it, and do the sums. Scale and experience economies inherent in data were locked inside processes, places, and value chains.

But digitization drove the cost of data replication to zero, communication drove the span of replication to the universe, and the cost of storage is falling by a factor of a thousand each decade. The "Internet of Things" is how we now gather data, ubiquitous mobility is one of many ways we both produce, transfer, and consume it, and the cloud is the architecture of storage and computation.

Economies of "mass" are extended: scale economies from exploiting the flows of data, and experience economies from exploiting the cumulating data stocks.

"Data wants to be Big." Finally, technology makes that possible.

Consequently, minimum efficient scale for data and the facilities that house it is growing, first beyond the reach of individual business units within the corporation, and ultimately in many cases beyond the corporation itself. Hence cloud computing and remote data centers: first within the corporations, then outsourced to providers such as Amazon enjoying even greater economies of scale. As data hyperscales, it becomes rational to treat it as infrastructure: general in purpose, capital-intensive, supporting multiple activities. It becomes long-lived, as much a stock as a flow.

But the collection of data, in itself, is of very limited value. The valuable thing is the *insight* that can be derived from the data. "Big Insight" requires that the analytical process scale along with the Big Data that it uses. Since the complexity of analysis is often far more than proportional to the number of data points employed, our ability to do analysis on very large data sets is not guaranteed by the progress of the Big Exponentials. A Cray supercomputer running traditional analytical methods at staggering speed is not the solution to the problem of analyzing immense data sets: beyond a certain throughput the machine simply melts. Instead statisticians and computer scientists have developed two new strategies to enable the scaling of insight.

The first is *iteration*: instead of striving for a formal and complete solution to an analytical problem, they construct computationally simpler algorithms that guess at the answer with progressively increasing accuracy. Any estimate, indeed the truth-value of any data point, is merely interim, subject to emendation or correction as new data points are collected. In essence, inference becomes a "Bayesian" process of revising probability estimates as new information is incorporated. And inference becomes a process rather than an act: instead of solving the problem once, the solution is approximated and re-approximated continuously.

Statisticians and computer scientists have developed two new strategies to enable the scaling of insight. The first strategy is *iteration* and the second is *decomposition*

The second strategy is *decomposition*: solving a large problem by breaking it into many small pieces that can be computed in parallel. This is a rapidly developing branch of statistics: finding new ways to solve *in parallel* problems that traditionally have been solved *sequentially*. Such solutions can be calculated, not with a supercomputer, but with racks of cheap, low-performance

commodity servers. So data centers, with hundreds of thousands of such servers, become repositories not just of Big Data but also of computing Big Insight. Instead of the data going to the query, the query must go to the data.

Together, iteration and decomposition allow insight to scale. The "poster child" example of Big Insight is Google Search. The underlying problem is to calculate the "centrality" of each page of the World Wide Web, as defined by the number of other pages pointing to it, but weighting each pointing page by its own centrality score. Mathematically this is the calculation of something called "eigenvector centrality," a trivial piece of linear algebra. The problem is that the number of arithmetical operations required to solve it is proportional to the *cube* of the size of the World Wide Web: with four and a half billion web pages, it cannot be done. Larry Page's inspiration was to develop an algorithm that approximated the solution to this problem well enough for practical purposes. That is PageRank. To implement the algorithm Google runs a crawler: software that searches the internet continuously for new web pages and links. The content of the web pages and their locations are continuously re-indexed and stored in literally millions of servers: each server might contain, for example, a list of the addresses and PageRanks of every web page that contains a given word. When you or I perform a Google search, the heavy work is done by an instance of a program called Map/Reduce, which decomposes our query into its constituent words, sends those queries to the relevant index servers and then reassembles the results to sort the pages most likely to satisfy our search. The Map/Reduce program does not need to know where a specific index resides: instead there is a "virtualization" layer of software, called Big Table, which stands between the Map/Reduce programs and the index servers. Big Table adds and backs up servers, reassigns data among servers, and works around machines that fail, all without the Map/Reduce software needing to know.

Three principles: data-as-infrastructure, iteration and decomposition. In Google Search they work together to solve problems unsolvable by conventional methods, and do so at global scale. And in a quarter of a second. This may seem alien and exotic, but it is merely a pure case of three principles that apply in every corporate environment.

Google Search has an important complementary consequence: it *removes* traditional economies of scale and experience from the process of searching. The searcher does not need to be a professional librarian and does not need to be located in a research institution. All the searcher needs is an internet connection and a browser. So what was a profession, or at least a serious time commitment,

becomes a casual activity available to all. Within Google's own architecture the same thing is true: at low cost, Google can add new algorithms such as Spellcheck and Google Translate that sit on top of Big Table and tap into precisely the same data and computational infrastructure. Small and self-directing teams of engineers can experiment with new products and services, relying on the index servers and Big Table to do all the scale-intensive heavy lifting.

Google expose this architecture to outsiders. They have published about seventy APIs (Application Programming Interfaces) to make Google resources freely available to anybody with a website and simple programming skills. That is how your local restaurant uses a widget from Google Maps to provide driving directions on its web page. In all, some 12,000 APIs have been published by various companies. There is a cottage industry that has produced some 6,000 so-called "mashups" by combining these APIs to create new, small-scale services. These services may be small businesses, they may be hobbies, they may be fads, but it does not matter: precisely because the required resource commitment is so small, the cost of experimentation and the cost of failure have plummeted. The Very Small flourishes on top of the Very Large.

This is how Big Data emerges, not just as a new set of techniques, but as a new architecture for businesses and for industries. Interoperable interfaces such as APIs and Big Table allow different functions to evolve in accordance with their separate economics: they "deconstruct" the traditional value chain of linear inference. Once these interfaces are in place, scale-intensive assets (most notably data and data centers) and scale-intensive activities (most notably large, decomposed computations) can be centralized and managed for efficiency, capacity utilization, security and reliability. Indeed the performance of scale-intensive analytics can (and increasingly, must) be co-located with the data in the data centers. But conversely, tinkering with algorithms, the combination and recombination of different information resources to meet specific needs, and experimental inquiry, are all drained of their scale-intensity: anybody can do it anywhere. The cost of trial-and-error, replication, and redundancy become negligible. The overall "ecosystem" thus exploits the symbiosis between these two kinds of activities: infrastructure managed for efficiency, and communities self-organizing for innovation, customization and adaptability. The classic trade-off between efficiency and innovation is radically finessed.

> **The Very Small flourishes on top of the Very Large. This is how Big Data emerges, as a new architecture for businesses and industries**

So communities, cottage industries, amateurs, self-organizing teams, hobbyists and moonlighters, flourishing on immense platforms provided by the likes of Google, can now compete against the professionals in traditional

organizations. The typical corporation is thus challenged on two fronts: by swarms of individuals and small groups which can innovate, adapt, and experiment at lower cost, and simultaneously by organizations which have a scale and experience level beyond its grasp. The typical corporation may simultaneously be too big and too small.

Too Big: Tapping the Power of Communities

Companies can address the problem of being too big, slow, and cumbersome by exposing their data to the energies and imaginations of external communities. That is what Google do with their web APIs, and Amazon with their customer reviews. (And those companies are no slouches!) This is *risky*: intellectual property may be compromised, and privacy must be protected. Retailers like Amazon risk specific sales from publishing negative reviews, outweighed, they hope, by the greater trust and credibility of the store overall.

One way to tap the energy of communities is through contests. In 2006 Netflix launched a contest to improve its movie recommendation engine. They released an immense, anonymized data set of how some half million customers had rated some 20,000 movies. Netflix promised a grand prize of $1 million to whoever could first improve on their in-house recommendation algorithm by 10%. Intermediate prizes were offered for the best algorithm to date, conditional on partial release of the solution to other contestants to stimulate further innovation. Netflix thus cleverly set up a rich environment for both competition and collaboration. Over three years teams competed, and won intermediate prizes, but to win the grand prize, they were motivated to pool their insights. The winning algorithm, developed by a composite team, improved the predictive accuracy by 10.09%. A phenomenally cheap piece of R&D for Netflix, a common "Big Data" set as infrastructure, and hacker teams fluidly competing and collaborating. An alliance of the very large and the very small.

More recently Orange, the French telecommunications company, released a data set of mobile phone usage in Ivory Coast, where the company is the sole local carrier. The data recorded the usage patterns of some 50,000 randomly selected individuals over a five-month period, deeply anonymized. It showed how cellphone users moved from place to place, and who (by location) spoke to whom. The idea was to allow researchers simply to see what they could find with such an unusually rich data set. One of the most interesting projects was an analysis by some researchers with IBM[7] of travel patterns in Abidjan, the largest city. They used the cellphone data to understand where people originated and ended their daily commutes. This enabled them to re-optimize the bus routes in the city, potentially cutting the average commuting time by 10% without adding any buses. Another powerful application could be in public

health, where patterns of physical mobility predict the spread of epidemics, and patterns of communication can be tapped in propaganda campaigns to help combat disease. This promises a revolution in public health.

In all probability, Orange alone could never have identified these questions, still less solved them: they are a phone company. But the value of the data is bigger than the industry in which it originated, and by opening the data to investigation by all-comers, Orange is pioneering a new way of thinking about their business. Perhaps at some point in the future, phone companies will give away telephony and make their profits from the data: it sounds far-fetched, but so did free research services before the advent of Google. Orange are right to experiment: in the world of Big Data, the insights that the data will yield are unlikely to be knowable before the fact, still less will they be most apparent to the institution that happens to put the data together.

Too Small: Building Data Infrastructure

Big Data scales beyond the confines of the traditional business model in the operation of physical facilities; so companies are outsourcing data processing tasks to the providers of "cloud computing." Cloud providers such as Amazon Web Services enjoy economies of mass relative to their customers. Most departmental servers running one or two applications in the corporate environment achieve only 10-15% utilization, because of the need to provision capacity to accommodate the occasional peaks. Amazon can achieve higher utilization by exploiting the Law of Large Numbers: as long as demand fluctuations are somewhat independent, their sum is proportionately less volatile. Thus Netflix can efficiently serve its movies from Amazon facilities because its peak times—evenings—are out-of-sync with the peak times for many of Amazon's other corporate customers: work hours. Equally important, *managing* such facilities is a specialized skill: an increasingly sophisticated "core competence" that typical corporations may lack. Specialists can manage uptime, back-up, disaster recovery, upgrades, and patches with greater sophistication than can most end-users. They can respond faster to security threats. The cloud provider thus focuses on the classic virtues of general-purpose infrastructure: reliability, ubiquity and efficiency. Customers save money, but more important, gain flexibility. They can mobilize resources, scale up processes, even deploy entire new businesses, in a matter of hours instead of weeks. Flexibility and cheap adaptation are enabled by breaking a traditional value chain into its components and managing the scale-sensitive pieces in a separate organization.

But this story is not confined to facilities: the same logic applies to the data itself. Since Big Data opens the possibility of much larger data sets and far more sophisticated analytics, this can open new opportunities for competitive advantage.

In 1994 Tesco, the UK grocery retailer, piloted a new loyalty card called Clubcard. They hired a husband-and-wife team, Clive Humby and Edwina Dunn, both mathematicians, to do something revolutionary: understand customer behavior using what we would now call "Big Data." Clubcard gave Tesco granular transaction data, by SKU, checkout location, customer, and shopping trip. Dunn and Humby mapped the Tesco product range across about fifty abstract dimensions: size, price-point, color, sweet-salty, and so forth. They then looked at the baskets of goods that families purchased to establish correlations among these dimensions. Purchase of "marker products" revealed households' previously invisible segmentation variables such as budget consciousness, status anxiety, and vegetarianism. Plus segmentation variables that nobody could explain, and nobody *needed* to explain: in the world of Big Data correlation suffices. Tesco then used these correlations to identify non-obvious customer predilections, to identify product pairs that are variously substitutes or complements, and to promote across categories.

The results were spectacular. Redemption rates on promotional coupons reached 20% (compared with 1% for the industry at large).[8] Tesco saved about $350 million by targeting promotions more efficiently. And, propelled largely by Clubcard, Tesco overtook Sainsbury's to become the leading grocer in the United Kingdom.

Big Data scales beyond the confines of the traditional business model in the operation of physical facilities; so companies are outsourcing data processing tasks to the providers of "cloud computing"

For some years, rival Sainsbury's struggled to find a response. Tesco's lead in scale and cumulative experience appeared insurmountable. Sainsbury's eventual and bold move was to *outflank* Tesco by opening Nectar, their new loyalty card, to other retailers. Nectar was launched in conjunction with department store Debenhams, oil giant BP, and credit card company Barclaycard, and managed by a neutral party, a company called Loyalty Management Group. Others have joined since. Nectar users get points to spend at more retail outlets, and Nectar gains both scale and scope in its user data. Sufficient scope might compensate for the initial disadvantage in scale and experience. But note the critical principle: in the era of Big Data economies of mass can extend beyond the boundaries of the traditional business definition; and so value and advantage can be created in new institutions that pool the data.

The same logic is likely to play out on a much larger scale in genomic medicine. Big Data techniques will be used to see fine-grained patterns among individuals' genomic data, medical history, symptoms, protocols, outcomes, real-time data from bodily sensors, and ambient data from the environment.

Medicine will advance by decoding *immense, linked, cheap, noisy* data sets, instead of the *small, siloed, expensive, clean,* and *proprietary* data sets generated by hospital records, clinical trials, and laboratory experiments. By accessing such databases, practitioners and even patients can become researchers, and evidence-based best-practice can be faster diffused across medical communities.

In the era of Big Data economies of mass can extend beyond the boundaries of the traditional business definition; value and advantage can be created in new institutions that pool the data

But an awkward question arises: how can such data be melded when providers, insurers, device companies, pharma companies, Google, patients, and governments not only possess different pieces of the data elephant but guard them jealously and compete on their information advantage? Where pooled data makes sense, how are privacy and patient rights going to be protected? Technology alone cannot solve these problems. The answer—the only possible answer—is architecture. We will need an infrastructure of trusted, neutral data repositories.

These shifts are already happening. Nonprofit organizations are positioning themselves as platforms for the anonymization, curation, and protection of genomic databases. The Million Person Genome Project is up and running, in Beijing. Registries, run by universities and medical associations, are emerging as living repositories for sharing data on evidence-based medicine. New anonymization and encryption technologies reconcile the scientific imperative to share with the personal right to privacy. Building a shared data infrastructure will be one of the signal strategic challenges of the next decade for the healthcare industry and for policymakers.

The Manager's Agenda

It goes without saying that the most immediate agenda with respect to Big Data is operational. People responsible for market research, process engineering, pricing, risk, logistics, and other complex functions need to master an entirely new set of statistical techniques. Highly numerate analysts trained as recently as ten years ago are waking to the discovery that their skills are obsolete. IT departments need to master data processing on an entirely different scale, and frequently in real time rather than offline batch processing. Non-specialist managers need to understand enough about the possibilities and pitfalls of Big Data to translate its output into practical business benefits. Data visualization is emerging as a critical interface between the specialist and the non-specialist. But every company, eventually, will get there: like the

transition from paper spreadsheets to Excel, the new capabilities will simply be "table stakes," not a source of sustainable competitive advantage.

The bigger issue is the potential for Big Data to "disrupt," both as a threat and an opportunity. Deconstruction and polarization of economies of mass are the two key vectors of attack. Deconstruction allows an insurgent to pick off a vulnerable sliver of another company's value chain, even in apparently unrelated businesses. "Negative" polarization of economies of mass allows small companies, maybe even communities of unpaid individuals, to swarm over a task in ways that corporations cannot easily replicate. "Positive" polarization of economies of mass allows corporations with really large data sets to force their way into new businesses, often giving away the product or service just to access even more data. In an alliance of the big with the small, these corporations often expose some of their data to communities, thus attacking the traditional business model from both sides.

In response, the incumbent corporation has to do precisely these things to itself. It needs to deconstruct its own value chains, open some of its own resources to the energies of communities, and, by one means or another, push some of its resources over a much higher threshold of critical mass. This is true whether the purpose is attack or defense. It may require redrawing business boundaries and redefining relations with customers and suppliers. It may require outsourcing functions previously regarded as "core." In some functions it will require a radical decentralization or devolution of authority, perhaps beyond the corporate boundary. In others it will require a radical centralization of resources. The key point—indeed the key corollary of deconstruction and polarization—is that these apparently contradictory strategies are mutually complementary.

As Big Data reshapes business, it will transform two fundamental aspects: internal organization, and industry architecture.

Organizationally, Big Data impels corporations to consolidate databases in order to achieve internal economies of mass. They need to establish a "single point of truth" in real time. This can be an immense challenge, because information on the same customer can be locked in different product lines and different channels. Most corporations cannot connect their online and offline data seamlessly. Rebuilding legacy databases from scratch is infeasible, so managers need to craft a migration path by which investments in a new, more functional architecture can pay for themselves as they are implemented. The legacy data warehouse needs to be shut down, but in stages. The financial case for doing this can appear unimpressive, but it must be evaluated *strategically*. Otherwise, a new entrant, with no legacy, will enjoy an immense advantage.

Big Data impels corporations to consolidate databases in order to achieve internal economies of mass

Conversely the analytical skills to query that integrated database, to find those "big insights," need ultimately to be decentralized into the business units. That will take time, since today those skills are in very short supply, and must be rationed. Corporations need to develop explicit plans to manage this evolution.

The implications of Big Data for industry architecture are all about tapping the superior capabilities of other players. It may require outsourcing innovation to small contributors, especially customers, by exposing APIs and proprietary databases. It may require outsourcing processing and facilities management to a cloud provider that enjoys superior economies of scale and experience. It might involve investing in data partnerships to achieve critical mass collectively that would be infeasible severally. In every case the definition of the business is being changed to accommodate the evolution of competitive advantage beyond the bounds of the traditional business model.

There is one final issue that is really beyond the scope of this chapter, but whose importance cannot be over-emphasized: data rights. It is profoundly ambiguous in most business contexts who "owns" personal data and what rights they have to use it. In principle there is a contract between the data subject and the data user that governs this question. But in practice it is pretty meaningless: data subjects do not read the contracts, have little choice but to sign, and do not know how their data is actually being used. If the terms of data exchange were tightened, as some policymakers have proposed, then the properly open-ended nature of Big Data exploration would be stymied. It is unlikely that these legal and perceptual ambiguities will be cleanly resolved in the next few years. In the interim, corporate (and governmental) use of personal data will depend critically on the *context* in which the data is gathered and used, and on the degree of *trust* enjoyed by the data-using organization. Establishing that context, and building that trust, will be fundamental challenges. Ultimately the legitimacy with which corporations use their data, in the eyes of their customers and the eyes of society, will constrain the rate at which the Big Data revolution transforms our world.

Notes

1
<http://www.businessinsider.com/the-future-of-mobile-slide-deck-2013-3?op=1>

2
<http://newsfeed.time.com/2013/03/25/more-people-have-cell-phones-than-toilets-u-n-study-shows>

3
<http://www.pewresearch.org/fact-tank/2014/02/03/6-new-facts-about-facebook>

4
<http://research.gigaom.com/report/a-near-term-outlook-for-big-data>

5
<http://www.sciencedaily.com/releases/2013/05/130522085217.htm>

6
<http://www.macobserver.com/tmo/death_knell>

7
M. Berlingerio, F. Calabrese, G. Di Lorenzo, R. Nair, F. Pinelli and M.L. Sbodio, "AllAboard: A System for Exploring Urban Mobility and Optimizing Public Transport Using Cellphone Data," *Machine Learning and Knowledge in Databases*, LNCS 8190 (2013), 663-66.

8
<http://www.information-age.com/channels/information-management/it-case-studies/277256/getting-relevant.thtml>

Big Data and the Future of Business

Kenneth Cukier

Cukier makes the point that no area of human endeavour or industrial sector will be immune from the complete shakeup that Big Data is about to bring, as it transforms society, politics, and business. As he says neatly "More isn't just more. More is new. More is better. More is different."

Although there are still limitations (usually based on privacy issues) on what one can get and do with data, most of our assumptions about the cost of collecting and the difficulty of processing data need to be completely overturned.

He sees this new world of data impacting on two main areas of public policy and regulation:

– Employment: we can expect a wave of structural unemployment to spring from the technology in the medium term.
– Privacy, as collecting data happens invisibly and passively, as a by-product of another service.

Cukier envisions Big Data changing business, and business changing society. He hopes that the benefits outweigh the drawbacks, but remains ultimately cautious as he sees society as not very proficient at handling all the data that we can already collect.

Kenneth Cukier
The Economist

Kenneth Cukier is the Data Editor of *The Economist* in London and co-author with Viktor Mayer-Schönberger of the award-winning book *Big Data: A Revolution That Transforms How We Live, Work, and Think* (2013), a *New York Times* Bestseller translated into twenty languages. He is a regular commentator on the BBC, CNN and NPR, and a member of the World Economic Forum's council on data-driven development. Mr Cukier was a research fellow at Harvard's Kennedy School of Government in 2002-04. He is a board director of International Bridges to Justice and a member of the Council on Foreign Relations.

Key Features for the Company of the Future:

Harness Big Data or "Moonshot" Innovations
Companies typically look for a 10% improvement. But this is only a "sustaining innovation" — learning from data to do the same thing that is already done, only marginally better. Over time, this approach distracts from the chances of major breakthroughs. Clever companies of the future will constantly be on the lookout to use Big Data to attain the "moonshot": disruptive innovations that create radically novel products and new markets. These do not improve what already exists, but open up ways to do things in entirely new ways.

Use Big Data for "Small Wins" That Scale Up
Alongside the "moonshot" is its contrary: data used to identify tiny improvements that on their own are insignificant, but when combined together, add up to an outsized gain in performance. In the past, it wasn't worthwhile for a company to go after such "small wins." But as the cost of handling data falls and it is easy to operationalize what is learned, the ability to find and put into practice these "small wins" becomes feasible. It will be the backbone of how companies of the future compete.

Embrace Data Alongside Values and Intuition
Successful companies of the future will learn from Big Data and accept its findings as a check on managers' cognitive limitations, biases and the like. But at the same time, the firms cannot blindly accept its answers, but integrate Big Data into human values of justice, decency and common sense. People must remain masters of the technology, not its servants, for the data is always just a simulacrum of reality, not the real thing. Companies of the future must embrace data alongside a healthy respect for its limitations.

Big Data and the Future of Business

Part I: More

The basis of commercial enterprise is information. Indeed, some of the earliest forms of writing and accounting come from Sumerian merchants around 8,000 BC, who used small clay beads to denote goods for trade and later kept written records of transactions. So when we look at the role of data today, it is easy to say that not much has changed. We may collect, store and use more information—but the nature of data and its importance isn't much different. In this view, Big Data is just a fancy term to describe how society can harness more data than ever, but it doesn't alter the timeless fundamentals of commerce from antiquity to today.

This view, however, would be terribly wrong. For lots of areas of life, when one changes the amount, one changes the form. For example, no one would suggest that because symbols had been pressed into clay tablets, and then words formed and written with ink on scrolls, that the printing press wasn't a major revolution when it was developed around 1450. Yes, there had been words and books before, and yes there were now more words and more books. But it wasn't the same. More wasn't just more: more was different.

The effects of the printing press were the dramatic increase in written materials and the decline in cost of producing them. It was so monumental that the era of "more words" was responsible for sweeping changes. It diluted the authority of the church and the power of monarchies; it gave rise to mass literacy, democracy, capitalism, and a society based on knowledge as an ingredient of labor, rather than just muscle.

Today, the notion of written material—"the book"—changes again, when we see digital tablet computers like the iPad that can store all the books in a major university library in a single device. And it can search it, index it, and allow portions to be easily copied and shared instantaneously. Here too, more isn't just more. More is new. More is better. More is different.

So much for words. Now, think of communications. Society was able to send messages long distances in the past. Carrier pigeons were used in ancient Rome. To communicate with his officers, Genghis Khan created relay posts for carrier pigeons throughout Asia and parts of Eastern Europe. In business, in the 1800s the Rothschild banking family sent their messages by pigeon, as did the market news service Reuters.

> **We have more information than ever. The change in scale leads to a change in state. The quantitative shift leads to a qualitative shift**

But at the dawn of the telegraph, no one could possibly claim that the wires and electric pulses were just an improved version of carrier pigeons. More was different. And then with the telephone: the greater communications, lower cost, and increased ease weren't just more of the same. Likewise, radio. Today, the internet is so fundamentally different than carrier pigeons that it seems ludicrous to compare the two. But that just underscores the degree to which more isn't just more; more is new, better, and different.

Like words and communications, so too data. We have more information than ever. But its importance is not that we can do more of what we already do, or know more about what we already examine. Rather, the change in scale leads to a change in state. The quantitative shift leads to a qualitative shift. By having more data, we can fundamentally do new things—things that we couldn't achieve when we only had lesser amounts.

In fact, we are just at the outset of learning what those things are, since we have always self-censored our imagination about what is possible with data. We did this, unawares, because we could never contemplate the notion of having so much of it around, since we had no idea it would become so easy and inexpensive to collect, store, process, and share. On what basis could we have extrapolated to divine this?

The wisest man with an abacus probably could never imagine the mechanical calculator with dials into the billions. The savant working those dials probably could scarcely imagine the electronic computer. And even once the transistor was invented several years after the first computers, it would have been hard for all but the most visionary engineer to fathom the pace of Moore's Law. As a principle of the digital age, it states that the number of transistors on a chip doubles about every two years, which has meant exponential reductions in cost and increases in power over time.

These changes in the degree to which society can collect and interact with information have had profound effects on how we understood the economy. The very idea of an economy is a relatively recent concept. When the classical economists emerged in Britain in the mid 1700s, their discipline was called political philosophy; the term economics only emerged later. Its veritable founding father, Adam Smith, was a moral philosopher whose major work before *The Wealth of Nations* was *The Theory of Moral Sentiments*.

It is easy to read passages from the classical economists and be led to appreciate the degree to which they were living in an observational and prose-laden world, where commercial affairs were described with the majesty of words rather than the nakedness of numbers—a world of ideas mostly free of data. But this would be incorrect. In fact, Smith's *Wealth of Nations* is teaming with page after page of wheat yields. The earliest thinkers on the economy in the 1700s relied on data significantly to form their ideas.

Yet when it came time to define the factors of production, they identified three: land, labor, and capital. They did not include "information" as a distinct component, even if Smith and others wrote eloquently on how markets rely on information. It is easy to understand why they excluded it. At the time, it was so blindly hard to collect, store and use information that the idea it could be a raw material of business in and of itself would have sounded preposterous. After all, the data would have had to be recorded by a person with a feathery quill pen on stiff parchment. It was expensive and cumbersome to handle and use information. Note that at this time, even basic statistics had yet to be invented. So even if one had the data, there wasn't much one could do with it.

These changes in the degree to which society can collect information have had profound effects on how we understood the economy

Obviously, the situation is totally different today. Of course there are still limitations on what one can get and do with data. But most of our assumptions about the cost of collecting and the difficulty of processing data need to be completely overturned. We still live with a "scarcity" mindset, like old people who hurry to the phone and keep the conversation short because a relative is calling "long distance"—a legacy behavior from the

days of expensive phone calls before market liberalization and new technologies would change the cost of telecoms forever.

And our institutions are still founded on the idea of information scarcity and high cost. Our airplane flight recorders maintain only a tiny amount of data, just several hours' worth of sparse mechanical and cockpit information—a legacy of the era in which they were designed. The recovery signal is weak and the battery is short, about 30 days. The world is now on track to fix these things after the tragedy of Malaysia Airlines flight MH370 that went missing in March 2014.

Yet the "black box" approach could help society in numerous ways: for instance, installing them on police vehicles and onto officers would help courts settle charges of police aggression versus the legitimate use of force. But only few places use them. Likewise, black boxes could enter operating rooms to help surgeons learn from mistakes, help patients harmed by negligence receive fair compensation, or prove that doctors performed flawlessly.

Yet doctors fear that it will open the door to a tsunami of malpractice suits, so have resisted their introduction. And neither the police nor doctors are wrong to hold their quasi anti-data views: it takes time for society to come to terms with how to accept and integrate a new technology and to develop the new culture that it requires. We are only just now getting comfortable with computers a half-century after their mainstream introduction.

In this regard, the experience of social media is instructive. In the critically acclaimed book *Delete: The Virtue of Forgetting in the Digital Age*,[1] Viktor Mayer-Schönberger of Oxford University (and my co-author of two books on Big Data) relates horrendous anecdotes of people denied jobs because of things like a photo of revelry that appeared years earlier on the job candidate's Facebook page. It highlighted the degree to which hiring managers hadn't recalibrated their practices for a world in which our past is ever-present online, and one's juvenile antics need to be "discounted" in a way that they never needed to before.

It will take a while for society to change practices and attitudes to find a reasonable way to bring the technology into our lives and institutions and our values

Likewise, in the Big Data world, many things will be passively recorded just because they exist or they happen. It will take a while for society to figure out how to manage this, and change practices and attitudes to find a reasonable way to bring the technology into our lives and institutions and our values.

Importantly, this tension—between what the technology is capable of and our attitudes and rules in which it exists—marks one of the main frictions the American political establishment has had to grapple with regarding the

Snowden disclosures on mass surveillance by America's National Security Agency. The inherent tension is this: the law was designed for an era when collecting and analyzing data was hard and costly, so embodies those presumptions. Once the same practices became easy and cheap, such as reviewing telephone metadata, activities that might have been considered impossible or at least exceptionally rare in the 1970s when the laws were codified could be considered commonplace in June 2013 when they were made public.

From the view of privacy advocates, the NSA mass surveillance activities were never authorized in law. From the NSA's point of view, the programs were just scaled-up versions of what the law does indeed allow. Shouldn't a security agency avail itself of the same modern tools that its adversaries are using to harm it?, goes the reasoning. The critics retort: get legal approval then, if you want those powers and believe the public will accept a dragnet.

Sadly, the American political system has yet to have a responsible and mature debate on these matters in order to find common ground. Although none of this analysis exonerates any activities, it perhaps takes a step forward in explaining them. Here again, we turn back the central motif of Big Data. More isn't just more. More is new. More is better. More is different.

No area of human endeavor or industrial sector will be immune from the incredible shakeup that is about to happen as Big Data ploughs through society, politics, and business. Man shapes his tools. And his tools shape him.

Part II: Different

The basis of commercial enterprise is information. That has not changed. Thus was it for Sumerian merchants many millennia ago, and so was it a mere century ago when Frederick Taylor performed his time-motion studies in American businesses.

Naysayers may feel that today's talk of Big Data is just a continuation of the past, but they are as wrong as if they were to claim that a tablet computer isn't fundamentally different from a stone tablet, or the web is just a continuation of the carrier pigeon, or an abacus similar to a supercomputer. It wouldn't be 100% wrong, but it would still be so preponderantly wrong as to be un-useful and a distraction.

The point of Big Data is that we can do novel things. One of the most promising ways the data is being put to use is in an area called "machine learning." It is a branch of artificial intelligence, which is a branch of computer science—but with a healthy dose of math. The idea, simply, is to throw a lot of data at a computer and have it identify patterns that humans wouldn't see, or make decisions based on probabilities at a scale that humans can do well but machines couldn't until now, or perhaps someday at a scale that humans can never attain. It's basically a way of getting a computer to do things

not by explicitly teaching it what to do, but having the machine figure things out for itself based on massive quantities of information.

Its origins are fairly recent. Though it was initially conceived in the 1950s, the technique didn't work very well for real-world applications. So people thought it was a failure. But an intellectual and technical revolution has taken place in just the past decade, as researchers have come up with lots of promising achievements using the technique. What had been missing before was that there wasn't enough data. Now that there is, the method works. Today, machine learning is the basis of everything from search engines, online product recommendations, computer language translation, and voice recognition, among many other things.

To understand what machine learning is, it is useful to appreciate how it came to be. In the 1950s a computer programmer at IBM named Arthur Samuel programmed a computer to play the board game checkers. But the game wouldn't be much fun. He'd win, because the machine only knew what a legal move was. Arthur Samuel knew strategy. So he wrote a clever subprogram that, at every move, scored the probability that a given board configuration would lead to a winning game versus a losing game.

Again, a match between man and machine wouldn't be very good—the system was too embryonic. But then Samuel left the machine to play itself. By playing itself, it was collecting more data. By collecting more data, it improved the accuracy of its predictions. Then Arthur Samuel played the computer, and lost. And lost. Man had created a machine that exceeded his own ability in the task that he had taught it.

So how do we have self-driving cars? Is the software industry any better at enshrining all the rules of the road into code? No. More computer memory? No. Faster processors? No. Smarter algorithms? No. Cheaper chips? No. All these things helped. But what really ushered in the innovation is that techies have changed the nature of the problem.

It's been turned into a data problem: instead of trying to teach the car how to drive—which is hard to do; the world is a complex place—the vehicle collects all the data around it, and tries to figure it out. It figures out that there is a traffic light; that the traffic light is red and not green; that this means the car must come to a stop. The vehicle might make a thousand predictions a second. The result is that it can drive itself. More data hasn't meant just more. More data produced different.

The idea of machine learning has led to some spooky findings that seem to challenge the primacy of human beings as the fount of understanding in the world. In a study in 2011, researchers at Stanford University[2] fed a machine-learning algorithm thousands of samples of cancerous breast cells and the patients' survival rates, and asked the computer to identify the telltale signs that best predict that a given biopsy will be severely cancerous.

And sure enough, the computer was able to come back with eleven traits that best predict that a biopsy of breast cells is highly cancerous. The nub? The medical literature only knew of *eight* of them. Three of the traits were ones that pathologists didn't know to look for.

Again, the researchers didn't tell the computer what to analyze. They simply gave the computer the cell samples, their general characteristics, and data on patient survival rates. (This one lived for another fifteen years; this one died eleven months later.) The computer found the obvious things. But it also spotted the nonobvious things: disease signatures that people didn't see, because it was naked to the human eye. But it was spotted by an algorithm. Machine learning works because the computer is fed lots of data—more information than any human being could digest in a lifetime, or instantly remember.

In this instance, though, the computer outperformed the humans. It spotted signs that specialists did not. This allows for more accurate diagnoses. Moreover, because it is a computer, it can do these things at scale. So far, Big Data's "more" has not just been more of the same, it has been "better." But does this constitute "new" and "different" too? Yes.

Consider: by employing this approach at scale, we might be able to read biopsies once a day, every day, on an entire population—not just once or several times in a lifetime. In so doing, we may be able to spot what cancer looks like at its earliest stages, so we can treat it with the simplest, most effective, and least expensive intervention—a win for the patient, a win for society, and a win for government healthcare budgets that pay for it.

How is it new? Keep in mind, the computer did not just improve the accuracy of the diagnoses by adding new signals. It also in effect made a scientific discovery. (In this case, the three traits of severe cancer previously unknown were the relationships among cells in cellular material called stroma, not just features within the cells themselves.) The computer produced a finding that eluded people, and which advances the state of human understanding.

> **Big Data's "more" has not just been more of the same, it has been "better." But does this constitute "new" and "different" too?**

What does it mean to have more data? A powerful example comes from Manolis Kellis, a genetic researcher at the Broad Institute in Cambridge, Massachusetts. As a White House report on Big Data in May 2014 noted: "A large number of genetic datasets makes the critical difference in identifying the meaningful genetic variant for a disease. In this research, a genetic variant related to schizophrenia was not detectable when analyzed in 3,500 cases, and was only weakly identifiable using 10,000 cases, but was suddenly statistically significant with 35,000 cases."[3] As Kellis explained: "There is an inflection point at which everything changes."

The medical industry offers another powerful example of how Big Data is poised to reshape business. Healthcare makes for rich examples because it already has a lot of data, yet it is rather behind the times in using it relative to its great potential. So some of the most impressive wins have begun to happen in the area of healthcare, even though restrictive privacy laws risk hindering progress.

Consider the issue of how to spot an adverse drug interaction; that is, a case when a person takes two different drugs that are safe and effective on their own, but when taken together produce a dangerous side-effect. With tens of thousands of drugs on the market, it is a hard problem to tackle since it is impossible to test all drugs together. In 2013 Microsoft Research and several US universities came up with an ingenious approach to identify these instances: by analyzing search queries.[4]

The medical industry offers a powerful example of how Big Data is poised to reshape business, even though restrictive privacy laws risk hindering progress

The researchers produced a list of eighty terms associated with symptoms for a known ailment, hyperglycemia (such as "high blood sugar" or "blurry vision"). Then, they analyzed whether people searched for one drug paroxetine (an antidepressant) and/or another drug, pravastatin (which lowers cholesterol). After analyzing a staggering 82 million searches over several months in 2010, the researchers struck gold.

Searches for only the symptoms but neither of the drugs were extremely low, less than 1%; background noise. People who searched for the symptoms and one drug alone came to 4%; the symptoms and the other drug alone was 5%. But people who searched for the symptoms and both drugs came to a startling 10%. In other words, people were more than twice as likely to be typing certain medical symptoms into a search engine if they were also looking for both drugs than for just one or the other.

The finding is powerful. But it is not a smoking gun. The police cannot storm the pharmaceutical executives' homes and haul them away. It is just a correlation; it says nothing about causation. However, the results are significant, with profound meaning for business and corporate value. This adverse drug interaction wasn't known before; it wasn't on the label. It hadn't been part of the medical study or its approval process. It was uncovered by analyzing old search queries—again, some 82 million of them.

The value of this data is immense. If you are a patient, you need to know this information. If you are a doctor, you want this information. If you are a health insurance provider, you especially want it. And if you are a drug regulator, you absolutely want it. And if you are Microsoft, perhaps you should

think about establishing a division to license the data as a way to develop a new revenue stream, not just earn income from the ads next to the search results.

This new world of data, and how companies can harness it, bumps up against two areas of public policy and regulation. The first is employment. At the outset, business leaders see the need for new sorts of workers in the labor force—the great age of the data scientist. Management consultants issue dire warnings about a shortage. Universities are gearing up to fill that demand. But all this is very myopic thinking. Over the medium to long term, Big Data is going to steal our jobs. We can expect a wave of structural unemployment to spring from the technology.

This is because Big Data and algorithms challenge white-collar knowledge workers in the twenty-first century in the same way that factory automation and the assembly line eroded blue-collar labor in the nineteenth and twentieth centuries. Then it was muscle that was seen as a commodity and machines could perform better than people. In the future, it will be our minds that are shown to be weaker than the machine. A study by researchers at Oxford University[5] predicts that as much as 47% of work that is done today in the United States is at risk of being taken over by computerization.

Consider the example of the pathologist who is no longer needed because a machine-learning algorithm can read cancer biopsies more accurately, faster, and more cheaply. Pathologists typically have medical degrees. They buy houses. They pay taxes. They vote. They coach their children's football teams on the weekends. In short, they are stakeholders in society. And they—and a whole class of professionals like them—are going to see their jobs completely transformed or perhaps utterly eliminated.

A study by researchers at Oxford University predicts that as much as 47% of work that is done today in the United States is at risk of being taken over by computerization

The benefit is that Big Data will bring about great things in society. The risk is that we all become yoga instructors and baristas to a small group of millionaire computer-scientists. We like to think that technology leads to job creation, even if it comes after a temporary period of dislocation. And that was certainly true for the disruption that took place in our frame of reference, the Industrial Revolution. Then, it was machines that replaced artisanal labor. Factories sprung up in cities and poor, uneducated farm hands could—once labor laws and public education emerged—improve their lives and enjoy social mobility. To be sure, it was a devastating period of dislocation, but it eventually led to better livelihoods.

Yet this optimistic outlook ignores the fact that there are some jobs that go away and simply never come back. As the American Nobel Prize–winning economist Wassily Leontief observed, the Industrial Revolution wasn't very good if you were a horse.[6] That is to say, once tractors were introduced in farming and automobiles replaced carriages, the need for horses in the economy basically ended. One sees the traces of that shift today, in the former stables throughout London's posh West End that have been converted into fancy mews houses.

The upheavals of the Industrial Revolution created political revolutions and gave rise to entirely new economic philosophies and political movements like Marxism. It is not too much of an intellectual stretch to predict that there will be new political philosophies and social movements built up around Big Data, robots, computers, and the internet, and their effect on the economy and representative democracy. Recent debates over income inequality and the occupy movement seem to point in that direction.

Big Data will change business, and business will change society. The hope is that the benefits outweigh the drawbacks

The second policy area is privacy. Of course, privacy was a problem in a "small data" era. It will be a problem in the Big Data era too. At first glance, it may not fundamentally look like a different problem, but only the same problem at a greater scale. But here too, more is different. The nature of securing personal information changes when the potential privacy harm does not happen once a day or once an hour but a thousand times a second. Or, when the act of collecting data does not happen by overt, active means but invisibly and passively, as a byproduct of another service.

For example, websites in Europe are compelled to inform web visitors that they collect "cookies" used to identify people visiting the sites. Such a requirement sounds reasonable on the surface. But what happens when every light fixture in a building is identifying if there is a person in the room on the grounds of security and protection (i.e., in a fire, rescuers know where to go). And the software, at near-zero marginal cost, is sophisticated enough to identify who those people are, based on their image, gait, or perhaps pulse. It is hard to imagine how classic privacy law would handle that world; how a person who feels wronged would take action—or even be aware of the situation.

It gets worse. A basis of privacy law around the world is the principle, enshrined by the OECD privacy guidelines, that an entity discards the data once its primary purpose has been fulfilled. But the whole point of Big Data is that one ought to save the data forever since one can never know today all the valuable uses to which the data can be put tomorrow. Were Microsoft to have deleted its old search queries from 2010, it never would have been able to identify the adverse drug interaction between paroxetine and pravastatin in 2013.

So just as a theme of Big Data is that more isn't just more, but more is new, better, and different, so too modern businesses will need regulators who understand that the rules that govern Big Data cannot just be more—more of the same. In fact, the rules today do a poor job of protecting privacy, so simply heading forward with more of a mediocre policy makes little sense. Instead, Big Data businesses cry out for regulations that are new, better, and different.

Big Data will change business, and business will change society. The hope is that the benefits outweigh the drawbacks, but that is mostly a hope. The reality is that all this is very new, and we as a society are not very good at handling all the data that we can now collect. It was only as recently as the 1893 Chicago World's Fair that a gold medal was won by the invention of the vertical filing cabinet, a then brilliant solution to the problem of the storage and retrieval of paper documents—an era when the stream of information swamped business; the "beta version" of Big Data in corporate life.

What is clear is that we cannot extrapolate to foresee the future. Technology surprises us, just as it would an ancient man with an abacus looking upon an iPhone. What is certain is that more will not be more. It will be different.

Notes

1
V. Mayer-Schönberger, *Delete: The Virtue of Forgetting in the Digital Age* (Princeton: Princeton University Press, 2009).

2
A.H. Beck et al., "Systematic Analysis of Breast Cancer Morphology Uncovers Stromal Features Associated with Survival," *Science Translational Medicine*, 3.108 (2011) <http://stm.sciencemag.org/content/3/108/108ra113.full.pdf>

3
"Big Data: Seizing Opportunities, Preserving Values," Executive Office of the President of the United States, May 2014 <http://www.whitehouse.gov/sites/default/files/docs/big_data_privacy_report_may_1_2014.pdf>

4
R.W. White et al., "Web-scale Pharmacovigilance: Listening to Signals from the Crowd," *Journal of the American Medical Informatics Association*, 20.3 (May 2013), 404-8 <http://www.ncbi.nlm.nih.gov/pubmed/23467469>

5
C.B. Frey and M.A. Osborne, "The Future of Employment: How Susceptible Are Jobs to Computerisation?" Oxford University, September 17, 2013 <http://www.oxfordmartin.ox.ac.uk/downloads/academic/The_Future_of_Employment.pdf>

6
W. Leontief, "National Perspective: The Definition of Problems and Opportunities," in *The Long-Term Impact of Technology on Employment and Unemployment: A National Academy of Engineering Symposium* (Washington: National Academy Press, 1983), 3–7 <http://books.google.com/books/about/The_Long_term_Impact_of_Technology_on_Em.html?id=hS0rAAAAYAAJ>

The Nature of the Firm—75 Years Later

Geoffrey Moore

Geoffrey Moore looks at Coase's influential 1937 article "The Nature of the Firm" and applies it to business leaders in 2014 looking to shape the future of their firms.

Among many findings he sees profound changes in the structure of the firm itself, as in the digital economy most of the resources will be contractors working outside the firm. This will be deeply disruptive to the hierarchical management structures that provided middle-management, middle-class jobs for most of the twentieth century.

As a result, more generally middle-class employment will shift from an economy dominated by its largest institutions to one where smaller, more agile firms will take up more of the burden; subsequently governments will struggle to deal with the impact caused by this new geometry.

Geoffrey Moore
Geoffrey Moore Consulting

Dr Geoffrey Moore is an author, speaker, and advisor to start-up companies in the Mohr Davidow portfolio and established high-tech enterprises, including Salesforce, Microsoft, Intel, Box, Aruba, Cognizant, and Rackspace. His life's work has focused on the market dynamics surrounding disruptive innovations. His first book, *Crossing the Chasm* (1991), sold over a million copies; his most recent work, *Escape Velocity* (2011), which addresses the challenge large enterprises face when they seek to add a new line of business to their established portfolio, has been the basis of much of his recent consulting. He is now chairman emeritus of three firms he helped found: The Chasm Group, Chasm Institute, and TCG Advisors.

Key Features for the Company of the Future:

Re-architect Your Firm from the Outside In
Begin by clarifying everyone's understanding of how the overall value chain and ecosystem that serves your customer creates value. Then circumscribe your role within that ecosystem and describe its interfaces both to the customer and to the other members. Then design your organization to deliver value to and through those interfaces. Finally, back everything up with a productivity capability to improve your capacity, efficiency, and effectiveness. Now you are ready to take on an ever-changing world.

Explicitly Distinguish Between the Roles of Manager and Leader
Management is the key to success in stable markets where the value proposition, the value chain, and your role within the chain all remain constant from year to year. Leadership, by contrast, is required when your market gets disrupted and you have to throw out the old playbook and make a series of high-risk, low-data decisions which then have to be adjusted in flight as you discover how the emerging new dynamics are actually playing out. Both management and leadership are key to a successful enterprise, but each is a mismatch for the other's job.

Redefine the Role of the Middle Manager
Abandon the notion of a hierarchical model where the middle manager takes instructions from above to deploy below and takes data from below to inform above. Instead, position the middle manager as master of the interfaces with the customer and the partners, empowering them to detect, analyze, and address mismatches through negotiation, adjustment, and reform. Let them own the customer and partner experience end to end, and have everyone else above and below support them in the effort.

The Nature of the Firm—75 Years Later

In 1937, Ronald Coase published a seminal article titled "The Nature of the Firm." In it he posed a couple of deceptively simple questions:

- Why do successful firms grow larger?
- Why does the growth in size of a successful firm at some point level out?

He answered both of these questions with a theory of *transaction costs*. In this context, he pointed out that doing any kind of non-core work outside the firm has the advantages of leveraging someone else's capital investment and expertise, but that procuring the right product or service from the right vendor as well as managing the relationship with that vendor and the workflow connecting the two companies imposes a transaction cost. When that transaction cost exceeds the benefits of outsourcing, then it behooves the successful company to bring the function in house. That, of course, increases the size of the firm.

At some point, however, the transaction costs of performing a function inside the company also begin to increase. The larger size of the organization and the bureaucratic processes that govern internal transactions begin to impinge on

the benefits gained. Eventually a point of equilibrium is reached where the cost to do the transaction internally approximates the cost to do it externally, and the growth of the firm attributable to internalizing non-core workloads levels out.

This is a very elegant idea, and it sheds important light on changes in the global business landscape over the past fifty years. In the era from 1965 to 1990, Western developed economies enjoyed a prolonged period of economic expansion meeting primarily domestic demands for modern industrial production capabilities and a higher quality of consumer life. Demand, in general, exceeded supply, putting the power of the economy in the hands of whoever deployed investment capital. The canonical successful firm of this era was a vertically integrated enterprise run by a hierarchy of executives and managers following a command-and-control paradigm familiar to many through exposure to military, church, or government organizations.

What the technology sector learned along the way was that it could respond much faster to disruptive innovations through the disaggregated model than it could through the older vertically integrated one

In the last decade of the twentieth century, developments in information technology began to erode the power base of this model. Within the tech sector, the vertically integrated "stack" of computing resources was becoming horizontally disaggregated. That is, a computing company in the 1970s and 1980s made all its own subsystems—from the CPU and memory chips and the printed circuit boards they plugged into, on up through the storage devices, networking equipment, operating systems, databases, and management systems, all the way up to and including the business application programs. By contrast, during the 1990s, first in the PC industry, then in the minicomputer industry, and finally globally across all IT platforms, these various domains were standardized and then outsourced to companies that specialized in just one level of the stack. This occasioned enormously rapid growth to the benefit of, among others, Intel in microprocessors, Samsung in memory chips, the Taiwanese manufacturing sector in printed circuit boards, EMC in storage, Cisco in networking, Microsoft in operating systems, Oracle in databases, IBM and others in management systems, and SAP in business applications. What the technology sector learned along the way was that it could respond much faster to disruptive innovations through this disaggregated model than it could through the older vertically integrated one. It was able to do this by standardizing the interfaces among the various layers of the stack so that transaction costs could be reduced in multiple ways—fewer design decisions, more vendors competing, less technical risk, faster time to market.

Interesting though these developments might have been had they simly been confined to the tech sector itself, in fact they were exported across the entire manufacturing sector, both industrial and consumer, primarily by leveraging the deployment of global ERP business applications enabled by internet connectivity. This IT infrastructure, initially trumpeted as an Information Highway, turned out to be a Work Transport Highway, and within the space of a decade enabled a massive shift in economic output from the developed economies to Asia, most notably China for manufacturing services, and India for English-speaking business services. No program of foreign aid has ever remotely accomplished the social good that this shift has engendered, so while it has created subsequent challenges for developed economies which have yet to fully come to grips with its destabilizing effects, nonetheless in itself it must be deeply honored.

To return to Coase's model, universal adoption of ERP systems dramatically reduced the transaction costs of outsourcing non-core business workloads across a global landscape. By using technology to provide round-the-clock visibility and timeliness of response, the new infrastructure enabled outsourcing to migrate from low-risk, low-value workloads to high-value, mission-critical processes, ones that not only generated massive savings in operational costs but also allowed enormous amounts of time, talent, and management attention to be redirected to innovations in the client companies' differentiating core.

That said, these global IT systems that drive both private and public enterprises are not without their drawbacks. They are complex to deploy, complicated to use, and challenging to maintain. This ultimately led to a leveling off at a new point of equilibrium during the first decade of the twenty-first century. Meanwhile, however, venture investment in computing technologies had already migrated away from the enterprise to explore and exploit a whole new sector of opportunity—consumers.

Led by Facebook, Google, Apple, and Amazon, consumer IT has arguably had an even more revolutionary impact on personal, social, and cultural life than industrial IT has had on global commerce. Smartphones and tablets are reengineering whole swaths of the consumer economy, from information access (Google) to communication (Facebook and Twitter) to media and entertainment (YouTube) to transportation (Uber) to hospitality (Airbnb) to dining (OpenTable and Yelp), and beyond. And in the process they are also reengineering our very selves as human beings, as anyone with a child or grandchild under the age of six can testify.

In the first decade of the twenty-first century venture investment in computing technologies had already migrated away from the enterprise to explore and exploit a whole new sector of opportunity—consumer

Most importantly for our discussion here, these facilities are so compelling they have demanded—and secured—representation in the enterprise, which means that the client end of the old client-server stack is being completely revamped by mobile and social technologies. At the same time, the big data analytics and cloud computing that enabled consumer IT to scale are now also being coopted by enterprises to help them scale their reach and increase their efficiency and effectiveness.

The end result is an IT infrastructure that is transforming before our very eyes, which in turn, perhaps less noticeably but no less profoundly, is transforming the way private and public enterprises will conduct their affairs going forward. And that is what this chapter is really all about:

What happens to the transaction costs of an enterprise once it has adopted both the global systems of record deployed in the 1990s and the human-centric systems of engagement deployed during the current decade?

Business Model Migration

Not surprisingly, transaction costs decrease—dramatically! All the overhead, all the delays, all the errors, all the confusion created by complex systems and well-intentioned but imperfectly informed human beings—all that sludge is being flushed from the system. The work has just started, of course, but wherever the pipes have been cleared, the money has flowed with abandon.

Interestingly, as transaction costs decrease, the value of services relative to products increases. That is because one of the key selling points of a product is that it eliminates future transaction costs once it has been purchased (exclusive of any ongoing maintenance). You buy a car so that you don't have to keep on renting one. But in a digitally instrumented economy, renting on demand becomes a much more viable alternative, not just for the occasional ad hoc requirement but for recurrent usage. Software as a service, media as a service, transportation as a service, manufacturing as a service—these are the engines driving economic growth in a digital economy. Their rise to prominence entails a shift to *consumption economics* as chronicled by J.B. Wood and Todd Hewlin in their book of the same name, a world in which risk has been transferred from the buyer to the seller—*caveat vendor*!

Developments of this sort should put every product company on notice to answer two questions:

— What is it about our product model that leads us to believe it can hold its own against rival service models?
— To what degree would our customers prefer us to recraft our offer into a service, and what would be the gains and risks of such a move?

A well-crafted hybrid model would almost certainly outperform a pure play, but it is far from obvious today what "well-crafted" should look like. Brick and mortar retailers, for example, are trying to sort this out in their competition with e-commerce giants like Amazon, and intellectual property owners in media and entertainment are seeking a comparable outcome with respect to licensed product versus subscriber service fees. In the short term, these dislocations can be excruciatingly painful as the shift in model, even if done on equal pricing footing, creates a major divot in cash flows.

As products become services, the value of the product's functionality itself commoditizes, and differentiation shifts to the experience of using the offer rather than the performance attributes of the offer itself. This is giving rise to an experiential economy first written about by Joe Pine in 1998

A second form of migration follows shortly upon the heels of this one as well. As products become services, the value of the product's functionality itself commoditizes, and differentiation shifts to the experience of using the offer rather than the performance attributes of the offer itself. This is giving rise to an experiential economy first written about by Joe Pine in 1998. As consumer preferences become increasingly determined by experiences, and as the landscape of experience becomes increasingly mediated by digital devices and communications, the zone of untapped value that future innovations can exploit is falling to a new job category—*user experience design*—with companies like IDEO and others capturing the early mindshare. It is now no longer just the "out-of-box" experience that warrants consumer product vendors' attention but the ongoing convenience and simplicity across the entire length of the consumption to disposal chain.

Finally, an indirect consequence of embedding digitally automated services into the consumption chain is a pronounced shift in power from the vendors and retailers to the consumers themselves. Competitive advantages based on price, availability, and selection—historically the three king-making elements of a successful wholesale-retail value chain—are largely neutralized in a digitally mediated landscape, allowing consumers themselves to become the new king-makers. To be sure, experiential innovation still holds power, but that experience is itself a negotiated outcome in which the consumer brings as much to the table as the service provider. This, in turn, is transforming marketing from a mono-directional broadcast affair in which the sponsor controls the content of the exchange end to end to a dialogue in which even such precious elements as brand attributes must be negotiated socially if they are to truly register and stick.

The Impact on the Firm

The net of all the above is that the very structure of the firm is evolving, its boundaries becoming more porous and less defined, as a digital value chain readily allows not only third parties but even consumers themselves to participate in the overall value creation effort. No doubt this will create a new generation of liability cases focused on determining the boundaries of accountability, and I do not envy the adjudicators of these cases as those boundaries are inherently fuzzy.

The structure of the firm is evolving, its boundaries becoming more porous and less defined, as a digital value chain readily allows consumers themselves to participate in the overall value creation effort

That said, we have learned something important from the world of marketing about fuzzy boundaries and how to manage them. For the world of market segmentation is just that—no market segment has a firm and fixed boundary. Every segment is a fuzzy set, in which any particular prospect participates to some degree, from 100% dead center to 1% at the absurdly lunatic fringe, with most of the "interesting" prospects being around 80% or more "inside" the set. But there is no line to be inside. Instead there is a center point in relation to which your "closeness" is assessed. And that is the key to managing fuzzy boundaries—keep your focus on the center point instead of arguing about the edge.

Applying this notion to the evolution of the firm, the digital reengineering of the global economy is driving a migration of the firm's center point from the means of production to the means of distribution and from management of its physical assets to management of its intellectual property. That is, in a world of pervasively outsourced manufacturing, power shifts from control of supply to control of demand, and the company that "owns" the relationship with the end customer prevails over the other members of the value chain, as we witnessed so dramatically in the rise of Apple first in the music business and then in smartphones. And if you look to Apple's power, or Amazon's or Facebook's or Google's or any other of the new digital powerhouses, it is in their intellectual property, be that patented technology or closely guarded trade secrets, far more than in the physical assets they control.

Now, to be sure, some sectors of the world economy are as yet still highly insulated from these effects. The energy sector, in particular, continues to value itself appropriately on physical assets almost entirely, although even there one can find digital disrupters reengineering energy storage and distribution in a variety of technologically enabled ways. And food, as long as we live on this earth, can never

be digital, nor can clothes, housing, and the other necessities of daily life. But all these things can be and are being transformed experientially via digital facilities. What you eat and how you procure it, whether you are buying baby clothes or sharing them, where you stay when you travel—all are fair game for being recast in the digital age. Firms which are able to pull these levers can be expected to outperform their peers considerably even in undisrupted sectors of the economy.

Taking Stock: 2014 and Beyond

What does all this mean for business leaders in 2014 looking to shape the future of their firms? First and foremost, it means rethinking the structure of the firm itself. Historically, as firms have scaled, they have done so hierarchically—meaning that they develop a management system that extends its span of control over larger and larger reporting structures. But in the digital economy, where a network of specialists trumps a cohort of employees, many if not most of the resources working on your behalf will be contractors working outside the firm.

Contracted services still require management, but of a very different kind. One is still responsible for what the contractors are doing but not for how they are doing it. This puts much more emphasis on framing and negotiating service level agreements at the beginning of work orders, insisting on monitoring systems to give visibility into work in process, and developing test and acceptance systems for signing off on the work at the end. The whole relationship is much more horizontal, more peer to peer, than managing an in-house team.

> **In the digital economy, where a network of specialists trumps a cohort of employees, many if not most of the resources working on your behalf will be contractors working outside the firm**

This change in orientation is having its primary impact on the middle of the organization. Top executives continue to focus on strategy, resource allocation, performance commitments and the like. And entry level workers continue to manage the transactional work that represents the day to day interactions with customers and suppliers, partners and employees, regulatory agencies and tax authorities. But the people we used to call "middle managers" are now finding themselves with fewer and fewer people to manage.

At the same time, however, this middle cohort has in its hands the core implementation of the enterprise's annual plan. To succeed they need to become more outward facing, more entrepreneurial, and more engaging than their parents' generation, and this in turn will require universities and graduate schools, as well as enterprise training and development programs, to revamp their curricula to build the new muscles required.

More generally, the whole underpinnings of middle class employment are shifting from an economy dominated by its largest institutions to one where smaller, more agile firms will take up more of the burden. Even the most successful specialist contractors will not scale to anything like the size of today's behemoths—that would only increase their transaction costs. The optimum configuration of resources will be one which maximizes its number of external touch points and minimizes its internal overhead. Think of this as a geometric figure that maximizes its surface area while minimizing its volume—something much more like a bunch of grapes than a watermelon.

Governments will be puzzled and frustrated by this new geometry. They are large-scale institutions designed to interface with other large institutions—plate to plate, as it were—particularly in relation to matters of economic policy and social welfare. Public/private partnerships are increasingly likely to stumble because the emerging economic units, the active ingredients of the new economy, are too granular and changeable to engage with a large, command-and-control infrastructure. Government hierarchies do not match up well with the smaller economic entities, nor does their funding and fund-raising. As a result, governmental policies are more likely to focus on propping up large decaying incumbents than accelerating economic growth by supporting the new crop of winners—not a recipe for success.

This in turn has serious implications for middle-class welfare. As we have noted, the digital economy is deeply disruptive to the hierarchical management structures that provided middle management, middle-class jobs for most of the twentieth century. Where will middle-class incomes come from in the future? And can we reasonably expect our governments to even be looking in the right places, given their structural tilt in the wrong direction?

To sum up, taking stock of both the opportunities and the challenges digital disruption is bringing forth, here are some key implications for business leaders and investors to contemplate as we migrate toward a post-industrial economy:

– Low-cost operational excellence based on supply chain efficiencies is becoming sufficiently universal as to no longer be a strategy for differentiation in a developed economy. It will still be possible to differentiate on price, but this will largely be based on revamping sales, marketing, and distribution processes leveraging big data and analytics—things outboard of the bill of materials.

– Product innovation will continue to be rewarded under this new system, but the length of time differentiation can be maintained will be shortened by virtue of an increasingly quick to respond supply chain. Products themselves, as we have noted, will be reconfigured as services wherever that is to the benefit of the customer, something which will also entail considerable use of big data and analytics.

– Digitally enabled customer service on the demand side is the new battleground, where companies can seek to neutralize (e.g. catch up) or differentiate (get a competitive advantage). Mobile devices and social communications networks have become pervasive and powerful. Firms cannot afford to stand pat with their old non-digital approaches, regardless of how successful they have been in the past.

– Removing the cost of the middle man will be the primary source of funding to pay back investment in this next generation of digitally enabled customer service. Service providers whose primary differentiation has been helping customers navigate the complexities of an inefficient marketplace will find themselves disintermediated by digitally enabled systems that either mask this complexity or bypass it altogether. This is already commonplace in financial services and high tech, is well under way in retail and media & advertising, and is on the horizon for health care, education, and other citizen services.

These are not new ideas. Prognosticators have been forecasting much of this for decades. The whole dot.com fiasco was based on making big early bets on just these trends. But as with all things disruptive, we humans tend to overestimate the impact in the short term and underestimate in the long term. All we are saying now is that the long term is arriving.

Business Models, Information Technology, and the Company of the Future

Haim Mendelson

Professor Haim Mendelson addresses the evolution of business models while considering the huge impact of the advances in information technology. Taking a long-term view, he sees information technologies continuing to evolve along their current performance trajectory. He argues that the combined effect of mobile technologies, wearable devices and sensors, cloud computing, and "Big Data" technologies will refine the structure of future business models. To this end he envisions scenarios such as:

- Customer intimacy agents being customers' digital representatives in the marketplace, using data to find and solicit solutions that will make them better off.
- Value chain coordinators matching supply and demand, assembling customized solutions and engaging in electronic customer-data-driven innovation.
- Producers increasingly engaging in marketplace selling and data-driven innovations.

At the same he believes that traditional forms of innovation will continue to remain key differentiators, and that underlying business models will require continuous innovation which will likely take a traditional form, with breakthrough products still continuing to require traditional forms of innovation.

Haim Mendelson
Stanford University

Professor Mendelson is the Kleiner Perkins Caufield & Byers Professor of Electronic Business and Commerce, and Management at the Stanford Business School and codirector of the Stanford Value Chain Innovation Initiative. He leads the School's efforts in studying electronic business and its interaction with organizations, markets, and value chains, and incorporating their implications into the School's curriculum and research. His research interests include electronic business, the information industries, electronic markets, supply chain management, and market microstructure. He has been elected Distinguished Fellow of the Information Systems Society in recognition of outstanding intellectual contributions to the Information Systems discipline. He has published more than a hundred papers in leading journals and is an author of the book *Survival of the Smartest* (2004).

Key Features for the Company of the Future:

A Well-Articulated Business Model
The company can effectively recalibrate it for the demands of the future: a value-creation model identifying the company's target customers, its offerings, and how they create and deliver value to these customers; a profit model identifying the drivers of profitability; and the logic of the business, showing how and why the company will achieve its profitability and growth targets. An explicitly defined business model will facilitate dynamic changes as well as enable the company to interface with customer intimacy agents and value chain coordinators.

Agility and a High Organizational IQ
As described in my book, *Survival of the Smartest*, these are necessary to cope with the demands of dynamic changes in the company's environment and its own business model.

An Ecosystem That Enables the Company to Focus on Its Core Competence
At the same time it would provide end-customers with a comprehensive solution. As I argue in this chapter, successful companies will interact with other participants of their ecosystems to dynamically reconfigure their offerings.

Business Models, Information Technology, and the Company of the Future

I. What is a Business Model?

Business models are stylized models that describe how companies create and deliver value to their customers, and how they get rewarded for doing that. The business model construct encompasses the product or service, the customer and market, the company's role within the value chain, and the economic engine that enables it to meet its profitability and growth objectives. Business models are often used by startups as modeling tools to help them design, prototype and build their new ventures. They are also used by established companies to plan, develop and support their innovation process. In this chapter, I use the business model construct to predict how companies' architectures and business model development processes will evolve into the future.

A business model is a structured blueprint which attempts to bring order and discipline to the chaotic process of building, growing and operating a business. Some authors define the business model concept broadly,[1] which I think reduces its usability. My view of the business model concept focuses on the way the business creates value and extracts revenues and

profits, which is defined by three core elements: a *value-creation model*, a *profit model*, and the *logic* of the business. Each of these elements is specified by answering a few basic questions:

- **Value-Creation Model**
 - Who are the venture's customers and what is its product or service offering?
 - How does the offering create differentiated value for these customers?
 - What are the venture's go-to-market strategies?
 - What is the value chain for the offering, and what parts of the value chain does the venture participate in?

- **Profit Model**
 - What are the venture's sources of revenue?
 - What is the venture's cost structure?
 - What are its key drivers of profitability?

- **Logic**
 - How will the venture meet its profit and growth objectives?

Specifying a Value Creation Model

The first step in business model construction or analysis is the specification of a value-creation model. This involves first identifying the target customers and the offering that will create differentiated value for them. Differentiation is important: to attract customers and make a profit, the offering has to be better than the competition on a dimension that makes a substantive difference to customers. The dimensions of differentiation vary across companies. For example, Walmart creates differentiated value for cost-sensitive consumers by selling a large variety of products at low prices. Apple creates differentiated value for consumers who are willing to pay for well-designed, "cool," innovative products. USAA provides financial services to US military personnel and their families at superior quality by targeting their specific needs: for example, it accepts check deposits from soldiers' smartphone cameras,[2] and it heavily discounts customers' auto insurance premiums when they are deployed overseas.

Having a product or service that truly solves a significant problem for a well-defined customer segment is a good start, but it's not enough. Any business needs to have effective go-to-market strategies that focus on getting the product or service to market, acquiring customers, securing revenue and market traction, and growing the market. A go-to-market strategy

specifies how the business will bring customers in and how it will ultimately deliver to them the value it creates.

Finally, value creation takes place along an end-to-end value chain. However, companies have to choose which parts of the value chain they will actually participate in. For example, a company that develops new technology may choose to license its technology to an established player without being involved in either production or distribution. Or, the company may manufacture the product in-house and sell it as a component to a better-known company that embeds it in its own branded product. Another alternative is to manufacture and market the product under the company's own brand name. As we proceed from the first option to the third, the company covers an increasing portion of the value chain for the final product.

Specifying a Profit Model

The profit model of a business starts with an identification of its revenue streams and the associated costs. Since revenue = price × quantity and price is a key dimension of the value created for customers, it links the value-creation model to the company's profit model.

– Revenue Models

The most common revenue models are *transactional*: customers pay a fixed price per unit of the product or service, for example, $3 for a dozen eggs at the supermarket or $3 per gallon of gasoline. Transactional revenues may also incorporate fixed fees and quantity discounts.

A different type of revenue model is a *subscription model* under which customers pay a fixed fee per unit of time, and they receive in return a fixed number of units of the product or service (e.g, one copy of a newspaper each weekday) or unlimited use over the subscription period (e.g., monthly membership at the gym).

Another revenue model, commonly used for intellectual property, is the licensing model whereby the customers pay a royalty or license fee which allows them to use, sell or copy the product within a given period of time (unlimited in time if the license is perpetual), subject to limits on the scope of use based on geography, nature of use, etc. For example, software is mostly sold using a perpetual license, and the owner of a patent may license its technology to other companies in return for a license fee.

Businesses often receive multiple revenue streams, where different customers pay according to different formulas or revenue models, or hybrid revenue streams, where a given customer's payments combine different revenue models. For example, in the eBay marketplace, sellers pay a subscription fee if they

"rent" an eBay online store, a fee per listing, and a fee for each transaction which is consummated on the platform.[3] These fees vary based on the nature of the listing or transaction, the product category, and the pricing format, but their averages can be estimated. We can thus write the periodic revenue as the sum of subscription revenue, listing revenue, and transaction revenue, where each of these in turn has different drivers.

– Cost Structure

The cost structure specifies the activities that drive the different costs of the business and how fixed and variable costs add up to total cost. For example, in a manufacturing operation, materials costs are proportional to the volume of units produced, whereas delivery costs may depend on both shipping distance and volume. Variable costs may be proportional to volume, or they may exhibit economies of scale—for example, purchased materials with a quantity discount. In some cases, they exhibit diseconomies of scale, for example, when an operation approaches its capacity limit, or when key resources are so scarce that their marginal costs are increasing. Each of these scenarios gives rise to a different cost structure.

Logic of the Business

The logic of the business explains how the business will meet its profit and growth targets. It comprises an argument showing why the business will be successful, that is, how it will attract customers, be competitive and profitable, and grow. This often takes the form of a "virtuous cycle" which shows how the basic elements of the business model reinforce one another.

There are a few recurring business model archetypes, each characterized by its own logic. I outline below the logic of three archetypes: one based on customer intimacy, where the business tailors solutions to customer demand at the front end; one based on operational excellence, which is based on superior back-end processes; and one based on value chain coordination, which creates value by coordinating front- and back-end elements of the value chain. I chose these three business model archetypes as I believe each will play an important role in structuring the company of the future.

– Customer Intimacy: Tailoring Solutions at the Front End

Our first business model archetype uses customer information to tailor solutions that satisfy unique, or highly-targeted, customer needs. This logic is often called *customer intimacy*.[4] The logic of customer intimacy is based on a continuous learning relationship with customers, which means that the business has to initiate explicit or implicit dialogues with them, capture information

about their behaviors and preferences, and use that information to customize products or services to these preferences. Customer intimacy has been practiced for literally thousands of years, but as I argue below, developments in IT will make it one of the central building blocks of the company of the future.

As an example of traditional customer intimacy, consider Ritz-Carlton, the operator of five-star luxury hotels and resorts around the world.[5] Ritz-Carlton is the first and only hotel company that received the prestigious Malcolm Baldrige National Quality Award twice, and is the winner of multiple awards for its high-quality customer service. Ritz-Carlton's credo reads as follows: "The Ritz-Carlton Hotel is a place where the genuine care and comfort of our guests is our highest mission. We pledge to provide the finest personal service and facilities for our guests who will always enjoy a warm, relaxed, yet refined ambience. The Ritz-Carlton experience enlivens the senses, instills well-being, and fulfills even the unexpressed wishes and needs of our guests."[6]

To achieve its mission, the company focuses on customer loyalty via customization which relies on extensive data gathering and capitalizes on both employee attitudes and IT capabilities. Information is gathered and recorded during each customer interaction and service request. The information is systematically entered into a database which is accessible to all Ritz-Carlton hotels worldwide. Using the database, hotel staff strive to anticipate on a daily basis the needs of each guest and initiate steps that ensure a customized, high-quality service experience. Returning guests give Ritz-Carlton increasingly refined information about their preferences and needs, which enables the company to provide them with a superior experience. Because of this experience, guests are loyal to Ritz-Carlton and tend to book a Ritz-Carlton hotel whenever possible. This in turn gives Ritz-Carlton information that enables its staff to serve guests better than the competition, creating a virtuous cycle: information enables a superior experience, resulting in customer loyalty which generates yet better information.

> **Developments in IT will make customer intimacy one of the central building blocks of the company of the future**

- **Operational Excellence: Superior Back-End Processes**

A different logic governs operationally excellent business models, which strive to minimize the delivered cost of the products or services they offer to customers by creating superior back-end processes. Having a lower cost base, they can have a price advantage over competitors. Alternatively, operationally excellent businesses may price their products or services competitively while reducing the intangible costs borne by their customers as the product and service is

delivered to them. Thus, operational excellence is not about price alone—consider, for example, FedEx, which attempts to differentiate its offering on timeliness and reliability ("when it absolutely, positively, has to be there overnight"—the company's tagline during its formative 1978-1983 years).

Walmart provides an example of operational excellence in retailing. Its tagline has evolved from "Always Low Prices" in the sixties to "Save Money. Live Better" in more recent years, but its value-creation model and logic have remained essentially the same.[7] Customers consistently cite low prices as the key reason for shopping at Walmart. In the US, Walmart customers' average income is well below the national average, and about 20% of them don't even have a bank account (which creates an opportunity for Walmart to provide financial services to the unbanked). Walmart is positioned at the inbound logistics and retailing end of a standard product value chain (although it also designs some "white label" products and sells some services). It sells a large variety of quality merchandise at lower prices and higher availability than most competitors based on its back-end processes.[8]

The goal of operationally excellent business models is to minimize the delivered cost of the products or services they offer to customers

Profitability in retailing is driven by the return on inventory investment, given by the product of inventory turnover (how many times a year the retailer turns over its inventory) by the markup over the cost of goods. A small, independent merchant may mark up its products by 100% and have two inventory turns a year, leading to a return of 200% on his inventory investment. A department store that reduces its markup to say 66.7% can achieve the same return on inventory investment by turning its inventory three times a year, attracting customers through lower pricing and greater product selection and innovation.

Walmart's superior back-end processes and lower cost structure allow the company to increase inventory turns to reach the same or greater profitability than full-price retailers in spite of its lower markup. A markup of 50% and an inventory turnover of four would be sufficient to match the return on inventory investment of the department store and the independent merchant in the above example, and doing better would make Walmart more profitable (by 2014, Walmart increased its inventory turnover to 8 with a 32% markup). Walmart achieves lower markups coupled with high availability and low inventory levels by focusing on procurement, logistics, and distribution and using IT to track and identify demand on a product-by-product basis, to increase transparency and to lower supply chain costs.[9] These increased efficiencies allow Walmart to lower prices, leading to increased volume and scale, which in turn enable Walmart to invest further in technology and process improvement. This virtuous cycle, which Walmart calls "The Productivity Loop" is shown in Figure 1.

Figure 1. Walmart's "Productivity Loop"

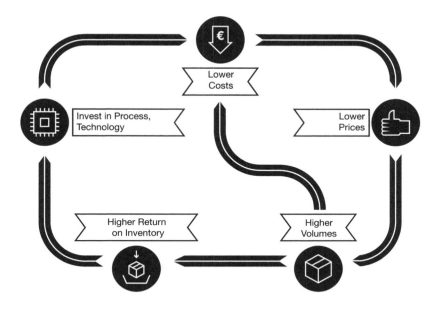

- **Value Chain Coordination**

Value chain coordinators create value by coordinating the front- and back-end of the value chain. A value chain coordinator may orchestrate major activities along the entire value chain or be focused on a narrow slice of the chain. In the electronic commerce domain, value chain coordinators are often *platform businesses* which facilitate transactions or interactions among the users of their platforms. They relegate direct value creation to other participants in the value chain, while the platform itself coordinates activities, streamlines business processes, and reduces search and transaction costs.

eBay is a classic online platform that enables buyers and sellers to find and trade with each other. While the platform users themselves shoulder the burden of direct value creation (eBay does not hold or sell product inventories—only the sellers do), the company is focused on matching buyers and sellers and facilitating transactions among them. Value chain coordinators such as eBay continuously improve and refine their platforms to enhance the performance of the value chain. They often engage in acquiring new customers and seeding new activities to create additional sources of value for their customers.

The eBay.com marketplace is a platform business which is focused on the use of Information Technology to support and facilitate trading communities. All other activities are provided by others—merchandising and product inventories by the sellers; shipping by eBay's logistics partners

(such as national postal services or UPS); financing, insurance, and vehicle inspections in eBay's automotive marketplace are provided by partners, etc. As a result, eBay can focus on the development of its technology platform and on creating a vibrant trading community and developing vertical marketplaces such as eBay Motors, its collectibles marketplace, and its event ticket marketplace StubHub.

In the electronic commerce domain, value chain coordinators are often *platform businesses* which facilitate transactions or interactions among their users. They relegate direct value creation to other participants in the value chain

eBay's "virtuous cycle" (Figure 2) illustrates the logic of value chain coordinators which are characterized by two-sided network effects, in this case between buyers and sellers. First, buyers attract sellers to the platform. With more sellers, buyers are more likely to find any product they are looking for at a desirable price, which increases the number of buyers and the frequency of their visits to eBay. This, in turn, makes the platform more attractive to sellers, who are looking for buyers, so more buyers join the platform, and the cycle continues.

Figure 2. eBay's Virtuous Cycle

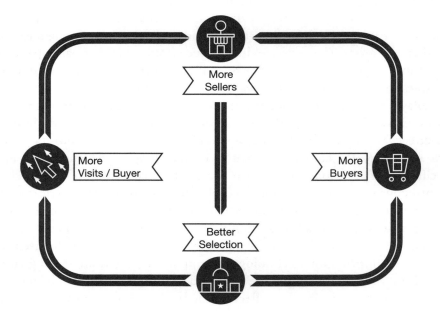

II. Business Model Development

Customer-Driven Innovation

As discussed above, business models play a key role in the innovation process. There are many approaches to innovation, and I'll focus on the customer-driven innovation approach that we teach and practice at Stanford University. This process parallels the "lean startup" approach which guides the development of startups and established-company innovations in Silicon Valley.[10]

Customer-driven innovation employs the business model construct in an iterative process that starts at the front end, centering on a target customer (this is sometimes called "customer development").[11] The process then proceeds to the back end and finally links them to one another. It is initiated by identifying a customer need which is not well addressed by existing marketplace solutions. It then proceeds with *empathy*, a deep ethnographic dive into the life and/or work experiences of the target customer. Empathy comprises three types of activity:

- Observe – view users and their behavior in the context of their lives;
- Engage – interact with and interview users through both scheduled and short "intercept" encounters; and
- Immerse – experience what your user experiences.[12]

The empathy stage is followed by a *definition* stage that unpacks and synthesizes our empathy findings into compelling needs and insights which allow us to come up with an actionable problem statement.[13] This is followed by an *ideation* stage that generates multiple potential solution ideas. The goal of the ideation stage is to explore a wide (i.e., encompassing a broad range of diverse ideas) and deep (i.e., exploring a large number of ideas) solution space. The ideas are then sorted out using the business model construct discussed above: each idea is analyzed in terms of the value it may potentially create for customers, what it takes to deliver that value, and the resulting profitability and growth potential. This means that the analysis starts at the front end (focusing on value creation potential) but is then filtered using a back-end perspective (focusing on feasibility, cost, and profitability).

The initial business model resulting from this process is incomplete; it is in effect a *business model prototype* with a given logic. To prove or disprove this logic, we need to test its central assumptions or premises. We thus identify the key premises and proceed to test them. The results of each test are used to revise the business model, modify its logic, identify the new central premises, test them in turn and continue to iterate. This iterative process ultimately results either in a business model which is believed to be viable, or in abandoning the

specific innovation on the grounds that based on the tests to date, it is unlikely to lead to a viable business model. The latter outcome is often manifested in the form of running out of funding.

At the front end, the focus of the process is on customer needs and value creation. At the back end, the focus is on putting together a solution that efficiently fulfills that customer need, costing it out, and trying to make a profit. In both cases, the business model development process calls for extensive human judgment, combining experience and creativity. As a result, it takes months, quarters or years to develop a proven, viable business model.

IT Trends and Business Model Development

The business model concept has been used often in the context of electronic business. Indeed, the use of the term "business model" took off in the mid-nineties and paralleled the growth of the internet,[14] and the vast majority of its definitions in the literature are related to applications of IT.[15] This is not surprising, as IT has been a major force reshaping business models over the past twenty years. As Tim Berners-Lee, the inventor of the World Wide Web, put it before the turn of the century:

> The next century is going to turn our world upside down. The Internet combines people and ideas faster than they have ever been combined before. And that combination changes everything. The basic social conventions of the industrial era—the stable career, the 9-to-5 job, the gradually (but steadily) increasing salary—were all built around the notion that people moved their bodies in response to information. If you wanted to buy something, you went to a store. If you wanted to build something, you worked in a factory. In the Net economy, the creation of value doesn't require that kind of physical movement. Income accumulates not in the form of cash but in the form of clicks… The great thing about technology is that it forces us to figure out the world from scratch. In so doing, it gives us a chance to rediscover what's really important. So maybe the 21st century won't turn your world upside down. Maybe it will turn that world right side up.[16]

By changing the focus of innovation from atoms to bits and from hardware to software, IT has dramatically accelerated the process of business model development. Prototyping and testing that used to cost hundreds of thousands of dollars and took months to execute can now be effectively completed in a week at a fraction of the cost. Software is more malleable than hardware, making it possible to adapt to customer needs faster than ever before. And, the

development of cloud computing has made IT infrastructure highly elastic, making it possible to test and implement new software-based business models quickly and effectively.[17] The end result is that IT has greatly accelerated the business model development process and with it the pace of innovation.[18]

What we have seen to date is, however, only a modest beginning. Developments in IT are likely to fundamentally change the nature of the firm and with it the essence of innovation. I address three of these developments below: the convergence of virtual and physical identities, the convergence of models and reality, and the convergence of atoms and bits. All three developments are highly interrelated.

Convergence of Virtual and Physical Identities

IT can be used to create a virtual reflection of physical-world activities. For example, a consumer's credit card account is a partial digital representation of his or her financial life. It includes (among other things) profile information such as the consumer's name, address, and social security number; credit data; and transactional data. In essence, the real-life consumer is shadowed by a virtual identity that tracks some of his or her financial activities. Historically, the information embedded in this virtual identity was quite incomplete, as most payments were made in cash, credit card transactions were consummated with a delay of weeks, and it was hard to relate them to one another. Today, a large and increasing percentage of payments are made electronically, they are recorded and made available in real time, and it is faster, easier and less expensive to process them to obtain a more complete picture of the consumer's finances. As a result, the consumer's virtual identity provides a more accurate representation of his or her real financial life.

Virtual identities are converging to real identities as a result of the increased use of mobile devices and sensors and the use of cloud computing

More generally, virtual identities are converging to real identities as a result of the increased use of mobile devices and sensors as well as the use of cloud computing. Mobile devices and sensors accompany people anywhere and they touch many different aspects of everyday activities. They generate a rich digital footprint that enables the replication of an increasing number of consumer activities ranging from physical movements to transactions and communications. Cloud computing in turn enables real-time recording of the data as well as its retrieval and processing on demand.

This applies not only to consumers but also to devices and machines used by businesses. Radio Frequency Identification (RFID) chips enable product tracking throughout the supply chain, and an increasing number of connected sensors are collecting machine data in real time. The resulting digital footprints create comprehensive digital representations of the physical activities of devices and machines that comprise the "industrial internet."

Virtual identities are thus converging towards physical identities to the point where the former can serve as effective surrogates for the latter.

Integration and the Convergence of Models and Reality

A related trend applies to the ability to create integrated, high-fidelity models of behavior based on multiple, synchronized data sources. For example, a customer's behavioral data may be combined with social network data to infer, based on both the customer's own past transactions and behaviors as well as those of her friends, which product configuration will likely be most attractive to her. "Quantified self" models in the fitness and healthcare field combine data from wearable sensors, electronic health records, and other sources to improve wellness and performance. Companies such as Netflix use customer ratings and past viewing habits in conjunction with other customers' information and market-wide trends to recommend movies and TV series a customer may be interested in viewing.

By integrating data from multiple sources and developing models that can estimate prospective customers' preferences and predict their future behaviors with increasing precision, such "Big Data"[19] approaches are able to test how a customer might react to a prospective offer without actually making that offer. While the results of such estimates are always subject to error, these errors may be diversified away once such offers are made to a large number of prospective customers. And, customers' responses to the models' estimates provide further information that may be used to further calibrate and refine the models.

Convergence of Atoms and Bits

People spend an increasing percentage of their time in the virtual world, where customized information products and services can be produced through the use of software. Software can make "bit" products fully responsive to customer demands, albeit at a cost.

As for "atoms," manufacturing is increasingly driven by software which makes it possible for physical products as well to be more responsive to customer demands. Robots can be programmed to support flexible and still low-cost manufacturing processes which are increasingly replacing the assembly

lines of the twentieth century. Mass customization and postponement allow companies to combine the cost advantage of scale with the benefits of customization to create customer-responsive products. And, a host of new technologies enable the creation of a unique yet affordable product for each customer, ranging from custom-made T-shirts and shoes to one-of-a-kind industrial components. As a result, back-end processes are becoming increasingly responsive to front-end demands.

Additive manufacturing (also known as "3D printing") is an emerging technology that amplifies this trend. Product design is inherently an information ("bit") activity, but converting the design into an affordable physical product ("atoms") requires costly tooling and machinery which in turn lead to the cost structure that characterizes mass production, based on economies of scale. With 3D printing, a digital design can be converted into a physical product one unit at a time, increasing the variable unit cost but dramatically reducing the fixed cost that characterizes traditional, scale-based production. Today, 3D printing is used largely to create product prototypes, accelerating the product development process that leads to mass-produced products. However, 3D printing is increasingly being used to create custom gifts, apparel, and industrial components, not to speak of tattoos, body parts, and food. Today, expensive 3D printers are largely used to create plastics products in a matter of hours. In the future, the variety of materials that benefit from 3D printing will expand, and the cost and time per unit will shrink. As a result, low-cost manufacturing of fully customized products will likely become a norm rather than the exception. This does not mean that mass manufacturing will become extinct—rather, it will be augmented by a variety of affordable customization options.

III. Business Models in the Company of the Future

The foregoing discussion suggests that IT will not only accelerate the process of business model development—rather, it will lead over time to a substantial qualitative change. A market comprising customer intimacy agents, suppliers/producers, and value chain coordinators will be able to provide better solutions than today's firms. The customer intimacy agents will specialize in identifying customers' current and future preferences and in helping customers to choose among alternative solutions. Producers and suppliers will specialize in developing and selling physical or digital products. Value chain coordinators will match supply and demand, configuring solutions that use existing physical or digital products (or components), as well as mediate the creation of new products based on the information they receive on customer preferences and supplier capabilities.

Emerging seeds of this structure already exist today. Multiple marketplaces are matching supply and demand for products (eBay), business supplies (Ariba),

people's time (TaskRabbit), space (Airbnb) and transportation options (Uber), to name just a few. Some of them offer value added services and customized solutions. In most cases, however, customers have to explicitly state their preferences in crude form and they then have to spend time and effort and exercise judgment to make the final selection. And, new product development is within the domain of producers.

To explain the transformation I anticipate in concrete terms, consider for example the travel market. Today, consumers may express their preferences involving price and schedule among competing airline flights to a travel search engine, which then looks at supplier data and configures a travel solution for them. In most cases, the preferences are expressed in rudimentary form (e.g., price or schedule, with no tradeoffs between the two), the solution is not comprehensive (e.g., airlines are selected separately from hotels, although some travel providers offer a rudimentary form of bundling, based primarily on available discounts rather than on consumer preferences), and the consumer has to make the final choice because the search engine does not truly understand his or her preferences.

Future business models in the travel industry will be based on three separate functions:

– A customer intimacy agent that tracks the consumer's travel preferences and represents him or her in the choice process. Conceptually, the agent may support other consumer activities beyond travel, but I believe domain expertise will continue to be important, and as a result we are likely to have domain-specific agents, at least early on. Looking at the consumer's schedule, future plans, and past experiences, the agent will continuously seek proactive travel solutions to be offered to her. In some cases, the agent will not be able to anticipate the consumer's travel needs; in that event, the consumer will trigger a solution search which will be managed by the agent on her behalf.

It is easy to imagine conceptually how the consumer might delegate her travel choices to an agent who has comprehensive data on her entire travel experience, schedule, opportunity cost of time, etc., vast information on consumers like her, and the ability to analyze the alternatives and select the best solution. The key dimensions of competition among customer agents might then be based on their analytic capabilities and on their ability to consistently find best solutions for a given customer segment. The revenue model of the customer intimacy agent will likely be subscription-based, with a component based on performance.

– Travel suppliers, who offer pre-configured travel components (similar to today's flight schedules and airfares, as well as available hotel rooms and their prices) as well as spare capacity which is available for future configuration.

- A value chain coordinator, who mediates the customer intimacy agents vis-à-vis the travel suppliers. The value chain coordinator plays the role of both a marketplace and an entrepreneur.

 - As a marketplace, the value chain coordinator will configure customized solutions when prompted to do so by the consumer's agent. It will seek the different flight segments, hotel rooms, airport transportation, etc. among the available preconfigured travel components and will offer them to the customer's agent as fully configured solutions. The division of labor between the customer intimacy agent and the value chain coordinator will depend on the level of trust they have developed over time, as well as on the degree to which the customer's agent wishes to protect the customer's data.

 - As an entrepreneur, the value chain coordinator will suggest new products the supplier might want to offer (beyond its available preconfigured travel components) by matching information collected from the customer intimacy agents (i.e., their customers' preferences and needs) and the suppliers (i.e, available capacities for different travel components). The new product may be customized or "mass produced." For example, the value chain coordinator could suggest that a hotel might customize an available suite for a honeymoon, or it may use aggregate data from multiple customer intimacy agents to suggest a new flight route using the supplier's available capacity.

Thus, a customer's agent may tell the value chain coordinator it expects its client to travel to a conference in New York between April 12 and 16, possibly staying over for the weekend depending on price, and seeking a flight and a hotel room for the corresponding days. The value chain coordinator may then suggest an appropriate travel solution based on the available travel components. However, given the fine-grained information about both demand and supply which is available to the value chain coordinator, it may infer that enough people who value their time highly are taking the same route to justify the creation of a new nonstop flight. Further, the value chain coordinator will know which airline has the capacity to offer that flight and make it profitable. The value chain coordinator may then suggest that the airline offer the flight, and it will also suggest a price based on the opportunity cost of the marginal consumer. In this example, the value chain coordinator is doing more than matching demand and supply: it is commissioning the development of a new product based on the information it collected from customer agents and travel suppliers.

Similarly, in the case of industrial products, customer intimacy agents represent potential buyers' preferences, suppliers offer products and capacities that,

put together, create potential solutions, and value chain coordinators may match buyers and sellers, create value-added solutions by adding solution providers to the mix, suggest the creation of unique custom products, or commission the development of new products that may be sold to multiple buyers.

The ability to engage in more traditional customer-driven innovation for new products and service ideas that were not inferred electronically may be a strong differentiator for the most successful product developers

This structure automates key parts of the customer-driven innovation process. For preferences and needs that have already been captured by the customer intimacy agents, empathy can be performed in software. Importantly, this will not eliminate the traditional form of empathy; rather, it will raise it to a higher level. Customer intimacy agents will engage in a more traditional form of empathy to innovate their own business models —for example, to augment the data they already capture electronically and to suggest what new forms of data might be valuable to capture.[20]

Value chain coordinators will engage in an electronic form of ideation, based on electronic enumeration of potential product concepts. They will test each candidate product configuration in software, aggregating demand and preference data from the customer intimacy agents and capacity, supply and cost data from suppliers. By comparing value and cost, they will be able to determine which of the candidate products are viable, although the ultimate tests of the resulting products will take place in the marketplace.

A simple analogy to this form of automated innovation is provided by the use of combinatorial chemistry in the pharmaceutical industry. Drug development is a long and protracted process which can take ten to twenty years using traditional techniques. With combinatorial chemistry, molecular constructions are automatically synthesized and tested for biological activity. The technique takes a few molecular building blocks and uses an automated process to create numerous combinations by mixing and matching these building blocks. Thus, rather than engage in a manual, time-consuming screening process, machines create thousands of drug leads each day by mixing the chemicals under pre-specified test conditions. This "high throughput screening" process enables parallel testing of drug leads which dramatically accelerates the drug development process. And, once the results of these screening analyses are determined, they are stored in digital libraries, replacing *in vitro* laboratory tests (i.e., "test tube" tests) by *in silico* (i.e., computer-aided) tests, using computer programs to quickly sift through digital combinatorial libraries.

Turning to the business model of suppliers/producers, they will involve three types of activities:

– Offering pre-configured components and products as well as customization options in the marketplace, typically through value chain coordinators;
– Engaging in electronic customer-driven innovation along with the value chain coordinators, as discussed above; and
– Engaging in traditional customer-driven innovation for new products and service ideas that were not inferred electronically.

The latter form of innovation will continue to be important. While electronic customer-driven innovation can work well for products that are natural extensions of existing products, there will always be breakthrough products whose success cannot be inferred from the available data. In fact, the ability to engage in more traditional customer-driven innovation may be a strong differentiator for the most successful product developers.

Conclusion

This chapter has addressed the effects of developments in IT on future business models and their development processes. I argue that the combined effect of mobile technologies, wearable devices and sensors, cloud computing, and "Big Data" technologies will sharpen the structure of future business models. Three of them will play a particularly important role in the use of IT:

– Customer-intimacy agents will be customers' digital representatives in the marketplace, using data to find and solicit solutions that will make them better off.
– Value chain coordinators will match supply and demand, assemble customized solutions, and engage in electronic customer-data-driven innovation.
– Producers will increasingly engage in marketplace selling and data-driven innovations.

Traditional forms of innovation, however, will continue to be important and will become key differentiators. First, the underlying business models will require continuous innovation which will likely take a traditional form. Second, breakthrough products will probably continue to require traditional forms of innovation.

Notes

1
See, e.g., A. Osterwalder and Y. Pigneur, *Business Model Generation: A Handbook for Visionaries, Game Changers, and Challengers* (Hoboken: Wiley, 2010). For a comparison of common definitions of the business model construct, see C. Zott, R. Amit and L. Massa, "The Business Model: Theoretical Roots, Recent Developments, and Future Research," IESE Working Paper, September 2010.

2
USAA was the first to employ this method to support military personnel who did not have access to a physical branch. It has since been adopted by mainstream banks to facilitate the check deposit process.

3
The payments made to PayPal, which is a separate business, are not included in this analysis.

4
See M. Treacy and F. Wiersema, *The Discipline of Market Leaders: Choose Your Customers, Narrow Your Focus, Dominate Your Market* (London: HarperCollins, 1995); H. Mendelson, *Value Disciplines: A Quick Overview*, Graduate School of Business, Stanford University, 2011.

5
Marriott International purchased a 49% stake in Ritz-Carlton in 1995 and increased it to 99% in 1998.

6
<http://www.ritzcarlton.com/en/Corporate/GoldStandards/Default.htm>

7
Walmart's attempts to extend its appeal by deviating from this logic over the mid-2000s have been largely unsuccessful.

8
This is described in more detail in the case study *Walmart* by H. Mendelson, Graduate School of Business, Stanford University.

9
See H. Mendelson, *Walmart*, op. cit.

10
See Eric Ries, *The Lean Startup: How Today's Entrepreneurs Use Continuous Innovation to Create Radically Successful Businesses* (New York: Crown Business, 2011).

11
See Steve G. Blank, *The Four Steps to the Epiphany: Successful Strategies for Products that Win* (Menlo Park, CA: K&S Ranch Press, 2005).

12
d.school bootcamp bootleg, Stanford University, 2013.

13
id.

14
Zott, Amit and Massa, *op. cit.*

15
S.M. Shafer, H.J. Smith, and J. Linder, "The Power of Business Models," *Business Horizons*, 48 (2005), 199-207.

16
"Next Stop—The 21st Century," *Fast Company*, August 31, 1999.

17
See H. Mendelson, Cloud Computing: A Quick Introduction, Electronic Business Case Study Series Book 1 <http://www.amazon.com/Cloud-Computing-Introduction-Electronic-Business-ebook/dp/B00CNBFT64>

18
This trend has been recognized years ago. See H. Mendelson and J. Ziegler, *Survival of the Smartest: Managing Information for Rapid Action and World-Class Performance* (New York, Wiley, 1999).

19
For an overview of "Big Data," see "Big Data: The Next Frontier for Innovation, Competition, and Productivity," McKinsey Global Institute, May 2011.

20
Similarly, as discussed below, producers will engage in both electronic and traditional forms of innovation.

Customers and Markets

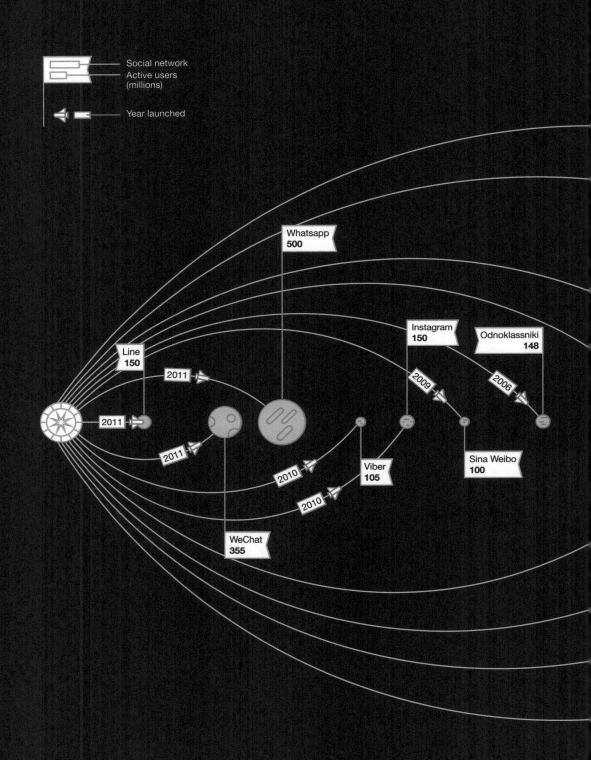

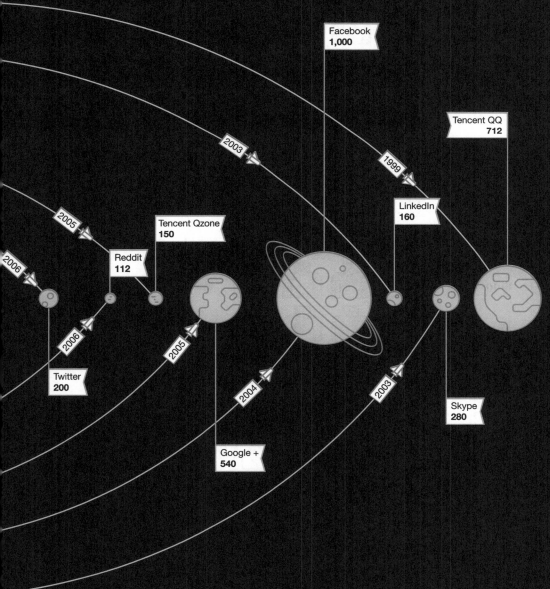

Leading 15 Websites and Their Unique Visitor Figures (2014)

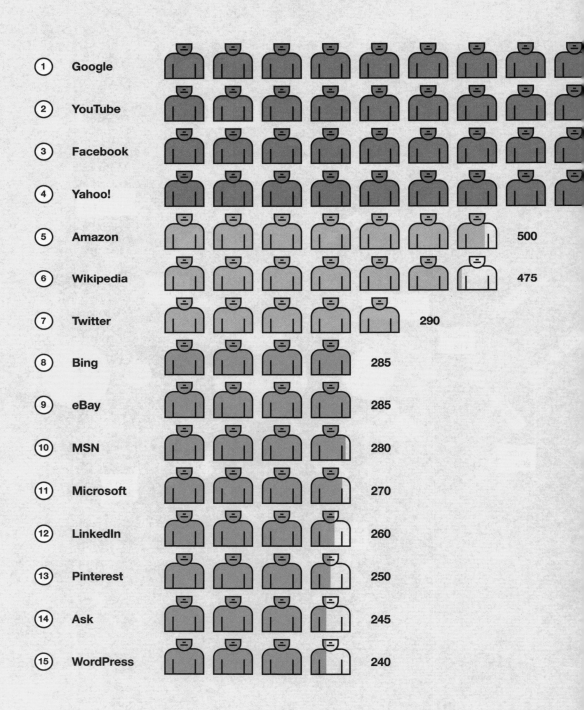

1,100

1,000

900

750

7,130

million unique visitors every month (equivalent to the world population)

Figures in millions of people

Source: EBizMBA

Top 10 Online Vendors in the US through User Share* Channels (2013)

*"User share" is a new form of electronic commerce whereby users form communities which put pressure on suppliers to grant deep discounts

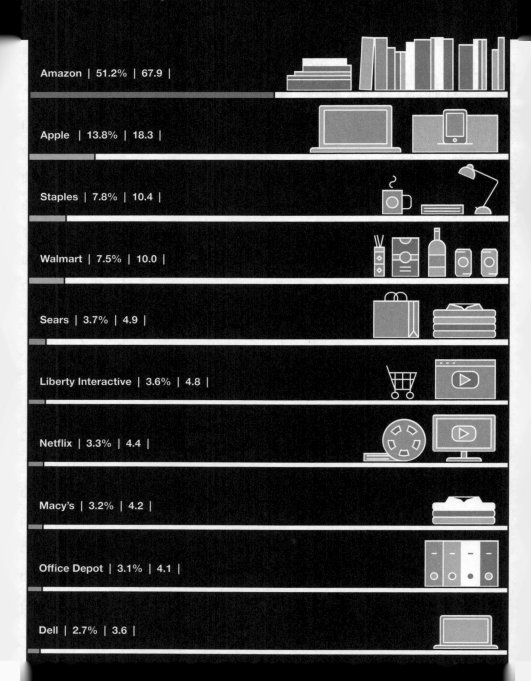

- Amazon | 51.2% | 67.9 |
- Apple | 13.8% | 18.3 |
- Staples | 7.8% | 10.4 |
- Walmart | 7.5% | 10.0 |
- Sears | 3.7% | 4.9 |
- Liberty Interactive | 3.6% | 4.8 |
- Netflix | 3.3% | 4.4 |
- Macy's | 3.2% | 4.2 |
- Office Depot | 3.1% | 4.1 |
- Dell | 2.7% | 3.6 |

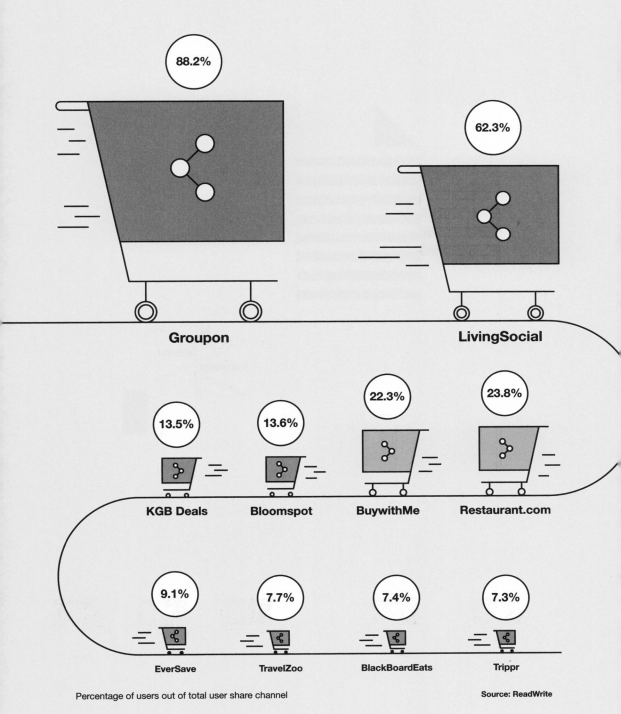

Online Buyers by Country (2012)

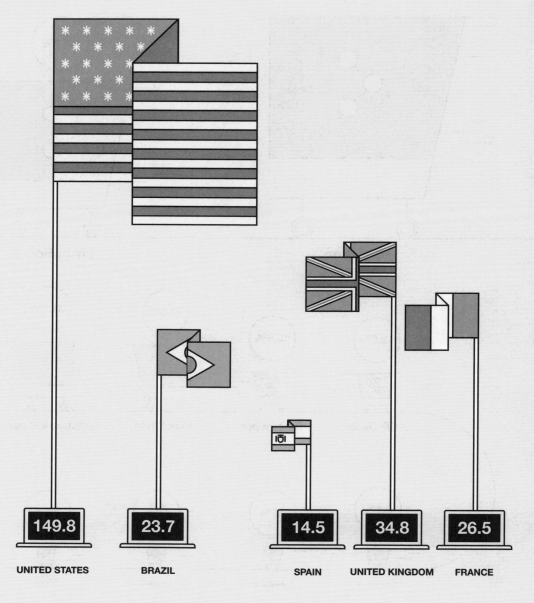

Figures in millions of people

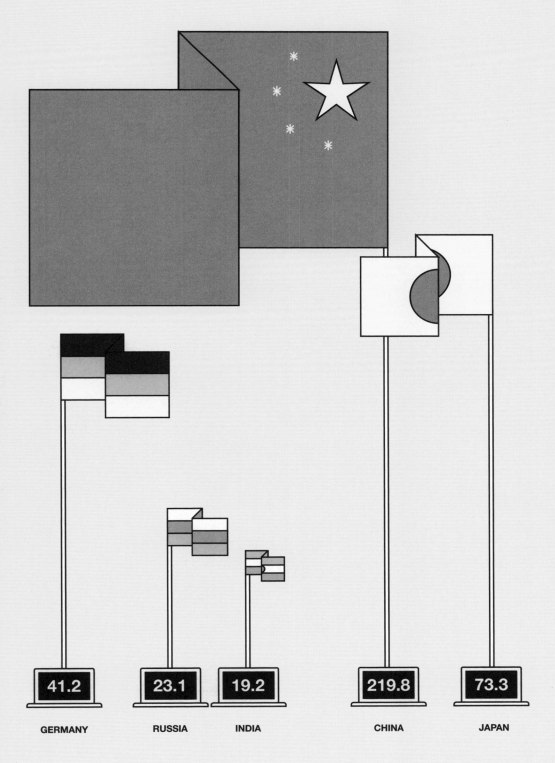

Reinventing Marketing in the Digital Era

George S. Day

Professor Day examines how the activities, responsibilities and design of the marketing organization are evolving to manage the uncertainties of the digital age. He states that this transformation will involve the interplay of three driving forces: the impact of digital technologies, the changing role of the Chief Marketing Officer (CMO), and emerging organizational designs.

 The increasingly central role of customer analytics and Big Data, predictive analytics and customer experience mapping are allowing organizations to deploy their marketing resources more efficiently and effectively; in this regard Day sees the role of the CMO changing so as to accept the dual responsibilities of creative and accountable delivery. In this way the CMO needs to create a marketing culture that fully embraces desired values and behavior, and one which fully takes on board these new core metrics and measurements.

George S. Day
Wharton Business School

George S. Day is the Geoffrey T. Boisi Professor, Professor of Marketing and co-Director of the Mack Institute for Innovation Management at the Wharton School of the University of Pennsylvania. He was previously the Executive Director of the Marketing Science Institute. He has been a consultant to numerous corporations, and he is the past chairman of the American Marketing Association. has authored eighteen books in the areas of marketing and strategic management. His last book is *Innovation Prowess: Leadership Strategies for Accelerating Growth* (2013).
He has won ten best article awards and one best book award, and two of his articles were judged to be among the top 25 most influential articles in marketing science in the past 25 years. He was honored with the Charles Coolidge Parlin Award in 1994, the Paul D. Converse Award in 1996, the Sheth Foundation award in 2003, and the Mahajan Award for career contributions to strategy in 2001. In 2003 he received the AMA/Irwin/McGraw-Hill Distinguished Marketing Educator Award. In 2011 he was chosen as one of eleven "Legends in Marketing."

Key Features for the Company of the Future:

Make Decisions From the Outside In
The management team will start the strategy dialogue by stepping outside the mental models and resources of the firm as it is, and look first to the market and where it will be in the future. How and why are customers changing? Where are we vulnerable to competitive threats? How can we better solve their problems and meet their emerging needs?

Be Guided by a C-Suite Team of Vigilant Leaders
Each member of the team will have a functional organization behind them that is respected by the rest of the organization. However, functional mastery will matter less than general business acumen, willingness to collaborate with other functions, and strategic thinking.

Have Mastered Digital Technologies
These organizations will use Big Data, customer analytics, experience mapping, and a myriad of emerging methods to deliver integrated experiences that are compelling, personalized, and consistent across all customer touch points. They will have developed adaptive capabilities for closing the gap between the ever expanding amount of data available and the capacity of the organization to make use of this data and convert it to useable information.

Reinventing Marketing in the Digital Era

Marketing is at the interface of the firm and its present and prospective markets, and is the organizational function that absorbs much of the environmental turbulence. How will the activities, responsibilities and design of the marketing organization evolve in the future? The answers will emerge from the interplay of three driving forces with the unique features of each firm's strategy, legacy, and the dynamics of their market. These driving forces are: the impact of digital technologies, the changing role of the Chief Marketing Officer (CMO) as a member of the C-suite, and emerging organizational designs. We will use the Chief Marketing / Commercial / Customer Officer as the lens by which we assess the impact of these driving forces on the practice of marketing. With this lens we will see why so many firms will have to reinvent their marketing organizations.

The Forces Transforming Marketing

When thinking about the future of marketing in an era of accelerating change, five years is a long time. To appreciate what can happen in five years, think back to 2008/2009. Facebook had only expanded beyond universities in 2006,

Twitter was barely on the horizon for most people, clouds were mostly in the sky, and the serious damage resulting from the credit meltdown was just becoming painfully evident. We can be sure that five years from now there will be equally dramatic changes. Yet there are some predictable changes—which we call driving forces—that are already at work and that CMOs and their C-suite partners can prepare for with confidence.

The Changing Digital Frontier

Marketing is already one of the most technology-dependent functions in the firm. In 2012 the research firm Gartner predicted[1] that CMOs would be spending more on digital technologies than the chief information officer by 2017. That forecast is becoming more credible as time passes and may happen sooner in some firms. Approaches for analyzing markets and interacting with customers that were at the cutting edge a few years ago are fast becoming obsolete, and new approaches seem to emerge weekly. The general nature of these new approaches is widely known. What is less appreciated is how they are changing marketing practice.

– **New Ways of Understanding and Connecting with Customers**

Next practice marketers are using customer analytics (also known as Big Data), predictive analytics, and customer experience mapping to deliver integrated experiences that are compelling, personalized, and consistent across all the points the firm touches their customers. They have many ways of connecting with these customers (video, SMS, social media, websites, mobile devices, as well as familiar direct mail and sponsorships, and traditional media such as television). Many CEOs say that digital marketing investments are the most important commitments their firms can make because they reshape the firm's relationship with their customers and enable competitors to gain an advantage if the firm responds too slowly.

> **In 2012 Gartner predicted that CMOs would be spending more on digital technologies than the chief information officer by 2017**

This burst of technology is proving hard to manage effectively. In addition to major platforms for customer relationship management (CRM), content management, and marketing automation, there are many new platforms for social media management, content marketing, and customer-facing applications. Of course their impact will be felt differently in different industries; banking is being transformed by mobility and new payment systems,

as well as the ability to personalize. Manufacturers of building products who serve only business-to-business markets will pay attention to CRM, salesforce control models, and social media.

– Advances in Decision Tools

Fortunately there is progress in methods for absorbing, interpreting, and acting in the face of the avalanche of data being generated by fragmenting markets and the proliferation of digital media and channels for reaching customers. Whereas marketers once had to exert significant effort to gain feedback from their customers, now they struggle to absorb the feedback from user-generated content and social media channels. In many markets we are close to being able to tailor the message and offer to each customer and prospect. The fuel is the plummeting cost of bandwidth, storage, and computing—and the result is that available data is doubling every eighteen months.

> **There is a widening gap between the ability of firms to comprehend and use the data and the growing amount of data they are getting**

There is a widening gap between the ability of firms to comprehend and use the data and the growing amount of data they are getting.[2] Fortunately there are advances in digital technology that promise to help narrow this gap, at least for those firms able to master the technology and build an organization capable of using expert systems and artificial intelligence approaches. Consider the potential of IBM's Watson, a cognitive technology that is a natural extension of what humans can do. Watson can read and understand natural language, which is important in analyzing the unstructured data that makes up as much as 80% of data today.

The Changing Role of the C-Suite

A recent analysis of C-level positions concluded that when people reach the C-suite, the skills and functional mastering that got them there matter less than their leadership skills and general business acumen.[3] The chief information officer, chief technology officer or CMO who thrives in the C-suite will be a team member who can lead without rank, with a functional organization behind them that has earned the respect of the rest of the organization. The skills that are increasingly in favor in the C-suite are strong communication, willingness to partner with other functions, and strategic thinking. Successful members of the C-suite will advise the CEO on key decisions and strategic choices, but offer their own well-informed insights.

For CMOs to thrive and survive in a collaborative C-suite, they will have to adopt a general management mindset and earn the respect of their peers with fact-based analyses. They will achieve the status of a trusted advisor to the CEO by:

- Being the acknowledged voice of the customer and consumer, and ensuring the strategy is built and executed from the outside in. Put most simply, this means standing in the customer's shoes and viewing everything the firm does through the customer's eyes.[4]
- Being the steward of the brand as a valuable asset, and rallying the entire organization to support and enhance the brand promise.
- Driving profitable organic growth, by continually searching for new ways to innovate new value for customers. They consider the full spectrum of possibilities for growth, instead of limiting themselves to the narrower possibilities of product innovation.
- Taking accountability for the returns on marketing investments.

They will gain further credibility by building a marketing organization that is nimble, agile, and informed by data and deep insights into the current and potential customers—and is demonstrably superior to the rivals. To get there, they will have to master three important trends in organizational design.

Emerging Organizational Designs

For decades three trends have been reshaping the structures of organizations: (1) flattening (or delayering) to eliminate layers in the hierarchy,[5] (2) teams organized around cross-functional activities and processes, and (3) the replacement of the traditional closed hierarchy with an open network model that shrinks the organization to the core while expanding the periphery.[6]

The latter trend especially caught the attention of a group of CMOs convened by the American Marketing Association in 2007 to develop scenarios for the future of marketing.[7] At that time the two uncertainties that were the most informative and potentially influential were: the system-wide resources available to marketing, and the dominant organizational models. These two critical uncertainties were each reduced to a single spectrum with the credible extreme states at each pole.

These two axes were crossed to form a 2x2 matrix, with four different quadrants of uncertainty. Each quadrant portrays a plausible, alternative hypothesis or scenario about how the environment might unfold, and highlights the risks and opportunities to the organization—or, in this case, to the function of marketing within the firm.[8]

These scenarios let marketers "learn from the future." They can rehearse the future to avoid surprises by breaking through the illusion of certainty.

Unlike traditional strategic planning, which presumes there is a likely answer to a strategic issue, scenario learning considers multiple futures. It meets the needs of marketers for plans, capabilities, and organization models that are robust across the scenarios, so the organization is prepared for whatever the future will bring.

The reason for uncertainty about the future structure of the organization at the time of the study was that the traditional organization model had shown an amazing level of adaptability. On the other hand, there was considerable evidence that companies with a network structure were more nimble and winning the market battle. Companies such as Cisco Systems Inc. or Li & Fung Ltd were organizing as a network structure to leverage and gain more resources. The best place to see open networks in action was the area of open innovation or innovation networks, but it was easy to contemplate how networks could be more widely applied to extend the reach of the firm.

Fast forward seven years to 2014, and the hierarchy is still in place in most organizations. Their advantages have generally prevailed. First, they keep critical functions in house, out of competitors' view. If you can do your analytics within your own walls, you don't have to reveal your talents, capabilities, algorithms, and resource-allocation decisions to others. Second, it can be difficult to find good external partners. True, there are many companies offering services such as data analytics, help with creating viral campaigns, social-media mining, and search-engine optimization. But the number of really good firms in these fields is limited, and many of them have already been snapped up by the biggest companies. Finally, there's the perennial difficulty of managing partnerships. The rate of disappointment in alliances and joint ventures is around 50%, partly because partners' objectives inevitably diverge as circumstances change.

> **Unlike traditional strategic planning, scenario learning meets the needs of marketers for plans, capabilities, and organization models that are robust across the scenarios**

The longevity of hierarchies, however, is due to more than these factors. In today's forward-thinking companies, hierarchies are proving to be highly versatile. Rather than being destroyed by digital technology, they're being strengthened by it. Technologies have allowed the marketing organization to become more efficient and effective. For example, the boundaries with other functional disciplines are blurring. Instead of siloed specialists there are cross-functional teams that are coordinated with shared information.

Within marketing the silos are collapsing. These more integrated organizations look more like a hub with spokes than the familiar horizontal-boxes-and-arrows

model. The CMO may now be called the chief engagement officer or chief customer officer to signal a shift in priorities. Roles akin to product manager, customer insights manager, PR manager, and advertising director are the spokes and rim of the wheel around the CMO, who is the hub and coordinator.

Those who speculated about the end of the hierarchy were premature. They didn't take into account the hierarchy's ability to adapt with the aid of information technology. It is a flatter, more relaxed hierarchy—but still a hierarchy.

The Reinvention Journey: Imperatives for the CMO

The average tenure of a CMO is between three and four years and is unlikely to be much longer in the future. Yet some CMOs will rise to the intensifying challenge created by the driving forces we just described, and earn "a seat at the table" of the C-suite. They will excel at the five priority actions needed to navigate the escalating complexity and uncertainty in their markets:

- Act as the visionary for the future of the company
- Build adaptive capabilities
- Integrate digital technologies
- Tighten the alignment with the sales function, and
- Take accountability for the return on marketing spending

How will they deploy these five priority actions to ensure their organization stays ahead of the driving forces that will shape the future? First and foremost, they will advocate outside-in thinking that starts with the market when designing strategies, rather than the other way around. Winning strategies will be viewed through a customer value lens and illuminated by deep market insights. Second, they will embrace the dual challenge of building a world-class marketing function that can anticipate and act on the driving forces of change.

The ability of marketing leaders to respond to these challenges will depend on their role within the organization. Whereas the job of the chief financial officer is well understood and accepted, the job of the marketing leader is more ambiguous and varied depending on the industry, the role of the sales function, and the importance of advances in information technology. The possible roles for the head of the marketing functions can be grouped into four categories:

- **Marketing as Top-Line Leader**

In this role, marketing has a central strategic guidance function that directs all customer-facing activities and is accountable for the brand strategy, driving the organic growth agenda, and positioning the business for the future. It has ownership of the customer value proposition. In many organizations,

the CMO will have shared P&L responsibility and will be accountable for the return on marketing investments. He may have direct oversight of sales. This emerging model of a CMO flourishes in companies with big global brands, such as Diageo or American Express.

- **Marketer as Market Advocate**

Like top-line leaders, these CMOs are advocates for the customer and are responsible for bringing longer-term market and brand-building considerations into C-suite deliberations. They lead teams that monitor the market setting, scan for shifts in the media and consumer environment, and then interpret these consumer insights to guide new product development. They differ from top-line leaders in that they have only a limited role in the broader strategic dialogue. They seldom have direct oversight of sales, strategy development or product development. While their role may be broad, they are primarily coordinators and communicators. Market advocates are especially prevalent in sales-driven organizations.

- **Marketer as a Service Resource**

This is the least influential type of CMO. Indeed, the leaders of these marketing organizations are rarely given the label of CMO, but usually have a title such as vice president of marketing services. They manage a group of marketing professionals that operates as a cost center, overseeing central marketing research and coordinating relationships with key marketing partners, such as advertising agencies, market research firms, direct-mail houses, and new media outlets.

- **Marketing as Sales Support**

In this model, marketing plays a subordinate and supportive role to sales, and many marketing activities have been folded into the sales group. The model is particularly prevalent in smaller B2B firms that are reliant on intermediaries. In these situations, sales usually wins the battle over budget allocations. Sales gains a further edge when the CEO is on a short-run earnings quest or when the economy turns bad. In the absence of agreed-upon metrics and credible data, the contribution of the sales group is easier to judge than the long-run investments in brand building, advertising, or new segment prospecting proposed by the marketing team.

Priorities for the CMO

When the CMOs agreed on the four plausible scenarios for the future of marketing, they were then asked for recommendations for actions that would be robust across the scenarios. That is, regardless of which scenario or combination of scenarios unfolded, these actions were deemed essential. That was

first done in 2007, and brought up-to-date through further conversations with CMOs. They have stood the test of time and have only been slightly modified to reflect progress in the practice of marketing.

- **Acting as the Visionary for the Future of the Organization**

Adaptive organizations continuously scan for opportunities in markets, competitive white spaces, and changing customer needs. They win by seeing opportunities sooner than their rivals. This will take an experimental mindset, a willingness to learn quickly from mistakes, and the ability to identify, test and deploy new models.

Increasingly, the CMO will be the person leading a function that is adept at monitoring markets and extracting insights for future growth. When Kim Feil, Walgreens' CMO, learned from her research group that some consumers viewed the retailer as a convenience store with a pharmacy on the back wall, she saw both a problem and an opportunity. At her urging, the company began to reposition itself as a premium healthcare brand, by showcasing its wellness offerings and walk-in clinic.

- **Building Adaptive Marketing Capabilities**

The CMO of the future must wear many hats and embrace sometimes competing, even contradictory, forces both within and outside the organization. Among the most challenging is the need to deliver business results today, while "creating" the business of tomorrow. Both are essential to a healthy business (and a successful CMO), but require very different marketing processes, skills, and capabilities.

Delivering today requires more proven, predictable and repeatable tools, skills, and processes. It is a bit more left- than right-brained. The marketing capabilities required are developing and executing repeatable models, simplification, executional discipline, rigorous measurement, and decisive action. Convergence, focus and delivery with a more short-term mindset is required. The CMO who does not master these capabilities and build them in the organization will not likely get the chance to spend much time on the longer-term challenges and opportunities.

"Creating" the business of tomorrow is an equally critical and longer-term challenge. The CMOs who do not master these capabilities will also find themselves at risk. The capabilities needed to identify and get the organization ready for the future state—both in finding new opportunities and addressing the challenge of changing consumer and competitive environments—tend to be quite different than the "today" capabilities. These include creative disruption (indeed of the very models that deliver today), divergence and adaptive market experimentation (vs. codification and convergence), vigilant market learning guided by curiosity (vs. conformance) and all the "open-ended" creative skills in innovation.

- **Integrate Digital Technologies**

In a digital world, software is the chief vehicle for engaging prospects and current customers, and recapturing defectors. The choice of software and its configuration and deployment can dramatically affect how the firm is seen by customers. This means mastering a new set of capabilities, supporting them with investment spending, and interfacing with service providers, agencies, and research firms, who have to be managed as partners.

In this changing digital space, the CMO and CIO must collaborate closely. One way to manage this interface in a holistic fashion, to ensure that what's possible with technology inspires what's needed by marketing (and vice versa) is to engage a new type of hybrid executive:[9] the chief marketing technologist or CMT. Their job is to serve as the connective tissue between marketing, IT, and external partners.

The CMT can't do this digital integration on his/her own. Most companies are facing a crisis in finding the talented people who understand the fast-changing digital landscape. Everyone wants the same scarce set of skills to undertake data analytics, utilize knowledge-sharing technologies, and deploy social media methods. Marketers will have to work with human resource professionals to identify the skill sets needed in the future, and develop a continuous talent-spotting and recruitment process.

There is a generational transformation under way today in marketing that is both a challenge and an opportunity. For most of history, the future generation learned at the "knees of the elders," as experience and wisdom were the primary sources of knowledge, expertise, and ultimate success. With the digital-technology-led transformation in communication, it is the "future generation" who have the greater knowledge, understanding and comfort with the new digital and social-marketing applications.

The adaptive organization will recognize the value in getting the best from the digital marketers, and will neither be stuck in the past, nor discard all the institutional knowledge and experience in jumping to a completely new model of marketing. Despite what many pundits say, the fundamentals of marketing strategy and consumer behavior have not been repealed. The adaptive organization will study the changes, understand how the consumer "consumes influence" with the new marketing technologies, will challenge old models and tactics and experiment with new ones. They will figure out what works in the new digital environment for their business and customer and evolve their models and practices. They will neither totally abandon the past, nor completely adopt the latest digital fad.

> **The adaptive organization will recognize the value in getting the best from the digital marketers, and will not discard all the institutional experience in jumping to a completely new model of marketing**

- **Tightening the Alignment with Sales**

Too often, there is an adversarial Mars vs. Venus coloration to the relationship of sales and marketing. It has historically been rooted in mutual incomprehension of the other's role, different time horizons and divergent goals and incentives. Typically the two functions occupied separate silos, and one function had more power than the other, depending on the industry.

Sales and marketing occupied separate silos, but now the traditional lines between the two functions are blurring

The traditional lines between marketing and sales are blurring. Key account managers serving large, powerful customers are engaged in long-run marketing strategy and brand development activities. Meanwhile, the number of possible points of contact with customers and consumers has been increasing exponentially, with social media, interactivity, and mobility demanding closer coordination. Increasingly, CEOs are looking for a single point of contact with all market-facing activities, who can take responsibility for the value proposition, innovation, marketing, and sales across all platforms. Many companies have responded with a new combined role of chief commercial officer. This combined function ensures closer internal and external alignment, by using the internet to coordinate all marketing and sales activities—from customer-service reps responding to complaints on blogs to systems for tracking sales calls and consumer web behavior.

- **Taking Accountability for the Returns on Marketing Spending**

There is no foreseeable future where marketing won't have to demonstrate that it can earn acceptable returns on marketing investments. While there is admittedly a fair amount of craft (even art) in effective marketing, the discipline at its core exists to create value for the enterprise. The CMO who doesn't understand this, embrace it, and build a marketing culture and capability around value creation through the returns on its marketing investment, will not survive. Key to this is recognizing that this is not a contradiction with the creative side of marketing. As Bill Bernbach, one of the creative giants of the twentieth century put it: "Properly practiced creativity MUST result in greater sales more economically achieved."

Summary and Conclusions

For the organization to succeed and win in the digital era by deploying the marketing resources both efficiently and effectively, the CMO must embrace the dual responsibilities of creative and accountable delivery.

The CMO will succeed by first adopting the mindset of the CEO, not the creative CMO. The marketing function exists to deliver increased enterprise value in the short-, medium- and long-term. And it does so by owning both the numerator and denominator of the "value equation"—optimizing the ability of marketing to generate top-line growth (the numerator) and reducing the cost of delivering that growth (the denominator). The CMO needs to adopt this mindset and create a marketing culture that fully embraces it. He or she needs to serve as the role model for the desired values and behavior, and embrace the core metrics and measurements—not avoid them.

Notes

1
L. Arthur, "Five Years From Now, CMOs Will Spend More on IT Than CIOs Do," *Forbes*, February 8, 2012.

2
G.S. Day, "Closing the Marketing Capabilities Gap," *Journal of Marketing*, 75 (2011), 183-195.

3
B.Groysberg, L. Kevin Kelly and B. MacDonald, "The New Path to the C-Suite," *Harvard Business Review*, March 2011, 60-68.

4
G.S. Day and C. Moorman, *Strategy from the Outside In: Profiting from Customer Value* (New York: McGraw-Hill, 2010).

5
J. Wulf, "The Flattened Firm: Not As Advertised," *California Management Review*, 55 (2012), 5-23.

6
R. Gulati, *Reorganize for Resilience: Putting Customers at the Center of Your Business* (Boston: Harvard Business School Press, 2009).

7
See P.J.H. Schoemaker, "Scenario Planning: A Tool for Strategic Thinking," *MIT Sloan Management Review*, 36 (Winter 1995), 35-40; and L. Fahey and R.M. Randall, *Learning From the Future: Competitive Foresight Scenarios* (New York: John Wiley & Sons, 1998).

8
Portions of this section have been adapted from G.S. Day and R. Malcolm, "The CMO and the Future of Marketing," *Marketing Management*, Spring 2012, 34-42.

9
S. Brinker and L. McLellan, "The Rise of the Chief Marketing Technologist," *Harvard Business Review*, July-August 2014, 3-5.

The Rise of the New Multinationals

Esteban García-Canal and Mauro F. Guillén

Professors Guillén and García-Canal investigate the proliferation of the new multinationals. Many of these firms were marginal competitors until recently and are now challenging the world's most accomplished and established multinationals. In their article they examine some fundamental questions in relation to this phenomenon. What common distinctive features do these firms share that sets them apart from traditional multinational enterprises? What advantages have made it possible for them to operate and compete not only in host countries at the same or lower level of economic development but also in the richest economies? How have they been able to expand abroad at such speed, defying conventional wisdom in relation to international expansion?

In answering these questions they redefine the established theory of the MNE. They find that in effect, globalization, technical change, and the coming of age of the emerging countries have facilitated the rise of a new type of MNE in which foreign direct investment is driven not only by the exploitation of firm-specific competences but also by the exploration of new patterns of innovation and ways of accessing markets.

Esteban García-Canal
Universidad de Oviedo

Mauro F. Guillén
The Lauder Institute, Wharton School

Esteban García-Canal is a professor of Management and International Business at the University of Oviedo (Spain). He is also a member of the Institute of Business and Humanism at the University of Navarra. His research interests are focused on the confluence between organizational economics, corporate strategy and international business. He is the author of over 80 articles published in leading management journals, and his most recent books are *The New Multinationals* (2010) and *Emerging Markets Rule* (2013), both co-authored with Mauro Guillén.

Mauro F. Guillén is the Zandman Professor of International Management at the Wharton School, and Director of the Lauder Institute of Management and International Studies. He is Vice-Chair of the Global Agenda Council on Emerging Multinationals at the World Economic Forum, and a recipient of the Aspen Institute's Faculty Pioneer Award. He previously taught at the MIT Sloan School of Management. He received a PhD in Sociology from Yale University and a doctorate in Political Economy from the University of Oviedo in his native Spain.

Key Features for the Company of the Future:

A Company That Can Deal With Growing Uncertainty
It will be willing to make decisions incrementally and to be always on the look-out for new opportunities. This company will be integrated in networks with partners, clients and suppliers.

A Company That is Flexible in Its Relationships with Employees
It will enable older employees to stay with the company under flexible formulas so that the company can benefit from their experience and society can cope with population ageing.

A Company That Embraces Innovation and Adaptation
The company of the future will be a learning organization, in continuous interaction with the environment, becoming an open, borderless organization.

The Rise of the New Multinationals

Perhaps one of the most far-reaching developments of the last twenty years has to do with the rise of emerging economies, which once represented no more than 15% of the global economy and now have come to account for nearly 50% of economic activity. These economies are growing fast and are located around the world, including the BRICs (Brazil, Russia, India, and China), MITS (Mexico, Indonesia, Turkey, and South Africa), and many other economies in Africa, East Asia, South Asia, Latin America, and the Middle East. Some of these countries have become major exporters of manufactured goods while others sell agricultural, energy or mineral commodities. In the last few years, the emerging economies have also become major sources of foreign direct investment, that is, companies based in emerging economies have expanded throughout the world, making acquisitions and setting up manufacturing and distribution operations not just in emerging economies and developing countries but in developed ones as well, becoming Multinational Enterprises (MNEs).

The literature has referred to Emerging Market Multinationals in a variety of ways, including "third-world multinationals",[1] "latecomer firms",[2] "unconventional multinationals",[3] or "emerging multinationals".[4] In some cases, these firms are labeled according to their region of origin, using terms such as

"dragon multinationals",[5] or "multilatinas".[6] We label them as "The New Multinationals".[7] They have become key actors in foreign direct investment and cross-border acquisitions.[8]

The proliferation of the new multinationals has taken observers, policymakers, and scholars by surprise. Many of these firms were marginal competitors just a decade ago; today they are challenging some of the world's most accomplished and established multinationals in a wide variety of industries and markets. In this chapter we try to answer three fundamental types of questions. First, do these firms share some common distinctive features that distinguish them from the traditional MNEs? Second, what advantages have made it possible for them to operate and compete not only in host countries at the same or lower level of economic development but also in the richest economies? Third, how come they have been able to expand abroad at dizzying speed, in defiance of the conventional wisdom about the virtues of a staged, incremental approach to international expansion? Before being in a position to answer these questions, one must begin by outlining the established theory of the MNE and explore the extent to which its basic postulates need to be reexamined.

The Theory of the Multinational Firm

Although MNEs have existed for a very long time, scholars first attempted to understand the nature and drivers of their cross-border activities during the 1950s. The credit for providing the first comprehensive analysis of the MNE and of foreign direct investment goes to an economist, Stephen Hymer, who in his doctoral dissertation observed that the "control of the foreign enterprise is desired in order to remove competition between that foreign enterprise and enterprises in other countries. Or the control is desired in order to appropriate fully the returns on certain skills and abilities."[9] His key insight was that the multinational firm possesses certain kinds of proprietary advantages that set it apart from purely domestic firms, thus helping it overcome the "liability of foreignness."

Multinational firms exist because certain economic conditions and proprietary advantages make it advisable and possible for them to profitably undertake production of a good or service in a foreign location. The most representative case of foreign direct investment is horizontal expansion, which occurs when the firm sets up a plant or service delivery facility in a foreign location with the goal of selling in that market, and without abandoning production of the good or service in the home country. The decision to engage in horizontal expansion is driven by forces different than those for vertical expansion. Production of a good or service in a foreign market is desirable in the presence of protectionist barriers, high transportation costs, unfavorable currency exchange rate shifts, or requirements for local adaptation to the peculiarities of local demand that

make exporting from the home country unfeasible or unprofitable. However, these obstacles are merely a necessary condition for horizontal expansion, but not a sufficient one. The firm should ponder the relative merits of licensing a local producer in the foreign market (or establishing an alliance) against those of committing to a foreign investment. The sufficient condition for setting up a proprietary plant or service facility has to do with the possession of intangible assets—brands, technology, know-how, and other firm-specific skills—that make licensing a risky option because the licensee might appropriate, damage or otherwise misuse the firm's assets.[10]

Scholars in the field of international management have also acknowledged that firms in possession of the requisite competitive advantages do not become MNEs overnight, but in a gradual way, following different stages. According to the framework originally proposed by researchers at the University of Uppsala in Sweden,[11] firms expand abroad on a country-by-country basis, starting with those more similar in terms of socio-cultural distance. They also argued that in each foreign country firms typically followed a sequence of steps: on-and-off exports, exporting through local agents, sales subsidiary, and production and marketing subsidiary. A similar set of explanations and predictions was proposed by Vernon[12] in his application of the product life cycle to the location of production. According to these perspectives, the firm commits resources to foreign markets as it accumulates knowledge and experience, managing the risks of expansion and coping with the liability of foreignness. An important corollary is that the firm expands abroad only as fast as its experience and knowledge allows.

> The multinational firm possesses certain kinds of proprietary advantages that set it apart from purely domestic firms

Enter the "New" Multinationals

The early students of the phenomenon of MNEs from developing, newly industrialized, emerging, or upper-middle-income countries focused their attention on both the vertical and the horizontal investments undertaken by these firms, but they were especially struck by the latter. Vertical investments, after all, are easily understood in terms of the desire to reduce uncertainty and minimize opportunism when assets are dedicated or specific to the supply or the downstream activity, whether the MNE comes from a developed country or not.[13] The horizontal investments of the new MNEs, however, are harder to explain because they are supposed to be driven by the possession of intangible assets, and firms from developing countries were simply assumed not to possess them, or at least not

to possess the same kinds of intangible assets as the classic MNEs from the rich countries.[14] This paradox becomes more evident with the second wave of foreign direct investment (FDI) from the developing world, the one starting in the late 1980s. In contrast with the first wave FDI from developing countries that took place in the 1960s and 70s,[15] the new MNEs of the 1980s and 90s aimed at becoming world leaders in their respective industries, not just marginal players.[16] In addition, the new MNEs do not come only from emerging countries. Some firms labeled as born-global, born-again born-globals or born-regionals[17] have emerged from developed countries following accelerated paths of internationalization that challenge the conventional view of international expansion.

> The new MNEs of the 1980s and 90s aimed at becoming world leaders in their respective industries, not just marginal players. In addition, the new MNEs do not come only from emerging countries

The main features of the new MNEs, as compared to the traditional ones, appear in Table 1. The dimensions in the table highlight the key differences between new and conventional MNEs. Perhaps the most startling one has to do with the accelerated pace of internationalization of the new MNEs, as firms from emerging economies have attempted to close the gap between their market reach and the global presence of the MNEs from developed countries.[18] A second feature of the new MNEs is that, no matter the home country, they have been forced to deal not only with the liability of foreignness, but also with the liability and competitive disadvantage that stems from being latecomers lacking the resources and capabilities of the established MNEs from the most advanced countries. For this reason, the international expansion of the new MNEs runs in parallel with a capability upgrading process through which newcomers seek to gain access to external resources and capabilities in order to catch up with their more advanced competitors, that is, to reduce their competitiveness gap with established MNEs.[19] However, despite lacking the same resource endowment of MNEs from developed countries, the new MNEs usually have an advantage over them, as they tend to possess stronger political capabilities. As the new MNEs are more used to deal with discretionary and/or unstable governments in their home country, they are better prepared than the traditional MNEs to succeed in foreign countries characterized by a weak institutional environment.[20] Taking into account the high growth rates of emerging countries and their peculiar institutional environment, political capabilities have been especially valuable for the new MNEs.

Table 1. The New Multinational Enterprises Compared to Traditional Multinationals

DIMENSION	NEW MNEs	TRADITIONAL MNEs
Speed of internationalization	Accelerated	Gradual
Competitive advantages	**Weak:** upgrading of resources required	**Strong:** required resources available in-house
Political capabilities	**Strong:** firms used to unstable political environments	**Weak:** firms used to stable political environments
Expansion path	**Dual path:** entry into developing countries for market access and developed countries for resource upgrading	**Single path:** from less to more distant countries
Preferred entry modes	**External growth:** alliances, joint ventures, and acquisitions	**Internal growth:** wholly owned subsidiaries
Organizational adaptability	**High,** because of their recent and relatively limited international presence	**Low,** because of their ingrained structure and culture

The first three features taken together point to another key characteristic of the new MNEs: they face a significant dilemma when it comes to international expansion because they need to balance the desire for global reach with the need to upgrade their capabilities. They can readily use their home-grown competitive advantages in other emerging or developing countries, but they must also enter more advanced countries in order to expose themselves to cutting-edge demand and develop their capabilities. This tension is reflected in Figure 1. Firms may evolve in a way that helps them to upgrade their capabilities or gain geographic reach, or both. Although some emerging market multinationals can focus only on emerging markets for their international expansion, becoming what Ramamurti and Singh[21] call local optimizers, the corporate expansion of the new multinationals typically entails moving simultaneously in both directions: capability upgrading and geographic reach. Along the diagonal, the firm pursues a balanced growth path, with the typical expansion pattern of the established multinationals. Above the diagonal it enters the region of capability building, in which the firm sacrifices the number of countries entered (i.e., its geographic reach) so as to close the gap with other competitors, especially in the advanced economies. Below the diagonal the firm enters

Figure 1. Expansion Path of New MNEs in Developed and Developing Countries

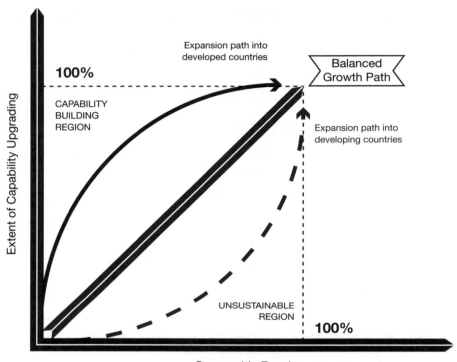

the unsustainable region because prioritizing global reach without improving firm competences jeopardizes the capability upgrading process. The tension between capability upgrading and gaining global reach forces the new MNEs to enter developed and developing countries simultaneously since the beginning of their international expansion. Entering developing countries helps them gain size and operational experience, and generate profits, while venturing into developed ones contributes primarily to the capability upgrading process. The new MNEs have certainly tended to expand into developing countries at the beginning of their international expansion and limit their presence in developed countries to only a few locations where they can build capabilities, either because they have a partner there or because they have acquired a local firm. As they catch up with established MNEs, they begin to invest more in developed countries in search of markets, though they also make acquisitions in developed markets in order to secure strategic assets such as technology or brands.

A fifth feature of the new MNEs is their preference for entry modes based on external growth (see Table 1). Global alliances[22] and acquisitions[23] are used by these firms to simultaneously overcome the liability of foreignness in the country of the partner/target and to gain access to their competitive advantages with the aim of upgrading their own resources and capabilities. When entering into global alliances, the new MNEs have used their home market position to facilitate the entry of their partners in exchange for reciprocal access to the partners' home markets and/or technology. Besides the size of the domestic market, the stronger the position of new MNEs in it, the greater the bargaining power of the new MNEs to enter into these alliances. This fact is illustrated by the case of some new MNEs competing in the domestic appliances industry like China's Haier, Mexico's Mabe or Turkey's Arcelik, whose international expansion was boosted by alliances with world leaders that allowed them to upgrade their technological competences.[24] Capability upgrading processes have been possible in some cases due to the new MNEs' privileged access to financial resources, because of government subsidies or capital market imperfections.[25]

A final feature of the new MNEs is that they enjoy more freedom to implement organizational innovations to adapt to the requirements of globalization because they do not face the constraints typical of established MNEs. As major global players with long histories, many MNEs from the developed economies suffer from inertia and path dependence due to their deeply ingrained values, culture and organizational structure. Mathews[26] shows how the new MNEs from Asia have adopted a number of innovative organizational forms that suited their needs, including networked and decentralized structures.

When analyzing the foreign investments of the new MNEs of the 1960s and 70s, scholars focused their attention on two important questions, namely, their motivations and their proprietary, firm-specific advantages, if any. The following sections deal with these two issues.

Motivations of New MNEs

Table 2 summarizes the main motivations identified in the literature. As noted above, scholars documented and readily explained the desire of some of the new MNEs to create backward linkages into sources of raw materials or forward linkages into foreign markets in order to reduce uncertainty and opportunism in the relationship between the firm and the supplier of the raw material, or between the firm and the distributor or agent in the foreign market. Research documented, especially in the cases of South Korean and Taiwanese firms, their drive to internalize backward and forward linkages through the creation of trading companies, in some cases with government encouragement and financial support.[27] For example, while during the 1960s

Table 2. Motivations for Foreign Direct Investment by the New Multinational Enterprises

DIMENSION	NEW MNEs	TRADITIONAL MNEs
Backward linkage into raw materials	Firm seeks to secure supplies of crucial inputs in the face of uncertainty or asset specificity.	Fields;[27] Lall;[13] Moghaddam et al.;[65] The Economist;[66] UNCTAD;[33] Wells[1]
Forward linkage into foreign markets	Firm seeks to secure access to the market in the presence of asset specificity.	Fields;[27] Moghaddam et al.;[65] UNCTAD;[33] Wells[1]
Home-country government curbs	Firm attempts to overcome growth restrictions imposed by the government in its home market.	Lall;[13] UNCTAD;[33] Wells[1]
Spreading of risk	Firm locates assets in different countries to manage risk.	Lecraw[13]
Move personal capital abroad	Firm invests abroad so that owner(s) diversify their exposure to any one country.	Wells[1]
Follow a home-country customer to foreign markets	Firm follows home-country customers as they expand horizontally to other countries.	Guillén and García-Canal;[7] UNCTAD;[33] Wells[1]
Invest in new markets in response to economic reforms in the home country	Firm enjoying monopolistic or oligopolistic position in the home market is threatened by liberalization, deregulation and/or privatization policies.	Goldstein;[4] Guillén[34]
Acquire firm-specific intangible assets	Firm invests or acquires assets in more developed countries.	Deng;[67] Guillén and García-Canal;[16] Lall;[13] UNCTAD[33]
Exploit firm-specific intangible assets	See Table 3	

a tiny proportion of South Korea's exports reached foreign markets through the distribution and sale channels established by South Korean firms, by the 1980s roughly 50% of them were fully internalized, that is, handled by the exporters themselves.[28] As would be expected, the new MNEs felt the pressures of uncertainty and asset specificity more strongly if they had developed intangible assets. For instance, using evidence on a representative cross-sectional sample of 837 Spanish exporting firms as of 1992, Campa and Guillén (1999)[29] found that those with greater expenditures on R&D

were more likely to internalize export operations. A survey performed by CNUCYD in 2006 of the empirical evidence determined that many of the new MNEs, especially in the extractive and manufacturing sectors, became multinationals when they internalized backward or forward linkages.

Scholars also documented that developing-country MNEs wished to expand abroad in order to overcome limitations imposed by the home-country government in the domestic market. In many developing and newly industrialized countries, limitations such as licensing systems, quota allocations, and export restrictions deprived firms from having enough growth opportunities at their disposal; hence the desire to expand abroad.[30] In part related to the previous motive, firms felt the need to spread risks by locating assets in different countries.[31] This motivation was driven by the macroeconomic and political volatility characteristic of so many developing and newly industrialized countries. A variation on this effect has to do with the case of family-owned MNEs from developing countries under the threat of government scrutiny or confiscation.[32]

The early literature on the new MNEs also identified buyer-supplier relationships as motives for a supplier establishing production facilities in a foreign country in which the buyer already had a presence.[33] In some cases, both the buyer and the supplier are home-country firms that followed each other abroad, while in others the buyer is a multinational from a developed country that asks its supplier in a developing or newly industrialized country to co-locate either in its home country or in other countries.[34]

Firm-Specific Assets

Scholars also devoted attention to the proprietary, firm-specific intangible assets of the new MNEs, noting that they engaged in foreign direct investment with the purpose of not only acquiring such assets but also exploiting existing ones. Foreign expansion with a view to acquiring intangible assets, especially technology and brands, was not very important during the 1970s and 80s, but has become widespread in the last two decades.[35] With the advent of current account and currency exchange liberalization in many developing and newly industrialized countries, the new MNEs have enjoyed more of a free hand in terms of making acquisitions, including multi-billion dollar deals. Many of these have targeted troubled companies or divisions located in the United States and Europe that possess some brands and product technology that the new MNE is in a better position to exploit because of its superior or more efficient manufacturing abilities.[36]

Acquisitions have not been the only way to gain access to intangible assets. The evidence suggests that the acceleration in the international expansion of the new MNEs has been backed by a number of international alliances aimed at gaining access to critical resources and skills that allow these firms to catch

up with MNEs from developed countries. As argued above, these alliances and acquisitions have been critical for these firms to match the competitiveness of MNEs from developed countries. For this reason the international expansion of new MNEs runs in parallel with the process of upgrading their capabilities. Sometimes, however, capability upgrading precedes international expansion. This is the case, for instance, of some state-owned enterprises that undergo a restructuring process before their internationalization and privatization.[37] In other cases the capability upgrading process can follow international expansion. This can happen in regulated industries, where firms face strong incentives to commit large amounts of resources and to establish operations quickly, whenever and wherever opportunities arise, and frequently via acquisition as opposed to greenfield investment.[38] As opportunities for international expansion in these industries depend on privatization and deregulation, some firms lacking competitive advantages expand abroad on the basis of free cash-flows as opportunities arise. As noted above, horizontal investments seemed to pose a challenge to established theories of the MNE. The literature had emphasized since the late 1950s that MNEs in general undertake horizontal investments on the basis of intangible assets such as proprietary technology, brands, or know-how. The early literature on the new multinationals simply assumed that firms from developing or newly industrialized countries lacked the kind of intangible assets characteristic of American, Japanese or European multinationals.[39] In fact, study after study found that the new multinationals scored lower on technology, marketing skill, organizational overhead, scale, capital intensity, and control over foreign subsidiaries than their rich-country counterparts.[40]

Still, horizontal investments cannot be explained without the presence of intangible assets of some sort. Even though new multinationals may lack proprietary assets, they have developed other kinds of competitive advantages that they can display in foreign markets.[41] Table 3 summarizes the main types of intangible assets possessed by the new MNEs, as reflected in the existing literature. During the 1970s and 80s, the scholarly attention focused on capabilities such as the adaptation of technology to the typically smaller-scale markets of developing and newly industrialized countries, their cheaper labor, or imperfect input markets.[42] Consumer-goods MNEs from these countries were also found to possess a different kind of intangible asset, namely "ethnic brands" that appealed to customers not only in the home market but also to the ethnic diaspora in foreign countries, especially in Europe and the United States.[43] Other scholars noted that the new MNEs possessed an

Table 3. Intangible Assets of the New Multinational Enterprises

INTANGIBLE ASSET	DESCRIPTION	REFERENCES
Technology adaptation	Adaptation of available technology to small-scale product markets, cheap labor, and/or imperfect input markets.	Ferrantino;[42] Heenan and Keegan;[42] Lall;[13] Lecraw;[13] Ramamurti and Singh;[4] Tolentino[42]
Early adoption of new technology	Implementation of new technology developed by someone else, especially in infrastructure industries such as construction, electricity or telecommunications.	Guillén;[34] UNCTAD[33]
Reverse innovation/jugaad	Make the most out of scarce resources.	Govindarajan and Ramamurti;[54] Guillén and García-Canal;[16] Kumar and Puranam[55]
Ethnic branding	Consumer brands with appeal to immigrant home-country communities abroad.	Ferrantino;[42] Heenan and Keegan;[42] Lall;[13] Lecraw;[13] Wells[1]
Efficient production and project execution	Ability to absorb technology, combine resources and innovate from an organizational point of view in ways that reduce costs and enhance learning.	Amsden and Hikino;[45] Goldstein;[4] Guillén;[46] Guillén and García-Canal;[16] Kock and Guillén;[46] Mathews;[16] Ramamurti;[19] Ramamurti and Singh;[4] UNCTAD[33]
Product innovation	Incremental product improvements; specialized products for market niches.	Lall;[13] UNCTAD[33]
Institutional entrepreneurial ability	Skills or know-how needed to operate in the peculiar institutional conditions of less developed countries.	Caves;[10] Lall;[13] Lecraw;[57] Ramamurti[19]
Expertise in the management of acquisitions	Experience gained in the home country in the management of M&As and corporate restructuring that help to extract value from cross-border acquisitions.	García-Canal and Guillén;[20] Colli et al.;[41] Guillén[34]
Networking skills	Ability to develop networks of cooperative relationships.	Buckley et al.;[25] Dunning;[68] Mathews[16]
Political know-how	Advantage in dealing with host governments and with political risk in less developed countries.	Cuervo-Cazurra;[20] Diaz Hermelo and Vassolo;[57] García-Canal and Guillén;[20] Goldstein and Pritchard;[59] Lall;[13] Lecraw[13]

uncanny ability to incrementally improve available products and to develop specialized variations for certain market niches.[44]

During the 1980s students of the so-called East Asian miracle highlighted yet another intangible asset, one having to do with the ability to organize production and to execute large-scale projects efficiently with the help of technology borrowed from abroad in industries as diverse as steel, electronics, automobiles, shipbuilding, infrastructure development, and turnkey plant construction.[45] Scholars also proposed that these capabilities facilitated the growth of diversified business groups,[46] which in turn made it easier for firms within the same group to expand and invest abroad by drawing on shared financial, managerial, and organizational resources.[47] A specific type of managerial skill that becomes critical in accelerated internationalization is the ability to manage effectively organizational combinations such as mergers and acquisitions or strategic alliances. These abilities become critical when extracting value from these deals, deals that are necessary to learn and gain access to critical resources to increase the international competitiveness of the firm.[48] The accrued skills in the management of M&As and corporate restructuring by large Spanish firms competing in regulated industries were critical for their international expansion in Latin America.[49] Buckley et al.,[50] analyzing the success of Chinese firms capitalizing on the Chinese diaspora, argued that some firms have the ability to engage in beneficial relationships with other firms having valuable resources needed to succeed in global markets. The adoption of network-based structures has also helped the development of the new MNEs by making easier the coordination of the international activities.[51] However, home-country networks in several cases have also allowed these firms to take advantage of the experience of the firms with whom they have a tie.[52]

A specific type of managerial skill that becomes critical in accelerated internationalization is the ability to manage effectively organizational combinations such as mergers and acquisitions or strategic alliances

In more recent years, students of the new MNEs have drawn attention to other types of intangible assets. On the technology side, research has documented that firms in developing, newly industrialized, and upper-middle-income countries face lower hurdles when it comes to adopting new technology than their more established counterparts in rich countries. This is especially the case in industries such as construction, electricity, port operators or telecommunications, in which companies from Brazil, Chile, Mexico, South Korea, Spain, and Dubai, among other countries, have demonstrated a superior ability to borrow technology and organize efficient operations across many markets.[53] Interestingly, Govindarajan

and Ramamurti[54] point out that new MNEs are also capable of coming up with innovative products which they later sell in developed markets in a process called "reverse innovation".[55] Another area of recent theoretical and empirical research has to do with the political know-how that the new MNEs seem to possess by virtue of having been forced to operate in heavily regulated environments at first, and then rapidly deregulating ones, as illustrated by the expansion of Spanish banking, electricity, water, and telecommunications firms throughout Latin America and, more recently, Europe.[56] This "political" capability was not lost on the early students of the new MNEs; they duly pointed out that these firms possessed an "institutional entrepreneurial ability" that enabled them to operate effectively in the peculiar political, regulatory, and cultural conditions characteristic of developing countries.[57] Political and regulatory risk management was identified in some early studies as a key competitive capability.[58] In the last twenty years a new twist has been added to this theoretical insight after observing that the new MNEs are making acquisitions and increasing their presence in the infrastructure industries of the rich countries of Europe and North America, including electricity generation and distribution, telecommunications, water, and airport, ports and toll-highway operation, among others.[59] The recent corporate expansion into Latin America of Spanish firms from regulated industries illustrates how firms tend to invest in those countries where their political capabilities are more valuable, that is, those with high political instability. Spanish firms from regulated industries reduced over time their propensity to invest in politically unstable countries, showing that it is easier to move from politically unstable countries to stable ones than the other way around.[60]

It is cardinal to note that while the managerial, organizational, and political skills of the new multinationals may not be "patentable," they are rare, difficult to imitate and valuable, the three conditions identified in the resource-based view of the firm as characterizing a true "capability".[61] The international expansion of the new multinationals cannot be understood without taking into account these non-technological proprietary intangible assets, which have enabled them to obtain scarcity rents in addition to the extraordinary profits arising from imperfect competition. Thus, intangible assets have played a key role in the rise of the new multinationals, but the assets themselves tend not to be technology and brands, as in the case of traditional multinationals,[62] but managerial, organizational, and political in nature.

Learning from the New Multinationals

In our recent book[63] we have distilled the competitive capabilities of the emerging-market multinationals into seven principles that companies from any country in the world should adopt in order to be ready for the new kind

of intense global competition of the 21st century. First, we argue that action should take precedence over strategy. In the rapidly changing global economy, companies need to experiment and to adapt incrementally rather than wait for the "perfect" strategy to arrive. We illustrate this principle with the rise to global prominence of Bimbo, whose emphasis on operations and execution rather than strategy enabled it to become the world's leading bread company. The second principle has to do with niche thinking. Companies must follow the path of least resistance into foreign markets, which typically is a narrow niche they can dominate. Later, they can use that niche as a platform or beachhead for mounting an assault on the mainstream of the market. This is the strategy followed by Haier in the United States, a company that first targeted college students, and now is the world's largest appliance brand in the world.

The third principle involves building up scale fast so as to pre-empt competitors, attract price-sensitive customers, and build up market share. Samsung Electronics is perhaps the company that illustrates this principle best. It bet the farm by investing in huge factories for new products not just once but several times. It is now the world's largest consumer electronics company. If scale is important in the global economy, so is the ability to embrace chaos, the fourth principle. Acer expanded throughout the world without fearing chaos, either externally or internally. It used a network of local partners to minimize risk and maximize adaptation. Today the company is the second largest personal computer brand in the world. In order to sustain rapid growth, and to learn new capabilities along the way, we propose a fifth principle which urges companies to acquire smart, in the dual sense of buying assets that complement its existing capabilities, and doing so at the right time and with a clear integration strategy in mind. Scale through internal and external growth should enable the company to implement our sixth principle: expand with abandon. We argue that if a company waits to make a foreign move until it is ready, then it has waited too long. Foreign expansion cannot be planned day by day. Companies need to be willing to experiment, to engage in trial-and-error, to expose themselves to new opportunities and ways of doing things.

And it is at this point where our seventh, and most important, recommendation comes in. In this new, rapidly-changing global economy companies must abandon the sacred cows. What brought them success in the past cannot become a hindrance for pursuing the new opportunities that are becoming available around the world.

Conclusion

The new MNEs are the result of both imitation of established MNEs from the rich countries—which they have tried to emulate strategically and organizationally—and innovation in response to the peculiar characteristics of

emerging and developing countries. The context in which their international expansion has taken place is also relevant. The new MNEs have emerged from countries with weak institutional environments and they are used to operating in countries with weak property-rights regimes, legal systems, and so on. Experience in the home country became especially valuable for the new MNEs because many countries with weak institutions are growing fast and they had developed the capabilities to compete in such challenging environments.

In addition, the new MNEs have flourished at a time of market globalization in which, despite the local differences that still remain, global reach and global scale are crucial. The new MNEs have responded to this challenge by embarking on an accelerated international strategy based on external growth aimed at upgrading their capabilities and increasing their global market reach. When implementing this strategy, the new MNEs took advantage of their market position in the home country and, ironically, their meager international presence allowed them to adopt a strategy and organizational structure that happens to be most appropriate to the current international environment in which emerging economies are growing very fast.

> **The meager international presence of the new MNEs allowed them to adopt a strategy and organizational structure most appropriate to the current international environment**

It is also important to note that the established MNEs from the rich countries have adopted some of the patterns of behavior of the new multinationals. Increased competitive pressure from the latter in industries such as cement, steel, electrical appliances, construction, banking, and infrastructure has prompted many American and European firms to become much less reliant on traditional product-differentiation strategies and vertically integrated structures. To a certain extent, the rise of networked organizations[64] and the extensive shift towards outsourcing represent competitive responses to the challenges faced by established MNEs. Finally, a special type of new MNE is the so-called born-global firm, which resembles the new MNE in many ways but has emerged from developed countries.

Taking all of these developments into account, it is clear that the traditional model of MNE is fading. In effect, globalization, technical change, and the coming of age of the emerging countries have facilitated the rise of a new type of MNE in which foreign direct investment is driven not only by the exploitation of firm-specific competences but also by the exploration of new patterns of innovation and ways of accessing markets. In addition, the new MNEs have expanded very rapidly, without following the gradual, staged model of internationalization.

It is important to note, however, that the decline of the traditional model of the MNE does not necessarily imply the demise of existing theories of the MNE. In fact, the core explanation for the existence of MNEs remains, namely, that in order to pursue international expansion, the firm needs to possess capabilities allowing it to overcome the liability of foreignness; no firm-specific capabilities, no multinationals. Our analysis of the new MNEs has shown that their international expansion was possible due to some valuable capabilities developed in the home country, including project-execution, political, and networking skills, among other non-conventional ones. Thus, the lack of the classic technological or marketing capabilities does not imply the absence of other valuable capabilities that may provide the foundations for international expansion. It is precisely for this reason that the new MNEs are here to stay.

Notes

1
L.T. Wells Jr., *Third World Multinationals: The Rise of Foreign Investment from Developing Countries* (Cambridge, MA: The MIT Press, 1983).

2
J.A. Mathews, *Dragon Multinationals: A New Model of Global Growth* (New York: Oxford University Press, 2002).

3
P.P. Li, "Toward a Geocentric Theory of Multinational Evolution: The Implications from the Asian MNEs as Latecomers," *Asia Pacific Journal of Management* 22.2 (June 2003), 217-42.

4
Accenture, "The Rise of the Emerging-Market Multinational", 2008; A. Goldstein, *Multinational Companies from Emerging Economies* (New York: Palgrave Macmillan, 2007); R. Ramamurti and J.V. Singh (eds.), *Emerging Multinationals in Emerging Markets* (Cambridge: Cambridge University Press, 2009).

5
Mathews, *Dragon Multinationals*, 2002.

6
A. Cuervo-Cazurra, "The Multinationalization of Developing Country MNEs: The Case of Multilatinas," *Journal of International Management*, 14.2 (June 2008), 138-54.

7
M.F. Guillén and E. García-Canal, *The New Multinationals: Spanish Firms in a Global Context* (Cambridge and New York: Cambridge University Press, 2010).

8
CNUCYD (United Nations Conference on Trade and Development), "World Investment Report 2008" (New York & Geneva: United Nations, 2008).

9
S. Hymer, "The International Operations of National Firms: A Study of Direct Foreign Investment," PhD thesis (MIT, 1960), p.25 (publ. Cambridge: The MIT Press, 1976).

10
For a summary of the basic economic model of the multinational firm, see R.E. Caves, *Multinational Enterprise and Economic Analysis* (New York: Cambridge University Press, 1996). Stephen Hymer [1960] was the first to observe that firms expand horizontally to protect (and monopolize) their intangible assets. Other important contributions are: P.J. Buckley and M. Casson, *The Future of the Multinational Enterprise* (London: Macmillan, 1976); J.F. Hennart, *A Theory of Multinational Enterprise* (Ann Arbor: University of Michigan Press, 1982); and D.J. Teece, "Technology Transfer by Multinational Firms: The Resource Cost of Transferring Technological Know-How," *Economic Journal*, 87.346 (1977), 242-61.

11
J. Johanson and J.-E. Vahlne, "The Internationalization Process of the Firm: A Model of Knowledge Development and Increasing Foreign Market Commitments," *Journal of International Business Studies*, 8.1 (1977), 23-32; J. Johanson and F. Wiedersheim-Paul, "The Internationalization of the Firm—Four Swedish Cases," *Journal of Management Studies*, 12 (October 1975), 305-22.

12
R. Vernon, "International Investment and International Trade in the Product Cycle," *Quarterly Journal of Economics*, 80 (1966), 190-207; "The Product Cycle Hypothesis in a New International Environment," *Oxford Bulletin of Economics and Statistics*, 41.4 (November 1979), 255-67.

13
Caves, *Multinational Enterprise*, 1996, pp.238-241; S. Lall, *The New Multinationals* (New York: Wiley, 1983); D. Lecraw, "Direct Investment by Firms from Less Developed Countries," *Oxford Economic Papers*, 29 (November 1977), 445-57; Wells, *Third World Multinationals*, 1983.

14
Lall, *New Multinationals*, 1983, p.4.

15
Lall, *New Multinationals*, 1983; Wells, *Third World Multinationals*, 1983.

16
Guillén and García-Canal, *New Multinationals*, 2010; M.F. Guillén and E. García-Canal, *Emerging Markets Rule* (New York: McGraw-Hill, 2013); J.A. Mathews, "Dragon Multinationals," *Asia Pacific Journal of Management*, 23 (2006), 5-27.

17
C.G. Asmussen, "Local, Regional, or Global? Quantifying MNE Geographic Scope," *Journal of International Business Studies*, 40 (2009), 1192-1250; J. Bell, R. McNaughton, and S. Young, "Born-again Global Firms: An Extension to the Born Global Phenomenon," *Journal of International Management*, 7.3 (2001), 173-90; N. Hashai, "Sequencing the Expansion of Geographic Scope and Foreign Operations by *Born Global* Firms," *Journal of International Business Studies*, 42 (2011), 995-1015; S. Khavul, L. Pérez-Nordtvedt, and E. Wood, "Organizational Entrainment and International New Ventures from Emerging Markets," *Journal of Business Venturing*, 25 (2010), 104-19; T.K. Madsen, "Early and Rapidly Internationalizing Ventures: Similarities and Differences Between Classifications Based on The Original International New Venture and Born Global Literatures," *Journal of International Entrepreneurship*, 11.1 (2013), 65-79; A. Rialp, J. Rialp, and G.A. Knight, "The Phenomenon of Early Internationalizing Firms: What Do We Know After a Decade (1993-2003) of Scientific Enquiry?" *International Business Review*, 14.2 (April 2005), 147-66; L. Zhou, W. Wu, and X. Luo, "Internationalization and the Performance of Born-Global SMEs: The Mediating Role of Social Networks," *Journal of International Business Studies*, 38 (2007), 673-90.

18
P.J. Buckley and N. Hashai, "The Role of Technological Catch Up and Domestic Market Growth in the Genesis of Emerging Country Based Multinationals," *Research Policy*, 43.2 (2014), 423-37; Mathews, "Dragon Multinationals," 2006.

19
P.S. Aulakh, "Emerging Multinationals from Developing Countries: Motivations, Paths and Performance," *Journal of International Management*, 13.3 (2007), 235-40; L.A. Dau, "Learning Across Geographic Space: Pro-market Reforms, Multinationalization Strategy, and Profitability," *Journal of International Business Studies*, 44 (2013), 235-62; J.F. Hennart, "Emerging Market Multinationals and the Theory of the Multinational Enterprise," *Global Strategy Journal*, 2 (2012), 168-87; D. Lessard and R. Lucea, "Mexican Multinationals: Insights from CEMEX," in *Emerging Multinationals*, ed. by Ramamurti and Singh, 2009; P.P. Li, "Toward an Integrated Theory of Multinational Evolution: The Evidence of Chinese Multinational Enterprises as Latecomers," *Journal of International Management*, 13.3 (2007), 296-318; Mathews, "Dragon Multinationals," 2006; R. Ramamurti, "What Have We Learned About Emerging Market MNEs?" in *Emerging Multinationals*, ed. by Ramamurti and Singh, 2009, 339-426; A. Verbeke and L. Kano, "An Internalization Theory Rationale for MNE Regional," *Multinational Business Review*, 20.2 (2012), 135-52.

20
A. Cuervo-Cazurra, "Extending Theory by Analyzing Developing Country Multinational Companies: Solving the Goldilocks Debate," *Global Strategy Journal*, 2 (2012), 153-167; A. Cuervo-Cazurra and M. Genc, "Transforming Disadvantages into Advantages: Developing-Country MNEs in the Least Developed Countries," *Journal of International Business Studies*, 39 (2008), 957-79; F. Diaz Hermelo and R. Vassolo, "Institutional Development and Hypercompetition in Emerging Economies," *Strategic Management Journal*, 31 (2010), 1457-73; E. García-Canal and M.F. Guillén, "Risk and the Strategy of Foreign Location Choice," *Strategic Management Journal*, 29.10 (2008), 1097-115.

21
Ramamurti and Singh (eds.), *Emerging Multinationals*, 2009.

22
E. García-Canal, C. López Duarte, J. Rialp Criado, and A. Valdés Llaneza, "Accelerating International Expansion through Global Alliances: A Typology of Cooperative Strategies," *Journal of World Business*, 37.2 (2002), 91-107; J. Johanson and J.-E. Vahlne, "The Uppsala Internationalization Process Model Revisited: From Liability of Foreignness to Liability of Outsidership," *Journal of International Business Studies*, 40 (2009), 1411-31.

23
P.J. Buckley, S. Elia, and M. Kafouros, "Acquisitions by Emerging Market Multinationals: Implications for Firm Performance," *Journal of World Business*, 49 (2014), 611-632; H. Rui and G.S. Yip, "Foreign Acquisitions by Chinese Firms: A Strategic Intent Perspective," *Journal of World Business*, 43 (2008), 213-26.

24
F. Bonaglia, A. Goldstein, and J.A. Mathews, "Accelerated Internationalization by Emerging Market Multinationals: The Case of the White Goods Sector," *Journal of World Business*, 42 (2007), 369-83.

25
P.J. Buckley, L.J. Clegg, A.R. Cross, X. Liu, H. Voss, and P. Zheng, "The Determinants of Chinese Outward Foreign Direct Investment," *Journal of International Business Studies*, 38 (2007), 499-518; Buckley et al., "Acquisitions by Emerging Market Multinationals," 2014; J. Lu, X. Liu, M. Wright, and I. Filatotchev, "International Experience and FDI Location Choices of Chinese Firms: The Moderating Effects of Home Country Government Support and Host Country Institutions," *Journal of International Business Studies*, 45 (2014), 428-49.

26
Mathews, "Dragon Multinationals," 2006.

27
K.J. Fields, *Enterprise and the State in Korea and Taiwan* (Ithaca, NY: Cornell University Press, 1995), 183-237.

28
D.S. Cho, *The General Trading Company: Concept and Strategy* (Lexington, MA: Lexington Books, 1987).

29
J.M. Campa and M.F. Guillén, "The Internationalization of Exports: Firm and Location-Specific Factors in a Middle-Income Country," *Management Science*, 45.11 (November 1999), 1463-78.

30
Lall, *New Multinationals*, 1983; Wells, *Third World Multinationals*, 1983.

31
Lecraw, "Direct Investment," 1977.

32
Wells, *Third World Multinationals*, 1983.

33
CNUCYD (United Nations Conference on Trade and Development), "World Investment Report 2006" (New York & Geneva: United Nations, 2006); Wells, *Third World Multinationals*, 1983.

34
M.F. Guillén, *The Rise of Spanish Multinationals: European Business in the Global Economy* (Cambridge and New York: Cambridge University Press, 2005).

35
CNUCYD, "World Investment Report 2006."

36
In "Down with MNE-centric Theories! Market Entry and Expansion as the Bundling of MNE and Local Assets," *Journal of International Business Studies*, 40.9 (2009), 1432-54, J.F. Hennart argues that the greater efficiency in markets for assets and asset services in developed countries makes firms less diversified and, for this reason, more modular, i.e., easier to be taken over and integrated by an emerging market multinational willing to acquire external technology and know-how.

37
A. Cuervo and B. Villalonga, "Explaining the Variance in the Performance Effects of Privatization," *Academy of Management Review*, 25 (2000), 581-90.

38
Buckley et al., "Acquisitions by Emerging Market Multinationals," 2014; García-Canal and Guillén, "Risk and the Strategy of Foreign Location Choice," 2008; Guillén and García-Canal, *Emerging Markets Rule*, 2013; M.W. Peng, "The Global Strategy of Emerging Multinationals from China," *Global Strategy Journal*, 2 (2012), 97-107; M.B. Sarkar, S.T. Cavusgil, and P.S. Aulakh, "International Expansion of Telecommunication Carriers: The Influence of Market Structure, Network Characteristics and Entry Imperfections," *Journal of International Business Studies*, 30 (1999), 361-82.

39
Lall, *New Multinationals*, 1983, 4.

40
Lall, *New Multinationals*, 1983; Lecraw, "Direct Investment," 1977; Wells, *Third World Multinationals*, 1983.

41
A. Colli, E. García-Canal, and M.F. Guillén, "Family Character and International Entrepreneurship: A Historical Comparison of Italian and Spanish New Multinationals," *Business History*, 55.1 (2013), 119-38; A. Madhok and M. Keyhani, "Acquisitions as Entrepreneurship: Asymmetries, Opportunities, and the Internationalization of Multinationals from Emerging Economies," *Global Strategy Journal*, 2 (2012), 26-40; Ramamurti and Singh (eds.), *Emerging Multinationals*, 2009.

42
M.J. Ferrantino, "Technology Expenditures, Factor Intensity, and Efficiency in Indian Manufacturing," *Review of Economics and Statistics*, 74.4 (1992), 689-700; D.A. Heenan and W.J. Keegan, "The Rise of Third World Multinationals," *Harvard Business Review*, 57 (January-February 1979), 101-9; Lall, *New Multinationals*, 1983; Lecraw, "Direct Investment," 1977; Ramamurti and Singh (eds.), *Emerging Multinationals*, 2009; P.E. Tolentino, *Technological Innovation and Third World Multinationals* (London: Routledge, 1993).

43
Ferrantino, "Technology Expenditures," 1992; Goldstein, *Multinational Companies*, 2007, 117-122; Lecraw, "Direct Investment," 1977; Wells, *Third World Multinationals*, 1983.

44
Lall, *New Multinationals*, 1983; CNUCYD, "World Investment Report 2006."

45
A.H. Amsden and T. Hikino, "Project Execution Capability, Organizational Know-How and Conglomerate Corporate Growth in Late Industrialization," *Industrial & Corporate Change*, 3.1 (1994), 111-47.

46
M.F. Guillén, "Business Groups in Emerging Economies: A Resource-Based View," *Academy of Management Journal*, 43.3 (June 2000), 362-80; Guillén and García-Canal, *Emerging Markets Rule*, 2013; C. Kock and M.F. Guillén, "Strategy and Structure in Developing Countries: Business Groups as an Evolutionary Response to Opportunities for Unrelated Diversification," *Industrial & Corporate Change*, 10.1 (2001), 1-37; Ramamurti, "What Have We Learned About Emerging Market MNEs?" 2009; Ramamurti and Singh (eds.), *Emerging Multinationals*, 2009.

47
Goldstein, *Multinational Companies*, 2007; M.F. Guillén, "Structural Inertia, Imitation, and Foreign Expansion: South Korean Firms and Business Groups in China, 1987-1995," *Academy of Management Journal*, 45.3 (June 2002), 509-25; Lall, *New Multinationals*, 1983, p.6; Mathews, "Dragon Multinationals," 2006; CNUCYD, "World Investment Report 2006."

48
Guillén and García-Canal, *Emerging Markets Rule*, 2013; S. Henningsson and S. Carlsson, "The DySIIM Model for Managing IS Integration in Mergers and Acquisition," *Information Systems Journal*, 21 (2011), 441-476; P. Kale, H. Singh, and H.V. Perlmutter, "Learning and Protection of Proprietary Assets in Strategic Alliances: Building Relational Capital," *Strategic Management Journal*, 21 (2000), 217-37; M. Ruess and S.C. Voelpel, "The PMI Scorecard: A Tool For Successfully Balancing the Post-Merger Integration Process," *Organizational Dynamics*, 41 (2012), 78-84; M. Zollo and H. Singh, "Deliberate Learning in Corporate Acquisitions: Post-Acquisition Strategies and Integration Capability in US Bank Mergers," *Strategic Management Journal*, 25 (2004), 1233-56.

49
García-Canal and Guillén, "Risk and the Strategy of Foreign Location Choice," 2008; Guillén, *The Rise of Spanish Multinationals*, 2005.

50
Buckley et al., "The Determinants of Chinese Outward Foreign Direct Investment," 2007.

51
Mathews, "Dragon Multinationals," 2006.

52
B. Elango and C. Pattnaik, "Building Capabilities for International Operations through Networks: A Study of Indian Firms," *Journal of International Business Studies*, 38 (2007), 541-55; D.W. Yiu, C.M. Lau, and G.D. Bruton, "International Venturing by Emerging Economy Firms: The Effects of Firm Capabilities, Home Country Networks, and Corporate Entrepreneurship," *Journal of International Business Studies*, 38 (2007), 519-40.

53
Guillén, *The Rise of Spanish Multinationals*, 2005; CNUCYD, "World Investment Report 2006."

54
V. Govindarajan and R. Ramamurti, "Reverse Innovation, Emerging Markets, and Global Strategy," *Global Strategy Journal*, 1 (2011), 191-205.

55
N. Kumar and P. Puranam, *India Inside: The Emerging Innovation Challenge to the West* (Cambridge, MA: Harvard Business Press, 2012).

56
García-Canal and Guillén, "Risk and the Strategy of Foreign Location Choice," 2008.

57
Caves, *Multinational Enterprise*, 1996; Cuervo-Cazurra, "Extending Theory," 2012; Diaz Hermelo and Vassolo, "Institutional Development," 2010; Goldstein, *Multinational Companies*, 2007, pp.99-102; Lall, *New Multinationals*, 1983; D. Lecraw, "Outward Direct Investment by Indonesian Firms: Motivation and Effects," *Journal of International Business Studies*, 24.3 (1993), 589-600; Ramamurti, "What Have We Learned About Emerging Market MNEs?" 2009.

58
Lall, *New Multinationals*, 1983; Lecraw, "Direct Investment," 1977.

59
Guillén, *The Rise of Spanish Multinationals*, 2005; see also A. Goldstein and W. Pritchard, "South African Multinationals: Building on a Unique Legacy," in *Emerging Multinationals*, ed. by Ramamurti and Singh, 2009.

60
García-Canal and Guillén, "Risk and the Strategy of Foreign Location Choice," 2008.

61
J. Barney, "Strategic Factor Markets: Expectations, Luck, and Business Strategy," *Management Science*, 32.10 (1986), 1231-41; C.C. Markides and P.J. Williamson, "Corporate Diversification and Organizational Structure: A Resource-Based View," *Academy of Management Journal*, 39.2 (April 1996), 340-67; M.A. Peteraf, "The Cornerstones of Competitive Advantage: A Resource-Based View," *Strategic Management Journal*, 14.3 (March 1993), 179-91.

62
Caves, *Multinational Enterprise*, 1996.

63
Guillén and García-Canal, *Emerging Markets Rule*, 2013.

64
C.A. Bartlett and S. Ghoshal, *Managing Across Borders: The Transnational Solution* (Boston: Harvard Business School Press, 1989).

65
K. Moghaddam, D. Sethi, T. Weber, and J. Wu, "The Smirk of Emerging Market Firms: A Modification of the Dunning's Typology of Internationalization Motivations," *Journal of International Management*, 20 (2014), 359–74.

66
"China Buys Up the World," *The Economist*, November 11, 2010.

67
P. Deng, "Why do Chinese Firms Tend to Acquire Strategic Assets in International Expansion?" *Journal of World Business,* 44.1 (2009), 74-84.

68
J.H.Dunning, "Relational Assets, Networks and International Business Activity," in *Cooperative Strategies and Alliances*, ed. by F.J. Contractor and P.E. Lorange (Amsterdam and Boston: Pergamon Press, 2002), 569-94.

Business Models for the Companies of the Future

Joan E. Ricart

Professor Ricart explains how our hyper-connected, digital high density world is opening up to innovation in business models. Although it is difficult to predict exactly what innovations the future holds regarding business, he catalogs possible emerging business models.

These are concentrated in several groups. The first has the premise that anything that does not create value for the consumer should be removed. The second group is "platforms" business models that serve two or more markets simultaneously. A third group is the "global business" opening up to rapid international growth. He underlines the importance of the "pursuit of excellence" focused on developing innovation in order to promote virtuous circles, which is the primary goal of any good business model.

Joan E. Ricart
IESE Business School

Joan E. Ricart, Fellow of the SMS and EURAM, is the Carl Schrøder Professor of Strategic Management and chairman of the Strategic Management Department at the IESE Business School, University of Navarra. He was Director of the Doctoral Program (1995-2006), Associate Dean for Research (2001-2006), and Associate Director for Faculty and Research (2006-2014). He is also vice-president of the Iberoamerican Academy of Management. He was the founding president of the European Academy of Management (EURAM) and president of the Strategic Management Society (SMS). He has published several books and articles in leading journals including *Strategic Management Journal*, *Harvard Business Review*, *Journal of International Business Studies*, *Econometrica* and *Quarterly Journal of Economics*.

Key Features for the Company of the Future:

Rebuild the Company From the Outside In
Make sure everybody is aware of how the value chain and ecosystem serving the customer both create value. Then identify your role in the ecosystem, and understand how it interacts with other ecosystem players and with customers. Next, design your organization so that it creates value for, and through, those interactions. Finally, underpin your whole venture with capabilities that enhance productivity, efficiency and effectiveness. Now you are ready to face a constantly shifting world.

Draw a Visible Distinction Between Management and Leadership Roles
Effective management drives success in stable markets where the value proposal, the value chain and the role of the company remain largely unchanged from one year to the next. Leadership, however, is called for when our market breaks away on an unexpected course, rendering the old ground rules obsolete and requiring us to take high-risk decisions based on scant information – later, we have to adapt on the fly while the new dynamics play themselves out. Management and leadership, while both necessary for success, are not interchangeable.

Redefine the Role of Middle Management
We should forget about the hierarchical model whereby a middle manager gets instructions from above, sends them "downward," then gathers information from below to be reported "upward." Instead, the middle manager must be put in charge of interactions with customers and partners and empowered to detect, analyze and resolve issues through negotiation, adaptation and reform. She must be given overall control of the relationship with customers and partners, relying on the full support of everyone both "below" and "above" her.

Business Models for the Companies of the Future

The business models for the companies of the future are in the making today. A company that cannot reinvent itself and develop a workable business model has no future at all: it will fade and die. We are in the midst of change and, as Peter Drucker said, where there is change, there is opportunity. Those unable to see opportunity see only threats. The future starts now.

A Connected World

Every generation believes itself the witness of the greatest upheavals in history. But this belief is questionable. How can we compare the invention of the printing press to the Industrial Revolution or the emergence of the internet? We can't. What we can do is pinpoint some of the features of the changes taking place now, and think about how and why they shape business, government, and society.

The forces driving change today are tied to technology, particularly information and communication technologies (ICTs), as discussed in earlier chapters. Even at the expense of repetition, it is vital to discern the lineaments

of this change—because today change itself is different from the ICT-led developments seen in earlier years.

Technological change is driven by four forces. First, mobility: an explosion in the number of points of contact with the internet. Everyone is connected, anywhere, any time. The connected world embraces not just people but things. All sorts of devices in all manner of places "talk" to each other.

The ease of connectivity multiplies in the "cloud." Information no longer rests at a single place (although there is a physical sense in which it still does): it is accessible everywhere. Any data you might need is available at any point of contact. You are always connected and have a way in to the information.

This force might seem sufficiently powerful in itself. But, what's more, it enables different uses of connectivity. People are social beings, and develop their connections across social networks. They do not just connect: they communicate, interact, influence one another. Social media and broadband connections let us share pictures and videos, chat with our friends, engage in debate—collectivity is experienced as another form of natural human interaction. One of the hallmarks of collectivity is its social angle.

Technological change is driven by four forces. First, mobility: an explosion in the number of points of contact with the internet. The ease of connectivity multiplies in the "cloud"

And the weave of connections, interactions, and information brings forth vast amounts of data in an unstructured form. This information lets us find out what consumers want, what they buy, what they do. There's a lot we can learn about how to improve our performance, provide services, and interact with users. This is the world of Big Data—the analytical study of huge amounts of information so as to improve the way we live.

When we view these four elements in combination, what we see is not just a connected or "hyper-connected" world: we also find that increased connection enhances interaction. The information we share exponentially drives up "digital density."[1] As the creators of the concept would have it, "digital density" requires both an increase in the number of connections among agents, and a rise in the degree of interaction and the volume of information they share. When these elements come together, "digital density" grows, setting off the potential for change. The impact of digital density encompasses all sectors of activity. Yet that impact can be dampened by the specific regulatory environment. The fewer the regulatory constraints on the network of connections, the higher the impact. Increased digital density opens the door to innovation in business models. This is an emerging battleground in a competitive world.

The Business Model[2]

Let's start from the beginning. What is a "business model," and why has it become more important nowadays? Every enterprise has a business model, and always has. A business model is the logic of the enterprise, the way in which it creates and captures value for its stakeholders.[3] So business models have always existed and always will.

An example drawn from a bygone era may help us understand this concept—the underlying logic by which an enterprise "makes money." Think of the early days of photography, and, specifically, the Kodak company. At one time photography was in the hands of professionals who created black-and-white images on a glass surface. In 1883 George Eastman invented a new process which, he believed, was revolutionary: transferring the complex chemical process of photography to a less delicate, more easily handled medium: roll film, first made of paper and soon to be made of plastic. This marked the emergence of the photographic film reel as we knew it until the digital revolution. But Eastman's invention, great though it was, failed to take off. The quality was not quite as good as that obtained by the conventional method, so professionals gave the new technology a miss.

But Eastman persevered. He realised that, while his innovation was of little use to established photographers, it might be of interest to a different, so far unheeded category of consumers. Many households would be keen, he thought, to memorialize family events by their own hand, easily and cheaply; recourse to a professional photographer would become the exception. But selling this idea to the public demanded a different business model. First, Eastman had to make available a cheap, easy-to-use camera that used the new reel-based technology. This was something he proved able to develop. Secondly, there had to be a chain of stores where people could buy the camera and photographic reels, and get their photographs developed. To put these ideas into practice, in 1888 Eastman founded Kodak, and created a wide-reaching service chain which over the years spread around the world. Film reels and development services became available all over the planet.

> **Kodak developed the first digital cameras and invested heavily in digital for many years. The real difficulty was that digital photography was consigning Kodak's business model—which was hard to change—to obsolescence**

Based on this new business model, Eastman's invention changed the world of photography. Later, Kodak developed serious capabilities in the fields of

chemistry, optics, and services. Then digital photography made its appearance. Many mistakenly believe that Kodak dragged its feet in the digital age and failed to develop digital technology, but this is far from the truth. In fact, Kodak developed the first digital cameras and invested heavily in digital for many years. The real difficulty was that digital photography was consigning Kodak's business model—which was hard to change—to obsolescence. In the digital world, chemistry is irrelevant. There is no film, no developing. These were the mainstays of Kodak's business model. In digital photography, revenue is generated not by the film, but by the device itself—because film and developing are unnecessary. So all those service centres, all the chemical technology … dropped off the radar. And the change went even further. Today, a camera is a relatively rare purchase. Mass photography has shifted to mobile phones and tablets—which also let you share your pictures with other people. The change Kodak needed to make was not a technological one, but a change of business model. In this, Kodak failed. The winners in the world of digital photography are those that help people share their pictures (social networks and mobility) and sell and distribute images. These are business models where Kodak's capabilities were of little use.

While Kodak, at one time, represented the future, the future was wrested from it by technological change. But while some entrepreneurs let the future slip from their grasp, others see it coming. For instance, Zara

The Kodak example shows what a business model is, and why it is important; it also reveals the impact of technology on how we use things. Photography used to be a handmaiden of remembrance. Images became available only some time after the event (a trip abroad, a celebration); they were shared among narrowly selected circles; they came at a considerable cost. Now it is instantaneous. It is easily distributed anywhere in the world, to anyone, almost at the same time as the event being recorded. Pictures can be posted to open social networks or circulated across large groups of viewers. Quite a different world.

While Kodak, at one time, represented the future, the future was wrested from it by technological change. But while some entrepreneurs let the future slip from their grasp, others see it coming. For instance, Zara (the Inditex group) emerged in the 1970s, when the textile industry in Spain was in decline, having been hit hard by manufacturing in low-cost countries. Amancio Ortega formed a new vision. His insight was that the answer was not to produce large volumes in countries where labour was cheap. It was a matter of quickly making available what women wanted—even if this meant higher production

costs, because the net price would be higher.[4] This idea enabled him to build an empire of labels and establishments all over the world.

While the end product is still just a garment, the business model is radically different. The key is to be sensitive to which specific garment is desired, and then to design, manufacture and distribute it so that as quickly as possible it can be in the hands of a buyer whose choice is already known to us. Today, given the group's sales volume, international expansion, and vast number of points of sale, a lot of skill is needed to do what Zara does: to deliver what a woman wants two to four weeks after her buying preference is detected. Speed allows for minimizing advertising or dispensing with it entirely; this means the net price is higher; and increased margins more than make up for higher manufacturing costs. Zara's business model is now a case study in all the world's business schools: the "fast fashion" model.

So a business model is important: it is the underlying logic whereby we create and capture value for our stakeholders. There always have been opportunities to create new and disruptive business models that change the ground rules of an industry—like Kodak, like Zara. Today, however, technological progress, globalization, deregulation, demographic shifts, and the behavioral changes driven by technology enable us to do things in radically different ways. Not just a little bit better, not just a little bit more efficiently: in a way that is completely different. The opportunities for innovation in business models, and the threats posed by innovations in our competitors' business models, have both increased exponentially. A revolution is under way.

Business Model Innovation

Technological change and its related developments allow for far-reaching innovation in business models. The companies of the future will surprise us with novel and original business models. In this new world, opportunities are on the rise. It is by definition impossible to predict what will take us by surprise or what will prove innovative. But we can to some extent cast our gaze over the businesses that are now emerging—because, as we have said, the future starts today.

One strongly rising trend in business models might be dubbed "cost obsession." The paradigm is perhaps the low-cost airline, based on the scheme developed by Southwest Airlines in the United States—the only American airline that has never failed to turn a profit. Southwest decided to fly point-to-point using smaller, less crowded airports, and used a range of operational measures to make sure its aircraft spent more time in the air and carried more passengers on each flight. Costs came down hugely, flights could be sold more cheaply, more passengers became willing to buy—this made routes more profitable, and a virtuous circle took care of the rest.

With variations, this is the business model of Ryanair in Europe, Air Asia in Asia, and any number of other carriers that operate this same model today. Cost obsession has emerged in many other industries. It is present in retail, for instance, Walmart being a prime example. The cost obsession philosophy—developed with care by Sam Walton at Walmart—has spread to an increasing number of sectors. The idea is to get rid of frills and make use of economies of scale, scope, utilization, experience and other factors for the benefit of consumers. Anything that does not create value for the consumer is stripped out.

Another business model category that is powerfully on the rise is the "platform." This term refers to a business model that supports two or more markets at the same time. A conventional market attracts buyers by providing a venue that supports the presence of sellers, and attracts sellers by the promise of the presence of buyers, all for a specific domain of goods or services. Modern technology, however, removes barriers of time (accessible 24 hours a day) and place (accessible from almost anywhere). Platforms spring up in increasing numbers and compete with one another. One fascinating feature of inter-platform competition is that each platform seeks to achieve network externalities[5] leading to a "winner takes all" outcome. Another feature is that competitors put a lot of effort into raising the costs for the weaker party to switch platforms in a bid to keep members captive. A well-known example is eBay. This platform started out auctioning second-hand goods, then grew into a third-party market where businesses of all kinds sold all sorts of products, creating a huge online bazaar.

Other examples of platforms include game consoles, operating systems, and smartphones. The key variable is the "installed base." If a video game platform—Nintendo, say—makes big sales, it achieves a large installed base. This makes it attractive to game developers, seeking to reach a wide range of potential buyers. A continued influx of more and (one hopes) better games in turn enhances the attractiveness of the platform, further aiding the growth of the installed base. This entrenches the virtuous circle of this network externality.

A third category of business model is the "global business" that opens up to the world in a brief lapse of time. Take Mango. Unlike Zara, Mango creates its own fashions. The firm designs collections and places them on the market at affordable prices, driven by manufacturing in low-cost countries and the flexibility to produce goods that get sold rather than selling goods that get produced. From the outset, Mango focused on urban, modern, professional, relatively young women.[6] So the target segment was not particularly large, and required operating in fairly big cities. International growth was crucial to achieving economies of scale and attaining the mass that would enable the firm to develop and manage its production and logistics efficiently. Swift

globalization was key. An apposite supporting example is Desigual: though targeting a different segment, its strategy is analogous to Mango's, and its internationalization was even quicker.

Elsewhere, we can look at Metalquimia, a small company in Girona, Spain, which makes machinery for the meat processing industry in a highly specialized niche. Because each individual country's market is so small, internationalization is essential. This enables Metalquimia to learn from its most demanding customers, wherever they may be based, and apply this learning to create an effective innovation process that makes the firm the spearhead of its niche, while lending it the scale for its innovation costs to pay for themselves.

> A third category of business model is the "global business" that opens up to the world in a brief lapse of time. Swift globalization is key

The example of Metalquimia brings us to a fourth business model category which one might classify as "seeking excellence." These companies focus on innovation, surprise their customers with new features, and satisfy needs which weren't even there when the product comes out. The paradigm is Apple. After inventing the personal computer and almost the battle against the Wintel alliance, Apple revolutionized the world of media players with the iPod and the world of telephony with the iPhone—then it created the entirely new world of the tablet, with the iPad. In its own niche, Metalquimia has made analogous breakthroughs.

Irizar, originally a family-owned firm in the Spanish Basque Country, became a cooperative partnership within the Mondragón group, then went its own way in 2005. It makes vehicle bodywork for upmarket buses for a worldwide client base. Its highly distinctive management model is based on independently led teams and on giving everyone who works for the company an ownership stake. This approach enables Irizar to achieve an unsurpassed standard of innovative excellence in the niche market of bodywork for high-end buses.

Each of the businesses mentioned so far operates a distinct business model that supports the specific way in which it seeks to develop its capabilities. However, they all share a continuing pursuit of excellence, distinctiveness of goods and services, and an ongoing bid to innovate.

Distinctiveness of goods and services is achievable through innovation, but can also be the outcome of other factors. Some business models, for instance, are based on "speed": adapting quickly to customer requirements, as seen in the paradigm case of Zara. Other enterprises find distinctiveness in their quality—whether intrinsic (Rolls-Royce), or linked to a highly characteristic market segment or "tribe" of buyers (Ducati). Still other firms adapt to local tastes or cater to relatively uninformed customers. The common

denominator of these business models underpins a fifth category, "distinctive/adapted." In the digital world, what's more, distinctiveness can be taken to an extreme, where the relationship is one-on-one. This model has earned itself the name "long tail." The concept flourishes on online sales platforms, which might take the form of a "store"—Amazon in its beginnings—or a "bazaar"—eBay. The crux is that drastically lowered transaction costs enable sellers to approach tiny market segments—sometimes comprising a single buyer—almost as efficiently as wide swathes of the market.

These five categories of business models are not exhaustive. There must be others that are unclassifiable now, and still less so in the future—innovation being unpredictable by definition. What's more, the categories overlap. A case study illustrating one category could just as easily illustrate another. So this outline, rather than providing a taxonomy, merely points out features that make a business model "good" at creating and capturing value. These business model features set in motion virtuous circles[7] and bring about a positive dynamic. The robustness of a given business model is determined by the number of positive dynamics it is capable of enlisting, so lending it the ability to survive competition with other models, both present and potential.

For further insight into these categories of business model, we can look at the virtuous circles that each of them entails. "Cost obsession" business models generate virtuous circles that gradually bring down the cost of manufacturing goods or providing services. The model might be driven by economies of scale (costs decrease as manufacturing volume increases), economies of learning (costs decrease as production accumulates), economies of capacity use (costs decrease as utilized capacity increases), or any combination of these elements and factors relating to scarce resources, such as location, technology or knowledge. To generalize, all these virtuous circles lie on the supply side. We should be aware that the behavior of these costs in the tangible world, which is subject to physical limits, is not the same as in the online world, where scalability may be unlimited.

The robustness of a given business model is determined by the number of positive dynamics it is capable of enlisting, so lending it the ability to survive competition with other models, both present and potential

By way of contrast, the virtuous circles garnered by "platform" models arise from network externalities and the "switch" costs accepted by the customer ("lock-in")—here, the onus lies on the demand side of the market. These powerful virtuous circles sometimes enable the "winner" to corner

most of the demand; but they are fragile, being easily transformed into vicious circles when another firm grabs the "winner" spot.

"Global businesses" also depend on demand-linked virtuous circles, but usually require interaction with a key variable on the supply side. Swift internationalization captures the volume to achieve economies of scale, cover overheads, and reach innovation and brand-value milestones that would be otherwise unthinkable.

The other two business model categories also depend on supply/demand interactions. In the "seeking excellence" model, the key is innovation. Triggering a cycle of innovation is tough, because it requires you to outdo your competitors in several different ways at once to keep ahead. You need to implement best practices, secure employee commitment and attract the best talent—this is hard to keep up sustainably over time.

"Distinctive/adapted" models impose the tough challenge of maintaining a sufficient standard of distinctiveness. Speed of adaptation is the key to winning the ongoing race to be first with what the consumer wants at the given time—the best she can get at that moment, because there is no other comparable choice. There is a constant struggle against the swift "commoditization" of the product or service.

A good business model is one capable of keeping alive a virtuous circle, or a combination of them. And in the competitive setting of the twenty-first century, strength lies in developing better and more innovative business models.

A New Overarching Objective: Reinventing the Business Model

Information and communication technologies let us address all these five dimensions at once. But whether our intended market is new or already out there, we need to give careful thought to designing a business model capable of triggering virtuous circles. The design-based approach that this requires is something of a newcomer to the field of strategy studies. We need to revive our "design thinking" skills—how to solve problems, how to bring out the strengths of the intended model, how to overcome the barriers thrown up by our environment.

These are the skills that the executives of the company of the future are called upon to develop. First, they must understand the nature of technological change and its implications. Secondly, they must go a step further, and apply their insights to designing a self-consistent entrepreneurial logic that reinforces and protects the targeted virtuous circles more effectively than the alternative approaches to the given market. Because these business models are both complex and holistic, the process of design entails experiment, trial and error, ongoing revision, and learning on the fly. We finally put together a model, but must immediately start to think about how it can be improved and upgraded—because any competitive edge is increasingly transitory and unsustainable.

And, while design is a tough challenge in itself, when we look at the demands of a model equipped with the internal dynamics capable of supporting the logic of the business, we face the further difficulty of remaining strong against the competition. It sometimes happens that a model that is objectively superior when considered in isolation loses the battle against inferior alternatives that enjoy entrenchment, as often happens in the sphere of "platforms." The older platforms outdo us in terms of user interaction. The installed base of an entrenched platform may prove too powerful an obstacle for an objectively more effective business model starting out with an installed base of zero.

The executives of the company of the future need to revive their "design thinking" skills—how to solve problems, how to bring out the strengths of the intended model, how to overcome the barriers thrown up by our environment

So business model design does not take place in a vacuum but in a setting where our competitors are also making decisions and creating their own business models. This interaction is a key element we need to incorporate to the design process. We must look to both existing and potential alternatives. We must bear in mind the significance of timing. If we move too slowly, we may find our intended space is already taken, and we now need to do something different. Or we might run ahead of ourselves without developing the capabilities needed for the next step. Managing the design process against a background of dynamic interactions is a tough and complex challenge: all the same, it is of the essence of the company of the future.

Developing a novel, innovative business model that is capable of rising to future challenges in an uncertain and connected high digital density environment requires the talent of an entrepreneur. This means the executive of the future must be good at design and strategically shrewd, and also a talented venturer. She must see where opportunity lies, how to ride the wave of change, how to reinvent oneself. We all too often think of a CEO as the steward of an existing state of affairs rather than as the shaper of a new reality. But the lever of change cannot be left in the hands of startups alone—we also need entrepreneurial executives in large, established companies.

The skills of design, strategy, and enterprise will lead to new business models which will change (and already are changing) both companies and whole industries, bringing about new ground rules and new ways of sharing out created value. We need the vision and leadership to transform entire industries from end to end, but we must see that this is done in a

way that brings us a meaningful portion of the value thus created. There lies ahead a tough "game" for senior executives in our century, the leaders of the companies of the future.

Business Models in the Company of the Future

In this chapter, we referred early on to technological change and the disruptive influence of emerging information and communication technologies. Significant though they are, however, these technologies are merely a medium of support. We must focus on the overarching business model: throughout the business transformation leading to the company of the future, the business model is the driving force. While making use of new technologies, in the awareness of the changes they entail and the swift developments they are still to bring, our real goal is to reinvent business models.

To achieve this we need business leaders with design talent, a flair for strategy, and the courage of the venturer. And even this is only the beginning, because the new era of design will no doubt demand new forms of leadership, a new organizational balance, and new skills in our employees and executives. Execution will be by no means easy.

Building the companies of the future will be tough. Business-building always *has* been tough. Overcoming difficulty is the calling of the effective leader. And today this role inevitably entails reinventing business models so that our business of the present is also the company of the future. The future starts now. We must not tarry in getting ready for it. It is upon our success in this challenge that the well-being of society depends. With leadership comes responsibility. Let's rise to the challenge today and reinvent the business model.

Notes

1
This concept was coined in the paper by E. Káganer, J. Zamora, and S. Sieber, "The Digital Mind-Set: 5 Skills Every Leader Needs to Succeed in the Digital World", *IESE Insight*, issue 18, 3rd quarter, 2013.

2
See also, on business models, the following by R. Casadesus-Masanell and J.E. Ricart:

"Competing Through Business Models (A). Business Model Essentials," Harvard Business School, note 708452 (2008); "Competing Through Business Models (B). Competitive Strategy vs. Business Models," Harvard Business School, note 708475 (2008); "Competing Through Business Models (C). Interdependence, Tactical & Strategic Interaction", Harvard Business School, note 708476 (2008); "From Strategy to Business Models and Onto Tactics," *Long Range Planning*, 43 (2010), pp.195-215; "How to Design a Winning Business Model," *Harvard Business Review*, January 2011, 100-07.
A summary is provided in J.E. Ricart, "Strategy in the 21st Century: Business Models in Action," IESE Technical Note SMN-685-E, 2013.

3
"Stakeholder" is a commonly accepted term meaning any party involved in the future of the organization, whether as a shareholder, employee, supplier, customer, government entity, society at large, etc.

4
The net price is the sale price adjusted by the effect of discounts and advertising and promotion costs. The resulting price is known as the "net price."

5
A network externality arises when the addition of an additional consumer is of benefit to all the consumers already present. This is a natural occurrence in a network setting. For instance, the value of having a telephone connection rises each time a new user joins the network. The same sort of externality arises indirectly on multi-market platforms —when one side of the market grows, value is increased for the other side, and vice versa.

6
After a few failed attempts, Mango recently branched out into collections such as HE by Mango (menswear), Mango Kids, Violeta, etc.

7
A business model can be formally defined as a set of choices and their respective consequences (see the references indicated at note 2). Choices lead to consequences, which in turn form the basis of further choices. Within this dynamic process the interconnectedness of choices and consequences brings about positive feedback loops, which can be either "virtuous" or "vicious." The emergence of a virtuous circle is a hallmark of a successful business model.

People, Talent and Culture

The Top 20 Skills of People Getting Jobs through LinkedIn (2013)

5	6	7	8
Statistical analysis and data mining	User interface design	Digital and online marketing	Recruitment

13	14	15	16
Web programming	Algorithm design	Database and software administration	Computer graphics and animation

Social media marketing

Mobile development

Distributed and cloud computing

Perl / Python / Ruby

Business development / relationship management

Retail information and payment systems

Business intelligence

Data engineering and storage

C / C++

Middleware and integration software

Java development

Software quality assurance and usability testing

Source: LinkedIn

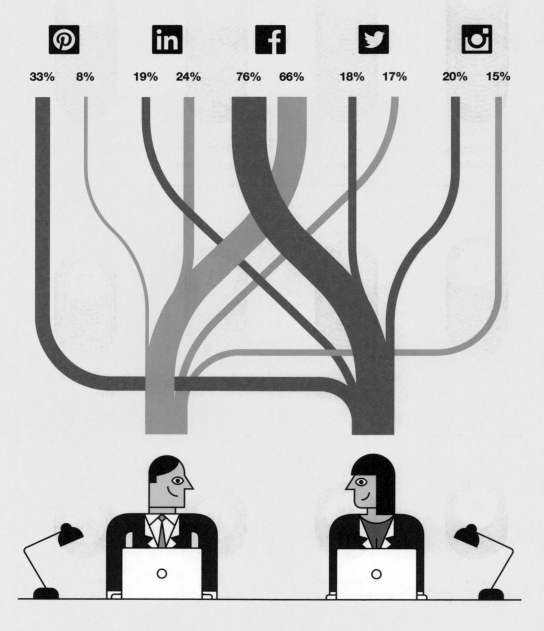

Percentage of Successful PhD Candidates out of the Total Population (2012)

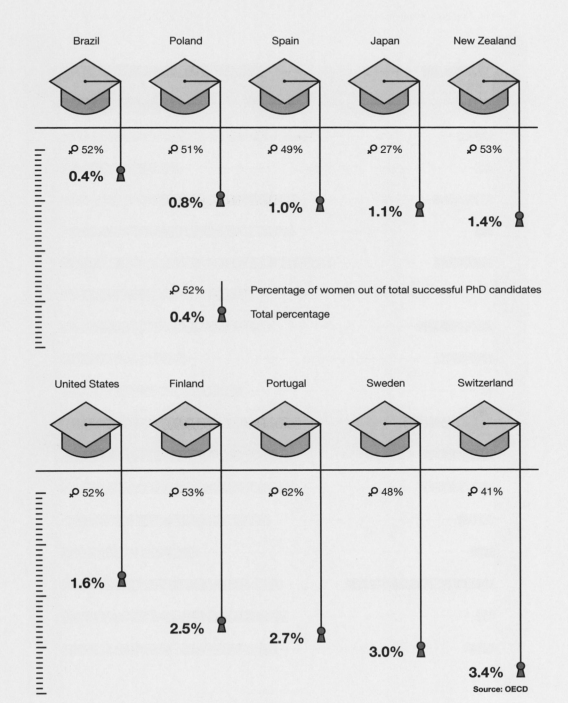

Source: OECD

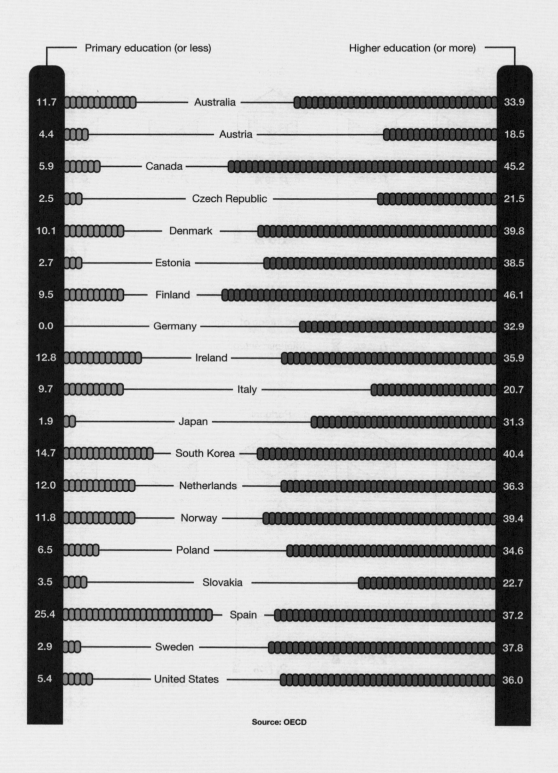

Percentage of Workers Underqualified or Overqualified to Perform the Required Task (2012)

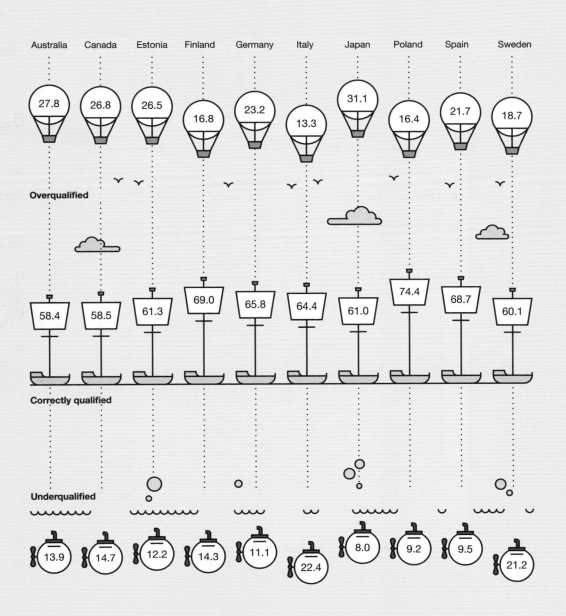

Source: OECD

Number of E-Learning Providers in Europe (2012)

E-Learning Companies

	
★ France	671
★ United Kingdom	532
★ Germany	378
Poland	303
Sweden	127
Czech Republic	109
Italy	98
Denmark	92
Norway	92
Spain	88
Belgium	84
Romania	76
Finland	64
Slovakia	54

Source: Statista

Global Mobile Education Market Volume (2011-2020)

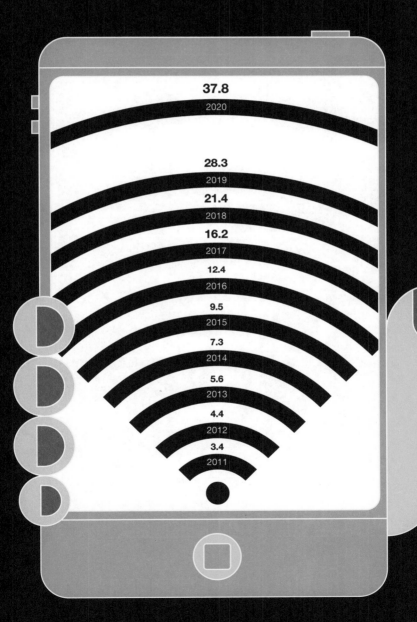

Amounts in billions of US dollars

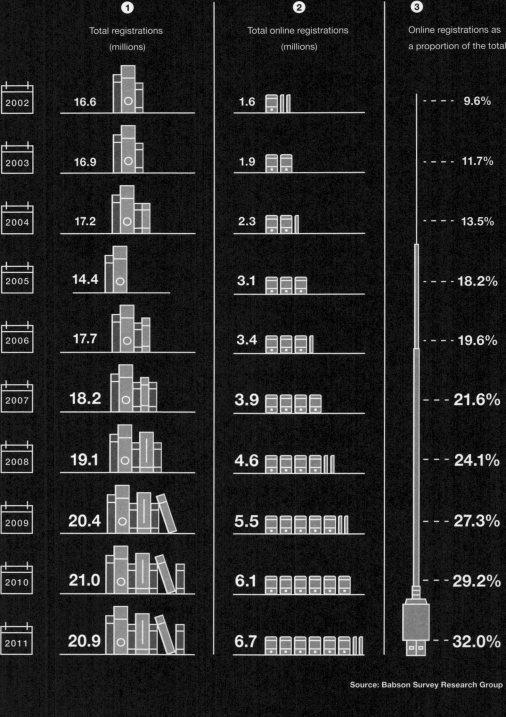

If It's Innovation You Want, Think About Job Quality

Chris Warhurst and Sally Wright

Warhurst and Wright's article outlines the current orthodoxy about innovation, showing that innovation is failing to deliver the anticipated enhanced performance, and how job quality and its potential role in helping lever innovation is underappreciated.

They argue that innovation is misconstrued and that its levers are misdiagnosed. They offer a solution to these problems, pointing out that a different model of innovation exists, one that can be boosted by drawing on a different kind of quality as a resource—job quality. Good job quality underpins organizational innovation and when adopting job quality as a lever for innovation, companies need to rethink how they manage and organize their employees inside the workplace. They see that developing an approach that integrates job quality and innovation would be not just desirable but also feasible for many companies.

Chris Warhurst
University of Warwick

Sally Wright
University of Warwick

Chris Warhurst is Professor and Director of the Institute for Employment Research at the University of Warwick in the UK. Previously he was Professor of Work and Organizational Studies at the University of Sydney, Australia, and Founding Director of the Scottish Centre for Employment Research in Glasgow in Scotland. His research focuses on three topics: job quality, skills, and esthetic labor. He is the author of 17 books and he has provided expert advice to departments and agencies of the UK, Scottish, Hungarian and Australian Governments as well as the OECD.

Sally Wright is a Senior Research Fellow at the Institute for Employment Research at the University of Warwick in the UK. Her research interests include minimum wages, low pay, working conditions, workplace restructuring, workforce and skills development, gender pay equity, and work/life balance. She previously worked in the Workplace Research Centre at the University of Sydney, Australia, where she managed the Australia at Work research project. She is currently investigating job quality and employment restructuring in Australia, with a project for Eurofound, an agency of the European Commission.

Key Features for the Company of the Future:

Consider Job Quality to Boost Innovative Performance
Innovation and job quality share many workplace practices and can be synergistic, mutually reinforcing each other.

Introduce Job Quality Audits
The aim should be for the company to maintain good job quality or improve existing job quality as a means of developing its innovative capacity.

Maximize Innovative Performance and Job Quality
The company can thereby contribute to its competitiveness as well as national economic recovery and competitiveness.

If It's Innovation You Want, Think About Job Quality

Introduction

For many years "quality" has been offered as the route to firm competitiveness. This quality was centered on the making of company products, whether goods or services, and "getting things right the first time," as the total quality management (TQM) movement highlighted.[1] In recent years there has been a new emphasis on innovation as a, if not the, route to competitiveness.[2] The European Union (EU) regards innovation as an overarching driver of economic recovery and growth and the Innovation Union is one of the seven flagship initiatives within Europe 2020, the new strategy for the EU.[3] National governments too within the EU understand and promote the importance of innovation: for example, the UK now has a ministerial department formally dedicated to innovation—the Department for Business Innovation & Skills. The EU and its member states are therefore keen to support innovation through policy.[4]

However, little real progress has been made in boosting innovation in the EU. Indeed, the current innovation performance of the EU continues to lag behind key international competitors amongst the advanced economies such as Japan, and its lead over new competitors from the developing countries

such as China is decreasing.⁵ Part of the problem, we argue in this chapter, is that innovation is misconstrued and, as a consequence, its levers are misdiagnosed. This chapter offers a solution to these twin problems, pointing out that a different model of innovation exists and one that can be boosted by drawing on a different kind of quality as a resource—job quality. This link is fortuitous, as job quality is also now back on the policy agenda within the EU, though not because it might help improve innovative performance but because it contributes to individual, firm and national economic well-being and offers a route to economic and jobs growth.⁶ In adopting job quality as a lever for innovation, companies will need to rethink how they manage and organize their employees inside the workplace.

The next section of this chapter outlines the current orthodoxy about innovation but how the dominant approach to innovation is failing to deliver the anticipated enhanced innovative performance. The following section outlines the changing attitudes to job quality but signals that its potential role in helping lever innovation is underappreciated. The subsequent section highlights the shared workplace practices of innovation and job quality, and how the latter can boost the former. The concluding section offers tentative suggestions as to how change might be achieved within companies so that they benefit from an integrated approach to innovation with job quality.

Innovation: Important but Underperforming

There are three types of competitive strategy that companies can follow, based on cost, quality or innovation.⁷ Governments in the advanced economies want their firms to avoid having cost based strategies, realising that they cannot compete with low cost labor in the developing economies. As one lande government-funded initiative in Germany put it, their firms "can't beat Beijing on price."⁸ As an alternative to cost, quality was heavily emphasized in the 1980s and 1990s, as best illustrated by the TQM movement. In the last decade more emphasis has been placed on innovation. And with good reason: innovation seems to offer a win-win opportunity for government and companies. Innovative companies in more innovative countries are growth-heavy and more productive, with a link established between innovation, competitiveness and productivity.⁹ In terms of employment outcomes, innovative firms create more and better jobs and offer an important stepping stone in the integration of some vulnerable groups into employment. Innovation thus contributes to an inclusive, not just high-skill, high-employment economy.¹⁰

The European Commission's "Innovation Union Scoreboard"¹¹ distinguishes and ranks four groups of countries in the EU according to their innovation performance. The top group, the "innovation leaders," include, significantly, Denmark,

Finland, and Sweden—Scandinavian countries. The bottom group, politely labeled "modest innovators," center on former Soviet Bloc countries such as Bulgaria and Romania. Country rankings have remained relatively stable over time, with the UK, for example, continuing in the second group of "innovation followers."

As an alternative to cost, quality was heavily emphasized in the 1980s and 1990s, as illustrated by the TQM movement. In the last decade more emphasis has been placed on innovation

Innovation encompasses a wide range of activities including new products and processes as well as marketing and organizational innovations. The *Oslo Manual*,[12] adopted by the European Commission, standardizes data collection and statistical measurement of innovation. It distinguishes four types of innovation within two categories of technological and non-technological innovations. The technological encompasses product and process innovations; the non-technological encompasses marketing and organizational innovations. Product innovation is the introduction of a good or service that is new or significantly improved with respect to its characteristics or intended uses. Process innovation is the implementation of a new or significantly improved production or delivery method. Marketing innovation is the implementation of a new marketing method involving significant changes in product design or packaging, product placement, product promotion or pricing. Organizational innovation is the implementation of a new organizational method in the firm's business practices, workplace organization or external relations.

In terms of inputs to boost innovation, the EU identifies three "enablers": first, human resources, meaning more graduates and PhDs; second, attractive research environments, meaning more and better cited scientific publications; and third, finance and support, meaning more research and development (R&D) and more venture capital investment. This emphasis centers on technological innovation and what is termed the STI mode—"science, technology, and innovation." It is a top-down, science-centric approach to innovation focused on having more workers with more qualifications and encouraging more R&D to create more, new intellectual property (i.e. products).[13] Intriguingly, none of these enablers focus on the innovative process within workplaces; rather they are contextual—improving the supply of both suitably qualified workers and available finance to companies most obviously.

The problem is that, as the European Commission notes,[14] EU innovation performance growth overall has been modest, touching just 1.6% over 2008-12. With the exception of the UK, innovation leaders and followers all improved their innovation performance. Worryingly, however, there is a growing divide

in innovative performance between the bottom and top ranked groups of countries in the EU. Moreover, with the economic crisis in Europe, it is the public sector that is currently propping up R&D expenditure. Holding tight onto its STI approach to innovation, the Innovation Union wants to boost innovation by having more firms with more new products and has set a target for investment in R&D of 3% of EU GDP by 2020.[15]

This type of innovation is important but not sufficient. It might work well for hi-tech manufacturing companies operating in niche high value added markets which employ relatively few workers, but has little relevance for companies in mass services where most workers are now employed.[16] Denmark is in that top ranked group of countries classified as innovation leaders, and one of the reasons for its economy doing relatively well, according to Lundvall,[17] is that its innovation focus envelops traditional industries, including those in services. In other words, it encourages a different approach to innovation. If full economic recovery is to be realized in the UK and the rest of the EU, innovation in companies needs to be boosted; the scope of innovation must be expanded and alternative approaches to innovation be developed in countries and their companies.

One way of understanding the current problem, is to recognize that the current model of innovation favored by many national governments and the EU is misconstrued and innovation's real enablers underplayed. Even in innovation leader countries such as Denmark, radical innovations account for less than 6% of all innovations, according to Nielsen et al.[18] As Keep states, the current top-down, science-centric approach to innovation ignores the "bottom-up, incremental workplace innovation that can enhance products, services and the means by which they are delivered."[19] Increasingly, companies in the service and manufacturing industries create value through a wide range of complementary technological and non-technological changes and innovations.[20] Indeed the majority of innovations are not of the STI type but are bottom-up non-technological innovations—new business practices and workplace organization within firms. That is, most innovation is organizational innovation. Importantly, non-technological innovation is one of the key factors explaining the difference in performance between the EU and its superior non-EU competitors. As the European Commission once acknowledged, "non-technical innovation may well be the 'missing link.'"[21] This claim has substance: organizational innovation has positive effects on growth at both national and company levels. "At the societal level, investments into organisational change … influence up to some ten percent of economic growth" and within companies, "the magnitude of the effects on efficiency outcomes is substantial, with performance premiums ranging between 15 per cent and 30 per cent for those investing in Workplace Innovation."[22]

As Arundel et al.[23] argue, instead of targeting higher R&D expenditure at the national level, which in any case is hard for governments to achieve, more attention should be paid to organizational innovation practices. This type of innovation is more achievable and likely to create innovation-friendly environments at firm level. Finland, for example, another one of the innovation leader countries in Europe, has adopted a "broad-based innovation policy," which incorporates this approach, "expanding the target of innovation policy to give more significance to non-technological innovations and increasing the positive joint impacts of technological and non-technological innovations."[24]

Orthodox approaches to innovation are thus misfiring. A new approach is needed; one that more readily envelops organizational innovation and identifies the workplace practices that boost this type of innovation. A shift in policy thinking is already discernible in this respect. The new European Growth Agenda, noting that the global economic downturn has adversely impacted innovation, now recognizes that a broad range of factors that stimulate innovation need to be explored.[25] It is here that job quality is relevant to improving innovative performance at the company level.

Job Quality: Important but Underappreciated

Aspects of job quality have long been a concern of researchers and policy-makers as well as some practitioners.[26] However, at least in the latter part of the twentieth century, a trade-off was argued to exist between job quantity and job quality. Efforts to improve the Quality of Working Life—a movement that emerged out of the Nordic countries in the 1960s and spread to other advanced economies by the early 1970s[27]—were abandoned in the mid-1970s in the face of (another) global economic downturn and rising levels of unemployment. Instead, governmental emphasis focused on job creation, regardless of the quality of these jobs. The argument was simple: better to create any jobs than push to create better jobs.[28] Intuitively, it appealed to policy-makers.[29]

Empirically, it turns out that this argument, was little more than a myth, Osterman asserts.[30] To make his point, he compares a lower job-quality country—the US—with higher job-quality countries—Sweden and Denmark. Using OECD data he shows that the latter countries have higher employment participation rates for both men and women. This pattern holds within the EU. In general, EU countries with more high-quality jobs have significantly higher rates of employment and employment activity.[31] Analyzing EU data, Siebern-Thomas[32] found that improvements in job quality increased national employment rates from 60% to 64% and decreased unemployment rates from 10% to 6% over a ten-year period. Another longitudinal analysis of European data confirms this finding, affirming a positive and significant correlation between employment

rates and components of job quality.³³ Referencing the research of Erhel and her team, the European Commission now accepts that „there is no trade-off between quality and quantity of employment: with a positive link between job quality and quantity."³⁴ There are good reasons why job quality and employment positively correlate: the links between human capital and economic growth, and the provision of security in work that increases productivity and labor market participation, for example. Policy thinking on job quality has thus shifted: the EU's new growth agenda accepts that job quantity and job quality are not mutually exclusive and can and should be pursued together. Synergies can be achieved between job quality and the other main objectives of the current European Employment Strategy—namely full employment, and social cohesion and inclusion.³⁵ This dual approach is most obvious in the European Commission's aim to create "more and better jobs" in Europe.³⁶

In general, EU countries with more high-quality jobs have significantly higher rates of employment and employment activity

However, better jobs not only have positive outcomes for countries within the EU; they can also have positive outcomes at the company level. Research indicates that job quality is positively and significantly correlated with job satisfaction, commitment, and individual well-being.[37] Moreover, job satisfaction is negatively correlated with absenteeism[38] and staff turnover,[39] thereby offering the potential for reducing companies' operating costs. In addition, job quality and job satisfaction have been linked to labor productivity, with more productive industries having higher proportions of good-quality jobs.[40] Importantly, research also reveals that industries and countries with above average job quality are more productive and innovative.[41] There are thus bottom-line benefits for companies pursuing higher job quality.

The problem is that job quality varies across European countries.[42] Prior to the global economic downturn and the EU crisis, job quality had various trajectories in the EU, though notably was upgrading in Nordic countries. With the crisis, job quality in the EU has come under pressure, with increased polarization in most countries.[43] Nevertheless, workplaces in the Nordic countries still offer the best job quality.[44] Moreover, better quality jobs have proved to be more resilient during the crisis and those countries with higher job quality, such as the Nordic countries, have fared better during the crisis.[45]

An additional problem for government policy-makers and practitioners in companies is that there is no consensus about what constitutes job quality.[46] Debate amongst researchers is expansive and also evolving. Conceptually, there are differences among disciplines. Crudely, economists typically focus on pay, sociologists on skill and autonomy, and psychologists on job satisfaction.[47]

There are also definitional differences. A key issue is whether job quality can or should be measured objectively or subjectively. Objective indicators focus on the characteristics of the job, whether economic or non-economic. Subjective indicators focus on the reported attitudes and experiences of the job-holder in relation to whether the job meets workers' needs.[48] As such, approaches to measuring jobs also vary. Some approaches measure job quality using a single indicator such as pay,[49] others use multiple indicators including pay, work organization, wage and payment systems, security and flexibility, skills and development and engagement.[50] Without scientific consensus, a lack of agreement exists amongst member state governments, and a comprehensive approach to job quality has not yet been actioned in EU policy.[51] At best, as Muñoz de Bustillo et al. admit, current job quality indexes are driven and limited by data availability. As a consequence, whilst the European Commission appreciates the importance of job quality generally, it has yet to adequately develop a bespoke research and policy agenda around it.

Despite the debates and differences, an implicit approach to job quality is beginning to emerge amongst key researchers in the field in Europe. Most academic research on job quality at the European level now adopts a multi-dimensional approach.[52] Even though the number of dimensions and/or indicators varies in these studies, there are clear overlaps about what constitutes job quality. Typically, both the work and employment characteristics of a job are analyzed, including, for example: work organization; learning, training and skill development opportunities; opportunities for skill use; career progression opportunities; pay and benefits; worker autonomy, participation and representation; and, more recently, employee well-being.[53] Importantly, many of these constituents of job quality align with prerequisites of innovation, particularly organizational innovation. Indeed, they are often the enablers of good innovative performance, and shift the focus onto the innovative process as it occurs within workplaces. However, the link between job quality and innovation is, to date, not made by governments, and the potential utility of incorporating job quality into innovation policy-thinking remains underappreciated.

Two Sides of the Same Coin: Innovation and Job Quality

Aside from not delivering sufficient and across the board improvements in innovative performance, the STI mode of innovation is disconnected from a wealth of long-standing research on what makes innovation happen in companies. Burns and Stalker's classic *The Management of Innovation* (1961)[54] focused very squarely on the top-down, science-centric approach to innovation currently favored by government. Yet, Burns and Stalker revealed in their organizational case studies, it wasn't enough to hire graduates and PhDs, put them

in company R&D facilities and then stand back to watch intellectual property flourish. Rather, the right working, management and organizational structures and practices had to be in place to lever and enable these workers' ideas and efforts. In the parlance of the time, "job design" was important, with these workers embedded in a network structure of control, authority, and communication; the latter lateral rather than vertical, and based on consultation rather than command, information rather than instruction. Similarly, and echoing much of Burns and Stalker's innovative "organic" organizations, Kanter's influential *The Change Masters* (1983)[55] identified "integrative" organizational structures and practices as delivering continual innovation. These integrative organizations featured cross-departmental and cross-functional working, with broad job definitions infused with autonomy, empowerment, challenges and, interestingly, job security, "making it possible, and interesting, for people to engage in exciting activities."[56] Policy-makers and practitioners ignore this research legacy at their peril. It is a useful reference point for anyone today interested in enabling and improving innovation in the workplace. Given the emerging, if still implicit, multi-dimensional approach to job quality amongst those key researchers in Europe, this research legacy also highlights the important role that job quality has to play in generating innovative performance.

The STI mode of innovation is disconnected from a wealth of long-standing research on what makes innovation happen in companies. Policy-makers and practitioners ignore this research legacy at their peril

The job quality of that multi-dimensional approach is associated with all four types of innovation outlined in the *Oslo Manual*. However, it is most strongly linked to non-technological innovation and, within this category, the most prevalent and effective form of innovation: organizational innovation. The reason for the strong link to organizational innovation is that this type of innovation is underpinned by a "doing, using and interacting" (DUI) mode. Resonating with organic and integrative forms of organization, this DUI mode of innovation, an alternative formulation to that of the STI mode, requires workers' skills acquisition and utilization, and employee voice and participation, for example.[57] As such, organizational innovation and job quality share many workplace practices.[58] Indeed, it might be reasonably argued that, in terms of workplace practices, innovation and job quality are two sides of the same coin.

For example, going beyond the EU's Innovation Union Scorecard, Valeyre et al[59] elaborated a typology of innovation potential amongst companies using the European Working Conditions Survey (EWCS). Fifteen variables were used to measure characteristics of work organization, including autonomous and

non-autonomous teamwork, task rotation, employee autonomy in work, constraints determining the pace or rate of work, repetitiveness and perceived monotony of work tasks, way of quality controlling, complexity of tasks, learning dynamics in work. Indicatively, these same EWCS variables were also used in a study of job quality by Holman.[60] Similarly, the OECD[61] notes that employees having opportunity for skills deployment is a key feature of innovative workplaces, but adds that so is (front-line) managers' capacity to accommodate employee participation. More broadly, effective labor-management relations matter; it is engaging employees and encouraging them to mobilize, share and develop their ideas in the workplace which fosters innovation and raises productivity.

> **EDI refers to active and systematic participation of employees in ideation, innovating and renewing of products and services**

An example of the importance of employees' active involvement in this type of bottom up innovation is provided by the Finnish government. The Finnish Funding Agency for Technology and Innovation (Tekes) has a dedicated program (Liideri—Business, Productivity and Joy at Work) to promote employee-driven innovation (EDI) in firms. It assumes that employees are willing and able to learn, and develop and deploy their creativity in their job. "At a general level, EDI refers to active and systematic participation of employees in ideation, innovating and renewing of products and services and ways of producing them, with a view to creating new solutions that add value."[62] In an assessment of this Finnish program, over 70% of the 400 funded cases demonstrated simultaneous improvement in operational performance and the quality of working life at the firm level.

Drawing on his previous Danish research, Lundvall[63] argues that different forms of work organization offer employees different levels of organizational learning; higher learning work organizations are more innovative. This learning, itself enabled by skill development and use, and worker voice and participation, is also an indicator of job quality, according to Lundvall. It therefore follows that higher job quality encourages firm innovation, he notes. This link is apparent in comparisons of the Innovation Union Scoreboard (2013) and data from Cedefop[64] on the link between work organization and innovation. As we noted above, in distinguishing innovation performance groups of countries, the Scoreboard classifies Sweden as an innovation leader and the UK as an innovation follower. Cedefop makes a similar classification in assessing learning-intensive work organization and innovation performance. Sweden is located in a high cluster of countries in terms of being learning intensive, and the UK in a middling cluster of countries. Thus for Cedefop, what levers innovative capacity is also a marker of job quality—the presence of workplace learning, whether formal or informal. Job quality therefore links to innovation, with higher job

quality (more intensive learning) underpinning higher innovative performance; lower job quality (as measured by low or absent workplace learning) correlates with low innovative performance.

Furthermore, innovation and job quality might not just share practices; they might also be mutually reinforcing, creating synergies. In other words, if companies want to boost innovation, they not only need to think about job quality, they need good job quality. As Lundvall succinctly argues, higher job quality encourages innovation within companies. Thus despite being treated separately, job quality and innovation not only overlap in terms of underpinning workplace practices but these practices seem to create a mutually reinforcing dynamic. As a consequence, practically, there is "potential for convergence" according to Totterdill et al.,[65] who note that "improved performance and enhanced quality of working life … [lie] at the heart of workplace innovation."

Concluding Comments

Innovation is regarded as a key source of competitive advantage for companies.[66] Boosting it has been adopted as a policy aim by the European Commission and EU member states.[67] At present a top-down, science-centric (STI) mode of innovation dominates policy thinking. This STI mode is levered by highly qualified researchers creating forms of new intellectual property supported by injections of external capital. This type of innovation is important but not sufficient; indeed, innovative performance within Europe is at best uneven, and even slipping behind non-European competitors. New ways of thinking about innovation and how innovative performance can be boosted are needed.[68]

Government policy thinking about innovation is like a supertanker at sea: changes of direction are slow to achieve. However, changes are needed. These changes do not require the STI mode to be abandoned but complemented by other modes of innovation with different levers, and with a different focus— the workplace. The starting point is to put more emphasis on the different types of innovation and particularly the type that occurs most in companies— organizational innovation. In this chapter we have argued that if companies want to boost their innovative performance, they need to think about their job quality. Good job quality underpins organizational inno-vation. Job quality and this type of innovation, with its doing, using and interacting (DUI) emphasis[69] share many workplace practices; integrated they may even be synergistic, mutually boosting each other.

There are signs, however, that a new course is being considered if not yet plotted. The European Workplace Innovation Network (EUWIN), launched in 2013 by the European Commission's Director General of Enterprise and Industry

(DG ENTR), has called for more research on the links between workplace innovation and job quality. Beyond the EU, the OECD countries too are being exhorted to develop innovation strategies to boost growth and productivity. As with the EU, the OECD also currently favors the STI approach to innovation.[70] At the same time, the OECD also encourages its member countries to focus on creating "better jobs and better lives."[71] The OECD[72] too is tentatively acknowledging the workplace practices that bridge innovation and job quality.

Once policy-makers embrace the link between innovation and job quality and realize that job quality can help boost innovation, the task then becomes one of identifying how policy can be translated into practice within companies. Although there are different points of intervention, some outwith the workplace, job quality occurs within workplaces. Existing research shows that senior management can and do make choices about the level of job quality within their companies. Different companies operating in the same industry and the same markets can have better and worse job quality.[73] Job quality, we have shown, impacts innovative capacity: good job quality tends to align with higher innovative performance; lower job quality aligns with lower innovative performance. A first practical step for companies would be to introduce job quality audits. These would enable companies to identify the level of job quality across their workplaces and internal hot and cold spots of job quality, with the latter requiring intervention to make improvements. Often these improvements are cost-free financially; they simply involve managing and organizing employees differently, guided by a multi-dimension approach to job quality. If companies undertake these audits it would then also be possible for benchmarks to be set whereby companies could decide to match their job quality level, and with it their innovative capacity, against their innovative intent. Support in introducing and implementing such audits would be helped by the development of a version of the innovation ecosystems identified in the Scandinavian countries by Ramstad.[74] These ecosystems involve a network of vocational colleges and universities, consultancies, companies, social partners, and policy bodies. There would be concept agreement (i.e. over what constitutes job quality), tools for its measurement and assessment (e.g. for companies, the audit), and funding and support from government and the social partners for workplace change. Government might start by reconfiguring or supplementing the current Innovation Union Scorecard so that it better encompasses the DUI mode of innovation.

> **Innovative performance within Europe is at best uneven, and even slipping behind non-European competitors. New ways of thinking about innovation are needed**

Need and opportunity exist for boosting innovative performance. Doing so at the EU and member state levels requires change within companies as well as government policy thinking. Improving contextual support through more and better finance and staff is not enough. Workplace practices need to become a focus and point of intervention. Job quality in its own right is now a feature of policy-thinking about economic growth. Developing an integrated approach between job quality and innovation would foreground the importance of those practices and how they can be better turned to the task of boosting innovation. With support, it's an approach that is not just desirable but feasible for many companies.

Acknowledgments

We would like to thank our international colleagues who attended the meetings held in Paris in Spring 2013 and Lund over Winter 2013-14 for discussions about job quality and innovation that led to the ideas for this chapter.

Notes

1
For example, P. B. Crosby, *Quality is Free* (London: Mentor, 1980).

2
For a review, see M. M. Crossan and M. Apaydin, "A Multi-Dimensional Framework of Organisational Innovation: A Systematic Review of the Literature," *Journal of Management Studies*, 47.6 (2009).

3
European Commission (EC), *Innovation Union* (Luxembourg: Publications Office of the European Union, 2013).

4
For example: A. Coad, M. Cowling, P. Nightingale, G. Pelligrino, M. Savna and J. Siepel, *UK Innovation Survey: Innovative Firms and Growth* (London: Department of Business Innovation & Skills, 2014); EC, *Innovation Union*, 2013.

5
EC, *Innovation Union*, 2013.

6
F. Green, *Demanding Work: The Paradox of Job Quality in the Affluent Economy* (Princeton: Princeton University Press, 2006); R. Muñoz de Bustillo, E. Fernández-Macías, J. Antón, and F. Esteve, "Indicators of Job Quality in the European Union," Study prepared for the European Parliament, Department of Employment and Social Affairs, Brussels, 2009; European Foundation for the Improvement of Living and Working Conditions, *More and Better Jobs: Patterns of Employment Expansion in Europe* (Dublin: Eurofound, 2008); European Foundation for the Improvement of Living and Working Conditions, *Links Between Quality of Work and Performance* (Dublin: Eurofound, 2011).

7
M. Porter, *Competitive Strategy* (New York: Free Press, 1980).

8
A. Vanselow, "A Tailwind for Workers' Councils: An Analysis of Modernisation Campaigns in the German Metal and Electronics Industries," Paper to the Scottish Trades Unions Congress, Glasgow, 2011.

9
M. A. Dutz, I. Kessides, S. O'Connell, and R. D. Willig, "Competition and Innovation-Driven Inclusive Growth," World Bank Policy Research Working Paper 5852, 2011.

10
J. de Kok, P. Vroonhof, W. Verhoeven, N. Timmermans, T. Kwaak, J. Snidjers, and M. Westhof, "Do SMEs Create More and Better Jobs?" EIM Business & Policy Research report, Zoetermeer, November 2011; OECD, "Innovation to Strengthen Growth and Address Global and Social Challenges," Ministerial report on the OECD Innovation Strategy, Paris, May 2010.

11
European Commission (EC), "Innovation Union Scoreboard," 2013.

12
OECD and Eurostat, *Oslo Manual: Guidelines for Collecting and Interpreting Innovation Data*, 3rd edn (Paris: OECD, 2005).

13
EC, "Innovation Union Scoreboard," 2013.

14
EC, *Innovation Union*, 2013.

15
EC, *Innovation Union*, 2013.

16
E. Keep, "Skills Utilisation in the UK—What, Who and How?" ESRC Centre on Skills, Knowledge and Organizational Performance (SKOPE), Universities of Oxford & Cardiff, 2014.

17
B. Å. Lundvall, *Innovation, Growth and Social Cohesion: The Danish Model* (London: Edward Elgar, 2002).

18
P. Nielsen, R. Nielsen, S. Bamberger, J. Stamhus, K. Fonager, A. Larsen, A. Vinding, P. Ryom, and O. Omland, "Capabilities for Innovation: The Nordic Model and Employee Participation," *Nordic Journal of Working Life*, 2.4 (2012), 95.

19
Keep, "Skills Utilisation in the UK", 25.

20
OECD, "Innovation to Strengthen Growth," 2010.

21
European Commission, "European Innovation Scoreboard 2004: Comparative Analysis of Innovation Performance," 2004, 15.

22
Dortmund Position Paper, "Workplace Innovation as Social Innovation: A Summary," Seminar organized by the SFS Dortmund/TU Dortmund and TNO, 2012, 9.

23
A. Arundel, E. Lorenz, B. Å. Lundvall, and A. Valeyre, "How Europe's Economies Learn: A Comparison of Work Organization and Innovation Mode for the EU-15," *Industrial and Corporate Change*, 16.6 (2007), 680-93.

24
T. Alasoini, "Promoting Employee-Driven Innovation: Putting Broad-Based Innovation Policy into Practice," Background paper for the International Helix Conference, Linköping, June 12-14, 2013, 1.

25
European Commission, "Horizon 2020 Call: H2020-EURO-SOCIETY-2014: The European Growth Agenda," 2014.

26
A. Knox and C. Warhurst (eds.), *Job Quality: Perspectives, Problems and Proposals* (Annandale, NSW: Federation Press, forthcoming).

27
L.E. Davis and A.B. Cherns, *The Quality of Working Life* (New York: Free Press, 1975).

28
For discussion, see Knox and Warhurst, *Job Quality* (forthcoming).

29
See, for example, C. Warhurst, "Towards the 'Better Job': Scottish Work and Employment in the 'Knowledge Age'," in *Tomorrow's Scotland: New Policy Directions*, ed. by G. Hassan and C. Warhurst (London: Lawrence & Wishart, 2002).

30
P. Osterman, "Job Quality in the US: The Myths That Block Action," in *Are Bad Jobs Inevitable? Trends, Determinants and Responses to Job Quality in the Twenty-First Century*, ed. by C. Warhurst, F. Carré, P. Findlay, and C. Tilly (London: Palgrave Macmillan, 2012).

31
European Commission, "Employment in Europe in 2002," in *Synergies Between Quality and Quantity in European Labour Markets* (Brussels: DG Employment, 2002).

32
F. Siebern-Thomas, "Job Quality in European Labour Markets," in *Job Quality and Employer Behaviour*, ed. by S. Brazen, C. Lucifora, and W. Salverda (New York: Palgrave Macmillan, 2005).

33
C. Erhel and M. Guergoat-Larivière, "Job Quality and Labour Market Performance," Centre for European Policy Studies Working Document Number 3, June 3, 2010 <http://dx.doi.org/10.2139/ssrn.1622244>

34
European Commission, *New Skills and Jobs in Europe: Pathways Towards Full Employment* (Luxembourg: Publications Office of the European Union, 2012), 47-48.

35
European Commission, *New Skills for New Jobs: Anticipating and Matching Labour Market and Skill Needs* (Luxembourg: Publications Office of the European Union, 2008), 1-15.

36
European Foundation for Living and Working Conditions (Eurofound), "Trends in Job Quality in Europe," 2012.

37
A. Clark, "What Makes a Good Job? Evidence from OECD Countries," in *Job Quality and Employer Behaviour*, ed. by S. Brazen, C. Lucifora and W. Salverda (New York: Palgrave Macmillan, 2005); D. Gallie, 'Direct Participation and the Quality of Work," *Human Relations*, 66.4 (2013), 453-474; B. Okay-Sommerville and D. Scholarios, "Shades of Grey: Understanding Job Quality in Emerging Graduate Occupations," *Human Relations*, 66.4 (2013), 555-84.

38
C. Clegg, "Psychology of Employee Lateness, Absence and Turnover: A Methodological Critique and an Empirical Study," *Journal of Applied Psychology*, 68 (1983), 88-101.

39
R. Freeman, "Job Satisfaction as an Economic Variable," *American Economic Review*, 68 (1978), 135-41.

40
Siebern-Thomas, "Job Quality in European Labour Markets," 2005.

41
M. Patterson, M. West, R. Lawthorn, and S. Nickell, "Impact of People Management Strategies on Business Performance," *Issues in People Management, No. 22* (London: Institute of Personnel and Development, 1997); P. Toner, *Workforce Skills and Innovation: An Overview of Major Themes in the Literature* (Paris: OECD, 2011).

42
Erhel and Guergoat-Larivière, "Job Quality," 2010; R. Muñoz de Bustillo, E. Fernández-Macías, J.I. Antón, and F. Esteve, *Measuring More than Money* (Cheltenham: Edward Elgar, 2011); C. Erhel, M. Guergoat-Larivière, J. Leschke, and A. Watt, *Trends in Job Quality During the Great Recession: A Comparative Approach for the EU* (Paris: Centre for Employment Studies, 2012); J. Antón, E. Fernández-Macías, and R. Muñoz de Bustillo, "Identifying Bad Jobs Across Europe," in *Are Bad Jobs Inevitable?* ed. by Warhurst et al., 2012; D. Holman, "Job Types and Job Quality in Europe," *Human Relations*, 66.4 (2013), 475-502.

43
European Foundation for the Improvement of Living and Working Conditions (Eurofound), *Employment Polarisation and Job Quality in the Crisis: European Jobs Monitor 2013* (Dublin: Eurofound, 2013).

44
D. Gallie, "Direct Participation," 2013.

45
Eurofound, *Employment Polarisation*, 2013.

46
S. Sengupta, P. Edwards, and C. Tsai, "The Good, the Bad, and the Ordinary: Work Identities in 'Good' and 'Bad' Jobs in the United Kingdom," *Work and Occupations*, 36.1 (2009), 26–55; Muñoz de Bustillo et al., *Measuring More than Money*, 2011; S. Hauff and S. Kirchner, "Cross-National Differences and Trends in Job Quality: A Literature Review and Research Agenda," University of Hamburg, January 2014; S. Wright, "Challenges in Researching Job Quality," in *Job Quality*, ed. by Knox and Warhurst (forthcoming).

47
See, respectively: M. Goos and A. Manning, "Lousy and Lovely Jobs: The Rising Polarization of Work in Britain," *Review of Economics and Statistics*, 89.1 (2007), 118–133; D. Gallie (ed.), *Employment Regimes and the Quality of Work* (Oxford: Oxford University Press, 2007); Green, *Demanding Work*, 2006; D. Holman, "Job Quality: A Perspective from Organisational Psychology," Making Bad Jobs Better ESRC Seminar Series, University of Strathclyde, 2010.

48
Eurofound, "Trends in Job Quality," 2012.

49
For example, P. Osterman and B. Shulman, *Good Jobs in America: Making Work Better for Everyone* (New York: Russell Sage Foundation, 2011).

50
Holman, "Job Types and Job Quality," 2013.

51
G. Raveaud, "The European Employment Strategy: Towards More and Better Jobs?" *Journal of Common Market Studies*, 45.2 (2007), 411-34.

52
For example: Muñoz de Bustillo et al., *Measuring More than Money*, 2011; Erhel et al., *Trends in Job Quality*, 2012; Holman, "Job Types and Job Quality," 2013.

53
M. Guergoat-Larivière and O. Marchand, "Définition et mesure de la qualité de l'emploi: une illustration au prisme des comparaisons européennes," *Économie et Statistique*, 454 (2013), 23-42; C. Warhurst and A. Knox, "Why the Renewed Interest in Job Quality?" in *Job Quality*, ed. by Knox and Warhurst (forthcoming).

54
T. Burns and G.M. Stalker, *The Management of Innovation* (London: Tavistock, 1961).

55
R.M. Kanter, *The Change Masters* (New York: Simon & Schuster, 1983).

56
R.M. Kanter, R.M., "Frontiers for Strategic Human Resource Planning and Management," *Human Resource Management*, 22.1-2 (1983), 9-21 (13).

57
M.B. Jensen, B. Johnson, E. Lorenz, and B.Å. Lundvall, "Forms of Knowledge and Modes of Innovation," *Research Policy*, 36 (2007), 680-93.

58
F. Pot, S. Dhondt, and P. Oeij, "Social Innovation of Work and Employment," in *Challenge Social Innovation*, ed. by H. Franz, J. Hochgerner, and J. Howaldt (Berlin: Springer Verlag, 2012).

59
A. Valeyre, E. Lorenz, D. Cartron, P. Czizmadia, M. Gollac, M. Illésy, and C. Makó, *Working Conditions in the European Union: Work Organisation* (Luxembourg: Office for Official Publications of the European Communities, 2009).

60
Holman, "Job Types and Job Quality," 2013.

61
OECD, "Innovation to Strengthen Growth," 2010.

62
Alasoini, "Promoting Employee-Driven Innovation," 2013, 4.

63
B.Å. Lundvall, "Deteriorating Quality of Work Undermines Europe's Innovation Systems and the Welfare of Europe's Workers!" Trade Unions as Knowledgeable Participants in Workplace Innovation, EUWIN Conference, Copenhagen, 2014.

64
Cedefop (European Centre for the Development of Vocational Training), "Learning and Innovation in Enterprises," *Research Paper No. 27* (Luxembourg: Publications Office of the European Union, 2012).

65
P. Totterdill, R. Exton, O. Exton, and M. Gold, "Closing the Gap Between Evidence-Based and Common Practice: Workplace Innovation and Public Policy in Europe," *Lifelong Learning in Europe*, issue 4, 2012, p.3 <http://www.lline.fi/en/article/policy/totterdill/closing-the-gap-between-evidence-based-and-common-practice-workplace-innovation-and-public-policy-in-europe>

66
Crossan and Apaydin, "A Multi-Dimensional Framework of Organisational Innovation," 2009.

67
EC, *Innovation Union*, 2013; EC, "Innovation Union Scoreboard," 2013.

68
Coad et al., *UK Innovation Survey*, 2014; EC, *Innovation Union*, 2013.

69
Jensen et al., "Forms of Knowledge," 2007.

70
OECD, "Innovation to Strengthen Growth," 2010.

71
OECD, *Better Skills, Better Jobs, Better Lives: A Strategic Approach to Skills Policies*, OECD, 2012 <http://dx.doi.org/10.1787/9789264177338-en>

72
OECD, "Innovation to Strengthen Growth," 2010.

73
H. Metcalf and A. Dhudwar, *Employers' Role in the Low-Pay/No-Pay Cycle* (York: Joseph Rowntree Foundation, 2010).

74
E. Ramstad, "Expanding Innovation System and Policy: An Organisational Perspective," *Policy Studies*, 30.5 (2009), 533-53.

Diversity and Tribal Thinking
in the Collaborative Organization

Celia de Anca and Salvador Aragón

Professors Celia de Anca and Salvador Aragón examine how collaboration has become one of the watchwords of the digital age, and how co-creation, co-sharing, co-working, co-design, and co-thinking are now key elements in a new form of economic activity. This is commonly referred to as the collaborative economy, with people increasingly organizing their lives on a collective basis, mixing their private and professional existences, and operating in small groups akin to traditional clans that can just as easily function on a neighborhood basis or at the other end of the world, as though the global and local were just one continuum.

This collective mind-set has changed our traditional understanding of diversity, expanding into new cultural identities in which, in addition to identities of origin, new, aspirational ones emerge. Anca and Aragón call this "tribal behavior" and look at how it can be channelled into economic activity, integrating it in the process into systems to successfully explore and exploit new business scenarios, as well as developing new business models.

Celia de Anca
IE Business School

Salvador Aragón
IE Business School

Professor Celia de Anca is currently the Director of the Centre for Diversity in Global Management at IE Business School. She is the author of *Beyond Tribalism* (2012) and co-author of *Managing Diversity in the Global Organization* (2007). She is a member of the Executive Committee at IE Business School and of the Ethics Committee of InverCaixa's Ethics Fund. She has received the award of Woman Executive of the Year 2008 by ASEME and is listed in the 2013 Thinkers50 global ranking of management thinkers.

In his roles as Chief Innovation Officer and Professor of Information Systems and Innovation at IE Business School, he aims to provide a coherent response to the challenges, problems, and opportunities of innovation within the company. From a research perspective, he defines innovation as an intersection between market, organization, and technology. He has published about digital convergence and society, the development of new services based on emerging technologies, innovation governance in the organization, and the role of diversity in organizational innovation. He has also been lecturing at the Business School faculty since 1997.

Key Features for the Company of the Future:

Building Collaborative Environments
By building environments that involve employees, customers and other stakeholders in their value system, we can encourage employees to make their jobs click in with their outside interest groups.

Understanding Diversity
The future may be "tribal," but modern groups are brought together not by duty but by individual choice. So the businesses of the future must understand diversity in all its array of meaning, embracing both source and destination identities – those which an individual chooses through free choice and affiliation.

Strategic Foresight
It requires us to create business models that grasp existing market opportunities and explore the possibilities of the future.
It also demands that we develop a wide range of capabilities to adapt to change. We should nurture a "tribal" model of thought where the key source of innovation is diversity.

Diversity and Tribal Thinking in the Collaborative Organization

Introduction: Is the Age of Individualism Over?

At the end of the 1980s, sociologist Michel Maffesoli[1] used the term "tribe" to illustrate a significant shift in society underway since the European Enlightenment, from one built around the individual to a world populated by "affective communities." More than two decades on, the collective energy the French thinker saw emerging is now developing at full speed, helped by new information technology systems. The myriad of existing global networks enables the simultaneous participation of individuals in a multitude of groups that they come to identify with.

Diversity in identity today goes beyond identities of origin to include additional identities that can be channeled via a multitude of cultural communities or tribes that individuals aspire to belong and contribute to.

The new form of collaboration is based on difference, not sameness. Old tribes were built on sameness, and were thus closed to others to protect their individual members, which usually led to confrontation and isolation. By contrast, the new tribes put individual differences at the service of collaboration, and are open to others and interlinked with other tribes in a multiplicity of networks that enable individuals to work together.

Shared action is the driving force behind collaborative economics. According to Von Mises (1949)[2] the central issue in traditional economies is human action as an nindividualistic application of human reason to select the best means of satisfying individual ends. In a complementary way, the collaborative economy could be defined as the collaborative application of human reason to select the best means of satisfying the collective ends of the group.

Two complementary factors define collaborative economics: the collaborative nature of needs (ends) and means. To qualify as collaborative, an activity must satisfy a shared need within a group. For example, car sharing is a response to a shared need for transportation. In addition, the sharing economy implies a shared use of need-oriented means within the group in order to satisfy a previous need. A clear example today of this is online crowdfunding: platforms used by lenders and those starting up a business or project to satisfy investment and funding needs.

> Collaborative economics is defined by two complementary factors: the collaborative nature of needs (ends) and means

This chapter will be divided into two main areas: the first will analyze diversity and the new forms of tribalism emerging in society; the second will deal with how tribes can be understood in the context of the collaborative economy, describing a few examples of how this tribal intelligence can help organizations to exploit and explore new business scenarios and new business models, as well as how to define a flexible structure in which multiple tribes can operate for the common good.

PART I: Diversity and the New Forms of Tribalism

Diversity: From Identities of Origin to Identities of Aspiration

"If action as beginning corresponds to the fact of birth, if it is the actualization of the human condition of natality, then speech corresponds to the fact of distinctness and is the actualization of the human condition of plurality, that is, of living as a distinct and unique being among equals." (H. Arendt, *The Human Condition*, 1958)[3]

To paraphrase Hannah Arendt, the contributions made by one's difference can only occur within a group of equals. Within hierarchies and under dominance, we tend to repress our differences to avoid punishment. Because of this defense

mechanism, certain identities of origin have traditionally been suppressed in order to conform to the majority: sexual orientation, accent, behavior, etc. The unease created by repressing our identities of origin creates barriers for individuals to reach their aspirational identities.

Identities of origin are those already incorporated within the person (being a man, Vietnamese, and so on), whereas aspirational identities are chosen and driven by affinity of interest (for example, belonging to the techno geek or environmentalist tribes, or in the case of migrants, being perceived as a member of the country of destination with all the rights that entails).

The word "identity" comes from the Latin *idem*, meaning same, and *entis*, meaning entity. Therefore it is the movement of becoming identical to some entity, implying a process. This process can have two directions: I might decide consciously or unconsciously that I belong to a certain group, and thus *identify* with it, meaning that I follow certain patterns of behavior to conform to the group; equally, the process can be outside of me because "they" (those in the outside world) have decided to *categorize* me within a certain group, which implies a certain pattern of behavior that people expect me to conform to accordingly, but which nevertheless I may or may not identify with.

Therefore, it is commonly assumed that there are two distinct processes of identification: one is self-identification, or group *identification*, which is the process through which an individual decides to identify with a certain group; and the second is that of *categorization*, when the process is external to the individual and he or she has no choice in the matter.

There are two processes of identification: one is self-identification, or group *identification*, and the second is that of *categorization*

Identities of origin tend to have a strong component of *categorization* and thus of the projection onto a given individual of the qualities assumed to be part of his/her group, as for example in the case of prejudices against a particular race or religion. These barriers exist in the community outside the individual who faces them (and also outside his or her group of affiliation).

By contrast, aspirational identities have a strong *identification component*. Social identity, and in particular group identification, has been widely studied in management literature, pioneered by Tajfel[4]. Social identification appears to derive from the concept of group *identification*[5] and could be defined as "the perception of oneness with, or belongingness to, some human aggregate."[6] This led Turner[7] to propose the existence of a "psychological group," which he defined as "a collection of people who share the same social identification or define themselves in terms of the same social category membership." A member of a psychological

group does not need to interact with, or like other members of the group, or be liked and accepted by them. The individual seems to reify or credit the group with a psychological reality apart from his or her relationships with its members.

If the outside world rejects one of our identities we tend to defend it or feel ashamed by it, but in any case that particular identity takes on a much bigger role in our multiple being than it would otherwise. If our different identities are accepted with normality—that is to say, if we can operate in a context based on equality—our regular being is fluid and highly adaptable to the external environment and to the different affiliations that can freely be sought. Managing multiple identities represents a model better adapted to the fluid and changing realities that characterize today's global society.

The inclusion policies of recent decades have enhanced the participation of individuals in identities outside their identities of origin. This increased acceptance of world diversity, together with important changes in ICT systems, consolidates an emerging collective paradigm of groups made up of individuals who want to belong.

The microgroups that dominate the landscape described by Maffesoli are not residuals of former traditional social life, but the key social fact of our experience in everyday living. These new organizations represent a new way of living everyday life based on a communal, as opposed to an individual basis. These new communal identifications define roles that people play (as in a play having a role in it), but are not a permanent form of association.

The increased acceptance of world diversity, together with important changes in ICT systems, consolidates an emerging collective paradigm of groups made up of individuals who want to belong. These new communal identifications define roles, but are not a permanent for form association

According to Bauman,[8] these new communities cannot play the traditional role of a community, since liquidity and a changing nature are their main characteristics. Providing shelter and protection from individual misfortunes is not one of the characteristics of these new forms of collectivity. Instead, they represent a temporary place within which to act.

Bauman proposes that the durable identities once associated with work have given way to looser and more provisional identities and conceptions of community that are subject to constant change and renegotiation. He defines this set of provisional and always-traded identities as liquid identity.

These communities of the network society appear as a result of the emerging forms of relationships enabled by new information and communication technologies. According to Castells[9], networks allow a new kind of social relationship characterized by collective behavior, rather than a collective sense of belonging. Networks are neutral and do not have personal feelings—it is what people do in the networks that can lead to certain social processes. In Castells' analysis, the power of identity within the new e-networks becomes the key driving force for identities whose source lies in *legitimizing identities*, which are provided by institutions such as the state, political parties, unions, the Church, or the patriarchal state, but which have lost their cohesive capacity, leading to the appearance of *resistance identities*, which are imposed from above and built around traditional values such as God, nation, and family, or can be built around proactive social movements like feminism or environmentalism. Finally, we see the emergence of *project identities*, whereby individuals link their personal projects together with others for a common good.

The collective energy of a new paradigm—whether labeled project identities, aspirational identities, or liquid identities—represents a form of temporary engagement to a group that is bound together for a common interest, and that uses the differences between its members to collaborate, co-create, or execute other kinds of joint action within a collaborative economy. This individual difference, freely given to the service of a given group, illustrates the main characteristic of the new emerging tribes.

Diversity and the Newly Emerging Tribes of the Collaborative Economy

The term "tribe" is troubling to the modern mind, suggesting a return to collective restrictions on our individual freedoms. But the tribalism emerging in this new paradigm of a collaborative economy is a sign of modernity, not of regression to darker times; the new emerging tribes enhance our individual freedoms, fostering individual contributions.

What both old and new tribes share is that their members identify emotionally with the group, as well as sharing mutual interests and organizing different aspects of their personal and professional lives jointly with the goal of fulfilling a common objective that is good for the community.

However, the new tribes differ from the old ones in seven major ways:

- **Openness**

Traditional tribes were closed entities with high entry and exit barriers to protect their members from any negative influence. By contrast, new tribes are open. People can join and leave easily; there is a high degree of mobility and a continual renewal of ideas and influences.

- **Interlinking**

In the past, due to poor communication, tribes had little contact with each other. This preserved their uniqueness. Thanks to technology, members of the new tribes belong simultaneously to many others. This creates multiple links among them as part of a super tribal global structure that allows individual participation within a comfortable small group, while at the same time providing exposure to a multiplicity of different groups.

- **Co-organization**

Traditional tribes were hierarchical, and obedience to the leader was the first requirement of membership. Members of the new tribes create rules and strategies collectively. They resemble flocks of birds, in that while they appear to be following a single leader, they actually follow different leaders, given that different individuals have different abilities, resources, and strengths that allow them to lead in certain stages, but not necessarily throughout the whole process.

- **Collaboration**

Old tribes were based on a pattern of continual confrontation against external tribes. In today's tribes, no one is sure who is external and who is internal, since membership interconnection makes it difficult to identify who belongs to what. Collaboration is thus a logical strategy between different tribes.

- **Short Stay**

Membership of old tribes usually lasted a lifetime and, often, beyond that, passing from one generation to the next. Only a cataclysm or an invasion could put an end to membership or the tribe. New tribes, by contrast, are short-lived; they emerge and disappear when the task at hand is complete.

- **Voluntary Membership**

Belonging to old tribes was dictated by birth, on the basis of family, color, gender, or class. In new tribes individuals can contribute by choice using their multiple identities.

- **Sameness vs Common Interests**

Perhaps the most salient feature differentiating the old tribes from the new ones is that old tribes were formed on the basis of sameness, while new tribes are formed out of differences bound together by a common interest. Sameness is what makes us equal, by biological composition.

We share our sameness, our fear, hunger, pain or pleasure. Sameness helps us to ensure the satisfaction of our individual needs, which might be the same as somebody else's: this sameness can unite us in pursuing a common fight. Commonality is something we can all feel part of, but it is not owned by anyone in particular. Our contribution to the common good is dictated by our individual differences, and does not help any other member in particular; it simply benefits the whole community, directly or indirectly.

Sameness can make us work in confrontation because we need to defend ourselves from the rest. By contrast, contributing to the common good is a voluntary activity, since we do not really need to, meaning we can be open to collaborate with other tribes, co-create, and be open to external influences, staying or leaving as we wish.

New tribes exist only for a purpose, and when their purpose is finished or no longer satisfying, we can leave. They do not provide us with a permanent shelter to guarantee our survival, and are instead a temporary space within which to act with other individuals who share our common interest.

These groups are not created for fun, although they can be fun. Individuals join in to act, and for that purpose the group will appreciate the different perspectives that can help achieve specific goals.

PART II: Diversity and Tribes in the Corporate World

Innovation, Ambidextrous Organizations, and the New Tribalism

Today, innovation is perceived as one of the pillars of a competitive economy. In addition, innovation has been widely recognized as a key factor in corporate success, closely related to three factors: the capacity of an organization to compete; the generation of competitive advantages; and the long-term survival of the organization.[10]

A major obstacle to corporate innovation is the way organizations acquire new capabilities that will allow them to be successful in both the short and long terms. It is often assumed that organizational exploitation of current capabilities reduces exploration of new capabilities, resulting in a short-term bias in organizational adaptation.[11]

A well-established solution to this is the ambidextrous organization. According to Duncan,[12] an ambidextrous organization is able to combine exploitation of existing capabilities with exploring emerging opportunities. As a result, a company can be creative and adaptable.

Tushman and O'Reilly[13] link the concepts of innovation and ambidextrous organization, defining them as "the ability to simultaneously pursue both incremental and discontinuous innovation...from hosting multiple contradictory structures, processes, and cultures within the same firm."

A major obstacle to corporate innovation is the way organizations acquire new capabilities that will allow them to be successful in both the short and long terms

By definition, the ambidextrous organization is able to combine multiple organizational structures and cultures depending on the time pressures created by pursuing short or long-term goals. The new tribalism offers a promising approach to innovation within the organization by the use of specific tribes for exploitation or exploration, with the objective of developing dynamic capabilities, which are defined as "the capacity of an organization to purposefully create, extend, or modify its resource base."[14]

In simple terms, dynamic capabilities could be used to create or discover an entirely new business model, or to expand, extend, or modify an existing one. According to Osterwalder[15] a business model is defined as a description of how an organization creates, delivers, and captures value.

Combining the exploration/exploitation approach with the business model's discovery/modification, a new map of tribalism focused on innovation in the firm appears. In this map four positions are defined, representing a unique approach for the use of tribalism in business model-based innovation:

- **Business Model Efficiency (BME)**

This is devoted to increasing the performance of an existing business model. The organizational focus is exploitation, and dynamics capabilities are devoted to business model modification without any substantial alteration.

- **Business Model Transformation (BMT)**

In this case, a better exploitation of the model implies substantial changes in the existing business model. The development of new dynamic capabilities is needed.

- **Business Model Growth (BMG)**

Without any substantial modification of the business model, the organization is focused on exploring new markets or products when the existing business model could grow, leveraged by its current capabilities.

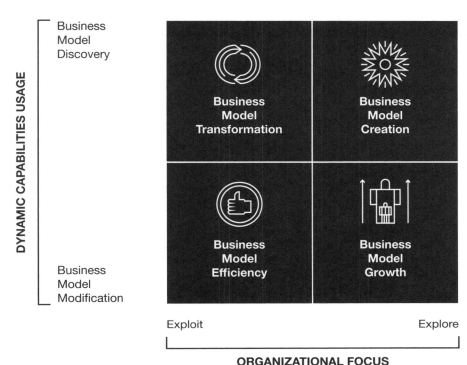

- **Business Model Creation (BMC)**

In this case, an entirely new business model appears as a result of the exploration of new opportunities in the market, technology, or any other environmental factor.

Some companies are able to take advantage of the multiplicity of tribes in a wide variety of contexts, either as a tool for exploitation or as a way to develop dynamic capabilities for the business model's modification of discovery. When organizations are not able to understand and use this form of social aggregate, opportunities for collaboration within different internal (inner) tribes or customers are lost.

In order to illustrate the success of a tribal mindset in the corporate world and its potential as an innovation enabler, four cases have been selected: Google (US), Dana (UAE), Prosper (US), and Bultaco (Spain). Each case provides a unique opportunity to understand the use of tribalism in organizations and in addition, identify four critical elements in the implementation of the new collaborative paradigm. Those elements are:

- The use of tribes for exploration and/or exploitation as the main organizational focus in a specific business model

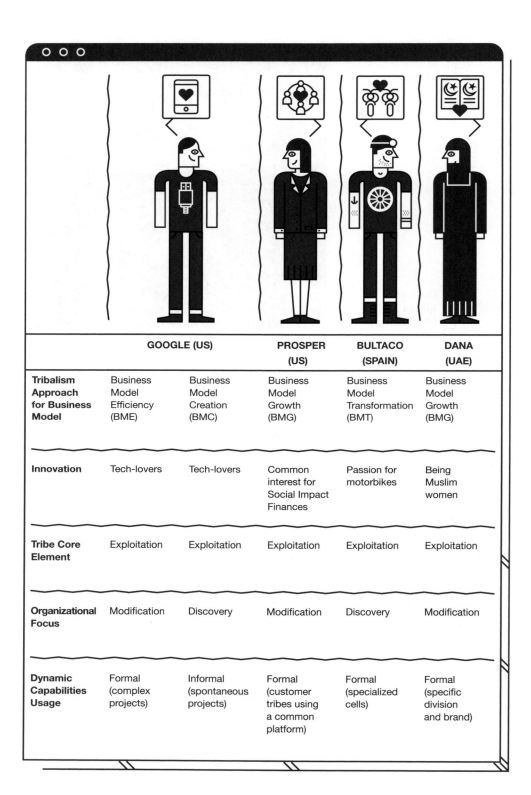

Diversity and Tribal Thinking in the Collaborative Organization

186

– The use of tribes for business model modification or business model discovery
– The core element around which the tribe is formed and keeps members bounded
– How the multiplicity of tribes is accommodated inside the organization using a variety of formal and/or informal mechanisms

The "plurality" in the use of the tribal paradigm in organizations is well illustrated in the proposed cases. Three of the proposed approaches are represented. An additional insight is highlighted in Google's case: multiple approaches to tribalism can coexist within the same organization.

Business Model Efficiency (BME) and Creation (BMC) in the Same Organization. The Case of Google

The organizational use of tribes is well documented in the technology industries as a way of tackling the exploration dilemma. The most common approach is the use of the so-called "geek tribe." A geek tribe is made up of highly skilled technology experts who focus on a relatively narrow field. The geek tribe is easily recognizable by being located in a specific space (often christened the lab) when the group talent is devoted to solving a concrete technological challenge. This kind of tribe is characterized as being highly meritocratic and goal oriented.

In the case of Google, the common element that glued the geek tribe together was technical expertise focused on exploiting new opportunities. The basic material of Google is made up of a swarm of small teams focused on solving a narrow problem for a very short period of time. The team can be disbanded once the task is finished, or if a more urgent one appears.

Let's imagine a geek tribe made up of six members trying to improve some feature of Google's Chrome browser. The tribe's main objective is to further exploit a well-defined business opportunity by solving a technical challenge related to the browser. Once the problem is solved, a new task could be assigned, or the tribe disbanded, with each member reassigned to another team where his or her personal technical expertise could be used. This usage of tribes could be seen as a Business Model Efficiency (BME) approach.

> At Google, the element that glued the geek tribe together was technical expertise focused on exploiting new opportunities

But Google's use of tribes is not only limited to business exploitation, and a certain amount of exploration is encouraged. According to the famous 70/20/10 model, each member of the tribe should utilize its time according to the following

ratio: 70% should be dedicated to core business tasks; 20% to projects related to the core business; and 10% to projects unrelated to the core business.

This remaining 10% of time can be used by a smart employee to explore a new technology with no relation to the current business. Eventually, this technology could lead to a new business opportunity. Furthermore, using an internal board system, collaboration with other employees could be requested and managed. In this case, tribes are used as a tool for exploring future opportunities, thus providing an excellent example of the Business Model Creation approach.

Multiplicity of tribes appears in formal and informal ways. The most common formal way is in the form of complex projects. A project is developed and directly encouraged by the company, and its task is fulfilled by several small teams in the form of a geek tribe. Because most of those teams are short-lived, in a standard project each employee could have been a member of several tribes across the project's lifetime.

The most common informal approach is related to spontaneous projects that emerged from the 10% slot of time involving some highly interested and motivated employees exploring a new opportunity which, if it shows potential, can be adopted by the company and assigned to a formal team.

Business Model Growth (BMG). The Cases of Dana (Abu Dhabi Islamic Bank) and Prosper

An interesting example is the case of Dana, the women's division of the Abu Dhabi Islamic Bank in the United Arab Emirates. In 2011, ADIB had a total of 60 branches, 23 of which were women-only and have been providing women with banking services since 2009, when the new brand called Dana integrated all the female divisions. The new brand created an impetus to develop innovative products for Muslim women. As one young employee explained, "We spend so much time with our clients that we know them well and we are very aware of their needs. This is the reason why we are successfully creating new products adapted to our clients' needs, as in the case of *Banun*."[16]

Women employees had for some time realized that their clients, particularly those who were divorced, needed to open accounts in the name of their children without the signature of their husbands required by law. Once the need was acknowledged, the managers consulted with the Shari'a[17] division, which asked the Shari'a board for advice, and after some discussion they agreed to create a special product called *Banun*. The *Banun* account was a solution for the targeted group of divorced women clients, allowing them to transfer their own money to special accounts for their children, thus conforming to the principles of Islamic law, as well as to the laws of the country.

The product was developed thanks to the strong community ties among clients, employees, and managers.[18]

In the case of Dana, the core elements around which the community emerged was clear: Muslim women who were interested in specific financial products to serve their particular needs. In this case, the dynamic capabilities development is focused on an existing business model, while the organizational focus is on exploring a kind of specific customer (women). As a result, a Business Model Growth (BMG) approach has been implemented.

> In a BMG model, the dynamic capabilities development is focused on an existing business model; the organizational focus is on exploring a kind of specific customer

In the case of Dana, the core element around which the community emerged was clear: being a Muslim and a woman. This led to a product that could be used for their community. However, the core element around a tribe is not always that clear. Sometimes the core element is a passion around an idea. In these cases of identities of aspiration, companies cannot organize the taskforce around the core element of the tribe, since this is not explicit. What they can do instead is to create a *context of possibility* within which those tribes can emerge and then monitor the emergent tribes and react quickly to their needs. The following example of Prosper is a good illustration of how a company creates a context of possibility.

Prosper is a pioneer in the field of peer-to-peer lending, whereby individuals are able to lend money to other individuals, thus avoiding traditional financial intermediaries. This kind of financial intermediation known as P2P (peer-to-peer) lending was one of the first examples of the collaborative economy.

Prosper represents another example that excels in the exploitation role led by customer tribes. In the case of Prosper, the customer tribe is made up of customers who have been able to identify a business opportunity and create a business model to exploit it within an existing community-based model led by a company. The core element of the tribe in this case is a common interest in having an investment that in addition to providing them with revenues, does have an impact on a given community. In terms of our definition of a collaborative economy, we found a set of tribes that shared a collaborative need (a business opportunity), and a collaborative means (Prosper's technological platform).

Prosper is able to create a specific context for each affinity group. Quite a common kind of group is comprised of former students of a university (an alumni group) that has decided to invest in current students by providing them with money to pay for tuition fees. This group of investors is held together by three complementary factors: the sense of belonging to the university; a common investment goal; and possessing very specific knowledge about the students' employability, which is extremely useful as a risk indicator.

Another customer tribe could be dubbed a neighborhood tribe. Residents of one district decide to invest as a group in a community in a neighboring district that needs to finance its mortgages. Taking advantage of local knowledge to assess real estate prices, neighborhood demographic changes, and even the presence of welcome or unwelcome new residents in a specific street, this investor tribe can generate a tremendous improvement in investment quality. In addition, investment-related information could include non-traditional sources such as neighborhood gossip. Based on Prosper's experience, customer tribes can appear around a clear customer need that is not being properly fulfilled. Despite Prosper offering basic information and mechanisms for credit scoring on borrowers, some kinds of borrowers could be assessed more precisely by using additional information and specific risk metrics. It is this kind of improvement where investor tribes appear within the Prosper ecosystem. In this case tribes are supporting a Business Model Growth (BMG) approach.

Instead of defining different core elements for each specific tribe of customers, Prosper creates open contexts in which each customer tribe emerges naturally

In this case, the multiplicity of tribes is empowered by the design of the Prosper online platform. Although the common interest can be defined as shared interest social-impact financing, each financial tribe uses the Prosper website as a common channel to access would-be borrowers, as well as a promotional tool to attract them. Instead of defining different core elements for each specific tribe of customers, Prosper creates open contexts in which each customer tribe emerges naturally, and it is only in a second stage that the company can define the core elements of each tribe. Within this open platform, some customers grouped themselves around niche investment opportunities, creating a rich environment of tribes of investors with very different interests and goals.

In addition, Prosper's website attaches great weight to creating and managing investors' groups, in the process providing a basic mechanism for the internal management of the tribe, including control over membership.

Business Model Creation (BMC). The Case of Bultaco[19]

If organizations want to harness tribal power, new forms of management styles are required. A good illustration of this is the one implemented by a Spanish start-up that was created four years ago by two engineers who got together a group of product managers passionate about motorbikes, creating a project out of that

passion. So passionate were these managers that they took it personally upon themselves to write a business plan and search for potential investors.

Once the project was underway, they decided that the company would need to be completely digitalized, which required a comprehensive, fully integrated information system for the entire company.

The information system required to support an up-to-date management model had to be flexible, robust, and potent, requiring a new approach, so that it would be able to accommodate the new social model being implemented.

For this reason, it was clear that traditionally hierarchical schemas would not work, given their inflexibility and the limitations they imposed on decision-making and response times.

Therefore, the team opted for a model based on specialized cells able to work together on a common goal. Once this was completed they would then join up to tackle a different task as required, showing their ability to respond to random events. A model of this kind requires independent decision modules coordinated to meet specific needs, able to recombine themselves in different ways. Each cell could be defined as a specific decision-making-oriented tribe.

If organizations want to harness tribal power, new forms of management styles are required. The Spanish start-up Bultaco opted for a model based on specialized cells able to work together on a common goal

To represent the structure graphically would require 3D diagrams incorporating mobility, making its representation, conceptualization, and understanding extraordinarily difficult.

For this reason, and after thorough analysis, we have opted for a two-dimensional "Wheel Model," based on the principles outlined below.

All companies have a series of scopes—a combination of decision-making spaces oriented to a specific managerial task—that are essential for the proper functioning of the whole. However, these scopes have to adapt to the needs of the company, and depending on the situation can be broken up into fragments, grouped, or disbanded, or give rise to new ones.

The scopes need to perform functions and tasks, or particular processes, which directly or indirectly involve others with varying intensity depending on the task at hand, and the temporality and opportunity it possesses.

In addition, the scopes, in the development of their functions and/or processes, consume the resources of other scopes and/or generate resources for other scopes.

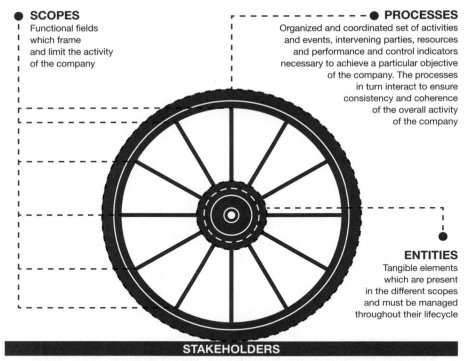

All this comes about through a dynamic process, simultaneously, responding to situations that are not specifically pre-programmed: the inputs set by the evolution of the market must be counteracted.

A graphical representation of this could be a wagon wheel, where the spokes constitute the scopes: functional areas, departments, working groups, etc. that develop the company's activity.

As such the wheel is formed by the processes (the rim): the organized and co-ordinated set of activities that involve as many scopes as necessary. It is represented in a circular fashion, because each scope interacts with the others, either to obtain information or, on the basis of this information, to develop new scopes that could be added to the hub and are accessible from another scope.

The shaft will be formed by the entities or resources available to be used from each scope.

The wheel will be driven by the stakeholders: groups or individuals the company has some type of relationship with, or who have some kind of interest (stake) in the project.

The Bultaco case illustrates Business Model Transformation (BMT), whereby organizational focus is about meeting the challenge of exploiting a highly

sophisticated business model, while trying to discover new competitive capabilities to allow the firm to compete under very volatile conditions. The nature of the collaborative action is based on the presence of a collaborative end (to develop a business based on a passion for motorbikes), and a collaborative means (organizational cells) that have enabled the creation of a very distinctive business model.

Conclusion

We believe that tribal thinking today embraces community without renouncing universality. The paradigm change we are witnessing is a shift from a longing for independence in a society made up of communities to a longing for belonging to a society made up of individuals.

Both individuality and community have value in the new tribal understanding. Individuality comes via one's background, perceptions, and ideas; in other words, everything that make us different. This difference is made valuable in a community that has gathered to accomplish a specific purpose which has a meaning for its members.

The new mindset of a collaborative economy based on groups sharing a common culture requires an equal playing field on which differences are valued rather than rejected, as well as a strong common interest that motivates members, along with contexts of possibility within which the magic of creation can occur.

Organizations cannot force motivation upon individuals, nor engineer creativity. But what organizations can and should do to capture collective energy is to create contexts of possibility. This is an opportunity (the collective energy of the new tribes) to spark new ways of innovation generation within the organization, allowing the modification or even creation of new business models, as well as enabling mechanisms for a better exploitation of current businesses, as well as the exploration of new products, markets, and technologies.

Notes

1
M. Maffesoli, *Le temps des tribus: le déclin de l'individualisme dans les sociétés de masse* (Paris: Méridiens Klincksieck, 1988).

2
L. von Mises, *Human Action: A Treatise on Economics* (New Haven: Yale University Press, 1949).

3
H. Arendt, *The Human Condition* (Chicago: University of Chicago Press, 1958; repr. 1998), 178.

4
H. Tajfel, "La catégorisation sociale," in *Introduction à la psychologie sociale*, ed. by S. Moscovici, 2 vols (Paris: Larousse, 1972-3), I (1972).

5
E.C. Tolman, "Identification and the Post-war world," *Journal of Abnormal and Social Psychology*, 38 (1943), 141-48.

6
B.E. Ashforth and F. Mael, "Social Identity Theory and the Organization," *Academy of Management Review*, 14.1 (1989), 20-39.

7
J.C. Turner, "Social Identification and Psychological Group Formation," in *The Social Dimension: European Developments in Social Psychology*, ed. by H. Tajfel, 2 vols (Cambridge: Cambridge University Press, 1984), II, 518-538.

8
Z. Bauman, *Community: Seeking Safety in an Insecure World* (Cambridge: Polity Press, 2001; repr. 2008).

9
M. Castells, *The Information Age: Economy, Society and Culture*, 3 vols (Cambridge, Mass. and Oxford: Blackwell, 1996-98), II: *The Power of Identity*, 2nd edn (2004).

10
M.E. Porter and C.H.M. Ketels, "UK Competitiveness: Moving to the Next Stage," DTI Economics Paper no. 3 (London: Department of Trade and Industry, May 2003).

11
J.G. March, "Exploration and Exploitation in Organizational Learning," *Organization Science*, 2 (1991), 71-87.

12
R. Duncan, "The Ambidextrous Organization: Designing Dual Structures for Innovation," in *The Management of Organization Design*, ed. by R.H. Kilmann et al. (New York: North-Holland, 1976), 167-188.

13
M.L. Tushman and C.A. O'Reilly, "The Ambidextrous Organization: Managing Evolutionary and Revolutionary Change," *California Management Review*, 38 (1996), 8-30.

14
C.E. Helfat et al., *Dynamic Capabilities: Understanding Strategic Change in Organizations* (Malden, Mass.: Blackwell, 2007).

15
A. Osterwalder et al., "Clarifying Business Models: Origins, Present and Future of the Concept," *Communications of the Association for Information Systems*, 16 (2005), 751-75.

16
C. De Anca, *Beyond Tribalism: Managing Identities in a Diverse World* (Basingstoke: Palgrave Macmillan, 2012), 99.

17
Shari'a means Islamic law. Islamic banks normally have a division of experts of Islamic law and a related board of Islamic scholars who decide on the conformity of the financial products to the Islamic law principles.

18
ADIB corporate website, 2014 <http://www.adib.ae>

19
Source: personal interview with Juan Perpignan, CEO Quavitam.

A Gender Power Shift in the Making

Alison Maitland

The author Alison Maitland examines the subtle shift away from the Western male domination that characterized much of the last centuries. She explains that this shift is manifesting itself in many different ways: the feminization of leadership styles, the decline of hierarchy and trust and the rise of soft power, the importance of female purchasing power, the disruptive impact of the internet on business models, the shift of economic power from West to East, and the change in roles and attitudes (especially men's) towards work and family life. Companies that wish to thrive in the future would do well to take action on these trends, as the gender power shift that is starting to happen in twenty-first-century companies will be an indisputable triumph for economic and social progress if it enables women at every level to realize their true potential.

Alison Maitland
London Cass Business School

Alison Maitland is an international author and speaker specializing in leadership, diversity, and the new world of work. A former long-serving journalist with the *Financial Times*, she is co-author of the books *Future Work* (2011) and *Why Women Mean Business* (2008). She is a Senior Fellow in Human Capital at The Conference Board, the business membership and research organization, and directs the Board's Europe-based Council for Diversity in Business. She is a Senior Visiting Fellow at Cass Business School, London. In 2012, she received a "World of Difference 100 Award" from The International Alliance for Women. Her website is www.alisonmaitland.com

Key Features for the Company of the Future:

Soft Power
The decline of hierarchy and the rise of the networked organization demand new ways of leading. The global shift of economic power away from the West also necessitates a rethink of culturally dominant leadership styles. Companies need to develop soft power in their leaders – the ability to attract followers and get things done through persuasion rather than coercion. Soft power involves listening and actively seeking out people and perspectives that are different. Such behavior, combined with more traditional requirements such as decisiveness, will better prepare leaders to respond to the disruptive forces of the digital era.

Work Autonomy
A growing number of companies across many sectors are responding to the digital revolution and demographic shifts by undertaking a wholesale shift in work styles and management culture. Rivals risk trailing in the wake of these pioneers. Progressive work practices give people much more autonomy over how they meet their objectives. This can boost productivity and cut costs for businesses while enabling individuals to achieve more balanced lives, contributing to a greener economy. There is a big battle ahead to make sure that technology is our servant, not our master.

Transparency
There is nowhere to hide in global business today. To respond to high levels of scrutiny and ubiquitous social media, companies need to be proactive, not reactive. Even the tech giants are discovering the need to volunteer information up front, rather than wait to be pressured into disclosing it. Transparency is a powerful stimulus to achieving the elusive goal of heterogeneous leadership teams. Collecting the evidence – for example, where women are at every level of the organization compared to men - is an essential first step. Calculating the risk of losing that talent, and acting to stop that loss, can then follow.

A Gender Power Shift in the Making

Here we are, well into the second decade of the twenty-first century, and the vexed topic of gender in corporate life is commanding more serious attention than ever before. Much of this focuses on why, so many years on from equality legislation, women have still not achieved parity with men at the top of the business world. A growing number of governments have opted to enforce better gender balance on company boards through quotas, while others resist legislation in favour of a high-pressure mixture of cajoling and praise.

This spotlight on the top of big businesses is obscuring signs of a subtle shift away from the Western male domination that characterised the nineteenth and twentieth centuries. It is showing up in many different ways: the feminization of leadership styles, the importance of female purchasing power, the disruptive impact of the internet on business models, the shift of economic power from West to East, and the change in men's roles and attitudes towards work and family life. Companies ignore these trends at their peril.

How Can This Be?

The figures that dominate the headlines reveal one part of the picture, and it is unquestionably important. Around the world, the low number of women on large company boards, and in CEO and chair roles, remains striking. This is frequently documented and commented upon in advanced economies such as the US, UK and Australia. The Gender Map™,[1] produced by Data Morphosis, a workforce analytics software firm, has recently gone further, surveying 14,500 companies worldwide and finding that women represent on average only 11% of board directors.

The number of female chief executives of Fortune 500 companies is 5%. Only 4% of chair people of the boards of Europe's largest publicly quoted companies are women

The number of female chief executives of Fortune 500 companies is still tiny at 5%. Only 4% of chair people of the boards of Europe's largest publicly quoted companies are women.[2] The executive committees of big companies—usually a better reflection than boards of what corporate culture is like—offer an equally dismal scene: women hold 17% of senior management roles in America's 100 largest companies, according to 20-first, a gender consultancy firm.[3] The equivalent figures for Europe and Asia are just 11% and 4%.

In terms of a gender power struggle, therefore, it is very one-sided. It is moreover bizarre, given that women make up nearly half the workforce in most advanced economies. The headlines also highlight the persistent pay gap between men and women, including senior managers. Campaigns run internationally via the internet, such as The Everyday Sexism Project, demonstrate graphically that harassment and belittlement continue to be part of women's experiences, both inside and outside work.

But there are other, less remarked-on, aspects to the picture that signal a shift is under way. Not the least of these is the very urgency that this issue commands, and the voices that have joined the calls for change.

Business and Economic Imperatives

To start with, the global "business case" for gender-balanced leadership, which my co-author and I set out comprehensively in our book *Why Women Mean Business*[4] in 2008, is becoming widely acknowledged in the corporate world. Women are half the population, more than half of university graduates, and dominate consumer spending. There is plentiful evidence to support the

common-sense observation that having both genders properly represented in corporate leadership should improve performance.

Research initiated by organizations such as Catalyst and McKinsey[5]—demonstrating better financial outcomes for companies with more women on boards and in senior teams—has been reinforced by more recent studies. The Credit Suisse Research Institute, for example, examined 2,400 companies worldwide and found in 2012 that investors would fare better holding shares in those with at least one woman on the board than companies with no female directors. Over a six-year period, the share prices of companies with a market capitalization of more than $10 billion, and with female directors, outperformed counterparts with no women on their boards by 26%.[6] In a fresh analysis of 3,000 companies published in 2014, the institute found that more balanced boards *and* senior management teams were both associated with higher returns on equity, higher price/book valuations and superior stock price performance.[7]

Given that the business case has taken firm root, many proponents of gender balance argue that it is now time to move on and focus instead on the deep-rooted cultural obstacles in the way of progress. Adam Quinton, a former banker who now invests in and advises early-stage female-led companies, captures this sense of frustration by saying: "In answer to questions like 'What is the business case for women on boards?' I have taken to replying: 'I don't understand the question. Please tell me the business case to have men on boards.'"[8]

Economic realities are meanwhile bringing broader recognition among governments that economic potential is dependent on women fulfilling their potential in the labour force. Women's growing dominance of the educated talent pool cannot be ignored. OECD projections, based on current trends, show that women will account for two out of three graduates across advanced economies in 2020.[9]

The Credit Suisse Research Institute examined 2,400 companies worldwide and found in 2012 that investors would fare better holding shares in those with at least one woman on the board

Governments from Norway to France, India and the United Arab Emirates have been forcing the "gender agenda" with quotas to increase the number of women on corporate boards in the interests of competitiveness. Even Japan, one of the most conservative of advanced economies when it comes to gender roles, has woken up to the importance of greater female participation in the workforce. In 2014, the Japanese prime minister announced plans to improve

women's career opportunities, saying that output could rise by 16% if they were able to work as much as men.

The growing adoption of quotas around the world has led CEOs in all regions to view "diversity in our leadership ranks" as a hot-button challenge that they must address.[10] In sectors where skills are scarce, such as engineering and IT, companies are recognising they must fight for the brightest and best talent and do whatever it takes to keep it—including stimulating schoolgirls' interest in computer programming, and adapting work patterns and career paths to women's needs and lifecycles.

More companies are using targets internally to push women's advancement, in the same way they would address any other business need. A few have set a higher standard by stating their policies publicly. They include Deutsche Telekom, the first major German company to take such a step, which decided on a quota of 30% for women in middle and senior management by the end of 2015. In the UK, Lloyds Banking Group announced a target of 40% female representation among the bank's top 5,000 jobs by 2020—up from 28% in 2014.

> **For a long time, the debate about gender equality was confined to women. Over the past decade, senior men have started to take responsibility for leading change**

In all of these cases, it is men in power who are finally opening the door, after decades of hard campaigning by women. For a long time, the debate about gender equality was confined to women. Over the past decade, and the past five years in particular, senior men have started to take responsibility for leading change. It was a male minister for trade and industry, Ansgar Gabrielsen, who pushed through 40% gender quotas on Norwegian boards, to an initially hostile reception from business and politicians. He was convinced the economy would benefit if it made better use of its massive investment in educating women by ensuring they were able to rise to serve on boards in the same way as men. Today, gender-balanced boards are "business as usual" in Norway.

In the cases of Deutsche Telekom and Lloyds Banking Group, male CEOs acknowledged they must make a stand to let more women into positions of power. This sends a clear message to their peers.

Men's leadership here is essential. Another good example comes from Australia, where Elizabeth Broderick, the sex discrimination commissioner, persuaded a group of CEOs and business leaders to establish Male Champions of Change to press their fellow bosses to improve on their generally poor record of promoting women. One of the group, Andrew Stevens, managing director of IBM Australia, made clear he was prepared to

do battle because it was so important to "stay ahead of the curve" on talent. "I tell people that we shouldn't rest until we reach census levels—50/50," he said. "When I see hesitation or resistance, I know I'm onto something—I find it energising!"[11]

Mainstream investors have been curiously slow to pick up on the business benefits of gender balance. But in 2013 an influential investor voice told his fellow men to wake up to their self-interest, since women were the key to America's future prosperity. Warren Buffett, billionaire chairman of Berkshire Hathaway, wrote in *Fortune* magazine: "The closer that America comes to fully employing the talents of all its citizens, the greater its output of goods and services will be." Buffett is supporting efforts by the UK-based 30% Club (regrettably not "50% Club") to persuade shareholders to demand more women on US boards. The Club, led by Helena Morrissey and backed by well-known chairmen, has now garnered support for its international cause from leading investment groups such as BlackRock and Pimco. A number of products, such as the Barclays Women in Leadership Total Return Index, has meanwhile been launched to track and invest in female-led companies or companies with mixed-gender boards.

Another important argument for gender balance at the top is to reflect society and respond better to market trends and customer needs. Female consumer power is immense. An oft-quoted statistic from Michael J. Silverstein and Kate Sayre is that women globally control at least $20 trillion of consumer spending per year. In their book *Women Want More*, they say that, while some people see economic and social developments in China and India as the most important of the early twenty-first century, "we believe that the emergence of a whole new social and economic order, which can accurately be labeled a *female economy*—in every country and every arena—is an even more significant upheaval."[12] Theirs is one of a growing number of books telling companies how better to market to women. Putting more women in decision-making roles is an important step to improving the ability of business to adapt to a changing marketplace. Having senior men talk about this persuasively—and more importantly take action—is a breakthrough that points the way to shared leadership becoming the norm in successful businesses in the twenty-first century.

The Decline of Hierarchy and Trust and the Rise of Soft Power

So far, I have been talking about the top echelons of big business. However, the very notion of power residing only at the top is under challenge. Technological and social changes are breaking down traditional hierarchies

and distributing power more widely both within companies and between them and their networks of external partners.

Businesses depend on a growing "contingent" workforce of external contractors and freelancers. New and smaller businesses often consist mainly of peers collaborating with each other, with very little if any hierarchy. These trends are set to continue as work becomes increasingly portable and people experiment with more autonomous ways of working. Dave Aron of Gartner CIO Research Group predicts the rapid growth of "clusters"—self-governed groups of professionals with a range of skills who are hired by businesses to work long-term on projects and operations. "I would project that by 2020, 30% of work will be performed by permanently employed, self-managed clusters," he wrote in *Harvard Business Review*.[13]

Status will instead rely increasingly on unique skills and talents, or the ability to connect people, or being an inspiring leader

The shift away from massive standalone corporate structures will undermine the link between status and position in a hierarchy. Status will instead rely increasingly on unique skills and talents, or the ability to connect people, or being an inspiring leader. "The whole approach to the new world of work is that you need to be a personal leader," Gonnie Been, manager of corporate communication and social innovation at Microsoft Netherlands, says in *Future Work*, which I co-authored with Peter Thomson. "You need to lead your own life rather than being controlled by the boss as in the past, and if you're able to do that you are able to lead others."[14]

The democratization of work environments runs parallel to a decline in trust in traditional authority figures. People are more likely to trust experts, or to put their faith in their peers. Trust in the CEO is at 43%, while trust in academics stands at 67% and trust in "a person like yourself" at 62%.[15]

This poses a challenge for leaders of traditional corporations. Those with their fingers on the pulse know they need to encourage a greater diversity of leadership styles. Many are grappling with how to do this, but there is growing recognition that achieving gender balance is part of the solution.

The reputation of business remains damaged by the great recession of 2008, especially for those organizations most closely linked to the financial crisis. António Horta-Osório, CEO of Lloyds Banking Group, sees a direct link between restoring trust and changing the gender mix in the bank's leadership ranks. Preparing to announce the 40% target for women in senior management, along with measures to support smaller businesses and homebuyers, he said: "The reputational impact of the financial crisis

upon the banking industry's stature has been immense. Rebuilding a sound reputation founded on the highest standards of responsible behaviour is key to the industry's long-term success. But words alone are not enough to change public perception and regain trust. We must be able to provide meaningful commitments and allow ourselves to be independently measured against those."

In the twentieth century, the exercise of hard power was much lauded in business—think of "Neutron" Jack Welch and his practice of firing the lowest performing 10% of managers each year at General Electric. Soft power—persuading people to do what you want by attracting and coopting them, rather than coercing them—is a concept developed by Joseph Nye, University Distinguished Service Professor at Harvard, in relation to world politics. It is now making headway in the business world, with a growing emphasis in leadership development on the ability to listen, to seek out other perspectives, and to "earn" followers, alongside standard leadership traits such as resilience and decisiveness.

The rise of soft power will make leaders more effective, and it will open the door more widely to women. On the first point, research shows that teams perform less well on assigned tasks when led by people who equate leadership with power, dominate discussion, and discount the contributions of other team members. Experiments have found that the psychological effect of power on a team leader had a negative impact on team performance.[16]

On the second point, studies suggest a feminization of leadership as demand grows for skills suited to flatter, more democratic organizations and the preferences of younger generations. "Emotional intelligence, people skills, and flexibility, traditionally regarded as more feminine leadership skills, will be particularly highly valued," says one report.[17] Over 80% of the senior executives who were surveyed agreed that tomorrow's leaders would need a different style to motivate people. "Women managers ... are more participative in their leadership style," says Professor Cliff Oswick, head of the Faculty of Management at Cass Business School. "They have a sensitivity to risk, they're less hyper-competitive, and all those things align themselves with a more democratic, participative workplace."[18]

Women are leading the way in reshaping how jobs are done, including at senior levels

This participative style, which of course is not confined to the female sex, is also linked to more productive teamwork. Women on average are known to score higher than men on social perceptiveness—correctly reading emotions. A study into the "collective intelligence" of teams—their ability to solve puzzles and problems—unexpectedly found that gender mix played a

big part. The researchers were looking to see if a team's collective intelligence equated to the average of the IQs of its members. IQ turned out not to be a key factor. However, the teams with more women had higher scores, demonstrating a stronger collective ability to solve the problems and achieve the goals.[19]

Teams are more collectively intelligent if their members are, on average, more socially perceptive, Thomas W. Malone, director of MIT's Center for Collective Intelligence, told the magazine *Strategy + Business*. Higher performing teams also allow everyone to participate rather than being dominated by one or two people.

"We're in the middle of a period of very significant change in the role of women in the workplace," said Malone. "There may be some unsuspected advantages of having more women involved in more working groups... I think that there is a very bright future for women in business relative to what the expectations for women in business were, say, 30 years ago."[20]

Technology and the Rise of Choice

Emoderation is a global agency that manages social media for brands such as HSBC, LEGO Group, MTV and Sprint. Six of the seven-strong management team of this technology-enabled business are women, including CEO Tamara Littleton, who founded the company in 2002. It is staffed by 370 online moderators and community managers around the world, most of whom work virtually from their homes, and it has developed a reputation for high-quality customer service and a supportive working culture.

Littleton sees both female and male entrepreneurs leading a shift in the way that businesses are run. "I think the role of the CEO is changing," she says. "I've noticed much more of an empathy for people and a real focus on communication. It may be down to the changes in the digital era and the rise of social media but there is a sea change towards getting the right culture. Get the culture right and the rest will follow. It's likely that the enhanced focus on people, communication and culture is an environment where women thrive. That's certainly our experience at Emoderation."[21]

Technology is putting more power into the hands of knowledge workers, many of whom have greater choice than ever before about how, where and when they work. People with skills that are in demand also have more choices about who to work for, or with. Large companies can no longer assume that workers will just accept standard conditions of employment or traditional working patterns.

Women are leading the way in reshaping how jobs are done, including at senior levels. They dominate an annual UK list[22] of 50 senior people—including CEOs, managing directors, finance directors and partners in professional service firms—fulfilling these roles while working less than

a standard five-day week. Technology enables them to keep in touch and flex their working pattern, but it takes courage, communication and careful time management to make it happen, especially in organizations and professions with conservative work cultures. These leaders are busting the myth that holding down a top job requires body-and-soul commitment to the corporation, and the sacrifice of personal life. While most of the role models are women, there are growing numbers of senior men breaking the traditional work mold too.

Women are also finding alternative leadership roles outside the big corporate world through which they can make an impact and shape their working lives. In the US, the number of women-owned firms grew at 1.5 times the national average between 2007 and 2014, according to a study commissioned by American Express OPEN.[23] These businesses now account for 30% of all enterprises. Barriers to female entrepreneurship, especially high-growth ventures, remain significant. Female-owned enterprises in the US tend to employ only a few people, and collectively contribute only about 4% of all business revenues.

In the US, the number of women-owned firms grew at 1.5 times the national average between 2007 and 2014, according to a study commissioned by American Express OPEN

Technology is breaking down barriers here, however, just as it is in the corporate arena. Julie Deane had a budget of just £600 when she founded The Cambridge Satchel Company with her mother from her kitchen table in the summer holidays of 2008 to raise school fees for her children. Over the next few years, by learning and spreading the word via the web, she gained celebrity backing and an international market for her brand, as well as awards for fast-growth entrepreneurship. The company now employs over 100 people and recently attracted $21m in venture capital for further expansion.

Women face even bigger obstacles to entrepreneurship in developing countries, including a lack of access to technology. Nearly 35% fewer women than men in South Asia, the Middle East and North Africa have internet access.[24]

Nonetheless, there are inspiring cases of women using technology to break into new business territory. One example is Yasmine El-Mehairy, co-founder of SuperMama, an Egyptian portal offering expert advice for women about pregnancy and motherhood.[25] Having held IT jobs with big companies, she used her savings to start the site in 2011, driven by her desire to make a difference. The website quickly gained visitor numbers and revenue through advertising, sponsorship and product placement, and has won competitions for entrepreneurship.

Women have a range of reasons for seeking influence in the economy outside traditional big business. In some cases, it may be their only option. They may also ultimately earn more this way: a study by Barclays on unlocking the female economy found that the gender pay gap was reversed for wealthy entrepreneurs and business owners, with men trailing behind their female counterparts. "This suggests that women will tend to achieve greater financial success in an environment that is purely market-driven, rather than a more traditional job in which pay must be negotiated," the study says.[26]

There also seems to be a link between entrepreneurship and well-being, especially for women. In its 2013 report, the Global Entrepreneurship Monitor found that entrepreneurs generally showed higher rates of subjective well-being than people not involved in starting up, or owning and managing, a business. "Interestingly, female entrepreneurs in innovation-driven economies exhibit on average a higher degree of subjective well-being than males," it says. Innovation economies include Japan, South Korea, France, Germany, Sweden, Switzerland, the UK, Canada, and the US. "These results are exploratory but show initial evidence that for women, being an entrepreneur is correlated with more subjective well-being."[27]

What are the implications for traditional male-led corporations? Adapt or disappear may be a good way to describe it. "The massive monolithic company is in danger of extinction, not because it can't compete in the marketplace but because it can't compete for talent," argues Sharon Vosmek, CEO of Astia, a California-based organization that supports high-growth, female-led firms with a network of angel investors, expert advisers, and an investment fund. "Women have too many choices to want to go and work for an all-white male company. Things have changed in relation to technology and how the market works. Small businesses can be global at a very early stage compared with 10 years ago. If large corporations want to be in that war for talent, they have to be something different from the large, white, male, fairly homogenous environments of the past, where people come from a specific economic, educational and family background."[28]

The evidence suggests it would make sense for investors to pay more attention to the gender composition of the management team when it comes to funding a growing business, just as it makes sense to do so when investing in big companies. An in-depth study by Dow Jones VentureSource shows that venture-backed companies' odds for success increase with more female executives at vice president and director level.[29] Another study by Illuminate Ventures reveals that high-tech companies built by women use capital more efficiently than the norm. "More than ever before, women are influencing the face of business," it says. "They are on the cusp of becoming a leading entrepreneurial force in technology."[30]

Few venture capitalists (VCs) have yet jumped in, however. Women entrepreneurs are "an under-appreciated opportunity," says Adam Quinton. Explaining his own pro-female investment stance, he says "there is what economists would call a market failure ... the level of interest in those opportunities is not appropriately correlated with the chances and degree of success." He adds that male domination of early-stage capital providers—angel investors and venture capitalists—is the problem. "It likely means the VC community is not as innovative as it likes to think it is."[31]

Lessons From the Rising Economies

The shift in global economic power from the West to the East and South makes it imperative to look at how women fare in business and what effective leadership looks like in these regions of the world.

Globally, women hold 24% of senior management roles, according to Grant Thornton's International Business Report, which surveys mid-market businesses around the world. But this masks big differences between countries, and within regions. Women hold much greater sway in Eastern Europe and Southeast Asia than in most Western economies. Russia tops the table with women in 43% of senior roles, followed by Indonesia, the Philippines, the Baltic States, Thailand and China. By contrast, the US (where women occupy only 22% of senior roles), Spain (also 22%), India (14%) and Japan (9%) are among the bottom 10 of the 45 countries surveyed.[32]

Women hold much greater sway in Eastern Europe and Southeast Asia than in most Western economies. Russia tops the table with women in 43% of senior roles

The growing economic importance of Asia and other regions poses a challenge for international businesses as they develop future leaders. Do they continue to promote people into leadership who display typical Western (and particularly US) traits such as overt self-confidence, assertiveness and individualism? Do they deliberately look for non-Western styles? Or do they seek a middle way, encouraging the best of different cultural and individual styles, and above all adaptability and appreciation of the "other"?

There is a link here with the rise of soft power and the emphasis on collective, rather than individual, achievement of results. In her book *Lean In*, Sheryl Sandberg, the California-based chief operating officer of Facebook, urges women to be more openly ambitious to get to the top. But this kind

of message does not necessarily resonate in other parts of the world in the way it does in America. According to Jane Horan, a Singapore-based expert in cross-cultural leadership and author of *How Asian Women Lead*, "presence—or leadership—appears differently in Japan, China, India and the United States. It is subjective, culturally specific and shaped through words. Using tentative or hedging language such as 'I think' or 'I'm not certain but …' does not instill confidence with American managers—but indirectness is often the lingua franca of business in Asia."[33]

The statistics on female entrepreneurship around the world also warn us not to make assumptions about advanced versus developing economies. In most regions, female early-stage entrepreneurship rates are lower than male rates. But women in sub-Saharan Africa are setting up businesses on a par with men. In Ghana, Nigeria and Zambia, there are even more female- than male-run early-stage businesses. Other countries where women are equal entrepreneurs with men are Brazil, Indonesia, the Philippines, Thailand, Russia, and Switzerland.[34]

> **Work-life conflict used to be seen primarily as a problem for women. But now employed fathers in dual-earning couples are more likely to experience such conflict**

Investors in Silicon Valley, where only 5% of venture-backed companies have women CEOs, could learn from the experience of microlending to female businesses in Africa. With her Astia network of 5,000 experts around the world, half of whom are women, Sharon Vosmek has sought to emulate the microloan system of peer and community involvement and evaluation to decide which businesses to back. "This provides a more robust set of measures than the traditional venture capital model of four guys around a table trying to decide the risk of a business based on gut instinct and their fairly homogenous experience or exposure," she says. "We have found ways to eliminate biases and reduce blind spots by engaging a larger community. Our pipeline of investable women-led companies is abundant and there's a great opportunity to drive female entrepreneurship by learning from emerging economies."

Shared Responsibility at Work and Home

If the future looks more promising than the past for women in business—and for businesses that adapt to women—there is a parallel opportunity for men. With greater power-sharing at work comes greater sharing of responsibility for children and the home. Companies have typically regarded "gender issues" as

"women's issues." That was always a mistake, but now the pressure is increasing on businesses to acknowledge that men have caring responsibilities too.

The model of male breadwinner and female caregiver is fast disappearing in many countries. A record 40% of US households with children under 18 have mothers who are the sole or primary source of income for the family. Of these, 37% are married women earning more than their partners, and 63% are single mothers.[35] A similar trend in the UK finds that almost one in three working mothers with dependent children are now the primary breadwinners for their families.[36]

The merging, or reversal, of traditional gender roles has major implications for business and society. Work-life conflict used to be seen primarily as a problem for women. But research reveals that employed fathers in dual-earning couples are now more likely than mothers to experience such conflict. There are ways for employers to reduce this, enabling both men and women to manage work and home life more effectively. A study by the US Families and Work Institute found that high job pressure increased the likelihood of work-life conflict, but that men who had greater autonomy at work, and more support from their supervisors, were less likely to experience it.[37]

If more men are able to play their full role as fathers, it will be good for women's progress, and thus for economic competitiveness. Moreover, shared parenting and earning is the best thing for the family. Adrienne Burgess, joint chief executive of the UK's Fatherhood Institute, says the participation of fathers at home takes pressure off mothers, helping them to parent more positively, while strong relationships between father and child are linked to positive outcomes for children, such as higher educational achievement and lower criminality and substance misuse.[38] In other words, when families benefit from a sharing of power and responsibility between women and men, societies benefit too.

Accelerating the Shift

I have argued that there is a gender power shift in the making. But it is happening more slowly than is necessary to benefit both individual men and women and the business world. I therefore conclude with some proposals to speed up the culture change that will propel women into shared leadership with men.

– Speaking Out Together

More male leaders need to take responsibility for driving change—and women must help them by welcoming them into the debate. Many events and conferences about women in leadership are still organized and attended almost

exclusively by women. Change will not happen without men being accountable too. Many men would like to see gender parity but do not feel part of the conversation, or do not see how they are part of the solution. Connecting male and female business networks is one important step, since it is an uncomfortable truth that people tend to look out for those whom they know and with whom they feel most familiar.

In persuading others of the need for change, committed business leaders need to draw on more than "the business case." They should speak from the heart, and explain their own conviction in personal terms. They should also seek out and listen to the real-life experiences of women in their organizations. It is much more powerful not only to understand the data, but also to be able to connect with the human consequences of the discrimination, deliberate or unintentional, that women continue to face.

– Active Intervention

Because leaders have typically been male, the image of the leader is still often associated with stereotypically male attributes. There is a prevalent view in many companies that the "ideal worker" is someone who is always available and present. Studies show that hidden bias against female job candidates—by both men and women—is deeply ingrained and persistent.

Many big companies have instituted "unconscious bias" training to raise awareness and try to eliminate these tendencies that work against women. Other active interventions are needed, including quotas or targets, to force change where resistance is greatest.

This requires a shift in thinking. Why settle for targets of 25% or 30%, when women are half the population? Why not 50-50, all the way through from graduate hires to the executive board? Companies should demand that their search firms look more widely and deeply, and that their recruitment teams and interview panels mirror the reality of the modern workforce. Only with persistent pressure will they find, and keep, the new leaders and the different perspectives they need for future success.

The shift in thinking has to extend, too, to working patterns and career paths. What does success look like in a company? Is it predicated on serving time, demonstrating "commitment" by putting in long hours, and following the traditional unbroken career path taken by corporate men in the twentieth century? If so, there's a serious risk that the best talent will go elsewhere. Today's most progressive companies are not treating flexibility as the exception—they are regarding it as the norm, for everyone.

– Transparency

It is hard to make further progress without knowing where women are—and where they are not—inside an organization. Without clear data that no one

can dispute, the arguments for action may not be taken seriously. Collecting the evidence is the first step. Calculating the very real risk of losing (or failing to make best use of) the talent that is available must then be the follow-up. Transparency is a powerful stimulus to change.

Technology, combined with human creativity, is enabling new applications of transparency. The Gender Map™ mentioned at the start of the chapter allows users to compare economies and industry sectors (consumer services and utilities are best for women, while oil and gas and basic materials are worst) and to check the composition of the board of any one of 14,500 companies around the world with a couple of clicks.

> Companies have focused their "gender diversity" efforts increasingly on top talent, and it has distracted attention from even bigger gender divides

However, large-scale comparisons are typically limited to data that is already publicly available. To make real headway, transparency needs to include the gender split at all levels in a company, as well as information about pay rates and how promotions are decided. The problem is that this information, if collected at all, is often tightly protected. So a shift to greater transparency depends on a few courageous companies in each sector taking the lead.

Social media are playing a growing role as companies are "named and shamed" for having few or no women in their senior teams or boards. Yet the workforce and leadership of the tech sector itself is still heavily male-dominated. In mid-2014, Google published its data on women and ethnic minorities after pressure from activists, saying that it had to do better. In a blog post, the company admitted: "We've always been reluctant to publish numbers about the diversity of our workforce at Google. We now realize we were wrong, and that it's time to be candid about the issues."[39] Other leading tech companies fell into line and published too.

– **Tackling the Biggest Divides**

I have argued that the spotlight that shines on the composition of boards and top teams in the world's biggest companies is a narrow one by which to grasp the full state of gender and power in twenty-first-century business. I have demonstrated the increasing influence of women across the changing business landscape, and the imperative facing companies and governments to ensure that women can play their full part in the economy.

It all started with the fight for equality. In the ensuing years, however, companies have focused their "gender diversity" efforts increasingly on what is described as top talent—the boardroom and the pipeline to the executive suite. While this is understandable, it has distracted attention from even bigger gender divides.

Gender segregation of jobs remains a major stumbling block to equality. Millions of women are concentrated in low-paid and often insecure "support" jobs such as cleaning, caring, and catering. Frances O'Grady, the first woman to head the British Trades Union Congress, has raised this as a serious moral issue, saying: "I sometimes wonder what it says about our economy and society when the skill of repairing a car is considered many times more valuable than that of caring for a child."[40]

There are other vast divides, too, such as the lack of internet access faced by many women in the developing world. Some 200 million fewer women than men are online today. In many regions, this gender gap amplifies existing inequalities between the sexes.[41]

Such divides present challenges as well as opportunities for governments, societies, and companies to address together—through investment in higher skills, persuasion, and imaginative breakthroughs. By giving women financial and educational opportunities, societies and economies derive great benefits.

Achieving balance in positions of power and influence across the business world, and across the world more widely, is an essential step forward. Ultimately, however, the gender power shift that is starting to happen in twenty-first-century companies will be an indisputable triumph for economic and social progress if it enables women at every level to rise to their true potential.

Notes

1 <http://gendergap.com/gender-map>

2 <http://ec.europa.eu/justice/gender-equality/gender-decision-making/index_en.htm>

3 Global Gender Balance Scorecard 2014 <http://20-first.com/wp-content/uploads/20-first-2014-Global-Gender-Balance-Scorecard.pdf>

4 A. Wittenberg-Cox and A. Maitland, *Why Women Mean Business* (Chichester: John Wiley, 2009).

5 "The Bottom Line: Corporate Performance and Women's Representation on Boards (2004-2008)," Catalyst report, March 1, 2011 <http://www.catalyst.org/knowledge/bottom-line-corporate-performance-and-womens-representation-boards-20042008>; McKinsey, Women Matter research <http://www.mckinsey.com/features/women_matter>

6 "Gender Diversity and the Impact on Corporate Performance," Credit Suisse Research Institute report <https://www.credit-suisse.com/ch/en/news-and-expertise/research/credit-suisse-research-institute/news-and-videos.article.html/article/pwp/news-and-expertise/2012/07/en/does-gender-diversity-improve-performance.html>

7 "The CS Gender 3000: Women in Senior Management," Credit Suisse Research Institute report <https://www.credit-suisse.com/ch/en/news-and-expertise/research/credit-suisse-research-institute.html>

8 Interview with author

9 A. Maitland, "Future Looks Bright as Flexibility Increases," *Financial Times*, April 19, 2012.

10 The Conference Board CEO Challenge 2014 <https://www.conference-board.org/press/pressdetail.cfm?pressid=5055>

11 "Male Business Leaders Champion Best Practice for Gender Equality," Australian Human Rights Commission, October 12, 2011 <http://www.humanrights.gov.au/news/stories/male-business-leaders-champion-best-practice-gender-equality-2011-news>

12 M.J. Silverstein and K. Sayre, "Women Want More: A Revolutionary Opportunity," BCG *Perspectives*, September 8, 2009 <http://www.bcgperspectives.com/content/articles/consumer_products_marketing_sales_women_want_more_excerpt>

13 D. Aron, "The Future of Talent Is in Clusters," *Harvard Business Review* Blog Network, February 1, 2013 <http://blogs.hbr.org/2013/02/the-future-of-talent-is-in-clusters>

14 A. Maitland and P. Thomson, *Future Work: Changing Organisational Culture for the New World of Work* (Basingstoke: Palgrave Macmillan, 2014) <http://www.futureworkbook.com>

15
Edelman Trust Barometer <http://www.edelman.com/p/6-a-m/2014-edelman-trust-barometer>

16
L. Tost, F. Gino, and R. Larrick, "When Power Makes Others Speechless: The Negative Impact of Leader Power on Team Performance," *Academy of Management Journal*, 56 (2013), 1465-1486 <http://amj.aom.org/content/early/2012/09/04/amj.2011.0180.abstract>

17
"After the Baby Boomers: The Next Generation of Leadership," Odgers Berndtson and Cass Business School report <http://www.odgersberndtson.com/en/after-the-baby-boomers>

18
"Leadership After the Baby Boomers," Cass Business School, Cass Talks, Episode 158, May 8, 2013 <http://youtu.be/1_FenZcBeeI>

19
A.W. Woolley et al., "Evidence for a Collective Intelligence Factor in the Performance of Human Groups," AAAS *Science*, 330 (2010), 686-688 <http://www.sciencemag.org/ntent/330/6004/686.abstract>

20
A. Kleiner, "Thomas Malone on Building Smarter Teams," *Strategy + Business*, May 12, 2014 <http://www.strategy-business.com/rticle/00257?pg=all>

21
Interview with author

22
Power Part Time List <http://timewise.co.uk/power-part-time>

23
State of Women-owned Businesses Report, American Express OPEN Forum <https://www.americanexpress.com/us/small-business/openforum/keywords/state-of-women-owned-businesses-report>

24
"Women and the Web," Intel <http://www.intel.com/content/www/us/en/technology-in-education/women-in-the-web.html>

25
"My Business: Egyptian Mothers on the Net," BBC News, February 1, 2012 <http://www.bbc.co.uk/news/business-16824208>; N. Syeed, "Egyptian Entrepreneur Quits IT Job to Start SuperMama," *Women's eNews*, April 6, 2014 <http://womensenews.org/story/preneurship/140405/egyptian-entrepreneur-quits-it-job-start-supermama#.U_4sOyjrR8N>

26
"Unlocking the Female Economy: The Path to Entrepreneurial Success," Barclays white paper, January 2013 <https://wealth.barclays.com/en_gb/home/research/research-centre/white-papers.html>

27
<http://www.gemconsortium.org>

28
Interview with author

29
"Women at the Wheel: Do Female Executives Drive Start-up Success?" (Dow Jones VentureSource)

30
<http://www.illuminate.com/whitepaper>

31
A2A: Analyst to Angel <http://www.analysttoangel.com/2013/11/investing-in-women-entrepreneurs-with.html>

32
<http://www.internationalbusinessreport.com/Reports/2014/IBR2014_Women_in-buisness.asp>

33
J. Horan, "Leaning in Differently in Asia," Today online, April 3, 2013 <http://www.todayonline.com/commentary/leaning-differently-asia>

34
<http://www.gemconsortium.org>

35
W. Wang, K. Parker and P. Taylor, "Breadwinner Moms," Pew Research Social and Demographic Trends, May 29, 2013 <http://www.pewsocialtrends.org/2013/05/29/breadwinner-moms>

36
D. Ben-Galim and S. Thompson, "Who's Breadwinning? Working Mothers and the New Face of Family Support," IPPR, August 4, 2013 <http://www.ippr.org/publications/whos-breadwinning-working-mothers-and-the-new-face-of-family-support>

37
E. Galinsky, K. Aumann, and J.T. Bond, *Times Are Changing: Gender and Generation at Work and at Home* (New York: Families and Work Institute, 2011).

38
<http://www.modernfatherhood.org/blog/earning-mothers-or-caring-fathers-why-convergent-gender-roles-are-best-for-families>

39
<http://googleblog.blogspot.co.uk/2014/05/getting-to-work-on-diversity-at-google.html>

40
Speaking at "Women in Leadership: What Needs to Change?", St Paul's Cathedral, London <http://youtu.be/WFF3-7go41Q>

41
"Women and the Web," Intel <http://www.intel.com/content/www/us/en/technology-in-education/women-in-the-web.html>

Implications of the Revolution in Work and Family

Stewart D. Friedman

Professor Stewart D. Friedman sees us in the midst of a revolution in gender roles, both at work and at home, as the context for major life decisions about careers and families has changed for young business professionals. Friedman has examined the radical shifts in young people's values and aspirations about careers and family life to find out what we need to do to ensure a brighter future for them and for subsequent generations.

He starts from the premise that we need to continue replacing the human population; that children will still need caregivers to lovingly care for, educate and support them, both financially and emotionally, as they grow; and that we must continue to build a society that is ripe with opportunity and choice for both men and women. Also for those people who want to become parents, it is essential for society to make it easy enough for them to foresee how they can realize this wish. Organizations and social institutions have an important role to play cultivating an increasingly adaptable and productive workforce that can both compete in the global economy and raise the next generation. He concludes by saying all of this must come together in order to empower individuals to create sustainable change, with a particular emphasis on the challenges and opportunities for the future.

Stewart D. Friedman
The Wharton School, University of Pennsylvania

Since 1984 Stew Friedman (PhD, U. Michigan) has been at Wharton, where he is the Practice Professor of Management. In 1991 he founded both the Wharton Leadership Program and the Wharton Work/Life Integration Project. In 2001 he concluded a two-year assignment at Ford, as the senior executive for leadership development. Stew is the author of several books, among them the award-winning best seller, *Total Leadership: Be a Better Leader, Have a Richer Life* (2008). His latest book is *Leading the Life You Want: Skills for Integrating Work and Life* (2014). His Total Leadership program is used worldwide. He was chosen by *Working Mother* as one of America's 25 most influential men to have made things better for working parents, and by *Thinkers50* as one of the "world's top 50 business thinkers." The Families and Work Institute honored him with a Work Life Legacy Award. He was selected as one of 2014's top 10 HR Most Influential International Thinkers. His Twitter account is @StewFriedman.

Key Features for the Company of the Future:

Set Clear Goals
And promote flexibility and provide support for childcare. Establish clear and measurable goals and give as much flexibility as possible as to where, when, and how the work is conducted. Recognize that employees' compensation is not just in the paycheck but, especially for Millennials, also in the control of their time. In addition, private-sector leaders should encourage government sponsorship of excellent childcare.

Make Work Meaningful
Connect work to social benefits, either by providing more direct feedback from clients about the value of a firm's services or undertaking other initiatives to serve some charitable aim. Young people today want to have a positive social impact through their work. If their jobs resulted in greater social impact and made more use of their talents they might not feel the need to split time between work and civic engagement.

Encourage Slow Careers
By providing models and encouragement for alternative paths, employers should demonstrate that it's acceptable to off-ramp and then on-ramp—for young men and women during the childbearing years, for older workers when they need to care for aging parents, and for all workers who need to take time off for any number of reasons. This is how we retain talented Millennials and experienced senior employees.

Implications of the Revolution in Work and Family

We are in the midst of a revolution in gender roles, both at work and at home. And when it comes to having children, the outlook is very different for those embarking on adulthood's journey now than it was for the men and women who graduated a generation ago. I recently published research, conducted under the auspices of the Wharton Work/Life Integration Project,[1] comparing Wharton's Classes of 1992 and 2012. One of the more surprising findings is that the percentage of Wharton graduates who plan to have children has dropped by about half over the past twenty years. It's worth noting that these percentages are essentially the same for both men and women, both in 1992 and in 2012. The reality today is that Millennial men and women are opting out of parenthood in equal proportions. This change in Wharton students' plans for parenting is part of a larger trend: a nation-wide baby bust that has implications for families, for society and for organizations.

The context for major life decisions about careers and families has changed for young business professionals. Where do we need to go from here—as a society, in our organizations, as individuals, and in our families—in the midst of what surely is a time of revolutionary change in gender roles, family structure, and career paths? What do the radical shifts in young people's values and

aspirations about careers and family life tell us about what we need to do to ensure a brighter future for them and for subsequent generations?

There are a few imperatives on which I don't think many will disagree: we need to continue replacing the human population, and children will still need caregivers to lovingly attend to them, educate them, and support them, both financially and emotionally, as they grow. We must continue to build a society that is ripe with opportunity and choice for both men and women. And for those people who want to become parents, it behooves us as a society to make it easy enough for them to foresee how they can realize this wish. We need our organizations and social institutions to cultivate an increasingly adaptable and productive workforce that can both compete in the global economy and raise the next generation.

The percentage of Wharton graduates who plan to have children has dropped by about half over the past twenty years

Our current capacity to meet these challenges is cause for serious concern. Yet there are reasons for hope, too. We observed that young people are not including children in their future plans for a complex web of reasons. So there is no one solution; partial answers must come from various quarters. In this chapter, I'll offer recommendations based on what we found and what others have learned. I'll begin with ideas for action in social policy and education, and then describe what organizations can do. I'll next describe a model for empowering individuals to create sustainable change, with a particular emphasis on the challenges and opportunities faced by men who are aiming to lean in at home and win in their careers, as so much is already written by, for, and about women. I'll close with a few thoughts about new conceptions of family life. But first, a quick review of our major findings.

Highlights of What We Discovered

We found evidence of increased freedom and possibility as both men and women feel less constrained by gender role stereotypes. But we also observed significant challenges for Millennials who value parenthood but don't see a clear path toward it.

The Millennials in our study reported that work is consuming more and more of life. And both their family and career aspirations were lower than those of their Gen X counterparts. They described pressure to conform to a narrow set of career paths, a finding that runs counter to what's being observed in the careers of MBA students,[2] who are moving toward

entrepreneurial ventures. I suspect that this shift among MBAs is in part a reaction to the limited options for meaningful and flexible work that many young people encounter in the standard post-undergraduate tracks. By their late twenties, young adults may come to realize that they want something more from their careers and they are able to assume greater control over their decisions than they were at the age of twenty-two.[3]

We observed, as others have,[4] the constraining effects of economic pressures on whether to have children (for men) and when to have them (for women). We also saw that men's plans for having children are shaped by their anticipation of future conflicts between work and family life, and that as their expectations of such conflicts have grown over these past two decades, their family ambitions have plummeted.

At the same time, we found that today's young people, and especially women, more so than in the past, planned to invest their energy in the social sphere, by addressing societal problems and by forming networks of friends and fellow professionals. While young women continue to value parenthood, many are expecting to find fulfillment through other means. Young women who highly valued their health were disinclined toward parenthood. And the increasing proportion of women identifying as agnostic is another factor linked to reduction in plans for children. Further, young women now expect to be respected, want more time for their personal lives, and are more knowledgeable about what it takes to advance in their lives beyond the home.

All told, there is a greater freedom for women to pursue paths that are uniquely meaningful to them, ones not prescribed by tradition or inherited norms. They're not locked into motherhood and seem better prepared now to forge their own paths.

Yet women we surveyed in 2012 were also more willing to accept either unequal career involvement in their relationships with life partners or no children at all because, as a number of them reported, they are aware (more than their Gen X counterparts seemed to have been) that someone needs to be with children when they are young. While much has been written about Gen X women opting out of their careers, we found that Millennial women are planning instead to opt out of motherhood. As many have decried, however, the so-called opting-out phenomenon may not actually be a choice, but rather an indication that we are providing neither the sustainable career pathways nor the childrearing supports women, and men, require to pursue rich and full work and family lives.

Young women now expect to be respected, want more time for their personal lives, and are more knowledgeable about what it takes to advance in their lives beyond the home

While gender-stereotypical differences between women and men about family and dual-career relationships persist, today's young men expect to see women as peers in the workforce, see engaged fatherhood as a way of contributing to society, and are increasingly cognizant of the impending difficulties in resolving conflicts between work and family life. They want flexibility as much as or more than women do.[5] Men's new awareness of and interest in the fullness of family life is a boon to women and children both.

Our study showed that men and women are now more aligned about deciding who in a dual-career relationship should "lean in" to their careers and when they should do so. And because they expect greater parity in career opportunities and commitments, Millennial men are increasingly motivated to experiment with new models for how both partners can have more of what each wants in life. Indeed I could write an entire book, with new material cropping up daily, about the young, highly educated men who are writing about being stay-at-home dads or about their experiences with paternity leave. Twenty years ago there was wide divergence between men and women; now there's more agreement about what it takes to make long-term relationships work. This convergence of attitudes promises greater collaboration and mutual support.

So, what does all this mean for what we should do now?

Strengthening the Infrastructure of Support through Social Policy and Education

As a commonwealth, we need to focus on what children in our society need: nurturing. How can they get it if the new norm is that both parents work and that we, unlike other developed countries and even many in the developing world, do not provide governmental and social supports for families? At present the US government spends less and less on our children.[6] Our social policies must evolve to catch up to new realities: women are in the workforce outside the home, men are conflicted about how to have rewarding careers and rich family lives, and children—"the unseen stakeholders"[7] at work—still need love and attention to thrive. Student debt is crushing the dreams of too many young people. They need relief from the astronomical and unsustainable cost of higher education. Our nation's youth are eager to serve society, but we don't provide a structure with incentives for national service. Indeed, those who want to pursue socially significant work anticipate that they will not be well remunerated; we as a society are not valuing service. What follows are actions we can and should pursue now.

– **Provide World-Class Childcare**
Children require care, yet the United States continues to rank among the lowest in the developed world in the quality of the early childhood care we provide.

Just as bad, the K–12 education we offer also falls short of our aspirations and of global norms. A massive overhaul could start with labor market compensation practices, which are now based on the principle that the closer one is to diapers, the lower one's pay. A more forward-thinking approach would be at least to reduce this ratio, with all the training and licensing requirements that would be needed to justify much higher rates of pay for those who care for our youngest citizens, arguably our most precious resource. Although this has not been a panacea in European countries, it does support the desires of our young people to become parents and also have careers.

– **Make Family Leave Available**

Family leave, including paternity, is essential for giving parents the support they need to care for their children. Right now, only 11% of US employees receive paid family leave from their employers.[8] The one public policy that covers time off to care for new children, the Family and Medical Leave Act, laudable though it is, still excludes 40% of the workforce. And millions who are eligible and need leave don't take it, mainly because it's unpaid, but also because of the stigma and real-world negative consequences.

We need to expand who's eligible for FMLA and to make it affordable. Family and medical leave insurance funds such as the ones established in California and New Jersey and elsewhere, where employees pay a small amount into an insurance pool and can then draw wages while on leave, would make a huge difference in the lives of parents and children.[9] Such laws alter the frames of reference for decisions about flexible work policies and practices, making them more normative and legitimate, and as researchers Shelley Correll, Joan Williams, and others have observed, this helps to reduce the flexibility stigma.[10] I talk about this later, under "Changing Organizations." Many Millennials value parenting but can't see how to make it work. Flexibility without penalty will help.

– **Support Portable Health Care**

Given the increasing rates of interfirm mobility in our labor markets and the rising costs of health care, working parents benefit greatly from health care policies and practices that don't punish them for taking time off or moving. The Affordable Care Act is a step in this direction. It will help families obtain needed care while avoiding crippling debt as both parents might now have to navigate careers in which they move from job to job. Our data revealed that if young people are to plan for children, they will need more support than they currently expect to receive.

– **Relieve Students of Burdensome Debt**

Skyrocketing interest rates on student loans and the increasing cost of higher education result in debt burdens that are too onerous. Our findings indicated

that too many young people simply can't envision a future in which they can afford to support children. This must be changed.

– Revise the Education Calendar

The standard school day is based on an outdated schedule. Other industrial and Western countries have children in schools for longer days and for a greater part of the calendar year. This provides much-needed support for working parents and, of course, greater enrichment for our children. The data from our 2012 sample indicated that though young people value parenting, they are struggling to envision how to make it work. This is another front on which the public sector can provide help.

– Require Public Service

The increasing emphasis on careerism doesn't mean that young people don't also want to do work that helps others. They do, despite their expectation that they will not be well compensated for it. But how do we as a society channel that enthusiasm and idealism? We could require a year of public service for post-secondary school youth, as is the case in some European countries. Professors of graduate students regularly observe that those who have served in the military (in the United States or abroad) are, as a rule, better organized, more serious about their studies, more conscious of their responsibilities as leaders, and generally better prepared to make decisions. Requiring some sort of service may improve our workforce and help all of us recalibrate what's really important.

– Display a Variety of Role Models and Paths

This might be an antidote to our finding that career paths have narrowed because students believe they must earn money quickly and that only a few career paths offer that option. The more that boys and girls hear stories about the wide range of noble, and economically viable, roles they can play in society, the easier it will be for them to choose freely the roles they are best suited for and want to play as adults. Young adults would benefit from opportunities to explore as wide an array of career alternatives as possible.

– Teach Young People How to Lead Their Lives

In both primary and secondary schools, boys and girls can be taught how to discover who they really want to be, and they can start to practice the skills they will need to fulfill their aspirations. In college, an increasing number of courses teach young men and women how to think about what's important and what success in life means to them; about their roles and responsibilities to society and in the different parts of their lives; and how to integrate them in creative ways, including how to harness the power of new technologies for communication while maintaining room in one's life for meaningful

in-person interaction. Placing greater emphasis on such training would enable young people to make more informed choices and would likely strengthen their resolve and their success in pursuing their aspirations. We have seen that religion has become less important in the lives of these young people, but it has not yet been supplanted by another lens through which we can view what really matters in life.

Changing Organizations

Frustration at not being able to pursue a career and a family—a condition many young people reported—may compel unfulfilled employees to leave an organization. This, too, has to change, and it can. Organizations have many possible routes for helping Millennials, as well as others, while adding to the bottom line. Smart organizations have already recognized that they benefit from doing so through increased productivity, engagement, health, and retention of talent.[11] The best interests of companies competing in the marketplace for talent are served by demonstrating a true embrace of work arrangements customized by and for each individual—Millennial or otherwise.[12]

Naturally it's easier for anyone to try something new if there are role models in the organization who've shown by example that there are various ways to succeed, if there's demonstrated commitment from top executives to trying new ways of contributing to the organization's goals while devoting real attention to the other parts of life, and if there are stories being told of others who are similarly engaged in experimenting with flexible means for achieving results.

Millennials want work with meaning, but they also want and need more flexibility—without which they can't imagine a rich life beyond work—and greater control over how they spend their time.[13] And they are not alone in these desires. Gen X women who have opted out are also calling for greater flexibility.[14] Others are as well. Here are ideas for actions employers can take that embrace these realities and support employees' development as valued assets to businesses:

– **Set Clear Goals Pursued by Flexible Means**
Establish clear and measurable goals and expectations and give as much flexibility as possible as to where, when, and how the work is conducted. Recognize that employees' compensation is not just in the paycheck but, especially for Millennials, also in the control of their time.[15]

– **Declare That It's Not for Women Only**
We don't need more initiatives that serve only to ghettoize work and family considerations as "women's issues." Men may be even more affected by

conflicts between work and family.[16] Frame non-work needs and interests, and all other family arrangements, as affecting not only mothers, but also fathers and single people.

- **Provide Support for Childcare**

Organizations should offer both regularly scheduled and emergency backup care. More important, for all businesses to be able to afford it, private-sector leaders should encourage government sponsorship of excellent childcare for all Americans, just as we have state-provided kindergarten and just as other first-world countries provide these types of family-friendly supports.

- **Make Work Meaningful**

Connect work to valued social benefits, whether this means providing more direct feedback from customers and clients about the value of a firm's services or products, or undertaking other initiatives to serve some charitable aim.[17] Compared to the past, young people nowadays want to have a positive social impact through their work.

As we've seen, young women who want jobs that will allow them to serve others are less likely to plan to have children. If their jobs were more fulfilling—that is, if they resulted in greater social impact and made more use of their talents—these women could pursue their career and social goals in one and the same role. They might not feel the need to split time between work and civic engagement, because working hard in their careers would mean progressing toward the goal of positive social impact. Being better able to pursue their career and social goals might give them room to have children, if they so desired. And of course, young women and young men are not the only ones who want meaningful work; we all do.[18]

- **Show How Children Can Benefit from Having Working Parents**

As journalist Lisa Belkin has pointed out, Millennial women have been inundated with messages about "opting out" and the difficulties of juggling career and family. What these conversations are missing out on is this: careers can enhance family life, and family life can enhance careers; there is a way to weave both into a rich, strong tapestry.[19] A focus on the positive spillover effects of working parenthood may mean that fewer women will feel they must choose between personal and professional success and fewer men will allow fears of work-family conflict to inhibit their plans for fatherhood.

Young people need more positive examples. They need to hear loud and clear about executives such as John Donahoe, CEO of eBay, who leaned back to share in the care of his children; or Richard Fairbank, CEO of Capital One, who had his young children go to afternoon kindergarten in order that they would be able to stay up late enough for him to see them, and who coached

and played every sport in which his eight children participated, all while pursuing a high-powered career. We need to let ambitious young people know that Double Dutch (jumping two ropes at once) is not only possible; it's fun.

- **Learn to Manage Boundaries and Change the Culture of Overwork**

We're still at the start of the digital age, and we're just beginning to learn how to harness the power of technology and live in a hyperconnected world. Many people, not just Millennials, feel overwhelmed, and they need help, which smart businesses can provide, mainly by experimenting with what forms of communication work best and for what purposes.

Young people in our study expected to work fourteen more hours per week more than their 1992 counterparts, and they associated these longer work hours with greater conflict between work and life. How to break this cycle? Reduced hours would help to retain Millennials and allow them to live rich lives outside work.[20] One avenue is through regulation. Another is through the encouragement of norms about boundaries between work and the rest of life. In too many workplaces and industries, long hours are still seen as a badge of honor. Changing these traditions can be accelerated by such programs as those described by Harvard professor Leslie Perlow, which give teams the tools for organizing their work so that members can have predictable time off.[21] Then tell the stories of successful alternatives to the standard model to make a range of such alternatives legitimate and culturally acceptable. End the glorification of the work warrior. Of course, saner work hours are better for all employees, not just Millennials. They are not the only ones experiencing the strain of overwork.

- **Fight the Flexibility Stigma**

Many organizations do provide "family-friendly" programs of one sort or another. Yet employees in non-standard work arrangements aren't seen in the same way as those who are,[22] to the detriment of much-needed innovations in how, when, and where work is accomplished. Too often those who manage workplace policies designed to be friendly to families inform parents about eligible leaves, then directly or indirectly question their dedication and commitment to the firm when they take advantage of those policies. Sharing the stories, far and wide, of admirably successful alternatives to the standard track must be part of the solution. We must create new norms and fight the flexibility stigma. To this end, slow careers may be a significant part of the solution.

- **Slow Careers**

The slow movement (applied most famously to food) is about appreciating the value of basic human needs for connection and reflective living. Three decades ago, in 1980, organizational psychologist Lotte Bailyn wrote about the "slow burn way to the top,"[23] the benefits of which include normalization of

alternative career paths; specifically slowing down during prime childrearing years without career penalties, and then ramping up again as children mature. Employers should demonstrate that it's acceptable, even desirable, to off-ramp and then on-ramp—for young men and women during the childbearing years, for older workers when they need to care for aging parents, and for all workers who need to take time off for any number of reasons. By providing models and encouragement for alternative paths[24]—and perhaps organizing work according to a series of projects rather than based on static positions—organizations can signal to employees that their job security is not affected by their having children. This is how we retain talented Millennials and experienced senior employees, and truly support our young families. Creating a variety of possible career paths is also a way of attacking the flexibility stigma.

Giving Individuals the Tools and Support to Choose the Lives They Want

Societal and organizational assistance is essential, but individuals, too, can be empowered and taught how to find solutions that work for them and also how to gain the support they need to achieve the lives they want to live. The central observation of our study is that not all young people today feel compelled to plan for children. For some, this represents an unfortunate constriction of their life goals—they want children but don't see how they can manage it. For others, not having children is what they truly want, at least at this phase of their lives, and thus represents a new liberation from outdated and constraining gender stereotypes.

In either case, it's critical that we focus on what can be done to help young people pursue their true interests with passion and confidence. If they are helped to see how they can realistically bring a sense of purpose to their careers and find the time, space, and support in their lives for all their aspirations, possibly including children, without having to suffer the unbearable conflict between work and the rest of their lives that many of them now foresee, then perhaps more of those who want to be a parent at some point will actually plan to become one.

Providing this kind of help begins with the recognition that one size cannot fit all. Solutions customized by and for individuals to meet their specific needs and interests must be the order of the day. Fortunately, there are proven methods now available that are applicable not only to the problems facing Millennials but for people at all life stages. Let me tell you about one such method.

In the 1990s the Wharton Work/Life Integration Project researched best practices for how people effectively pursue the ideal of aligning their actions with their values, in all parts of their lives. Out of this field research evolved three simple principles:

- Clarify what's important to you—your values and vision.
- Recognize and respect all domains of life—work, home, community, and self.
- Continually experiment with how goals are achieved.

At Ford Motor, where I was head of leadership development between 1999 and 2001, we successfully implemented a systematic process, Total Leadership, grounded in these principles. We designed a series of exercises that culminated in practical, individualized experiments designed to produce "four-way wins": improved performance at work, at home, in the community, and for the private self (mind, body, spirit). Our goal was to help individuals overcome the fear and guilt that inhibited them from taking action to make things better for themselves as individuals, *and* for their families, *and* for our business, *and* for their communities. There was no *or* in this equation; it was all *and*.

Here's how it works. You articulate your values and vision for the future and then identify the most important people in the different domains of your life. You clarify mutual expectations in dialogue with these stakeholders, strengthening trust in the process. You think like a scientist and design experiments intended to produce four-way wins. Then you implement a couple of these experiments, measure their impact in all four domains of life, and, finally, reflect on what was learned from trying something new.

The Total Leadership process is grounded in these principles: clarify what's important to you, recognize and respect all domains of life and continually experiment with how goals are achieved

The key is that for each experiment, there are consciously intended benefits at work, at home, in the community, and for the private self—and some way to measure progress toward these benefits in each of the four domains. This is different from standard flex-time approaches where you ask your employer to give you something you want.

The usual result of such experiments is that people shift some of their attention from work to other parts of their lives and—in what seems paradoxical—they see improved performance at work and in the other domains because of greater focus, with less distraction, on the people and projects that really matter. They feel a greater sense of meaning and purpose, greater support for pursuing goals that matter, and more optimism about the future. Whether or not the experiments succeed, after reflecting on what works and what doesn't, they generate insights about how to create change in their lives that is sustainable, because such changes are actively and intentionally planned to produce benefits for all

the different stakeholders in all domains of life. The most critical outcome is greater confidence and competence in their ability to initiate positive change. There's a shift in how they think about what's possible. They are less afraid to try new ways to make it all work. And this is why this model is not only sustainable, but also contagious! And because it's entirely individualized, it's applicable to any life circumstance; this is not just for Millennials.

With students (undergraduates, MBAs, and executives) and in a wide array of organizations since 2001, we have found that, when given the chance, people are eager to take up the challenging task of experimenting with new ways to braid together the strands of their lives. And they're able to muster the courage and support to do so because they believe that the purpose of their initiatives is to make things better not just for themselves, not just for their families and communities, but for their organizations, too. This not only helps them overcome fear and guilt, but also buffers them against the flexibility stigma, because experiments are undertaken with the intent of achieving demonstrably improved performance at work. This is neither a perk nor a favor the company is doling out. Just the opposite: it's a boon to firm performance.

This approach directly addresses the needs we observed in Millennials to have work that is meaningful, to lead social lives that are rich, and to have flexibility and control in weaving a coherent tapestry. And of course this isn't the only proven approach to have emerged in the past decade.[25]

So instead of first thinking about workplace flexibility as a program that one might want to somehow take advantage of, what is needed is a fundamentally different mind-set, with the individual asserting control and thinking, "This does not have to be a zero-sum game." The biggest hurdle to adopting this kind of method is the common construction "work/life balance."

As I've been arguing for decades, this term is retrogressive because it compels one to think automatically about conflict and trade-offs rather than encouraging creative thinking about practical ways of making life better in all its different parts.

Men Leaning In at Home

Much has been written already about how to help women succeed at home and at work, but men must be as much a part of the story as women. That's why I'm devoting this section to men. However you slice it, it's essential to have men's partnership in creating new alternatives—whether as stay-at-home dads, dads with extensive paternity leaves, or dads sharing care—and also in increasing their ownership of domestic responsibilities.

My subversive mission in creating the Total Leadership model was to provide the language and tools that men could use to address directly their

particular challenges in integrating work and the rest of life without feeling they were doing the "women's work" of "finding balance." This is critical still, especially in light of how, as we observed, gender role stereotypes linger in this period of transition.

The key words in this model were not *work/life*, *work/family*, and certainly not *balance*, but rather, *leadership*, *performance*, and driving change to produce *results*—words that convey the idea that this business is not for women only. And it worked. This language makes it easier for organizations to gain acceptance for using this approach to help people—men and women, at all career stages and all levels—learn what they can do personally to create meaningful, sustainable change that increases their productivity at work and their commitment to their work, and improves their lives beyond work.

Men today expect to make bigger contributions to their households than their fathers did,[26] and the anticipation of conflict between home and work has increased. Just as women need support from their organizations and their families to surmount the hurdles of fear and tradition that keep them from achieving, men, too, need help getting past the roadblocks that keep them from engaging more fully as caregivers and homemakers. Breaking the mold of deeply rooted gender stereotypes won't be easy, because men face substantial barriers at work, in their homes, in their communities, and inside their own heads.[27] But for their fulfillment, and for women to advance in the world of work, men must advance in the world of home. The good news is that when men find smart, creative ways to dive in at home, they also perform better at work.

> **Men today expect to make bigger contributions to their households than their fathers did, and the anticipation of conflict between home and work has increased**

Traditional gender stereotypes are prisons for men, too, and hold many men back from trying new approaches to work and family life.[28] Like women, men are penalized for requesting or enacting flexible schedules. Men may wonder, "What if I'm just not a good dad? What if I'm perceived by my friends as unmanly because I'm doing 'women's work'? What if my children see me as a poor role model because I'm not the breadwinner?" There is a whole new industry of stay-at-home dad (SAHD) bloggers; websites, books, and articles by and for SAHDs; and gatherings where they explore in nuanced and poignant detail what they are struggling with, and reveling in, as they try to weave a new fabric that combines breadwinning and caregiving.[29]

So how does a man garner the courage to act, despite these worries and real-world impediments, and get his boss and coworkers to encourage him to have breakfast with his family, leave work in time to pick up the kids at school, take

paternity leave, and be truly focused on his family when he's with them instead of constantly checking his digital device about work matters? How can a man ask for the help he needs to sustain his involvement with his family and his work? And how does he enlist his family to support him in taking a more active role at home so that they see it as a benefit, not a nuisance, to them? In short, how can we help empower men so that they can foresee both manageable and, indeed, rich family and work lives even in unsupportive work environments?

First, think about what really matters to you and figure out what's not working and what you wish you could do to ameliorate the situation. In what ways are you failing to act in accordance with your values? What if your spouse or partner is unhappy with your lack of engagement and availability? If you're a father, do you feel that you're missing out on your kids' childhoods? Are you distracted by work when you're with your friends or at home and distracted by concerns about your family when you're trying to work? Asking these kinds of questions often produces these kneejerk reactions:

- There is no solution that will work because my boss would never go for changes.
- I can't ask for something that's just for me and my family because it's selfish.
- I know I'm not happy, but I don't see how things can improve, short of my leaving the job.

To get to the next step, it helps to find a peer coach (or two)—someone preferably outside of your immediate work circle—to talk to about what you're thinking. I have never seen anyone voice a problem for which someone else, with a fresh perspective, could not find new ways of seeing possibilities for positive change.

Then talk to those who matter most to you about what they really expect of you, how you're doing, and what you could do better. More often than not, what we think others expect of us is greater than (or a bit different from) what they actually expect of us. For example, you might think that being at work until very late is seen by your coworkers as a sign of your commitment and great performance when it is actually viewed as an indication of your inefficiency—as in, "Why can't you get your work done faster so that you don't need to be here this long into the night?" Find out exactly what the people who matter most to you need from you. Once you know more about what's actually expected, you're ready for the next step.

Try an experiment, a small change for a brief period (a week or a month) and keep front of mind the benefits not to you—you will not forget those, I promise—but to key people at work and to people you care about in other parts of your life.[30] An experiment is time limited and has measurable outcomes. The proof will be in the pudding, and your colleagues, family, and friends will be the judges. Make it clear that after the agreed-upon duration, if the experiment

is not working for them, then you will return to the status quo, or try something else. No one has anything to lose, and all have something to gain. More often than not, when approached with this goal—to make it a win for all concerned—people around you might surprise you with their reasonableness.

When you invest intelligently in being a better father, or a better friend, or a better marathoner, then you will see how this makes you more confident in your parenting skills, friendships, or your physical condition, for example. The increased confidence spills over into other spheres; you become less distracted at work, more energetic, and have a clearer focus on business and family results that matter. As you grow more confident, you become less anxious about what others might think of you as you do more at home or spend less time at the office. Although the interventions can be fairly simple, the results can be dramatic—productivity usually increases at work because employees are happier and more focused on results that matter while retention increases because employees are more committed to an organization that respects and supports what is most important in their lives.

> **When you invest intelligently in being a better father, or a better friend, or a better marathoner, then you will see how this makes you more confident**

For employers, helping men be more active at home, helping all employees be able to engage in the things that matter most to them, makes good business sense. It's wise to encourage people to engage in dialogues with important stakeholders and to experiment with small changes that can enrich their families, enhance their engagement with their community, and improve their health—all while enhancing the bottom line. By making it easier for men, and women, to live more whole, fully integrated lives, employers indirectly contribute to paving the way for the women in their lives to give more of themselves to their work and careers. And, of course, children win, too. We as a society are all the beneficiaries.

Reimagining Family Life

I don't believe that companies should be in the fertility planning business, but they should care about their employees being happy, if only so they can be more productive and so the good ones don't quit. And while it is essential to consider what businesses can do, in the near term it will be difficult to come up with organizational changes that increase the willingness of young people to become parents. Governmental policy changes can be glacial, and societal norms often evolve slowly.

For those who do want to have children, there is a growing literature that can inform families about how to thrive when both parents are engaged as breadwinner and caregiver.[31] Jessica DeGroot, for example, has led the Third Path Institute's research on models of shared care, providing tools, inspiring examples, and support for families committed to the egalitarian ideal.

Men and women today are more likely than the previous generation to share the same values about what it takes to make dual-career relationships work. One implication of this finding is that there is greater solidarity among men and women and therefore more flexibility about the roles both men and women can legitimately take in society. There is now a greater sense of shared responsibility for domestic life. Young men are realizing they have to do more at home than their fathers did, and today's young men want to do so. The Families and Work Institute's research on the "new male mystique" affirms this trend, as do Brad Harrington's New Dad research at the Boston College Center for Work and Family and Michael Kimmel's decades-long studies of masculinity.

Of course the sharing of care can happen either in series or in parallel, with costs and benefits linked to both options. A clear pattern we observed is that young people are forestalling the arrival of children. Perhaps this foretells a "slow family" movement to coincide with slow-burn careers—a variety of family life models that enable both partners, at different stages of their lives or simultaneously, to engage more or less, depending on their needs and interests, in their families and in their careers.

With more available and legitimate choices for family life, stronger support from organizations, wiser social policy, and greater confidence in their ability to create meaningful change, young men and women can flourish in all the roles that matter to them—at work, at home, and in their communities—in ways we've not yet seen.

> Companies should care about their employees being happy, if only so they can be more productive and so the good ones don't quit

Adapted and reprinted by permission of Wharton Digital Press. The original version appeared as a chapter in Stewart D. Friedman, *Baby Bust: New Choices for Men and Women in Work and Family* (Philadelphia: Wharton Digital Press, 2013). All rights reserved.

Notes

1
For information, visit www.worklife.wharton.upenn.edu.

2
E. Rowe, "More Wharton MBAs Are Opting for Startups," *BloombergNews*, June 25, 2013.

3
R.B. Williams, "The End of Careers as We Know Them: Lifelong and Full-Time Careers Are Disappearing," *Psychology Today*, July 11, 2013.

4
R.F. Elliott and K.R. Zavadski, "Graduating with Debt," *The Harvard Crimson*, October 18, 2012; R. Fry, "Young Adults After the Recession: Fewer Homes, Fewer Cars, Less Debt," Pew Research Social and Demographic Trends, February 21, 2013 <http://www.pewsocialtrends.org/files/2013/02/Financial_Milestones_of_Young_Adults_FINAL_2-19.pdf>; T. Riley, "Average Debt Burden Highest of Ivies, Lowest in R.I.," *Brown Daily Herald*, November 7, 2012; J.E. Stiglitz, "Student Debt and the Crushing of the American Dream," *New York Times*, May 12, 2013.

5
E. Galinsky, K. Aumann, and J.T. Bond, *Times Are Changing: Gender and Generation at Work and at Home* (New York: Families and Work Institute, 2011); M. Berelowitz and N. Ayala, "The State of Men," *JWT Intelligence*, June 5, 2013 <http://www.jwtintelligence.com/wp-content/uploads/2013/06/F_JWT_The-State-of-Men_Trend-Report_06.04.13.pdf>; A. Dembosky, "The Rise of Silicon Dad," *Financial Times*, April 19, 2013; M. Fulcher and E. F. Coyle, "Breadwinner and Caregiver: A Cross-Sectional Analysis of Children's and Emerging Adults' Visions of Their Future Family Roles," *British Journal of Developmental Psychology*, 29 (2011), 330–46; K. Parker and W. Wang, "Modern Parenthood," Pew Research Social and Demographic Trends, March 14, 2013.

6
E. Porter, "Pro-Baby, but Stingy With Money to Support Them," *New York Times*, July 23, 2013; First Focus, *Children's Budget 2013*, Washington, DC <http://www.firstfocus.net/sites/default/files/ChildrensBudget2013.pdf>

7
The term Jeff Greenhaus and I use in *Work and Family—Allies or Enemies?* (New York: OUP, 2000).

8
L. Houser and T. P. Vartanian, *Pay Matters: The Positive Economic Impacts of Paid Family Leave for Families, Businesses and the Public* (New Brunswick: Center for Women and Work, School of Management and Labor Relations, Rutgers University, 2012).

9
E. Appelbaum and R. Milkman, "Leaves That Pay: Employer and Worker Experience with Paid Family Leave in California," Center for Economic and Policy Research, 2011 <http://www.cepr.net/documents/publications/paid-family-leave-1-2011.pdf>

10
J. Williams, S. Correll, J. Glass, and J. Berdahl (eds.), "Special Issue: The Flexibility Stigma," *Journal of Social Issues*, 69, no. 2 (2013), 209–405; C. Goldin and L. F. Katz, "The Cost of Workplace Flexibility for High-Powered Professionals," *The Annals of the American Academy of Political and Social Science*, 638, no. 1 (2011), 45–67.

11
E. Galinsky, J. T. Bond, and E. J. Hill, *When Work Works: A Status Report on Workplace Flexibility: Who Has It? Who Wants It? What Difference Does It Make?* (New York: Families and Work Institute, 2004).

12
J. Blades and N. Fondas, *The Custom-Fit Workplace: Choose When, Where, and How to Work and Boost Your Bottom Line* (Hoboken: Jossey-Bass, 2010).

13
See, for example, T. Erickson, "Gen Y in the Workforce," *Harvard Business Review*, February 2009; K. Foster, *Generation, Discourse, and Social Change* (New York: Routledge, 2013); L. Gratton, *The Shift: The Future of Work Is Already Here* (London: HarperCollins, 2011); A. Maitland and P. Thompson, *Future Work: How Businesses Can Adapt and Thrive in the New World of Work* (New York: Palgrave Macmillan, 2011); and H. Seligson, *Mission: Adulthood: How the 20-Somethings of Today are Transforming Work, Love, and Life* (New York: Diversion Books, 2012)

14
P. Stone, *Opting Out: Why Women Really Quit Careers and Head Home* (Berkeley & Los Angeles: University of California Press, 2007); K. Gerson, *The Unfinished Revolution* (New York: Oxford University Press, 2010).

15
Google famously grants employees a percentage of their paid work time to pursue their own projects, and Salesforce allows four hours per week or six days per year for volunteer work outside the company, on company time.

16
Galinsky, Aumann, and Bond, *Times Are Changing*; and K. Aumann, E. Galinsky, and K. Matos, *The New Male Mystique* (New York: Families and Work Institute, 2011).

17
A.M. Grant, "Leading with Meaning: Beneficiary Contact, Prosocial Impact, and the Performance Effects of Transformational Leadership," *Academy of Management Journal*, 55 (2012), 458–76; B. D. Rosso, K. H. Dekas, and A. Wrzesniewski, "On the Meaning of Work: A Theoretical Integration and Review," *Research in Organizational Behavior*, 30 (2010), 91–127. See Warby Parker, *Neil Blumenthal: Secrets to Warby Parker's Rapid Growth* <http://www.inc.com/neil-blumenthal/neil-blumenthal-warby-parker-secrets-to-rapid-growth.html>

18
C.M. Michaelson, M. G. Pratt, A.M. Grant, and C. P. Dunn, "Meaningful Work: Connecting Business Ethics and Organization Studies," *Journal of Business Ethics*, 121 (2014), 77–90.

19
For example, a Pew study found that working mothers felt slightly better about their parenting than did non-working mothers, and 78% of mothers who worked full or part time said they were doing an excellent or very good job as parents, whereas only 66% of nonemployed mothers said the same (Parker and Wang, "Modern Parenthood").

20
R. C. Barnett and D. T. Hall, "How to Use Reduced Hours to Win the War for Talent," *Organizational Dynamics*, 29, no. 3 (2001), 192–210.

21
L. A. Perlow, *Sleeping with Your Smartphone* (Boston: Harvard Business Review Press, 2012).

22
As Williams, Correll, Glass, and Berdahl, "Special Issue," point out.

23
L. Bailyn, "The 'Slow Burn' Way to the Top: Some Thoughts on the Early Years in Organizational Careers," in C.B. Derr (ed.), *Work, Family, and the Career: New Frontiers in Theory and Research* (New York: Praeger, 1980).

24
M. Alboher, *The Encore Career Handbook: How to Make a Living and a Difference in the Second Half of Life* (New York: Workman, 2013); K.E. Christensen, "Older Workers, Adult Children and Working Longer," *Huffington Post Business*, October 29, 2012.

25
For example, D.M. Rousseau, *I-deals: Idiosyncratic Deals Employees Bargain for Themselves* (Armonk: M.E. Sharpe, 2005).

26
See <http://www.bc.edu/content/bc/centers/cwf/news/TheNewDad.html> and Aumann, Galinsky, and Matos, *The New Male Mystique*.

27
J.A. Vandello, V.E. Hettinger, J.K. Bosson, and J. Siddiqi, "When Equal Isn't Really Equal: The Masculine Dilemma of Seeking Work Flexibility," *Journal of Social Issues*, 69, n.º 2 (2013), 303–21.

28
Gerson, *The Unfinished Revolution*.

29
A few examples of blogs, articles, and books by young, highly educated men staying at home or sharing childcare: <http://www.nycdadsgroup.com>; <http://fathersworkandfamily.com/about>; <http://dadoralive.com>; N. Brand, "Why I'm Not a Father," *The Good Men Project*, June 12, 2012 <http://goodmenproject.com/fathers-day/why-im-not-a-father>; R. Dorment, "Why Men Still Can't Have It All," *Esquire*, June/July 2013; P. Mountford, "I'm Not a Hero for Taking Care of My Kids," *Slate*, July 10, 2013; J.A. Smith, *The Daddy Shift: How Stay-at-Home Dads, Breadwinning Moms, and Shared Parenting Are Transforming the American Family* (Boston: Beacon Press, 2009); J.A. Smith, "Five Reasons Why It's a Good Time to Be a Dad," *Greater Good* (UC Berkeley), June 12, 2013 <http://greatergood.berkeley.edu/article/item/five_reasons_why_its_a_good_time_to_be_a_dad>; C.P. Williams, "Fatherhood, Manhood, and Having It All," *The Daily Beast*, June 28, 2013 <http://www.thedailybeast.com/witw/articles/2013/06/28/fatherhood-manhood-and-having-it-all.html>

30
There are infinite possibilities. See S.D. Friedman, *Total Leadership: Be a Better Leader, Have a Richer Life* (Boston: Harvard Business Review Press, 2008).

31
S. Meers and J. Strober, *Getting to 50/50: How Working Couples Can Have It All by Sharing It All* (Berkeley: Viva Editions, 2013).

Workplaces and Cyberworkplaces

The Ten Countries with the Most Data Centers (2013)

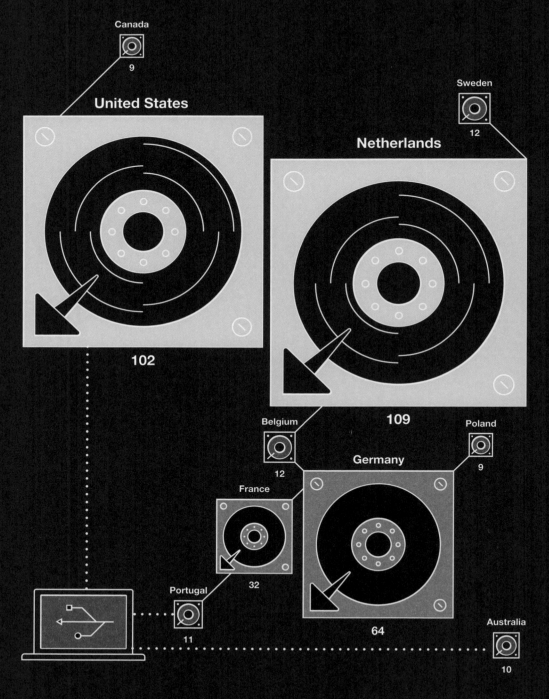

Source: ITU World Telecommunications

Telecommuters by Organization Type, United States (2012)

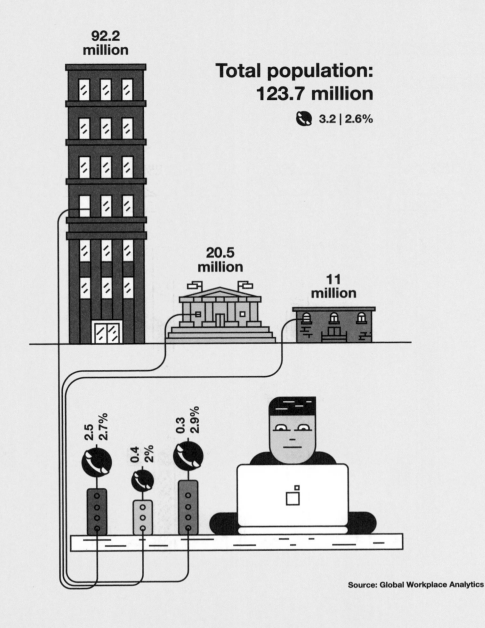

Source: Global Workplace Analytics

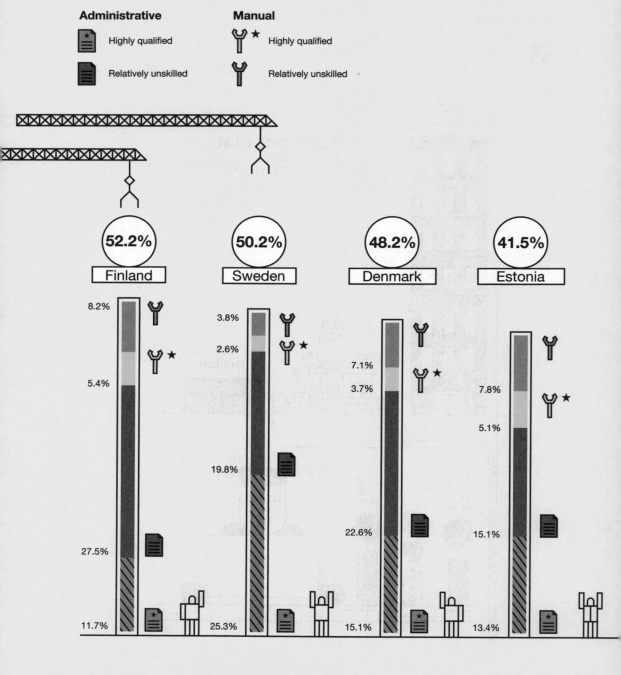

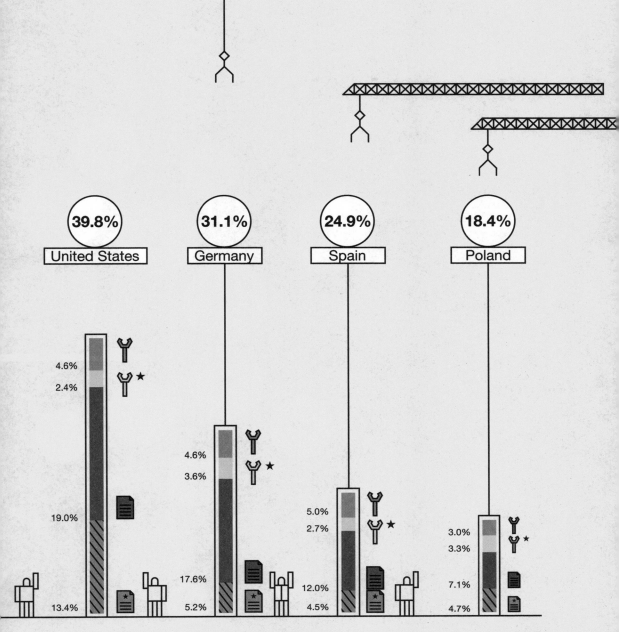

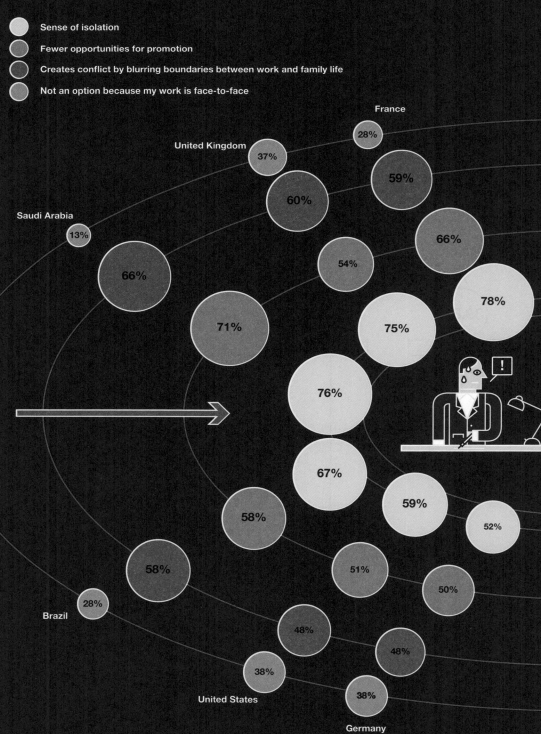

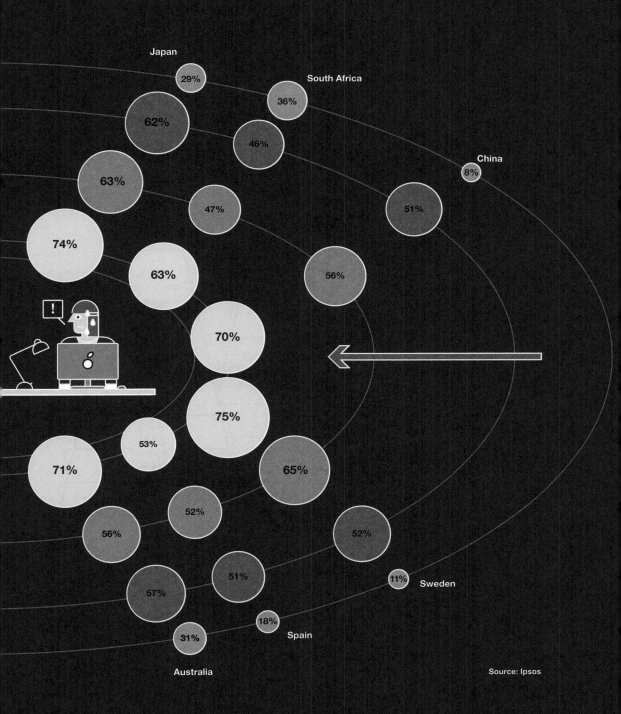

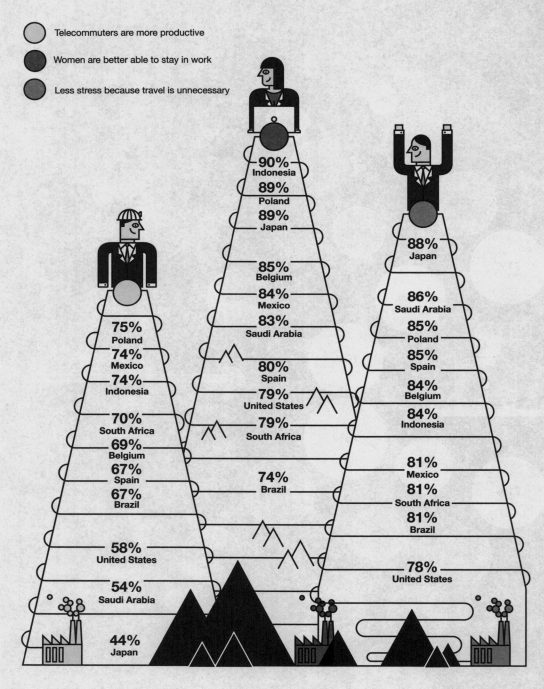

New Ways of Working in the Company of the Future

Peter Thomson

Peter Thomson argues that firms are still applying Industrial Age working practices to the new Information Age work patterns. Organizations are still run as hierarchical command systems in a world of networked individuals and self-employed entrepreneurs. Today we are in the middle of the Information Revolution, facing fundamental changes to the way we live and work. The difference is that the current revolution is bringing as much change in a decade as was spread over a century last time. Thomson states that the main issues pushing this tsunami of change are flexible/smart working and increasing demand for work/life balance and job satisfaction. In order for this transformation to work well, nothing less than a revolution in management practices must happen.

Peter Thomson
Henley Business School

Peter Thomson is co-author with Alison Maitland of the best-selling business book *Future Work* (2011). He is an acknowledged authority on the changing world of work and its impact on organizational culture and management practices. He is a Visiting Executive Fellow at Henley Business School where he was Director of the Future Work Forum for sixteen years. He has carried out research in the management of remote teams and has appeared on radio and television as an expert on flexible working. He spent eighteen years as the HR and OD Director of Digital Equipment covering Northern Europe.
www.peterdthomson.co.uk

Key Features for the Company of the Future:

Autonomous Employees
Power has to be delegated down to the people at the bottom of the organization for them to feel engaged. They will expect to be treated like adults and be able to decide when, where and how they get the job done. This will give them control over their lives resulting in less stress and higher motivation.

Virtual Teams
People will no longer have to be physically together to belong to a team. Through the use of social technologies and improved video conferencing systems, employees will be able to work together to make decisions and share ideas. There will still be a need for some face-to-face meetings but these will be seen as an expensive alternative, taking up valuable time.

Results Based Rewards
Instead of rewarding effort and encouraging long working hours the organization of the future will reward outcomes. Employees will be encouraged to achieve the results by using their own initiative and to get the job done in the shortest time. This will increase productivity and create a "short hours culture" where the person getting the work done the quickest is recognized as the most productive, not the person working longest.

New Ways of Working in the Company of the Future

The Information Age

We are sitting at a fascinating junction in the history of work. We still have the Industrial Age working practices that have been in existence for the last 200 years, running alongside the new Information Age work patterns. Organizations are still run as hierarchical command systems in a world of networked individuals and self-employed entrepreneurs.

It took many decades and several generations to make the last change of this magnitude. In the Industrial Revolution, work moved slowly from fields to factories and changed the face of society. Today we are in the middle of the Information Revolution, facing equally fundamental changes to the way we live and work. The difference is that the current revolution is bringing as much change in a decade as was spread over a century last time.

So we have twentieth-century working practices (with, in some cases, nineteenth-century management processes) lingering on in established companies whilst new enterprises are working very differently, enabled by technology. Some organizations have recognized that the world is changing around them and are trying to adapt, but many are continuing to operate as if nothing had

happened. Those that do not embrace the changes are in danger of being left behind in the race to attract and retain the most effective workforce, and lose out to more productive competitors.

New Working Patterns

It is obvious to even the most casual observer of working patterns that technology has revolutionized our ability to perform a whole variety of tasks. We can now send and receive emails wherever we are, join in meetings from the other side of the world and keep in touch with our colleagues through a variety of social media. We can access all the documentation from our "office" without ever going near the building and we can keep up with the latest developments in our field without having to attend endless conferences or meetings.

But despite the ability to do work at any place and any time of our choosing, we are still slaves to the routines established by a previous generation of workers. The "norm" for most people in work is to have a job with a fixed location and a fixed set of hours to be present. In return for turning up and fulfilling a job description we pay people a salary, provide benefits and offer a level of financial security. But increasingly this is being seen as a low productivity model which is not very satisfying for the employee and not very effective for the employer.

We now have a generation of young people joining the workforce who have never known a world without the internet. They expect to be able to communicate with their colleagues wherever they are and whenever they choose. They cannot understand the traditional boundaries between home and work life and the need to be tied to a fixed desk in order to get work done. They are questioning the long hours culture and the "presenteeism" pattern of work that has been inherited from previous generations. And they value their personal freedom, expecting to be given some discretion over the place of work in their lives.

Management Revolution

This combination of social change in attitudes towards work, combined with the freedom that comes with technology, is confronting traditional management practices head on. The idea that work has to take priority over the rest of life is now being challenged. Why should we have to fit our personal lives around a fixed pattern of work when many work activities can now be done flexibly? If I can answer my emails from home, or on the move, at a time to suit myself, why am I expected to be at my desk from 9 to 5.30? Why can't I take my children to school then come to the office later, instead of having to be in two

places at once? If we now carry our virtual desk and filing cabinet around with us in our pockets why are we still basing ourselves on fixed workstations at all?

The reason we have fixed patterns of work is largely historical. When work involved passing physical objects to the next person we had to be working alongside them. In manufacturing this is still largely true, although the passing of items is more likely to be between robots than humans in today's automated factory. In the office it is no longer true. We don't need to pass the paper from one desk to the other and we don't need to be in the same room to have a conversation. Yet the "standard" pattern of knowledge work is still to be based at a fixed location for a fixed time.

The management systems, leadership practices and communications processes that we use today were built during the Industrial Age of work. They assume that people are prepared to commit a fixed portion of their lives to their employer and fit their leisure, holidays, and family life around it. This used to work in the days when men were the "breadwinners" and went to work leaving their wife to manage the home and children. But this outdated approach to work does not fit with today's values of equality, freedom, and flexibility.

Flexible Working

Just introducing some part-time work to satisfy demands from parents is no longer sufficient to meet the expectations of the younger workforce. Whether they have caring responsibilities or not, they expect to have some choice about the way they work. They are used to having choice in the rest of their lives. They can shop and be entertained 24/7. They can make adult decisions about what they do at the weekends. But during weekdays they are treated like children. If they don't turn up on time they are likely to be disciplined (despite the fact that they are expected to travel to their workplace at the most congested time of day).

Many employers have introduced flexible working schemes to try to meet the demand from the workforce. Typically these assume the fixed working day as the starting point and allow variations on this to add some agility to the work schedule. So the idea of "core hours" being present in the office still remains strong. Provisions such as working from home or from a satellite office are seen as exceptions. "Presenteeism" rules, and people who are out of sight can easily get forgotten. Managers struggle with knowing what people are doing if they can't see them and often assume they are not as committed as those who come in to the office.

> **Working from home is seen as an exception. "Presenteeism" rules, and people who are out of sight can easily get forgotten**

Peter Thomson

"Flexible working" is typically an HR policy introduced as an employee benefit aimed at people with family commitments. It is usually associated with provisions such as maternity leave and is designed to accommodate people who can't work "normal" hours. Consequently it is not taken up by serious career-minded employees. They are still caught up in the long hours culture that dominated the twentieth century and has crept into the twenty-first.

But all that is about to change.

Smart Working

As we come out of a worldwide recession and move towards a shortage of key talent, employers will have to have a fundamental rethink of their approach to work. There already is extensive evidence that people are choosing to move jobs in order to improve their work/life balance. No longer does a big pay packet bring satisfaction to employees with scarce skills. They recognize that time is as valuable an asset as money. So they will be attracted to work environments where people are expected to have a personal life and not have sacrificed their freedom in the name of career progression.

> In the age of "smart" working, the new approach to work involves a shift in control from employer to employee

The new approach to work involves a shift in control from employer to employee. In the age of "smart" working an individual is in control of their own time. They decide when and where to work and are trusted to do so by their boss. There is no assumption that work can only be done in the usual daytime shift at the usual workplace. Many people, particularly those employed for their creativity, do their best work outside of the traditional hours. Why should we constrain people to work at times when they are at their least productive?

But the biggest hurdle that managers have to jump is to stop measuring inputs (hours worked) and start measuring outputs (achieving outcomes). If the basis of recognition for work is what is actually produced, then the time and place of the activity is almost irrelevant. There will be many jobs where there are constraints on when and where work can be done, but these do not have to be imposed by a manager. When someone is trusted to decide for themselves how the job is done they will know the constraints and will work within these parameters.

So, the old version of flexible working (a discretionary gift from management) is being replaced by agile working practices where the individual has genuine autonomy over their working pattern. This is not just a change in the employment contract; it is a revolution in work culture. It involves a shift from

a command and control mentality to a leadership style that empowers people and trusts them to get on with the work. It is a sign that employees are being treated as adults and can make decisions which take into account the needs of the employer as well as their own priorities.

Future Work

This evolution from fixed working patterns to highly flexible work arrangements is a journey currently being undertaken by many employers. The leaders are now introducing results-only measurement systems and autonomous working schemes where employees have high degrees of freedom. Others are following along behind with different degrees of "agility" and varying levels of empowerment for their people. But, regardless of where they are in this journey, there is one clear direction in which they are all heading.

Alison Maitland and I chose to call this "Future Work" in the book of the same name.[1] This reflects the fact that we are moving towards a future model of work which has truly adapted to the social, technological, and economic influences of the twenty-first century. Many organizations will struggle with this change since it challenges existing power bases and established management controls. It threatens the existence of some middle managers and erodes many of the trappings of power and status in hierarchical structures.

We came across many examples of new ways of working whilst researching for the book. There were some companies such as W.L. Gore and Semco that have been able to adopt radically new ideas thanks to the vision of their CEOs. Others such as IBM, Vodafone, and Cisco have used their technologies to facilitate change. And we discovered a few that were well along the journey, seeing benefits flowing to their bottom lines.

> **We are moving towards a future model of work which has truly adapted to the social, technological, and economic influences of the twenty-first century**

One such example is Ryan, the global tax services firm. Their MyRyan program allows employees to work anywhere any time as long as the work gets done. There are no hour requirements, no location requirements and no schedules. As reported in the book *Future Work*: "The results are impressive," according to Delta Emerson, now chief of staff. "We have won over 100 workplace excellence awards in recent years, including the coveted Fortune 'Great Place to Work' award, in both the US and Canada. Ryan

employees treasure flexibility and it has helped us become a 'talent magnet' and reduce turnover. Additionally, the other metrics that any CEO cares about—client satisfaction and revenue—have skyrocketed. Flex is a business imperative—not a nice-to-have.'"

Changing Cultures

None of this should come as a surprise. For the last fifty years, management gurus, occupational psychologists and inspired leaders have been saying the same thing. Give people instructions and they will simply follow them. Give people responsibility and they will be motivated to achieve more in their work. We have moved on from the era of "Taylorism" where work was reduced to its most simple elements and jobs were intrinsically boring. We now have the routine work done by computers and robots, and people are employed for their human skills.

But we still have organizational cultures that reflect the old approach to work. We have hierarchical structures where power is retained at the top and delegated down through layers of management. Knowledge is hoarded by managers as a way of justifying their existence rather than being shared amongst all employees. Instructions are issued from the top and obeyed by those at the bottom. People who comply with the prevailing culture are promoted into management. Those who challenge the status quo are marginalized. So it is hardly surprising to see that these organizations are resistant to change. They believe their own PR in the face of external influences and are only forced to change when they reach a crisis point.

We are about to reach the crisis point in the world of work. The generation of digital natives who have joined the working population over the last decade are questioning fundamental assumptions about employment. They are not prepared to simply do what they are told. They are asking questions about why we work the way we do, and they are not satisfied with the answers. In the rest of their lives they are using technology to free them from constraints of time and place, but their job is based on an assumption that these are fixed. They use social media to relate to friends at a distance but are expected to spend endless hours in office-based meetings as part of their jobs.

Rewarding Results

When many jobs could only be done in one place, life was simple. You turned up to work and contributed the hours. "Work" was a place you attended for your contracted time and you were paid for the hours you put in. The reward system reflected the input. Now life is more complicated. Technology has

freed work from the constraints of a fixed place and given the worker more choice over when to perform it. "Work" is no longer a place to go to, it's an activity for a purpose. It's a process for achieving results and it's the output that counts. Rewarding outcomes that contribute to the goals of the enterprise seems much more logical than rewarding effort that may contribute nothing towards business success.

In today's connected world, work is becoming more of a tradable commodity. Instead of converting work into a set of tasks to be performed by an employee it is being seen as a product that is paid by results. So to get a piece of work done it is quite practical to put out a request on the internet and to offer it to an independent contractor or freelancer. By 2020, more than 40% of the US workforce will be so-called contingent workers, according to a study conducted by software company Intuit in 2010.[2] That's more than 60 million people.

Contractors and consultants will increasingly bid for work online and will be paid for results. This is an emerging form of what has been termed "crowdsourcing"—using the power of the internet to allocate tasks to people anywhere in the world by issuing a request for work. Initially, this was largely associated with finding volunteers to contribute their expertise for free. The whole free, open-source software movement is based on this model and there are high-profile examples such as Wikipedia, the free encyclopedia.

However, there is now a growing market for paid work via the internet. Elance and oDesk, both launched in the US in the mid-2000s, are two of the better-known online marketplaces where businesses can find freelance professionals to carry out work on demand.

Since 2005, Amazon has run its Mechanical Turk as a marketplace for work that allows requesters to pose "Human Intelligence Tasks" and pay people to perform them. These are typically simple repetitive tasks, such as searching for information on the Web, paid a few cents for each successful result. At the other end of the scale is Innocentive where cash awards of up to a million dollars are given for successful solutions to research problems. It's a very attractive model for businesses able to allocate work across the internet as they can choose suppliers who will perform tasks for a fraction of the cost of employees. In fact it is quite possible to get the work done at no cost if there are enthusiastic contributors willing to donate their effort for free.

Work versus Jobs

These new ways of connecting people with work are cutting across the traditional jobs market. "Employers" no longer have to offer jobs, careers, and security to people to get their tasks performed. When they need to get something done they simply find someone to do it and pay them when it's

completed. They don't need "employees," they need just-in-time workers to perform tasks. They don't have to worry about employment legislation and may well be sourcing the work from someone located in a different country anyway. If the individual suppliers are being paid for results then they will be in control of their own time and regulations such as a minimum wage, expressed as pay per hour, are irrelevant.

It might seem that this development is heavily biased in favor of the "employer" and that it would not be attractive to "employees" who are missing out on the benefits of a conventional job. However, there are many people who find this a better way to earn a living than be constrained by a fixed commitment to an employer. They have the flexibility to choose when they work and are in control of their lives. They will be joining the growing ranks of self-employed who are prepared to exchange the security of a regular job for the flexibility of selling their expertise on the open market.

One option that is growing in popularity is the "zero hours" contract. This arrangement gives flexibility to the employer and employee and provides some of the employee benefits that do not exist for the self-employed. In a report published in November 2013,[3] the Chartered Institute for Personnel and Development in the UK looked into these contracts in depth. They reported that 23% of employers used these contracts and on average they apply to 19% of their workforce. Far from feeling exploited, almost half of these employees are satisfied with having no minimum guaranteed hours, with only a quarter saying they are not happy with the arrangement. Most zero-hours contract workers (52%) don't want to work more hours than they typically receive in an average week.

Despite some negative reactions in the media to these flexible arrangements, they are here to stay. In the CIPD survey, only 9% of the respondents said that they were not allowed to work for another employer when there was no work available under the zero hours arrangement. So, the age of the "portfolio worker" is dawning, where an individual may have several "employment" arrangements combining different part-time "jobs." The idea that someone can only work for one organization at once, and has to do this as a full-time job to be successful, is being consigned to history.

Rise of the Part-Timers

There are now many successful executives who have shed the burden of the full-time, long-hours, always-on work pattern and shown that part-time work can be equally as effective. In fact there is growing evidence that part-time workers are able to contribute more to the success of the business than full-time ones. They probably have a better work-life balance and are therefore

less stressed when doing their jobs. They are likely to bring in a more objective outside view and not be restricted to a narrow corporate version of reality.

The UK jobs website, Timewise, publishes a "Power Part Time" list which aims to bust the myth that part time is just for low-skill jobs. The list contains the inspiring stories of 50 men and women who exceed profit targets, drive innovation and manage large teams—all whilst working a contract that strikes a healthy balance with the rest of their lives. It includes chief executives, managing directors, finance directors and partners in professional services firms. These executives are doing extremely demanding roles, so they have to prioritize and manage their time well. Many of them emphasize communicating clearly and agreeing goals with their teams, and then trusting them to get on with the job.

> Organizations are transforming from rigid employers to flexible networks in order to get the best results from people

The traditional view that work has to be divided into jobs, that have to be done by full-time employees, is now clearly outdated. Organizations are transforming from rigid employers to flexible networks in order to get the best results from people. They need to be able to accommodate the varied wishes of their workforce, ranging from people content to hold a full-time fixed job through to individuals wanting full control of their own work pattern. Those that adapt will survive. Those that stick with the current model will struggle.

The Future is Here

This new world of work is here already in leading organizations. In the book *Future Work*, we identified many examples of employers who have recognized that the command and control culture of the past is now out of date. Where they have introduced "smart working" or "agile working" schemes as a business strategy and changed their leadership culture, they are seeing the benefits. But those leaders that have just paid lip service to new ways of working, and not adapted their culture, will end up with frustrated employees and low productivity.

It takes clear leadership from the top to throw out some of the hierarchical processes and introduce a flatter structure. Managers have to behave in line with the new values of the business and actively empower their employees. One example of this that we quote in the book is Unilever. They have introduced radically new ways of working to their operations around the world over the past few years. Their Agile Working program was launched at the end of 2009 and contains the following principles:

- All employees may work any time and anywhere as long as business needs are fully met
- Leaders must lead by example, working in an agile way themselves
- Performance is determined by results, not time and attendance—every employee has a personal work plan identifying desired results and how they will be measured
- Travel is to be avoided whenever possible
- Managers are assessed annually on how well they support agile workers and this feeds into the variable element of their pay

Senior leaders are required to be role models by adopting "Agile Working" principles, technology, and facilities themselves. Around 20% of jobs in senior management and above are "location-free," meaning that the executive may be based anywhere in the world. The company has invested in training people in the business benefits, in how to work and collaborate remotely, and in managing and being part of virtual teams.

Management Reactions

These new "smart working" schemes often face resistance from middle management. These are people who have worked their way up the organization by committing long hours and sacrificing their personal lives in the process. They are looking for this dedication from their employees and don't understand why their priorities are different. These managers justify their existence by having a visible team of people working for them and a large payroll budget. To suggest that the same work could be done by a smaller group of contractors, or by people working from home, is a direct threat to their status.

> **The new "smart working" schemes often face resistance from middle management. These are people who have worked their way up the organization by sacrificing their personal lives in the process**

They see their role as controlling their employees, allocating tasks, and showing people how to do the job. They enforce the company rules and ensure compliance in the correct procedures. In the interest of "quality performance" they insist on work being done in a standard way, which ensures consistency. They reward the people who put in the extra dedicated effort, are loyal to the organization, and don't question the existing system too closely.

Success in the twenty-first century will rely on managers being prepared to do the exact opposite. They will need to give employees autonomy and trust that they will not abuse the freedom. They will allow people to choose to do the work the way that suits them best. They will be clear about the results that are expected and not try to dictate the detailed methodology for achieving them. They will reward creative new ideas that challenge established practices. And they will be seen to be successful by achieving results with fewer employees and lower budgets.

Working in the "Smart" Organization

The people working in these organizations will feel genuinely empowered. They will make decisions on when and where they do the work to achieve their goals. If they know they are most productive working in the evenings they might choose to spend mornings as leisure time. Instead of having to turn up to their employer's workplace and be paid for putting in an appearance, they will choose the appropriate place of work to suit their own needs. They will be happy to be judged on results, not on the hours they spend on wasted effort.

People appreciate being treated like adults and being allowed to make decisions in their working lives that they would naturally make in the rest of life. It's in their interest to think of smarter ways of getting the job done and achieving it in the shortest time. The best workers become those who work the least hours. Individuals question the value of the time spent in pointless meetings and are rewarded for doing so. Managers become coaches who get the best out of their people by motivating them and providing support, letting go of the reins wherever possible.

The situation is summarized well by Gary Hamel in *The Future of Management*.[4]

> If there was a single question that obsessed twentieth-century managers, from Frederick Taylor to Jack Welch, it was this: How do we get more out of our people? At one level, this question is innocuous—who can object to the goal of raising human productivity? Yet it's also loaded with Industrial Age thinking: How do we (meaning 'management') get more (meaning units of production per hour) out of our people (meaning the individuals who are obliged to follow our orders)? Ironically, the management model encapsulated in this question virtually guarantees that a company will never get the best out of its people. Vassals and conscripts may work hard, but they don't work willingly.

The Virtual Workplace

Once we have broken the link between work and a fixed location, a whole range of potential workplaces emerge. It may be convenient for some people to work some of the time from home. Where this fits in with people's personal lives and their work commitments it can be highly productive. Just saving the time and hassle of a daily commute brings rewards but people also report significant improvements in output per hour worked at home versus a noisy office.

However, most jobs involve contact with other people. Technology is replacing some of this but there will still be a need for individuals to get together and share ideas. Some meetings will be replaced by videoconferencing or online discussion forums. Social media will help remote teams to build rapport. But there will still be a need for space for physical meetings. So the office of the future will cater for people meeting together and using some desk space on a "drop-in" basis. Activity-based workspace allows for people moving around the building depending on the task they are performing.

The worker in the new Future Work era will have to be able to manage this blurred border between home and work

But the just-in-time approach to the workplace raises a question about the need for any permanent space at all. If meeting space, or flexible office space can be rented by the hour or the day, why have the overheads of a permanent building? The workplace for many people might be a combination of a multi-user hub office, rented space in a Regus-style serviced office or a table in the local coffee shop, with the occasional day at home thrown in. For the truly mobile worker their workplace is wherever they are, as long as they have access to the internet.

Work-Life Integration

This ability to work anywhere is both a blessing and a curse for the individual employee. They may have control over when and where they choose to get their jobs done but they may also lose control of their personal lives in the process. If their boss expects them to be available at any time, wherever they are, then there is a danger that this can invade their personal lives. It can be tempting for managers to take advantage of the technology and expect their people to be available at all times.

It's also tempting for some employees to be available all the time, just to impress the boss. But eventually people start to resent the takeover of their

lives by their job. The worker in the new Future Work era will have to be able to manage this blurred border between home and work. Self management, project skills and effective communication will be important, whether someone is employed or working independently.

Along with the freedom to choose how to work comes the responsibility for producing results. Companies such as Netflix that trust their employees to control their own work patterns also expect people to be high achievers. They don't care about effort, it's all about accomplishing great work. This is illustrated by their "no policy" arrangement for vacations. Since they are not tracking the hours that people are working, it makes no sense to count the days that people are on leave.

This idea has been picked up by Sir Richard Branson who has introduced it for the Virgin parent company in both the UK and the US. As he says in his blog[5]:

> Flexible working has revolutionised how, where and when we all do our jobs. So, if working nine to five no longer applies, then why should strict annual leave (vacation) policies? … It is left to the employee alone to decide if and when he or she feels like taking a few hours, a day, a week or a month off, the assumption being that they are only going to do it when they feel a hundred percent comfortable that they and their team are up to date on every project and that their absence will not in any way damage the business—or, for that matter, their careers!

The ability to mix work and pleasure, aided by technology, will be a key factor in shaping people's lives over the next decade. If employers don't keep up with this trend they are likely to lose their best people, either to more agile organizations or to some form of self-employment. By starting from the assumption that work is an activity that can be performed anywhere and at any time, they will impose the minimum of constraints on their workforce. As long as they measure and reward output and treat people like adults they will be successful. This sounds like a simple task, but it conflicts with the prevailing culture in many businesses and may take a serious shake-up of leadership to achieve.

Notes

1
A. Maitland and P. Thomson, *Future Work: Changing Organisational Culture for the New World of Work* (Basingstoke: Palgrave Macmillan, 2014) <http://www.futureworkbook.com>

2
"Intuit 2020 Report: Twenty Trends That Will Shape the Next Decade" <http://www.intuit.com/2020>

3
"Zero Hours Contracts: Myth and Reality," CIPD Research Report, November 2013 <http://www.cipd.co.uk/hr-resources/research/zero-hours-contracts-myth-reality.aspx>

4
G. Hamel with B. Breen, *The Future of Management* (Boston, Mass. & London: Harvard Business School Press, 2007), 207.

5
"Why we're letting Virgin staff take as much holiday as they want," Richard Branson's blog, September 23, 2014 < http://www.virgin.com/richard-branson/why-were-letting-virgin-staff-take-as-much-holiday-as-they-want>

A Single Building and a Multifaceted Town: BBVA, Madrid, a Workplace for the Future

Herzog & de Meuron

The article from the architects who won the competition to design BBVA's new headquarters in Madrid describes the process of formulating the urban and architectural ideas behind the exciting new building that BBVA will be moving into in 2015.

They look at how the project had to find a very specific response to a unique architectural situation and also at how to create an identity that encourages new flexible models of collaborative working. Another vital issue was incorporating the criteria of sustainability as an integral part of the design process; this affected every decision, from the massing of the buildings down to the tiniest technical details. Herzog & de Meuron detail the collaborative process which demonstrated the maturity, perseverance and commitment of all parties involved; a successful collaboration which has resulted in a really outstanding building being produced, one which BBVA can call home and use in the next stage of its evolution.

Herzog & de Meuron
Architects

Jacques Herzog and Pierre de Meuron established their office in Basel in 1978. Herzog & de Meuron is now a partnership led by five senior partners – Jacques Herzog, Pierre de Meuron, Christine Binswanger, Ascan Mergenthaler and Stefan Marbach. Herzog & de Meuron designed a wide range of projects from the small scale of a private home to the large scale of urban design. While many of their projects are highly recognized public facilities, such as stadiums and museums, they have also designed apartment buildings, offices and factories. The practice has been awarded numerous prizes including The Pritzker Architecture Prize (US) in 2001. The New Headquarters for BBVA, one of the practice's major projects, is planned to be completed in 2015.
www.herzogdemeuron.com

Key Features for the Company of the Future:

People
Most important and, in fact, crucial to the success of an architectural practice, and of almost any business, are the people who are part of it. That means attracting those most talented, giving them room for growth and challenging them to the fullest. Being challenged is what makes you get up in the morning, and once at your desk, you want to share that energy with an inspiring mix of colleagues who are committed, ambitious and have a sense of humor.

Teamwork
One of the most rewarding aspects of work is getting things done together. A good team in a creative environment needs strong, confident leadership with the ability to delegate and encourage personalities to unfold. That means providing structures to hold on to and the freedom to ignore them when the need arises. Clients notice and respond to a good team; they appreciate the flexibility and enjoy being part of the process.

Renewal
Don't get complacent, especially not when you are successful. There is always room for improvement. When the status quo is questioned, be open—not out of principle but because you have something to learn. Never forget what you stand for and yet always be receptive to the possibility of change. Renewal happens best organically; regular watering is better than periodical floods. This applies as much to your products as it does to your structures.

A Single Building and a Multifaceted Town: BBVA, Madrid, a Workplace for the Future

Why has BBVA undertaken the complex and challenging task of concentrating its staff in one single location? Why, in an age of globalization and digitalization, has the bank chosen to build gigantic new headquarters when today's buzzword is flexible working models? Like other international groups, the bank still believes that personal encounter among staff and with clients is a decisive factor in being successful and competitive. What's more, architecture and quality at the workplace should encourage identification with the company and good employees to stay on at a time when loyalty tends to be considered old-fashioned and regular job change an indication of personal success.

The following thoughts aim to formulate the urban and architectural ideas behind the new headquarters of BBVA in Madrid. We lay no claim to building a reference project. On the contrary, the project is a very specific response to a unique situation. It is about creating an identity for a place that has neither a face nor a history—and about making meaningful use of what is already there.

Where Are We? Why Are We Here?

When BBVA invited international architects to submit ideas for a new campus in 2007, employees were still scattered at a variety of locations in the metropolitan area. The bank's headquarters were housed in a high-rise built in 1981 by Francisco Javier Sáenz de Oiza, who won the competition for the then Banco de Bilbao. It is located at Paseo de la Castellana, Madrid's prestigious main axis in the center of the city, and is one of the most famous and interesting buildings of its time in Spain. Quality and even avant-garde architecture was already a priority in those days and the new location was meant to follow suit.

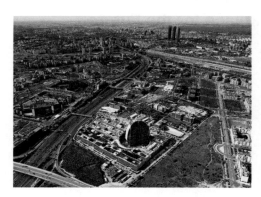

Since the location offered no points of urban reference, we developed the campus from inside out as a horizontal fabric, while ensuring that it can be seen from the motorway

It was necessary to find a piece of land within the city limits of Madrid, large enough to accommodate 6,000 workplaces. The bank found a suitable piece of property near the airport. It is surrounded by through roads in Las Tablas, one of the many burgeoning areas under development around the metropolitan area, thanks to the economic boom and real estate bubble of those days.

But it was not an empty piece of land: an office park was under construction, designed by architect Jorge Beroiz for Foresta Parque Industrial. It consisted of eight three-storey buildings, on some of which façades had already been mounted. The buildings, all of the same type and structure, were speculative in nature and intended for sale or rent to various companies. In urban terms, they were isolated blocks with streets in between.

One of the key requirements for the competition was to incorporate a considerable part of that architectural substance into the new complex in a first phase. These premises have to be ready for occupation before the new buildings.

For BBVA employees, the new company campus meant leaving the traditional, mixed-use city and moving to a monofunctional, synthetic, self-created place. In the competition brief, the bank listed not only quantitative but also qualitative specifications:

- A "tailor-made" building complex of exceptional architectural quality and representative character is to be created for the new headquarters of BBVA. It should have the potential of becoming an urban landmark.

— The already existing buildings are a specific challenge. They are to be modified so that they blend into the overall complex.

— The structure of the buildings is to be clear and rational to ensure economic sustainability. The efficiency and flexibility of the layout have priority. It must be possible to rent or sell parts of individual buildings.

The Concept

The location did not offer many points of urban reference, such as public buildings or spaces for the new complex to relate to. The real "public factor" was the motorway with some 60,000 vehicles driving by every day. As a logical consequence, we developed the campus entirely from inside out, while ensuring that it can be seen from the motorway.

We created a town governed by rules and exceptions. The rules define the type of workplaces, the size of the buildings, the way they interrelate, the logic of the circulation and, with it, orientation. Exceptions to the rules are the common areas: central meeting rooms, restaurants, cafés, reception rooms, which, in a real town, would correspond to schools and churches, movie theaters and museums. The rules with their exceptions enabled us to create a diversity of spaces and experiences without having to belabor imagination for its own sake.

Integrating the existing buildings was one of the greatest and most stimulating challenges. In contrast to other projects, which are about preserving existing structures, these were neither of historical interest nor of technologically exceptional significance; they were simply a substance that would be irresponsible to destroy.

We also wanted to respond architecturally to the climate and culture of Spain. We interpreted urban typologies and took inspiration from the geometric feel of Moorish gardens and the mastery with which they once created a fabric of built and natural worlds.

The most important components of the design as formulated in the competition are quickly described:

— A linear layout of three-storey buildings, repetitive at first sight, covers the entire site, like a carpet interwoven with lanes, gardens and cross connections. The existing buildings are part of this low-rise fabric which accommodates most of the workplaces.

— This overall structure is cut out in one spot to create a central Plaza. It is the middle of the new town, with such facilities as cafés,

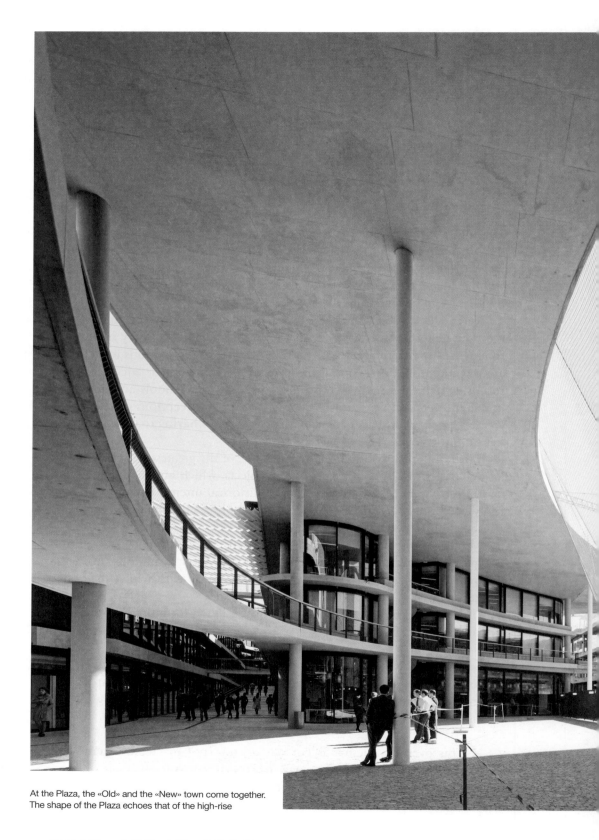

At the Plaza, the «Old» and the «New» town come together. The shape of the Plaza echoes that of the high-rise

A Single Building and a Multifaceted Town: BBVA, Madrid, a Workplace for the Future

restaurants and central meeting rooms. It is shaped like a circle that has been drawn freehand.

— A high-rise building placed on the Plaza makes the new campus of the bank visible to drivers passing by and inscribes BBVA in the skyline of Madrid. It has approximately the same shape as the Plaza and also serves as a point of orientation from within the town.

A Carpet of Buildings, Lanes and Gardens

The low-rise buildings account for 83% of the surface area. They are governed by the following basic rules:

— Employees are able to walk through the Campus to reach their place of work on foot. Streets, squares, gardens, lanes, and stairs are places of encounter; lifts are not.

— The buildings are narrow. Abundant daylight is atmospheric and a benefit in terms of artificial lighting and energy consumption. Relatively small spaces establish a more personal environment in contrast to traditional open-plan offices.

— Largely transparent façades allow for visual connections between the buildings. Interior and exterior spaces overlap; the distinction between them is blurred.

Competition Scheme

Completed Building

Completed Building versus Competition Scheme:

- The streets and the buildings become larger

- Better integration of the existing buildings

- New orientation of the high-rise

– One can look through the complex from one end to the other. This generates ambivalence—is it one single building or a number of individual ones?

– The existing buildings resemble the new ones. The workplaces should be similar for all the employees regardless of whether they are situated in the "old" or new part of the complex.

– The section of the buildings follows the natural topography although there is an underground garage. The wings, some of them very long, are therefore divided into shorter, stepped sections. The end of each lane segues seamlessly into the surrounding (urban) landscape.

– The natural environment is an integral constituent of the architecture and the workplace. Linear gardens run parallel to the long buildings with different kinds of vegetation, facilitating orientation. Water, collected on the roofs and in the gardens, is stored in a central cistern near the high-rise building and, from there, distributed again to water the gardens.

At the oral presentation of the competition entry, we were already asked by the bank if the texture of this low-rise carpet could be revisited.

Interestingly, redesign of the existing structures after the competition in the "Old town" resulted in lanes that have the scale of the alleys called for in the original proposal for the new part of town. These buildings are already in use now, and people really seem to like the ambiance in the streets, the urbanity as well as the light conditions in their offices. We are pleased that this original concept comes to the fore in the old part of town and it will be interesting to compare the different scales of streets, lanes and gardens throughout the complex. The variations may well be enriching.

The floors of the buildings follow the natural topography of the site. The wings, some of them very long, are therefore divided into shorter, stepped sections

Herzog & de Meuron

The Plaza

There is one place in the town where everyone meets: the Plaza. Its shape symbolizes community; it is a kind of arena. But while similar precedents are characterized by emptiness, 145 trees will be planted here in sandy ground. Walkways around the Plaza link the buildings in the horizontal town with each other and with the high-rise building. It is a coincidence that the size of the Plaza, some 100 meters in diameter, corresponds to that of the Plaza de Toros de Las Ventas in Madrid.

We have also adopted another traditional element of city planning in Spain by cutting a free-form out of the existing urban fabric. Such plazas are found in various larger and smaller cities throughout Spain and, not seldom, they are named Plaza Mayor as in Madrid, which is also comparable in size to the BBVA Plaza.

Since the circle of the Plaza is slightly distorted as if drawn by hand, the space is less monumental than it would be if it were a perfect circle. It is like the shape outlined by people gathered around a fire.

The typical "cut out" Plazas Mayores are found all over Spain. Plaza Mayor, Madrid

The BBVA Plaza is a kind of Arena. Plaza de Toros de Las Ventas, Madrid

The high-rise building divides the Plaza in half: the ground floor of the tower is an outside space, a kind of arcade that links the sunny and shady sides of the Plaza.

The High-Rise Building

The high-rise building is only 12 meters in depth, as narrow as the height of the lower buildings. It is more or less the shape of the Plaza, the arena, and therefore looks as if it had been cut out of the carpet and upended.

The "eccentric" shape is both baffling and fascinating; there is something ambivalent about it. It threatens to start rolling away or even tip over; it is precarious and possibly even frightening. However, the soft contours and transparency of the building also make it fragile and delicate.

The high-rise accentuates the visibility of the bank to the outside world and contributes to orientation from within. It can be seen from almost everywhere and thus marks the location of the central Plaza. It not only towers above the complex; it also serves as an anchor. Someone recently remarked that it is like the church in a village.

In combination with the high-rise, the brise-soleils are the most important feature of the face of BBVA's new headquarters

The organization inside is simple, governed by the building's slender shape: a central core with lifts and restrooms, with a room each to left and right, ideally as an open working area. It is not often that one can look out of the opposite sides of a high-rise.

These spaces, which offer spectacular views of the city and the sierra, accommodate programmatic areas from work stations to communal functions for the entire bank. Herzog & de Meuron designed part of the interiors of the low-rise buildings and of the high-rise.

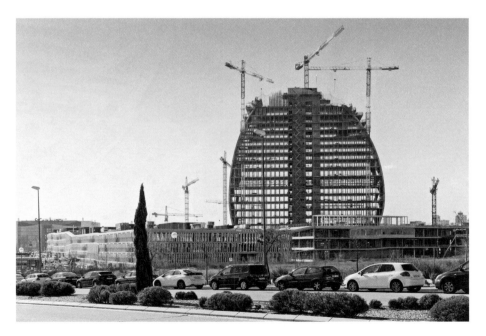

The high-rise accentuates the visibility of BBVA to the outside world. Its soft contours and transparency make it appear fragile and delicate

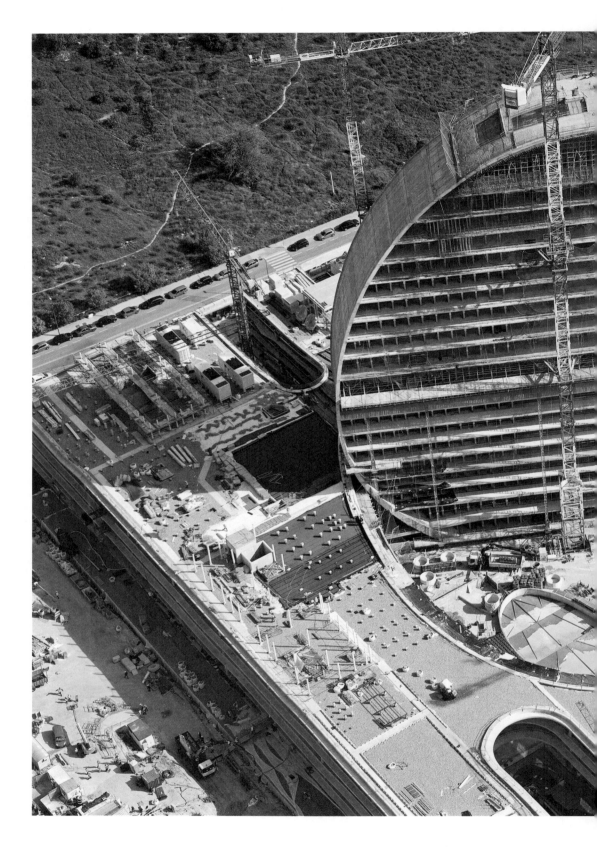

A Single Building and a Multifaceted Town: BBVA, Madrid, a Workplace for the Future

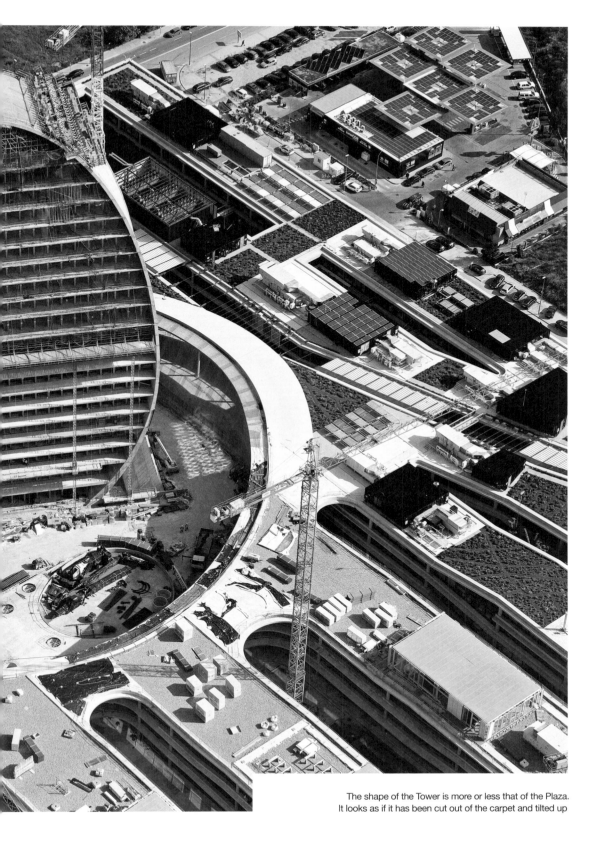

The shape of the Tower is more or less that of the Plaza.
It looks as if it has been cut out of the carpet and tilted up

Emergency stairs follow the curve of the façades along the contours of the building to minimize the size of the core. It was only later on that we fully realized how spectacular the resulting spaces would be.

In the beginning the high-rise was aligned with the horizontal wings. In connection with the design of the façade and related solar studies, we realized that the tower should ideally face south. Since the sun is high overhead in the south, a two-meter overhang provides enough shade for the standard office storeys without requiring additional vertical or movable shading devices on the exterior. Fixed brise-soleils as in the flat buildings would have obstructed the desired view from up there. Outdoor solar protection on a high-rise is not advisable because of maintenance. The north façade requires no exterior sun protection at all, allowing for a smaller overhang, only so deep as to facilitate cleaning the façade. The new orientation of the high-rise ensures full-height transparency and a maximum of spectacular views.

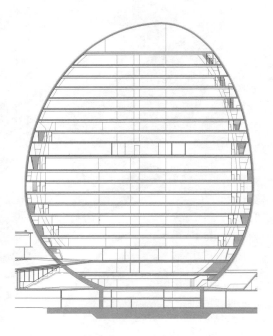

Emergency stairs follow the curve of the façades along the contours of the building

The proper placement of the building allowed for considerable savings in terms of building costs and energy consumption. Interestingly, as often happens, this "reasonable" decision led to other improvements. Since the high-rise is quite literally "path breaking," we aligned the main entrance with the tower and moved it to the northwest corner of the complex, which makes it more striking than if it had been accessed via one of the many lengthwise lanes. In a second step, we shifted the tower closer to the entrance so that it touches the so-called ring that runs around the entire Plaza as an outdoor space on the first floor.

Finally, by deviating from the overall geometric grid, the modified orientation of the tower makes it more visible from inside the complex and underscores its eccentricity.

The high-rise is only 12 meters in depth, as narrow as the height of the lower buildings

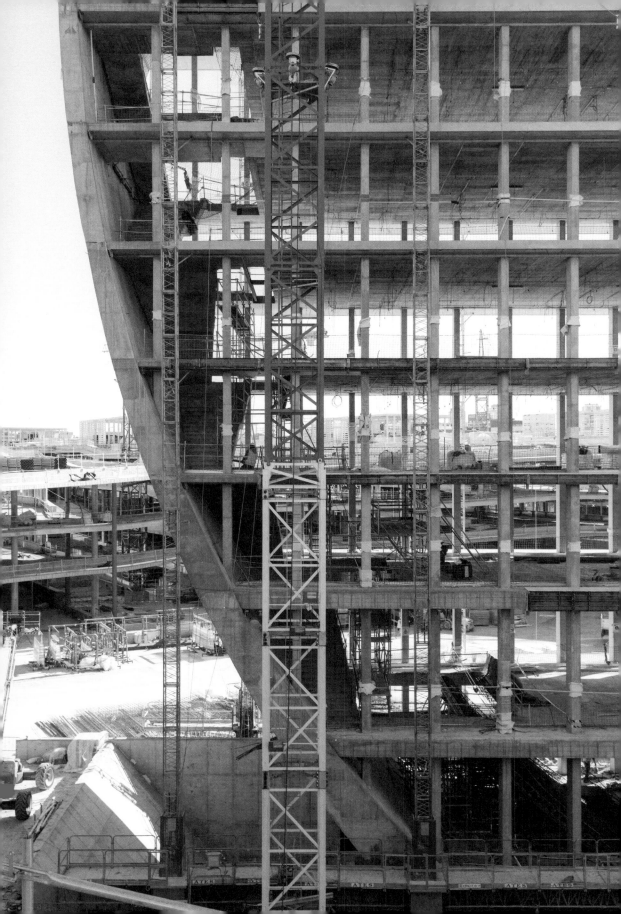

The Affinity of Existing and New Structures

In the competition design, we cut elongated courtyards into the existing structures in order to establish a connection across the streets between the buildings of the previous office park. In the next phase, we realized that reducing the building volume was not enough. There was still no cogent relationship between the existing structures and the "carpet" of new buildings. In addition, to accommodate the bank's need for more office area in the first phase of construction, we filled in several spaces between the existing buildings. As a result, a large semi-circular courtyard was eliminated that would have become an alien geometry in between the old and new parts of town. The fill-in also resulted in a clearly identifiable main passageway that accesses all of the existing buildings and links them to the main Plaza. It became the longest and narrowest lane in the town.

It was only by "swallowing" the old structures that the first phase of construction also became a fabric of linear buildings and lanes like that of the new buildings. The blend of old and new generated extremely interesting spatial transitions and variations in both floor plan and elevation; irregularities resulted. Some of the buildings, for instance, had diagonal geometries, which generated two bends in the main lane, so that our office nicknamed it Broadway. Existing buildings were placed staggered in the terrain; they were not at the same height because they had initially been planned as freestanding office buildings. The connections between the parts yielded slanted roofs and floors and also generated the natural feel of sloping lanes and courtyards.

The natural environment is an integral part of the architecture and the workplace

Existing Buildings | Demolition and Cut-Out Structure | Filled-In Structure | Completed Phase 1 | Completed Building (Phase 1 + Phase 2)

The necessity of linking loose parts, the overlapping of physically existing, irregular structures with the Cartesian order of new buildings and the great density of the first phase of construction that led to narrow lanes—these factors all converge to lend this part of the complex a very distinctive character. One might even say that it feels a little bit like a medieval town with its narrow, crooked streets and occasional dead ends. In contrast, the new part of town further west is characterized by clear rational geometries, a great deal of light and air and considerable repetition.

Floorplan level 1

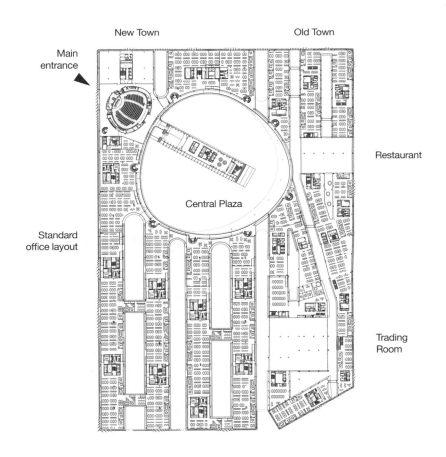

Two very large rooms were already required in the first phase, the Trading Room and a Restaurant, for which the standard height of the existing offices did not suffice. We therefore had to remove ceilings inside existing buildings and we tried to establish a visual correspondence between these

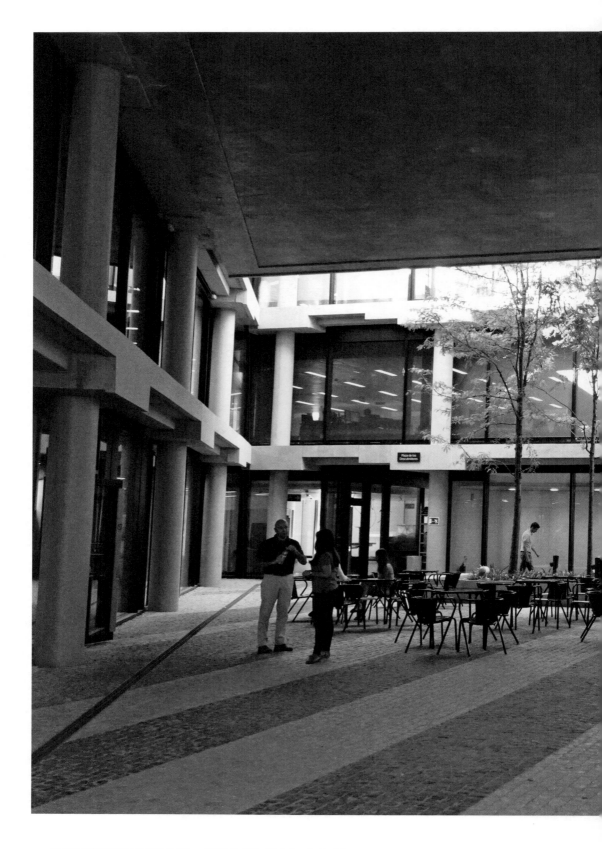

A Single Building and a Multifaceted Town: BBVA, Madrid, a Workplace for the Future

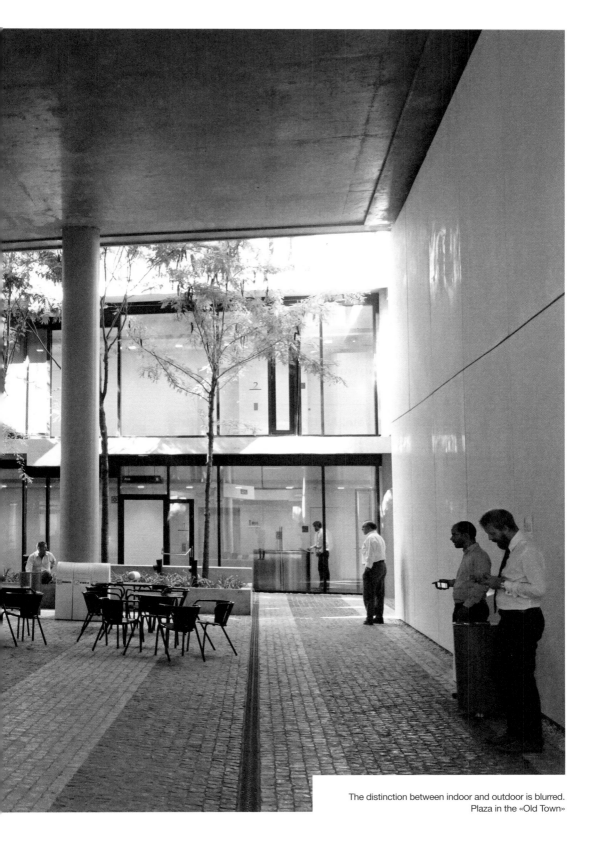

The distinction between indoor and outdoor is blurred.
Plaza in the «Old Town»

interiors and the linear lanes and courtyards outside. Both of these areas, occupied by many people at once, are exceptions in the fabric of office wings, which are all similar in size. They are like interior plazas and offer useful points of orientation.

Sustainability

To cover this subject would require an article of its own. However, a brief summary follows. Apart from the reuse of the existing structures, the entire complex was based on the principle of "passive architecture." This means incorporating the criteria of sustainability as an integral part of the design process, which affects every decision from the massing of the buildings down to the technical details. The aim is first to reduce the energy consumption and then to cover the remaining needs with sustainable resources. The most obvious measures taken are rigorous solar protection, water management, and low-energy consumption systems. (BBVA Madrid Headquarters is the largest complex in Europe illuminated only with LED technology.) Our aim is to satisfy the requirements for the LEED gold certificate.

Exposed Concrete, Architecture for the South

The existing buildings were also the most important point of departure for designing the façades throughout the new town. It did not make sense to us to remove the cheap, standardized cladding and replace it with "more beautiful" cladding of higher quality. By means of subtle distinctions, we wanted to express that some of the buildings are renovated and others entirely new. To this end, we moved all of the glazing inside and left the "naked" concrete supports and slabs on the outside. We show the raw structure of the existing buildings as it is; it remains visible although that was never part of the plan.

We applied the same strategy of showing unclad supports and slabs on the exterior of the new buildings, both low-rise and high-rise. Wherever possible, we also made structural and functional use of the exterior concrete elements. Upstand beams running the length of the façade in the horizontal wings and around the Plaza allow for larger spans between the supports. These upstands simultaneously serve as benches, while cantilevered slabs can be used as balconies and passageways, thereby animating the architecture in the truest sense of the word. The three-dimensional structural elements on the exterior are also part of the shading. They cast shadows and capture sunlight; they create contrasts in a fashion that could never be achieved by a

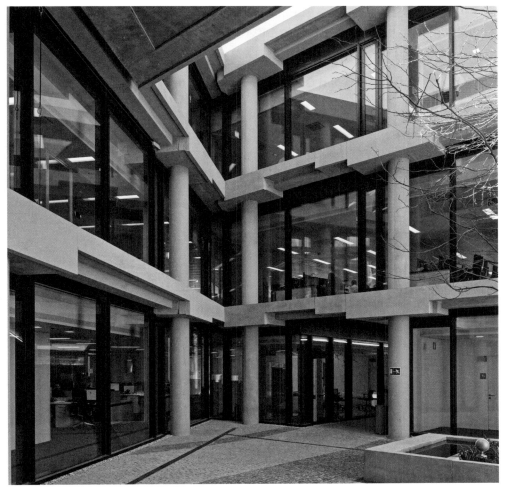

Remodeled structure in the «Old Town»

flush glass or metal façade. The sculptural syntax of concrete has taken root in architecture the world over ever since classical modernism and seems to us particularly suitable in the searing sunlight of southern latitudes.

In the high-rise, horizontal concrete cantilevers establish an affinity with the design of the lower buildings and lend it a raw appearance. In contrast to the buildings in the "carpet," the glazing in the high-rise rests outside on supports. As a result, there are no window mullions visible from inside on the regular floors; the very large panes of glass affording spectacular views over Madrid are framed by unclad concrete supports. In this way, the raw character of the building is felt inside as well.

The outline of the high-rise, the "ring," is clad in aluminium panels. This weather protection ends shortly above the ground. On the lowest floors, the

ring is exposed, where it melts into the horizontal walkways around the Plaza and the ramp in front of the main entrance.

Veiled Outside, Transparent Inside

Along the outer façade of the new town, brise-soleils, in various scales, are inserted between the horizontal slabs. These immovable storey-height elements are placed in front of both the existing and the new structures, linking old and new and making a unity of them. The result might be compared to a slatted fence encompassing the town, as in medieval times. At certain points, they are interrupted, creating gates that provide access to the BBVA town.

From an environmental standpoint, the brise-soleils block the sun and reduce the need for air conditioning. Their distinctive shape has been achieved through prolonged study to establish the ideal balance between sun protection, daylight and view. Their angle in relationship to the glass façade varies depending on orientation of the façade and corresponding to the course of the sun.

The brise-soleils are made of fiberglass. The weight of concrete would have put unnecessary loads on the structure and would have been too costly. Having settled on the choice of material, we then decided to make them white, which increases the daylight projected indoors and draws attention to the difference in material.

Working out the brise-soleils was crucial to the development of the project after the competition. We started out by working with simple right-angled panels

Working out the brise-soleils was crucial to the development of the project after the competition. In combination with the high-rise, they are the most important feature in defining the face of BBVA's new headquarters. We started out by working with simple right-angled panels, but these obstructed too much of the view. We then tried making them smaller at the bottom and reducing the mass just enough to ensure satisfactory solar protection. Before arriving at their final shape, we also studied three-dimensional elements, but they proved to be too technically challenging and therefore too expensive to produce. In terms of design, they would probably also have been too intrusive.

Inside the complex, movable textiles provide solar protection. While vertical blinds shade the windows facing the wider linear gardens in the new part of town, toldos cover the narrow lanes of the "old town." These white horizontal awnings

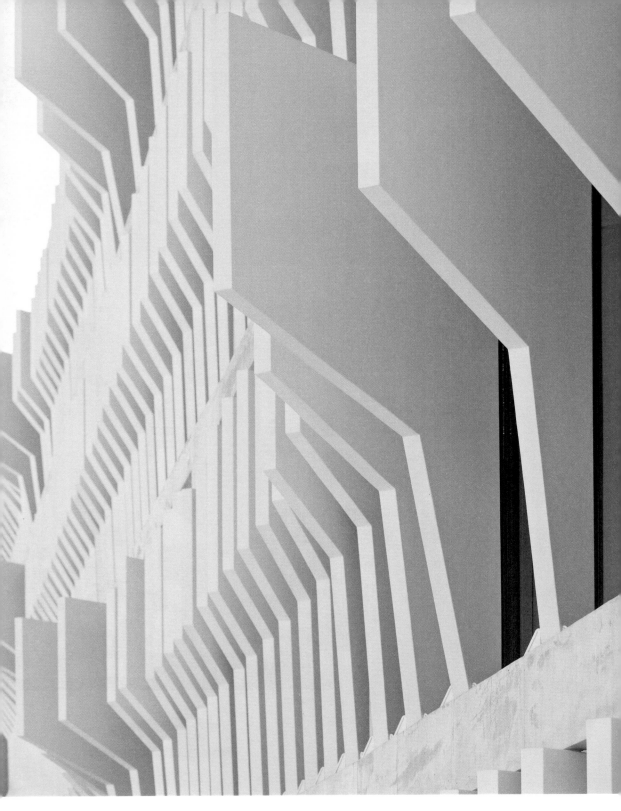

These immovable storey-tall elements are placed in front of both the existing and the new structures, unifying old and new

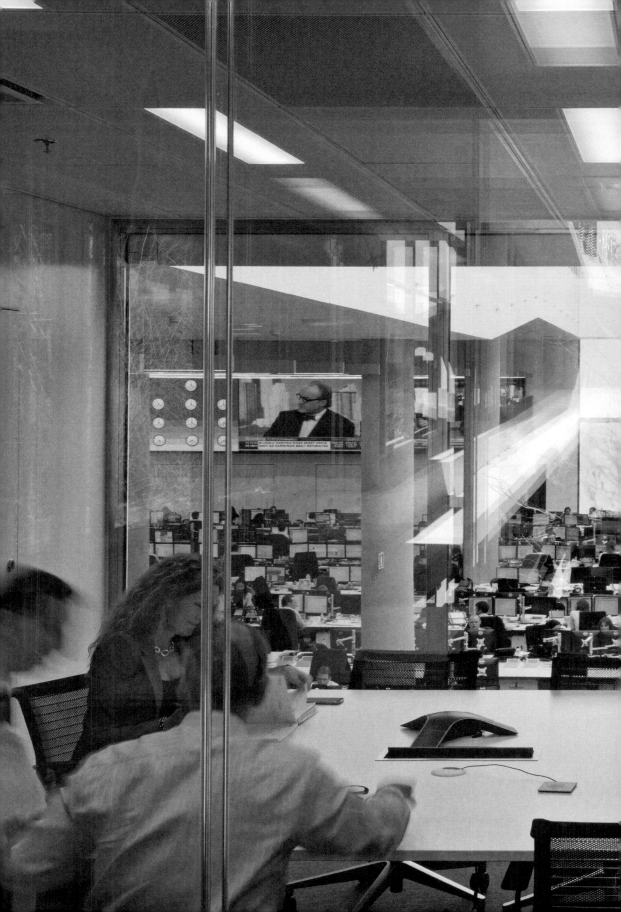

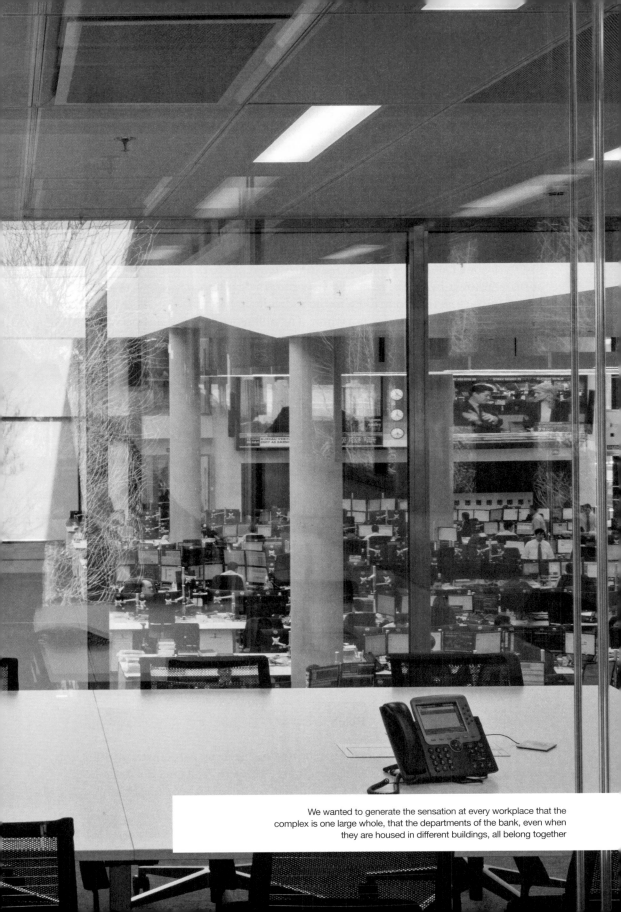

We wanted to generate the sensation at every workplace that the complex is one large whole, that the departments of the bank, even when they are housed in different buildings, all belong together

on cables, similar to those known from cities like Seville, periodically alternate with plants growing down the ropes. The play between fabric and vegetation adds rhythm to the light in the lanes but it was also the only means of including natural elements within the narrow spaces. It was not possible to load the underground garage with a layer of soil in order to plant from the ground.

The difference between interior and exterior protection from the sun is also a consequence of the somewhat barren surroundings in Las Tablas, especially the motorway, which we wanted to block from view. Inside, however, protection should be activated only when the sun is really shining in to ensure that the buildings remain as open and transparent as possible on sunny days as well.

On the one hand, we wanted to maximize reference to the outdoors in this horizontal town by maximizing the view into the gardens. The vegetation is one of the factors that contribute to the individuality and placement of each employee within the complex as a whole. The difference between one person's desk and that of a colleague lies, among other things, in the tree that is seen growing in front of the window.

In contrast to most campuses, the BBVA headquarters are at once a single building and a multifaceted town. For us, this ambiguity is essential to the project

On the other hand, we wanted to generate the sensation at every workplace that the complex is one large whole, that the departments of the bank, even when they are housed in different buildings, all belong together, like different parts of one and the same body. To describe it from a user perspective: you could be sitting in wing C, observing that shy, attractive person in wing D for years without ever talking to them—and still know that you somehow belong together, like neighbors, and not just because you happen to have the same employer.

In contrast to most campuses, comprised of single buildings laid out in one way or another, the BBVA headquarters are at once a single building and a multifaceted town. For us, this ambiguity is essential to the project. We feel there is a fruitful and intriguing potential in things that are not quite black and white.

Really a Town?

A certain amount of persuasion was required to make us participate in the competition for the new BBVA headquarters. We were reluctant for several reasons: the urban location posed a considerable challenge, the incorporation

of half-finished office buildings promised to be complicated and, at the time, our office was very busy with a number of other projects. In retrospect, we realize that the great potential of this project actually lay in the complexity of its givens. It is almost surprising to see what has come of it and we are very grateful to the bank that they insisted. It has become a project of high specificity and identity.

The campus has an atmosphere that fosters the feeling of being in a new town: there are lanes, streets, plazas and gardens, small buildings and big ones, new and old ones, rules and exceptions. It is astonishing to experience a real sense of urban density when there is a slight backup at the main entrance during rush hour. It is only at second sight that we realize that these are headquarters, and that this is one company.

The campus has an atmosphere that fosters the feeling of being in a new town with lanes, streets, plazas and gardens, new buildings and old ones, rules and exceptions

And what if we could look into the distant future? What would become of this town, tailor-made for the bank, if BBVA should someday decide to move on? Everything has been prepared so that anyone could move in here at any time. But maybe something else will happen rather than simply having other services occupy the premises. Maybe, if the walls come down someday, the surrounding city, characterized by large-scale building blocks, will discover the narrow lanes, the squares and gardens, and will turn them into its own new center, where people live and work, eat and sleep—just like the perfectly natural evolution of old village centers that are swallowed up by growing metropolitan areas and in turn give the cities an identity by mutating into their historical cores.

But let's return to the present. BBVA began moving in to the first part of their new premises last summer and the remaining employees in Madrid will move in next summer. At the latest when the trees have taken root and grown, and the ground has acquired a patina, people will begin to feel at home here. It's only after tomorrow that the new won't feel so brand new anymore. We hope that the inhabitants will soon take possession of their new town, living and working there with no thought of the architects who built it.

A Word of Thanks

Good architecture cannot come about without a good client. The many people in charge at BBVA were extremely engaged and committed, consistently detailing their requirements for us, for other planners, and for the contractors.

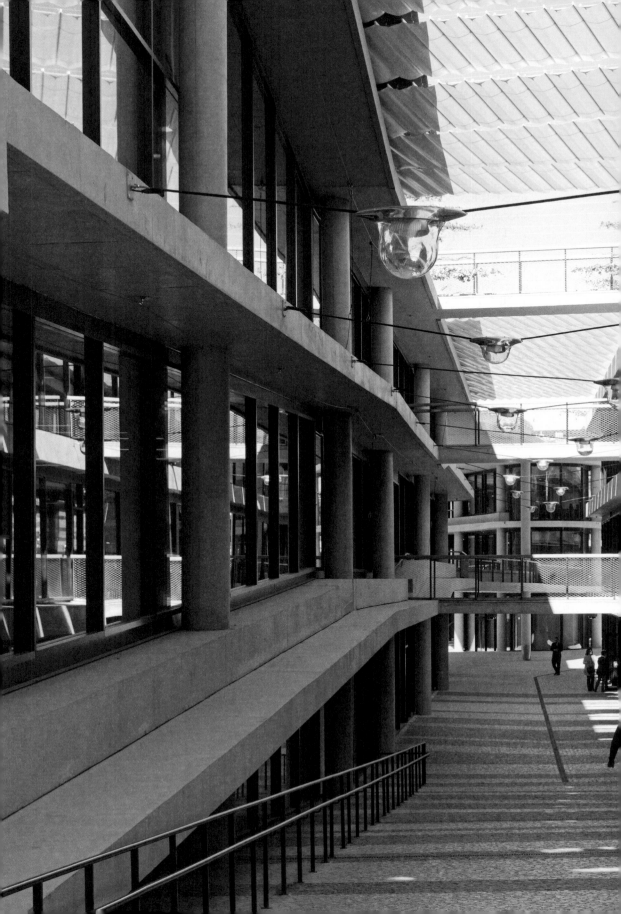

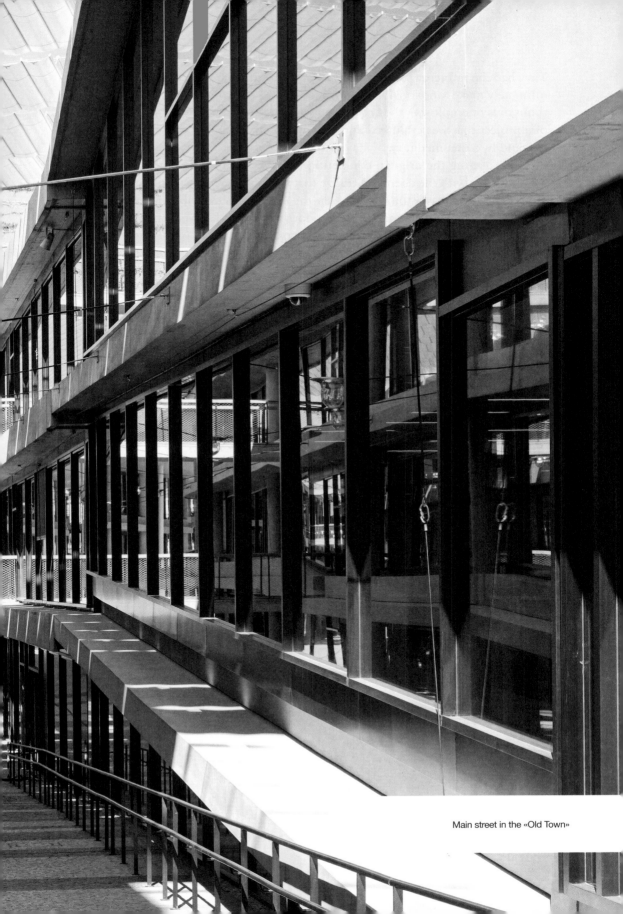

Main street in the «Old Town»

They had the immense responsibility of making sure that what they got would ultimately make functional, economic, social, and environmental sense for the thousands of employees they represent, whilst trying to maintain the identity of a project that was evaluated and finally chosen through a meticulous process and by a qualified jury.

On rereading the original competition entry, which we designed without any exchange with the client, we realize that what we see today is still quite the same project. This is astonishing, given the differences described above. This does not mean that we were right and it does not mean that we won more battles. But it does demonstrate the maturity, perseverance and commitment of all parties involved. Something really outstanding has become a reality because diverging concerns regarding details were always settled without putting the overall vision at risk. We want to thank EVERYBODY involved wholeheartedly for their personal contribution to this successful collaboration.

New Workplaces for BBVA: Promoting a Culture of Collaborative Work

The BBVA New Headquarters Team

In recent years BBVA has built new headquarters at various different sites. This article provides a glimpse of how this process took place at our group headquarters in Madrid. The original reasons for the move were economy and efficiency. But it was subsequently decided to use the new headquarters as a strategic tool to bring about a shift towards a culture of collaborative work. This far more flexible and open corporate culture—strongly supported by technology—nurtures collective intelligence and encourages innovation.

The "New Approaches to Work" project linked to the newly built BBVA headquarters focuses on the functional and personal needs of everyone working at BBVA. The aim is to guide the entire organization towards the goal of becoming the best—and first—genuinely digital bank; a bank capable of turning information into knowledge and offering a memorable and unique experience to each of its customers.

The BBVA New Headquarters Team
Various Authors

Each of the authors of this article belongs to a distinct organizational area and none of the authors is senior or junior to any of the others. The authors are proud to be a part of the major project for internal transformation discussed in this article, which has been made a reality thanks to the efforts of hundreds of people from all the regions of the world where BBVA has a presence. The article is itself an exponent of collaborative work. It was written using co-editing tools capable of bringing together the authors' expertise in real time. A collaborative setup enabled the authors to write the history of BBVA's engagement with new approaches to work.

Key Features for the Company of the Future:

Evolve
our organizations towards models of production and distribution that are increasingly efficient, personalized, easy to use, and useful to customers. The systems should be largely based on turning information into knowledge and using technology to offer every customer a memorable experience through any relationship channel they choose.

Enable
our institutions to respond quickly to customer requirements in a complex and swiftly changing environment in which threats and opportunities alike are frequent and often unexpected.

Develop
new approaches to work, aligned with corporate culture, using new methods, new technological tools and new, open, transparent workplaces that encourage fluid communication and collaboration in all company areas and empower our people to become knowledge workers.

New Workplaces for BBVA: Promoting a Culture of Collaborative Work

New Approaches to Work

Over the past two decades information and communication technologies have brought about a sea-change in the way we relate to one another as well as far-reaching social, economic and cultural transformations. The internet is a reality that still leaves a lot of room for discovery and surprise. This global, complex, exponentially growing phenomenon has the potential to change the status quo and even to transform its own nature.

The digital era of the twenty-first century is creating its own rules of behavior and offers up endless possibilities. This means many conventional business models are now facing new challenges. Mapping the best practices of a large company onto the digital environment is no simple task. Organizations are complex systems whose operation is shaped by the people within them. The operational and business know-how of a company and its people should —and can—adapt to the new setting.

The future belongs to those organizations that prove able to adapt swiftly to the ongoing changes of the digital world. Companies' survival and leadership over the medium and long term are outcomes that will be largely determined by the decisions they take today.

In the short term, acquisitions and strategic partnerships can paper over the cracks in an organization's digital presence. But if digital adaptation is to prove competitive and sustainable over time the change must be designed and propelled by the company's own people.

At BBVA, we believe the digital transformation process requires a comprehensive, end to end approach. We must meet the needs of twenty-first-century customers and rethink our way of doing banking to take it beyond the bounds of old conventions.

Our employees' on-the-job experience is a vital key in our strategy for internal transformation. BBVA's "New Approaches to Work" project—which this article is intended to explain—consists of designing and building a new on-the-job experience that makes the right fit with the possibilities and demands of the digital era.[1]

To implement new approaches to work, we have set in motion a range of actions designed to make life easier for our teams. One guiding principle is utmost respect for individuals. The project covers three distinct but interrelated areas: work environments, introduction and use of new technologies, and people management.

Many aspects of these new approaches to work are already part of the day-to-day reality at BBVA. Our project began in 2008. Today, everyone working at BBVA has access to the new collaborative working environment, which provides cloud-based co-editing office applications and lets us take part in the company's social network. Our corporate culture has evolved through the introduction of practices mirroring those of digital companies. Many BBVA employees have now moved to our new corporate sites, which have become powerful tools in speeding up cultural change.

The Power of Collaborative Work

In the digital age organizations face a whole raft of severe challenges. This is why they need to draw on the talent of all their people and develop a form of collective intelligence[2] to adapt to the new environment, achieving enhanced productivity, agility, innovation capabilities, and motivation, while interconnecting the skills and aptitudes of all the company's collaborators. All this has been made possible by the fact that technology has enriched the ways in which individuals communicate with each other. Information and communication technologies have ushered in a new wave of social, mobile, analytics and cloud (SMAC) technologies. This young technological reality enables people to connect from any location to social networks and interest-focused communities, and provides them with the tools to manage information and share it in real time.

When we work collaboratively, the likelihood of finding answers and timely solutions shoots up. And we can achieve this with the high efficiency seen in a shoal of fish or a flock of birds: every individual, faced with a threat or a change, is urged to move in the same direction by a natural mechanism. This is

a behavior we must emulate. 100% of the company must be active and aligned with a common objective.

Collaborative work, while increasing productivity and agility, goes beyond this: it is also key to innovation and creativity.

When they seriously address this change, companies adopt a new model of relationship with their people, where the priorities are to encourage cooperation among employees, nurture their ongoing learning ability, and reinforce their commitment to strategic objectives.

This effort garners decisive advantages throughout the entire process. It fosters people's motivation and their sense of belonging to a community in which work, cooperation and sharing are rewarding and worthwhile.

The quality of outcomes and decisions in collaborative work are of course largely determined by each individual's extent of understanding of and commitment to the company's mission and by his or her own skills and aptitudes. Another vital factor is the individual's attitude, because cooperation is a personal and voluntary choice.

At BBVA we believe that the combination of a team's knowledge and skills creates a broader and more complete vision than multiple intelligences and abilities working in isolation. Collaborative work creates collective intelligence and provides a crucial tool enabling us successfully to face this new chapter in our history. That is why we want to make sure that the necessary conditions of collaborative work are in place.

End to End Transformation Must Focus on People

Change both arises from and takes place in people. Our task is to create the necessary conditions to nurture a collaborative attitude in the day-to-day work of all areas of the group.

We have accordingly analyzed rising trends in working approaches within leading Spanish companies and drawn inspiration from the best practices achieved by successful firms to encourage collaborative work at BBVA[3] on the basis of three vectors of action: spaces, technology, and the human resource management model.

The main barrier to be overcome in any transformation process is resistance to change. We therefore needed to acquire an accurate understanding of people's habits, ingrained practices and usual pathways of action. We needed to be aware of how people were predisposed to change and how their motivations might influence the outcome.

To help us gain these insights, we carried out an ethnographic study consisting of intensive fieldwork in the form of workshops and in-depth confidential interviews with individuals. This research was conducted on a sample designed to reflect the plurality and multicultural diversity of BBVA's staff.

Workshops on change

This rich source of information enabled us to understand the functional and emotional needs of BBVA's people.

We examined functional needs from the perspectives of both mobility and information access. We discovered that regardless of a person's rank within the company functional needs were classifiable into four categories: leader, guru, problem-solver and producer.

When considering emotional needs, we avoided any sort of oversimplified socio-demographic analysis whereby we might have labeled people by generation and taken for granted that everyone within a given generation behaves the same way. We specifically assessed attitudes to technology adoption and willingness to accept change.

We did not classify our people on an individual basis. Instead, we drew up notional profiles on the basis of people's starting point with regard to the digital transformation process we were about to undertake. These profiles were predicated on two scales: innovative-conservative and analog-digital.

The new on-the-job experience at BBVA was intended to be all-inclusive so as to encourage collaborative work. Its design accordingly had to meet the needs of the sixteen study profiles (given that each functional profile can be found in combination with any of the four emotional profiles). The solutions we came up with addressed all three concerns targeted by the "New Approaches to Work" project, and had to be consistent with one another.

Chart 1. Functional and Emotional Profiles

EMPLOYEES

Very mobile

	Leader		Guru	
Management				Content
	Problem solver		Producer	

Not mobile

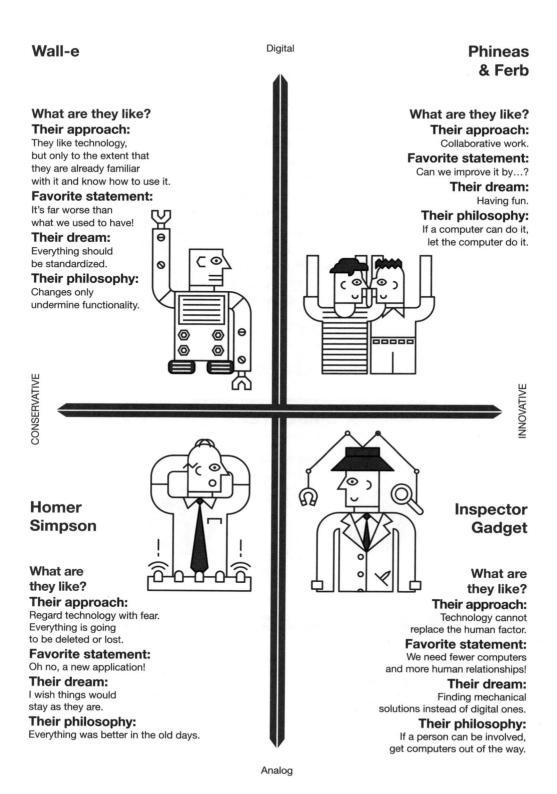

We found that employees' day-to-day work experience starts out from the tangible and evolves towards intangibles. The physical environment directly affects our comfort, attitude and state of mind. Digital-era technology shapes the way we work, communicate and relate with one another. Finally, everything we do is enveloped by corporate culture, urging us into action towards a shared vision (chart 2).

Chart 2. Design of Employee Experience Based on Solutions in the Spatial, Technological and Cultural Domains

Spatial Digital Intangible

Spaces for Working and Living Together

BBVA has almost 160 years of history behind it. Over this time, more than 150 different entities have been merged into the organization. As a result, the group occupied a very large number of buildings. In Madrid alone, in early 2010 our people were spread out across twelve different sites.

A comprehensive process of space streamlining offered us significant cost savings and increased efficiency. In addition, most of our buildings were located in entrenched city cores. This meant that the opportunity to enhance efficiency was compounded by the gains to be made from moving to suburban areas.

The decision having been made, we might have done no more than relocate within each of the cities where we operate, or refurbish the existing facilities. But we took a far more ambitious approach. Why not make a radical change in the way in which we work and live together? In answer to this question, the company conferred strategic status on this project.

At the start of this race towards change one of the most important lines of work embarked upon was the design of buildings, common areas, and work rooms. The new spaces had to reflect the way we are and the way we understand business. They had to be designed with a focus on people, and invite people to interact. We wanted simplicity—no outward or inward status symbols—and a distinctive identity imbuing every corridor and corner of a building that would welcome us both as professionals and as people. Every space had to be functional and practical for us to do our business, while offering comfort and being respectful towards the environment.

To try out the effectiveness of the designs we ran a pilot test. We conducted our tests at widely diverse workplaces: BBVA's first innovation center; the La Moraleja Campus, our main training site; the branch office network, to gather information about customer perceptions; Tres Cantos Technological Data-Processing Center in Madrid; and, finally, in a building adjoining our present corporate headquarters on Madrid's Paseo de La Castellana, to ensure that the new spatial designs were supportive of head office work. Our pilot test enlisted the active participation of everyone who at the given time was at work at our various sites, regardless of their function or organizational rank.

The highly encouraging results of the pilot test led us to introduce the initiative elsewhere: additional tests were run at our sites in London, New York, Asunción, and Lima. This helped us create a new workplace structure to leverage the end to end transformation we had envisaged.

The new spaces had to reflect the way we are and the way we understand business. They had to invite people to interact

The experience enabled us to produce the first version of the *Corporate Space Manual*, the content of which was applied during the construction of BBVA Compass Plaza Houston, our corporate headquarters in the United States.

This step forward taught us a key lesson: any reshaping of space must aim at a soft landing. Intelligent management mitigates people's sense of uncertainty, lays to rest various fears, and encourages involvement.

As a prelude to the arrival of the first employees to La Vela, our new corporate headquarters in Madrid, we created experience maps to identify every critical point entailed in the move. Our aim was to make sure our people would feel comfortable at all times and forestall any potential issues. We designed an

orientation program for those of us who were to move to the new venue. This initiative was dubbed "BBVA Discoverers."

The first moves took place in July 2013. By October, the transfer of close to 1,900 people had been completed. The key milestone in terms of business consequences was moving the Group's main cash management desk—this was achieved without incident.

La Vela: new spaces for work

The lessons learned from this big push forward informed our second version of the *Corporate Space Manual*, which we published in advance of further moves to La Vela in Madrid and new headquarters in Mexico City, Santiago (Chile), and Buenos Aires. By late 2015 more than 17,000 employees will be working in a new environment designed to foster a more collaborative and digital-based experience.

La Vela attracted a large number of visitors. As a result, many of our teams chose not to wait for the move and instead remodeled their existing buildings on the pattern of the new spatial design, leaving behind the conventional model.

The path we have taken goes far beyond a mere redesign of workstations and meeting rooms. It entails a new way of "living" together. And, what's more, it provides a stimulus for each one of us to develop new capabilities, face new challenges, and undertake new creative processes.

Design as the Catalyst of a New Mindset

The design of our new work environments was guided by three main criteria: the environment, consistency with brand values, and the fostering of collaborative work among people. The criteria, what's more, were to be global in scope: all BBVA headquarters had to be restructured in the same way.

As a result all our buildings around the world provide a uniform experience. There is no need for corporate logos or colors—as soon as you walk into one of our sites you immediately sense the BBVA "character." Any of our employees, regardless of their place of origin, will feel at ease in any of our buildings. They will recognize the entry systems, the elevators, the transparent meeting rooms, the open plan workstations, the brainstorming sessions. They won't need extra time to adapt, or special guidance—they'll fit right in straight away.

Pathways within buildings are identical across all headquarters, from entry points, workstations, meeting rooms, and lounges to other communal areas.

Our commitment to the host community and the environment was a priority from the outset and made its mark on the construction process, as borne out by the buildings' LEED certificates.[4] We also applied strict criteria in the domains of sustainability, energy efficiency, emissions reduction, disabled access and support for environment friendly practices, as shown by our ISO 14001 certificates.[5]

These principles inform the overall structure, interior decoration, and furniture, and can even be seen in minor details, such as built-in electronic noise canceling systems that lower the volume of people's conversations. Quality, comfort, human factors, and simplicity are the hallmarks of all our headquarters buildings.

Entry points are people-friendly. Security checks on entering and leaving the building are quick and easy, and follow a protocol designed to protect people in the event of evacuation. Regular and pre-accredited visitors can self-register using the booths in the entrance hall—this prevents long waiting lines. At any BBVA Group headquarters building you can identify yourself using a conventional swipe card, your fingerprint, or the NFC (Near Field Communications) chip in your phone.

La Vela: informal lounges

Openness and transparency are features of all our spaces—meeting rooms, workstations, and informal lounges.

Before designing the meeting rooms we considered the question of what sort of working dynamics we wanted to encourage. As a result we devised several different configurations, ranging from small hotspots for private calls —furnished with just a table and a telephone—to very large meeting rooms equipped with state-of-the-art videoconferencing systems and collaborative co-editing tools.

Personal workstations are positioned along collective workbenches which are free of any physical or visual barrier between colleagues. The design dispenses with the conventional concept of an "office" in favor of an open space.

Informal lounges are furnished with small armchairs and coffee tables to facilitate casual interaction and dynamic meetings conducted on the fly. To give BBVA headquarters a standardized image, in communal areas we installed screens, video walls, and totems that provide passers-by with useful local information.

One very powerful approach within the process of end to end transformation is to design open spaces that encourage an exchange of insights. We placed special emphasis on the need for each of these spaces to receive natural light and integrate with natural elements so as to help our people to concentrate and hold friendly, productive meetings.

The search for the most suitable setting for our headquarters led us to create services that make life easier for our people. For instance, our buildings are supported by urban mobility plans that enable our professionals to commute easily, whether using public transit or their own means (bus lines, walkways and covered passages connecting to our buildings, and so forth).

Restaurant and catering venues are available in the neighborhood and even within the workplace itself. All public locations—restaurants, cafés and plazas—provide meeting points and are equipped with mobile connectivity to enable use as informal workplaces.

Design and technology have evolved the workstation from being an individual, concrete point to becoming an array of location choices, both within and even outside the workplace.

BBVA has always been concerned with nurturing a good work-life balance for our people. Our headquarters accordingly had to be equipped with day-to-day services (tax advisers, pharmacies, dry cleaning, shoe repair, online purchase delivery points).

Family-related services, such as kindergartens and infant schools (on-site or at third-party facilities), provide support for employees with parental duties during school vacations.

One of the options that our employees value the most is the availability of spaces for enjoying time off and healthy living. BBVA headquarters embrace

sports facilities and places for meditation and relaxation, enhanced by ongoing programs focusing on suitable exercise, nutrition, and healthcare.

To optimize employees' use of these services, in 2014 we launched our app *Hoy Necesito* ("What I Need Today"). Starting out as a one-stop shop for service requests, the app evolved into a central point of access to all services available to BBVA people at any of our headquarters buildings around the world. Embedded in the collaborative work setting, the app looks at the user's digital profile and order history to help them fill out the new request and offer other services they might want.

Helping People Adapt and Listening to What They Say

The move to a new Group headquarters was an ambitious project involving almost 6,000 people spread out over a large number of buildings in Madrid. The program had to be comprehensive, embracing all our professionals, to help them adapt, forestall issues, and deal with potential misgivings.

When someone switches to a new workplace, they may feel disoriented and unsettled. To prevent this, we set up a website to help our people become familiar with the new headquarters and the details of the upcoming move. We created a personalized assistance plan for the "pioneers" (known as "blue jackets"). We also formed a small group—dubbed the "BBVA Discoverers"[6]—to look after the human and emotional aspects of the move.

We formed the group "BBVA Discoverers" to look after the human and emotional aspects of the move

This role was entrusted to a team of slightly over 100 carefully selected people. The features required were a highly positive attitude to change, a high degree of recognition among colleagues, and the ability to spot problems in advance.

This "discoverer" initiative became the key to unlock the whole process of adaptation. Organized into 15-member "expeditions," the pioneers got to know La Vela while it was still under construction. The adventure of moving to a new building proved a fun, rewarding experience. Once back at their usual work locations, the discoverers shared their experiences with their colleagues, teams, and bosses. They helped people see the move in a positive light—but for their role, this might have been impossible.

When the first buildings of the new complex were finished the "discoverers" undertook an even more meaningful task: they walked their department colleagues through the process of the move and shared their earlier experiences with them, so helping people to avoid stress and fears. They also served as a conduit to communicate the concerns, issues and suggestions arising in

the course of the first round of relocations. This feedback helped improve performance in the later stages of the move.

Because the "discoverers" experience had turned out so well, we created a specific team dedicated entirely to improving the day-to-day running of the headquarters—making sure people were happy there, responding to their concerns, complaints and suggestions, and conveying the BBVA experience to visitors to the complex.

In addition, we set up a Governing Board comprising members drawn from different departments. The Board meets regularly to coordinate fresh moves of employees from other sites, evaluate the success of each move, and draw any appropriate conclusions that might improve the process in future. This Board—a prime example of collaborative work at BBVA—has been replicated at other major headquarters of the Group.

La Vela while under construction

La Vela, an Icon of the New BBVA

The new Group headquarters in Madrid, designed by the highly regarded Herzog & de Meuron partnership, provides a unique opportunity to bring into being the paradigm shift we set out to achieve some years ago by designing new approaches to work.

BBVA did not play a passive role in the creation of the new headquarters, known as "La Vela." La Vela is the endpoint of a process of thorough introspection, in-depth familiarity with the various profiles of our professionals, and the internal renewal that we demand of ourselves to remain competitive in the new digital era. In addition, we engaged in an open dialog with the architects, who contributed broad-ranging experience and expertise, and a distinctive esthetic and philosophical vision.

Herzog & de Meuron's design deftly brings together the values we hoped to see in the project: efficiency, sustainability, innovation, and commitment to people. The new headquarters, spread out over six hectares of land, has the capacity to accommodate 6,000 workstations and 3,000 parking spaces. There are three types of building:

- A 19-storey tower, 93 meters high. The name of the building was not chosen at random. To get our people involved, we ran an open competition. We wanted a simple, short, easily remembered name with universal, positive connotations. The final choice couldn't have been better. In fact, the name of the tower—La Vela, or "the Sail"—is also the name of the whole complex.

- There are seven long, three-storey buildings, named after the continents, separated by alleyways named after seas and oceans. All the buildings cluster around a large central Plaza, measuring 100 meters across. Besides work areas, restaurants and services, this is the site of the visitor reception center and the auditorium.

- A services building where BBVA employees are provided with a kindergarten (for children aged 0 to 3), a sports center with a semi-Olympic swimming pool, a gym, and physiotherapy facilities.

When addressing the design of what was to become La Vela, we realized that this was an opportunity to undertake an inspiring metamorphosis in our approaches to work, cooperation, and coexistence, our way of understanding new challenges in the banking industry, and our insights into how best to contribute to our host environment. We wanted La Vela to help drive our internal transformation, without losing sight of the need to be "good

La Vela: BBVA walkway

The BBVA New Headquarters Team

neighbors" in the Las Tablas district by lending our support to the urban development of northern Madrid.

We did a lot of research to make sure the complex and our presence would be a model of corporate citizenship and add value to the community. We wanted residents to view us as part of their neighborhood. Our aim was to work with our neighbors to make sure our presence disrupted their day-to-day lives as little as possible.

So we gave much thought to the services we could contribute to the area —something that would be of real use to our neighbors. Some of the facilities built for our employees—such as the BBVA walkway—were accordingly opened to public use.

BBVA has always contributed to the urban development of cities where it opens for business. In Madrid, BBVA has played a key role in the core areas of the city and their growth, as exemplified by our buildings on calle Alcalá, paseo de Recoletos, and AZCA—and, now, our new headquarters at Las Tablas. The drive towards renewal—which changes us both inside and out—is the true engine of this organization. This hallmark of the company explains our new strategy and the determination with which we are carrying it out.

La Vela: detail of the façade

Environment: Sustainability and Energy Savings

At BBVA we take corporate citizenship seriously, and this, too, is reflected in our new headquarters. The campus is certified to the ISO 14001 standard. We have also fulfilled the sustainability criteria required to achieve a LEED (Gold Level) certificate, one of the most demanding standards of sustainable construction.

The building materials are low-environmental-impact and the complex is designed to support remote monitoring of energy usage. We installed rainwater collection systems on the roofs for landscape irrigation and greywater reuse. Our recycling collection points cover almost 100% of the waste produced.

Construction was carried out using recycled steel and aggregates, and most of the wood was certified by the FSC (Forest Stewardship Council): this means it was sourced from responsibly and sustainably managed forests.

Our complex is the largest in Europe to be lit using LED technology. This makes for 30% energy savings versus conventional fluorescent lights. The lighting management system saves a further 60% through presence detection and accounting for the contribution of natural light. The system automatically raises and lowers the blinds in response to the position of the sun and interacts with climate control devices to optimize temperature when spaces are left empty.

The state of installations and energy usage are monitored in real time from a central control room, allowing for outstandingly accurate energy management and maintenance services.

A large proportion of energy requirements are fulfilled using on-site renewable sources, such as thermal and photovoltaic solar panels and closed-loop geothermal energy, which draws on the stable temperature of the subsoil. Overall, our systems lead to 7.6% savings in carbon dioxide emissions and 8.3% savings in energy usage.

Active chilled beams remove the need to generate and shift large volumes of climate-controlled air throughout the complex. Compared to conventional systems, this approach makes for 5%-11% energy savings. The chilled beams are equipped with micro jets which use induction to push air through cold/hot water batteries, thus achieving climate control without need of inbuilt fans. Beyond the chilled-beam system, climate control throughout the campus is designed for high energy efficiency and uses the highest-performance engines and production systems available on the market.

The façade is made up of large, transparent, low-reflective, air-chambered glass panes shielded by strategically oriented outer slats. By acting as a filter for radiant energy from the sun the outer slats reduce the heat load inside our offices. These high-performance glass panes and slats minimize undesired energy losses and gains through the façade.

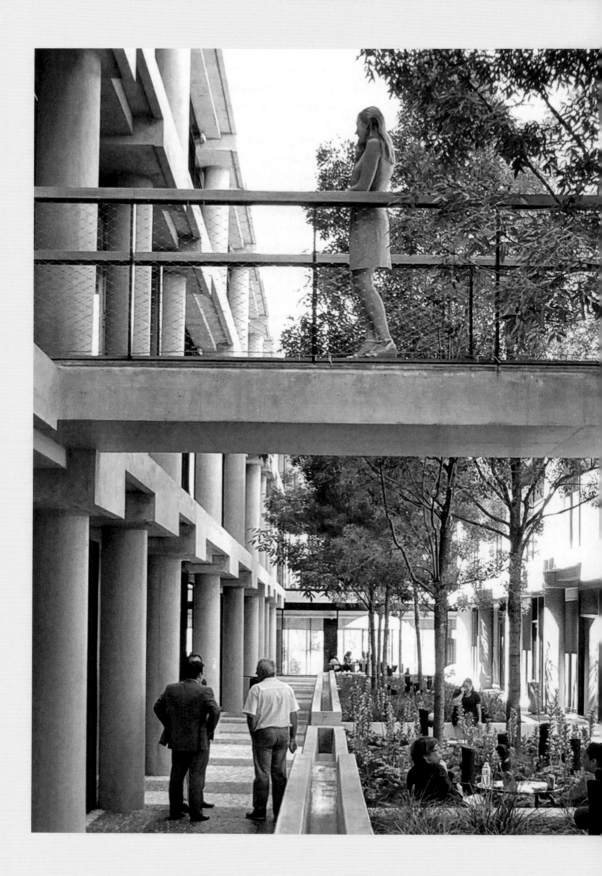

La Vela, green areas

Perhaps one of the most distinctive aspects of the project is the envelope of each building. The façades reduce energy usage and integrate new structures with existing ones. With more than 49,000 m² of glass façade on campus, almost all office space is endowed with views of the surroundings or of inner courtyards. Employees are shielded from sunlight by a total 2,800 prefabricated slats which have been anchored to the structure in carefully calculated configurations.

Rainwater captured on the roofs is channeled to treatment tanks and reused for irrigation. Wastewater generated by hand basins is reused for lavatory flushing, leading to a 50% decrease in the consumption of drinking water.

Landscaping with a wide diversity of trees, plants and shrubs provides sound insulation for our buildings. The broadleaf trees in the Plaza provide shade in the summer while letting through sunlight in the winter. The climbing and hanging greenery in the inner "streets" shield pedestrians from the sun. The gardens have been populated with native plant species capable of surviving the dry local climate. The watering facilities interact with a system of canals and other cooling water features to encourage the emergence of microclimates.

La Vela has more than 31,000 m² of green areas, close to 100,000 brushwood and shrub specimens, more than 400 hanging plants, and over 450 trees. The roofs are covered with extensive vegetation which requires minimal maintenance and reduces carbon dioxide emissions. The green roofs, combined with the fact that parking facilities are located underground and that campus materials are highly reflective, make for lower temperatures within the buildings and mitigate the "heat island" effect.

Technology Within Reach of Everyone

On our way towards new approaches to work, technology is not just a facilitator—it can and should be an engine and accelerator of change.

Like the other domains of BBVA's end to end transformation, the process of technological upgrade focuses on people. Our starting point was to listen to our people to gain a first-hand understanding of their real technological needs, both present and future.

This was no routine in-house survey: it was a far-reaching effort designed to elicit people's personal motivation. We conducted interviews and use-case sessions with a twofold objective: first, to identify individuals' needs targeting specific tasks; secondly, to ascertain what they wanted as managers of specific areas of BBVA. This approach resolves the person/employee dichotomy which might stand in the way of effective implementation. Rather than be imposed as a mere corollary of membership of an organization, the change we want to achieve must take place within each person.

The process gave rise to stimulating concepts, such as "What I Need Today" —the service request system referred to earlier—"Bring Your Own Device" (BYOD) initiatives, and the perceived need for being permanently connected.

The BBVA New Headquarters Team

This exploration and analysis enabled us to produce a comprehensive catalog of the technologies required to underpin the day-to-day experience of a BBVA employee. The compilation was drawn up on the basis of user experiences. For example, "What do you need for a videoconferencing session?" "What services would you like to see in your nearest digitization center?" The answers to these questions enabled us to write our *Technology White Paper*, which specifies the minimum experience that must be available at every point where an employee comes into contact with technology.

***Technology White Paper:* A Compendium of the Technology Experience at BBVA and the Technical Requirements of Supporting It**

The development of the *White Paper* has proved decisive in this process of internal change. One key conclusion was that the boundaries between physical and virtual workspaces were blurred. We also found that spaces and technology are closely interrelated, as are the new approaches required to achieve change.

The technology infrastructure must be able to support basic requirements. This is something everyone took for granted during the interviews, but it truly is of the essence for everything to work. That infrastructure includes connectivity, communications, and the intelligence of the building itself (hundreds of kilometers of fiber optic, thousands of kilometers of cable, thousands of grid connection points and sensors, hundreds of Wi-Fi antennas, scores of electronics rooms, distributed data centers, etc.), and must be implemented in step with the construction of the whole headquarters.

Smart Headquarters

The main purpose of the infrastructure is to support voice and data communications at any time and at any location. But it must serve other aims, too. Electronic development has led to a second internet revolution: what is now known as the "Internet of Things." At BBVA we are getting ready to make best use of the potential this involves.

A wide variety of sensors (presence, temperature, humidity, light intensity, etc.) have been installed at our headquarters; they are all connected to one another and controlled in a centralized way to allow for smarter energy management. They also let us analyze the way the buildings are used. The vast quantity of information captured by the sensors requires us to use Big Data techniques to sift through it for patterns and anomalies in various parameters. We can then find ways to improve service standards and human factors.

Our transfer to a new headquarters involved moving not just equipment but also a mass of information. Some of the company's data is in the form of decades-old sheets of paper. For legal reasons this content must be preserved; but it doesn't fit in with the design of the new digital environment. We accordingly set in motion an ambitious digitization scheme. We saved costs in terms of paper and storage space, shortened implementation timeframes and acquired new capabilities in digitization.

To achieve comprehensive digitization and avoid the use of paper entirely we designed spaces called "digitization islands," which provide all the necessary services to port paper documents to electronic files. People can then work with the documents from any location and share them quickly and easily. Digitization islands also let you print—it's not forbidden, and nobody will call you out for it—but we have found that printing decreases exponentially when easier and more efficient methods become available.

At the new Group headquarters in Madrid we attained an 80% reduction in the space given over to storing paper, and moved on from a ratio of one personal printer for every 1.5 people to one printer for every 50 people. Thousands of personal

printers have been replaced by a few hundred digitization islands, thus drastically reducing the environmental impact of ink cartridges and the use of tons of paper.

A key challenge when deciding what technology is needed in the new dynamic, collaborative spaces is identifying the requirements of meeting rooms. It is here that the convergence of the three aspects of the project—technology, spaces, and culture—becomes most visible. Our chosen solutions start out from the initial step of booking a venue. A single process has been put in place so that you can book a room anywhere in the world (regardless of your own location at the time), tie services into your booking (videoconferencing, catering, etc), invite the attendees, and share the relevant documents with them.

> In the meeting rooms the convergence of this three aspects of the project—technology, spaces and culture—becomes most visible

Our people's jobs entail frequent mobility; when someone cannot be physically present at a meeting we need to put them in the room in virtual form. In addition to providing telephone and videoconferencing communications, digital workspaces must be shareable and support remote co-editing. We have in place state-of-the-art audio conferencing, videoconferencing and remote-presence systems, as well as collaborative video call solutions that meet a variety of needs. To make sure that all this complexity is transparent the systems are interoperable. Within one and the same meeting you can link a telephone call to a videoconferencing session and a hangout, for instance.

Multimedia technology is also present at building entry points, auditoria, common areas (hall, café, etc.), cash management facilities, and elsewhere. The design of "digital signage" is shaped by the specific features of each building, but its content can be managed locally and globally to create and maintain a "family language."

In years to come, all screens and video walls in all our buildings will be "smart," providing personalized information and multiple forms of interaction (gesture, voice, touch and personal devices).

When the "interactive window-dressing" concept is combined with personal identification devices and location-based services, you could say that at BBVA you're not necessarily crazy if you "talk to the wall"!

It is increasingly common to see people wearing sport wristbands, smart watches, augmented reality glasses and devices that track the body's vital signs. These gadgets supply us with information about ourselves and our environment. They are even able to send out an alert into the environment about our own situation—this could prove a lifesaver in medical emergencies. The possibilities of this technology are already being tried out in day-to-day life at La Vela. We are testing a new visitor accreditation system using Google Glass to streamline the process and shorten visitor waiting times.

Technology for Digital Content and a Family Language

Interior location-based services currently depend on a complex system of beacons. In a couple of years, La Vela will be "aware of itself" and "know" everything going on within it. At any given time, the building will know where each person and object is located. One potential benefit among others will be that we can respond more effectively to emergencies and events requiring evacuation.

Collaborative Environment in the Cloud

The BBVA Collaborative Environment is a desktop in the cloud. Any employee can access their own information and shared files from any location, at any time, using any device.

This secure cloud-based platform lets people quickly roll out the solutions needed at the given time. With a single click the Collaborative Environment administrator can make a new app available to the bank's 110,000 employees,

who can use it instantly, without need of updating. These capabilities are unlimited. The processing and storage capacity of the cloud is infinite, and there's no need to deploy new infrastructure.

Leaving aside the technical details of the digital environment, the key is that it was designed with an eye on the needs pyramid of its users. The pyramid sets up an order of priority for the various elements of the Environment, ranging from mere function (Functional) through availability in all contexts (Reliable), assurance of a unique user experience (Usable), and collaborative work before individual work (Community), to the top of the pyramid—an enjoyable experience (Fun).

In the digital age users are not just information consumers: they want the ability to create their own information and share it with others. The design of the Collaborative Environment focused closely on BBVA employees' shift from consumers to "prosumers."

Another hallmark of the Collaborative Environment is extreme personalization. Minor details such as menus and personalized alerts, configurable sections and user profile pictures help people to acquire a sense of belonging to the Collaborative Environment and to manage their own desktops. The platform also supplies all the tools required to safeguard the confidentiality of the data handled by each person: information is shared according to a scheme of different roles and permissions.

The bedrock of the Collaborative Environment is the power of data to provide users with unique experiences. For instance, the search engine embedded in the web-based desktop uses heuristic algorithms that generate results in line with the given user's specific search patterns and successful past searches. Another example is that when the documents linked to a user are viewed by someone else, a permission-based filter comes into play. All user interactions with the Environment are logged and made available for analysis in the aggregate. This means we can identify usage patterns with a view to developing new functionalities.

What's more, the fact that the social network ties in with every element of the Environment makes collaboration among users in each functionality a reality. You can comment on company news, vote in favor of other people's initiatives and create special-interest communities. Integrated use of the social network within the Environment creates a new model of company/employee relationship, and new communication channels among employees themselves. The concept of a "digital community" has thus emerged for the first time at BBVA.

The web-based version of the Collaborative Environment provides access to all the tools you might need for day-to-day tasks: email, directory, documents, news, BBVA social network, and management applications. In addition, you can share and co-edit documents and place information in personalized folders ("My Tasks" or "My Projects").

In a hyper-connected world the Collaborative Environment supports BBVA employees wherever they go by means of a corporate smartphone with an ecosystem of native apps offering equivalent functionalities.

This ties in with the "personal assistant" app. For example, the app looks at traffic conditions to tell you what time you need to start making your way towards a meeting to get there on time. The concept involves a shift in the role of a particular category of employees. The traditional personal secretary role has evolved towards a team assistant role. Through specific training in new collaborative tools these employees can become "viral" agents for change.

The bedrock of the Collaborative Environment is the power of data to provide users with unique experiences

To be Digital or Not to Be, That is the Question

For BBVA, technology is a means, not an end in itself—it should therefore never be viewed as a status symbol. Equipment is allocated to our employees on the basis of need, not rank. To meet their needs, we identify two main axes: mobility and portability.

"Mobility" means immediate access to information within the Collaborative Environment and immediate connection to colleagues. So mobile devices (tablets and smartphones) are allocated to all employees.

"Portability," however, means access from outside the workplace to systems containing sensitive or confidential information. This type of access must be protected by security safeguards as to data authentication and transfer; we achieve this using appropriate security filters, encryption and app virtualization. Employees requiring this kind of access receive latest generation ultra-books. Desktop computers are allocated to employees who do not need to use those systems except when at their workstations.

For us, technology is a means, not an end in itself—it should therefore never be viewed as a status symbol. Equipment is allocated to our employees on the basis of need

We cannot ignore the Bring Your Own Device (BYOD) trend. Mechanisms are in place—information authentication and encryption systems—so that personal devices like smartphones and tablets can be brought securely into workplaces.

Once a given individual's equipment has been allocated, it becomes a priority to ensure that they can use its full potential. A prerequisite for this to happen is a change in personal attitude towards technology. Our "citizenship" of the digital world requires us to have a "digital identity" where our personal values are consistent with our professional values. In the world of work today, being digital is no longer a choice—it is now, and will continue to be in future, a duty.

To develop our digital identity, we need to move forward on two fronts. First, we need to handle our equipment's hardware and software as adeptly as a digital native. The new tools of the digital era provide professionals with more independence, but also require a longer learning process. We need to self-manage the security of our personal and professional information, monitor our own image on social media, edit files effectively, be aware of the uses of mobile apps, etc. Secondly, we need to develop new skills, such as active listening, critical thinking, and assertive communication.

To guide people along this path, BBVA runs specific training actions. The technical support service is located in common areas, spread across a number of highly visible booths called "Smart Techs." Smart Techs are always open and available to deal with queries and issues with devices and software.

These new technology spaces are highly effective for many reasons. People are far more receptive to advice and training when they approach tech support on their own initiative. The outcome of the advice is then shared across our

knowledge communities, which means other colleagues can identify the solution when a similar issue comes up.

Going still further, the digital medium itself provides a tech support point. We have launched a help website where tech support experts and users can publish and view tutorials. We created a community on the BBVA social network through which employees can make suggestions and help solve one another's problems. Page views for this community have risen exponentially from the very first day it came online. Actions requested from the "official" tech support service have decreased—this is a robust indicator of effective collaboration, which shows that the process of transformation has already begun and will accelerate from now on.

Our Common Ties: Corporate Culture

The extensive literature on collective intelligence agrees that organizations' most important asset is knowledge. This insight is even more relevant today, because knowledge is the engine that drives emerging technologies.

George Pór has pointed out, however, that collaboration is vital to ensure that knowledge arising in an individual's mind acquires added value through being processed by others, leading to further stages of knowledge. This is the purpose of collaborative work.[7]

Information technologies let us manage our knowledge, but in themselves create nothing. The key is to get people to collaborate with one another. This has a lot less to do with IT platforms than with a change of mindset: a change of culture.

This is why companies need to create a framework that nurtures the new collaborative paradigm. To be genuinely effective and embed the collaborative spirit in the organization's DNA, that framework must be accurately aligned with corporate culture and be fully consistent with it.

To encourage collaborative work has given us a compass-needle in everything we have done since we began the project in mid-2008. Since then, we have adapted our corporate culture step by step, guided by the vision we share as an organization: "At BBVA, we work towards a better future for real people."

Delivering the Best Possible Customer Experience

By linking together new technologies—like Big Data, cloud computing, artificial intelligence and smart devices—we can create predictive models to diversify and personalize our services and deliver them effectively to consumers. It is not enough to create and distribute a product or service, however

excellent it may be in itself. We need to satisfy customers' emotional needs by giving them an experience that goes beyond their expectations.

Thanks to social media "virality," digital businesses have turned good user experiences into a global movement that favors those businesses' interests. The traditional rule was that a satisfied customer would report their good experience to their social circle less than half the time that an unsatisfied customer would report their bad experience. The internet, however, means that both good and bad experiences can reach millions of potential consumers.

Customer experience is key, and its design has become a strategic function within a company. Over the past decade design has moved on from being a purely esthetic discipline to guiding everything that a successful digital company does, starting with the service concept itself. To deliver the best possible customer experience we need an accurate understanding of customer behavior and motivation. Traditional know-how must be enriched with disciplines which the business world has so far ignored, such as anthropology, sociology, and psychology.

For such a wide range of disciplines to be addressed successfully we need a team with the right talents and the ability to work collaboratively. To align the members of a multidisciplinary team with a common goal the work to be done must be rigorously organized, and there must be a consensus on a robust evidence-based decision-making process. The principles of Design Thinking are best suited to the situation. The first step in the method is to gain insight on customers (what they say, do, think, feel and, finally, believe). Next, the team develops a wide range of creative alternatives for reaching customers. Finally, the best approach is selected on an objective basis.

After the customer experience has been fully designed, it must be made a reality. The construction of digital products and services requires tech profiles in many different fields (security, data, coding languages, etc.). Technology departments traditionally worked in sequential, non-overlapping phases: technical design, programming, testing, deployment, and so forth. This approach is now obsolete because it is too slow to respond to new market demands.

In the digital age, everything is in real time. Given a context where things happen immediately, delay in developing the chosen design solution is simply not an option. A company can take the lead in its market and then be driven out of it altogether by being too slow to launch its next product. Similarly, a late response to a customer risks destroying their loyalty to the brand.

To make development more agile, the construction of the design experience should be divided into blocks of product functionalities that customers perceive as valuable. This division allows for several small development teams to work swiftly and in parallel. The end product is built by

successive approximations, each of which is improved using customer feedback after each iteration. The teams involved work collaboratively in short cycles, in the awareness that every decision they make directly impacts final customer satisfaction.

In the field of software development "Agile" methods such as "Scrum" make a perfect fit with these new and far more dynamic approaches to work.

Team-based structuring and correctly delimiting blocks of tasks are the toughest propositions in the process of implementing new approaches to work. To be effective they cannot be limited to a rethink of organizational structure. There needs to be a change of mindset and behavior in employees themselves. One of the outcomes of this new way of designing and building products is that empowerment arises naturally, because in order to create an experience that fires up the customer's enthusiasm the multidisciplinary team makes a wide range of strategic decisions.

The presence of all the disciplines involved throughout the various stages of designing and building the product or service ensure that the changes called for after each iteration are implemented in an agile and coordinated way. The greater the number of people adopting collaborative work dynamics within an organization, the higher their ability to synchronize delivery timetables. This is the way to build a more dynamic organization step by step, which gradually becomes a genuinely digital company.

Design of a collaborative work room for Agile and Design Thinking projects involving people at different locations

New approaches to work clearly require new environments to be implemented intuitively and effectively. At BBVA we have designed specific collaborative rooms to accommodate Design Thinking and Agile work methods. These are multipurpose spaces in both the physical and digital senses, bringing together people trained in different disciplines who are working on the same project, even when located in different buildings or even cities.

The features of a collaborative room go far beyond audiovisual media and videoconferencing facilities. They are constantly evolving "living labs" where you can experiment with a range of tools, like digital whiteboards and furniture arrangements, until you find the setup that best fits the specific needs of the project in hand. Project participants who are physically absent can write on the same "whiteboard" and on the same "sheets of paper" as the people actually sitting in the room.

Another plus point is that you don't need to set up and then undo the arrangement within the room for each project you are working on, as would normally happen using physical equipment alone (panels and whiteboards). The content collaboratively generated during the session is saved in the cloud until the project team's next meeting.

A Passion for People

Adopting new work habits isn't easy, but it's perfectly possible. Science has shown that the brain continues to form new neural pathways and modify existing ones in order to learn, create new memories, and adapt to new experiences.

For the process of change to make real headway, though, it isn't enough for people to change their habits as individuals. It is also necessary to create working teams that can serve as benchmarks for the rest of the organization.

Creating multidisciplinary teams is powerfully aided by global People Management processes. It is important to get to know each professional as an individual, but it is just as crucial to create the opportunities for people themselves to take the initiative and seek inclusion in collaborative teams. BBVA's internal job posting app, *Apúntate* ("Join In"), has made a meaningful impact on talent mobility within the company. It is people themselves who, using the platform to find out if their skills and experience make a good fit with the given project, take the initiative to join the new team. As a rule and wherever possible, BBVA favors internal development over hiring externally.

> BBVA's internal job posting app, *Apúntate* ("Join In"), has made a meaningful impact on talent mobility within the company

The speed at which the environment is evolving calls for ongoing learning to safeguard the competitiveness of organizations and individuals alike. Every employee must be provided with the tools they need to manage their own development plan autonomously, and open the door to the best training resources.

In this respect BBVA's scheme combines highly specialized training with more general programs aimed at the entire Group. In both cases courses are taught by leading institutions such as Wharton, Chicago Booth, Babson College, The Aspen Institute España, IESE, LECE, TEC de Monterrey and the CFA Institute, among others.

BBVA uses a wide array of training media. E-learning, for instance, is a universally accessible resource that provides a flexible and self-managed learning pathway, enabling our people to decide for themselves as to the scope and pace of their own training.

In this context, one alternative that opens up possibilities which would be hard to find by conventional means is provided by Massive Online Open Courses (MOOCs). This form of training, now being tested at BBVA, is set to become a revolutionary educational tool in the coming decades.

To give a wider echo to inspiring ideas we invite all our teams to a broad range of conferences—recurring schemes hosted by the Group itself include TEDxBBVA, Fronteras del Conocimiento, BBVA Research, Business Traveler and OpenMind. Talent finds support in high-quality intellectual exercise.

BBVA uses a wide array of training media. E-learning, for instance, is a universally accessible resource that provides a flexible and self-managed learning pathway

Another vector of transformation and knowledge is human emotion. A positive attitude to a process of change raises your ability to learn and embrace new approaches to work and new ways of relating to others.[10] This fact, as well as neural plasticity, implies that emotional intelligence is a learnable skill.

If education in general is a process of "learning for life," then emotional education lies at its core, because it supports personal well-being and enables us to understand where our real limitations lie.

Effectively managing our emotions brings us meaningful benefits. A broad range of research has shown that emotional skills are twice as good at garnering outstanding performance than intellect or experience. Emotional intelligence gives rise to better leaders and bolsters the engagement of working teams.

In the age of knowledge, engagement has become a key management philosophy to drive competitiveness, sustainable performance and change. Many leading companies have appointed a "Chief Engagement Officer" in the awareness that they need a working environment that qualifies as a "best place to work."

An individual who is happy to work for his or her company works more productively. The idea is to foster an environment where people feel recognized and can develop their full potential and creativity. They should be able to find meaning in their jobs and feel proud of the company they work for.

At BBVA we believe it is vital that our teams feel engaged with and enthused by our business mission. So it is now an established practice with us to pay real attention to the emotional backdrop of the employment relationship so that people feel valued and recognized. In addition we encourage our people to support the progress of the community at large by taking part in corporate voluntary work. Our concern with our working teams—which we implement in the framework of a corporate program called *Pasión por las Personas* ("A Passion

for People")—has meant that in 2013 the consulting firm Great Place to Work named us as one of the 25 best multinationals to work for in the world.

Transformation Leaders

At BBVA we want the process of adopting new approaches to work to be supported expressly and consistently, and to feed through to our performance as soon as possible.

To mobilize the organization in that direction, the first step was a major awareness raising effort, particularly among employees having people-management roles. They are the main "agents of change" and must set an example. The campaign was guided by the creative concept Make It Happen! and, to one extent or another, involved everybody who works at BBVA.

In light of the importance of symbolic gestures in a process of change, in 2010 we became the first European company to provide tablets as working tools to every member of management, thus laying the groundwork of the "paperless" concept.

The process was bolstered by a range of actions designed to encourage a more innovative and participation-oriented style of leadership, break down traditional departmental structures and foster a more open and collaborative form of communication.

To achieve a more open and democratic culture of communication driven by people themselves, we set in motion an internal platform dubbed Ask & Vote. This electronic channel lets you send questions to senior Group management and vote and comment on other people's questions. Every quarter the CEO chairs a webinar to address the issues that employees are most interested in.

We must help people acquire new knowledge, deal effectively with digital environments and develop new skills like active listening, critical thinking, and collaboration. We also need to support them when they apply the lessons learned to form new habits and behaviors.

Not everybody is equally willing to accept change and adopt technology. The psychographic distribution described by Geoffrey Moore in his book *Crossing the Chasm*—about the specific aspects of selling high-tech products in their early days—also takes place to some extent within organizations.

It is for this reason that the shift in the way we work and in our mindset has been implemented using an inclusive approach that looks at the needs of everybody within our organization. As we have said, technology—though a powerful catalyst—is not enough in itself to change a company. It is people, especially those in management positions, who make change a reality and, by providing a role model, lead the way to a more open, collaborative and innovative culture.

The BBVA Collaborative Environment has led to a key cultural shift by creating a transparent relationship model. Everybody knows what everybody else is doing. Knowledge management finally becomes real: since the platform was set in motion, more than 11 million documents have been shared, and the figure is growing exponentially.

One of the hallmarks of the platform is its ability to support knowledge communities, which are integrated with the rest of our collaborative tools. Deployment began in January 2013 and continues step by step. Membership of the BBVA community is voluntary. In September 2014, 73,000 employees had access to knowledge communities, 21,500 of whom had created profiles and were actively using the feature.

Collaborative work is not restricted to the internal sphere: it reaches beyond the company itself. Examples of this outreach include BBVA Innova Challenge Big Data, an event open to developers around the world with the aim of creating apps, services and content based on vast amounts of anonymized credit card transaction data. The initiative—the first of its kind in Spain and Mexico—is an open innovation exercise that has brought us into contact with new ideas and talent.

Becoming an increasingly digital bank means we also have to convert the data about our own employees into useful knowledge. Our human resource teams use HR Analytics techniques to develop predictive models to foresee key talent gaps in the near future. The end goal of these efforts is to identify the professional profiles and leadership styles that contribute the greatest value to customers and the business.

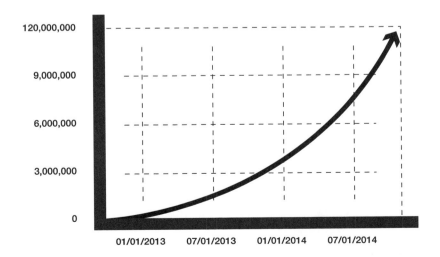

Number of Documents Shared in the Cloud

The rethinking of BBVA to face the digital era is now in motion. It entails a far-reaching transformation of the entire Group. Radical improvement of technological capabilities is essential to the process. This, however, is a necessary but not sufficient condition. The key to success lies in the cultural mindset. An in-depth change must be achieved in the way things are done throughout the organization. The new BBVA headquarters have become a powerful tool in this process by encouraging people to change their mental frameworks, both in terms of day-to-day work and of the symbolic impact of the new venues. La Vela and the other cutting-edge sites built by the Group inwardly and outwardly convey our determination to lead the transformation of the financial services industry, and in themselves meaningfully contribute to that transformation.

The BBVA New Headquarters Team, who produced this article, comprises **Iván ARGÜELLES CARRALERO** (Observatory on Lean Management and New Approaches to Work), **Gloria LAMAS RULL** (Head of BBVA City), **Beatriz LARA BARTOLOMÉ** (Head of Corporate Transformation), **Susana LÓPEZ ARIAS** (New Headquarters Project Leader), **Belén PISERRA de CASTRO** (Head of Corporate Buildings and Services), and **Alfonso ZULAICA ALFONSO** (Head of Corporate Culture).

Notes

1
The strategic formulations and actions described in this article are the outcome of the expertise and effort of hundreds of BBVA employees who are committed to developing New Approaches to Work at BBVA. The authors of this article are members of that broadly-based team that undertook this project, drawing on the various disciplines in play. We should like to express our special thanks to Juan F. Cía, David Zafrilla, Angel Galván, Abdallah Aberouch and Carlos Benítez Donoso for their valuable support.

2
Collaborative work can be expressed mathematically as $Nx[2(N-1) - 1]$, i.e., the sum of interactions among N people. For example, five people can come up with five ideas individually. But when they work as a team they can generate ten ideas through cross-interactions among them. However, when they work collaboratively, they can work in parallel —individually, in pairs, in groups of three or four, or as the full group of five. Under this approach the sum of their interactions is 75.

3
We should like to acknowledge the work they are doing and thank them for sharing it with the BBVA New Approaches to Work team. Our thinking has been stimulated by visits to the headquarters of Apple, Cisco, IBM, Microsoft, Telefónica, Repsol, Google, SRI, Commonwealth Bank of Australia, Macquarie Bank, Zara, and other companies.

4
LEED certificates: Campus BBVA in Madrid, Spain (Gold, 2012); BBVA headquarters in Asunción, Paraguay (Silver, 2010); Gold in the United States, at 5576 Grove Blvd. (Hoover), 430 NM Hwy 528 (Bernalillo), 8333 Douglas Ave. (Dallas), 2200 Post Oak Blvd (Houston), 2640 E. Harmony Rd. (Fort Collins), 15580 E. 104th Ave. (Commerce City), 2707 W. Lake Houston Pkwy (Kingwood), and 4868 Garth Road (Baytown); Silver, 2012, for 10923 E. Baseline Road (Mesa, US) and a 2013 certificate for 1703 West 5th Street (Austin, US).

5
ISO 14001 certificates in Spain: Castellana 81 (Madrid), Gran Vía 1 (Bilbao), San Nicolás 4 (Bilbao), Recoletos 10 (Madrid), Plaza de Santa Bárbara 2 (Madrid), Manoteras 20 (ICh) (Madrid), F. Mompou 5 (LT-I) (Madrid), Pza. Catalunya 5 (Barcelona), María Tubau 10 (LT-II) (Madrid), Batanes 3 (Tres Cantos), Santa Bárbara 1 (Madrid), Gran Vía 12 (Bilbao), Alcalá 17 (Madrid), Isla Sicilia 3 (Madrid), Clara del Rey 26 (Madrid), La Palmera 61-63 (Sevilla), Pza. Ayuntamiento 9 (Valencia), Campus BBVA (La Moraleja), Isabel Colbrand 4, Castellana 79, Rambla d´Egara 350 (Terrassa), Monforte de Lemos s.n. (Vaguada) and Ciudad BBVA (Phase I). Certificates in other countries: ISO 14001 in Buenos Aires, Argentina; Venezuela 538-540, Reconquista 199, Reconquista 40, Maipú 356, Reconquista 281, Alsina 1717 and 60 other offices.

6
In countries where the word "discoverer" might bear a negative connotation, other terms were used ("pioneers," "facilitators," etc.).

7
George Pór defined collective intelligence as "the capacity of human communities to evolve towards higher order complexity and harmony, through such innovation mechanisms as differentiation and integration, competition and collaboration" <http://blogofcollectiveintelligence.com/author/coevolvingwithyou/>

Bibliography

J. Collins, *Good to Great: Why Some Companies Make the Leap—And Others Don't* (New York: Harper Business, 2001).

R. Connors and T. Smith, *Change the Culture, Change the Game: The Breakthrough Strategy for Energizing your Organization and Creating Accountability for Results* (Portfolio Trade, 2012).

IFTF (Institute for the Future), "Future of Work" <http://www.iftf.org/our-work/people-technology/technology-horizons/the-future-of-work>

B.D. Johnson, *Screen Future. The Future of Entertainment, Computing, and the Devices We Love* (Intel Press, 2010).

D. Kahneman [winner of the Nobel Prize in Economics], *Thinking, Fast and Slow* (New York: Farrar, Straus and Giroux, 2011).

D. Kelley and T. Kelley, *Creative Confidence. Unleashing the Creative Potential Within Us All* (New York: Crown Business, 2013).

T.W. Malone, *The Future of Work. How the New Order of Business will Shape Your Organization, Your Management Style, and Your Life* (Boston: Harvard Business Review Press, 2004).

G.A. Moore, *Crossing the Chasm* (New York: Harper Collins, 1991).

K. Sheridan, *Building a Magnetic Culture. How to Attract and Retain Top Talent to Create an Engaged, Productive Workforce* (New York: McGraw-Hill, 2012).

C.-M. Tan, *Search Inside Yourself* (London: HarperCollins, 2012).

C. Taylor, *Walking the Talk. Building a Culture for Success* (London: Random House Business Books, 2005).

World Economic Forum, "The Global Competitiveness Report 2013-1014" <http://www3.weforum.org/docs/WEF_GlobalCompetitivenessReport_2013-14.pdf>

Leadership, Strategy and Management

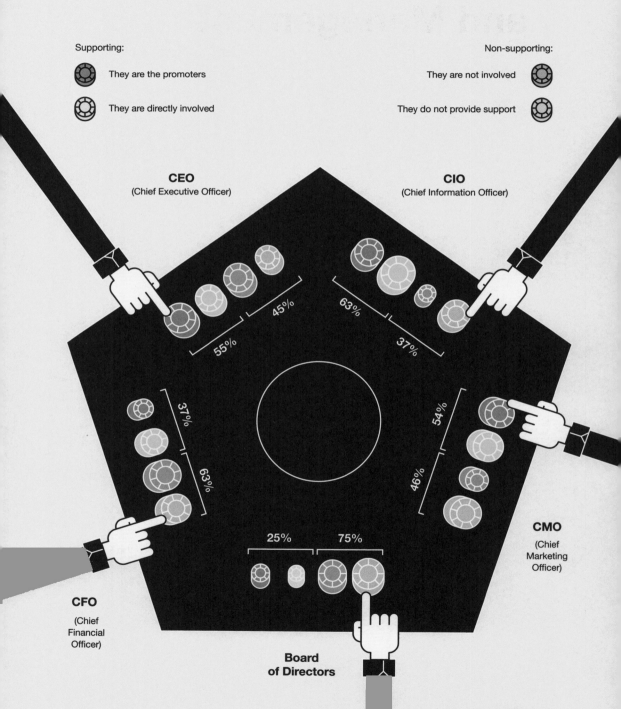

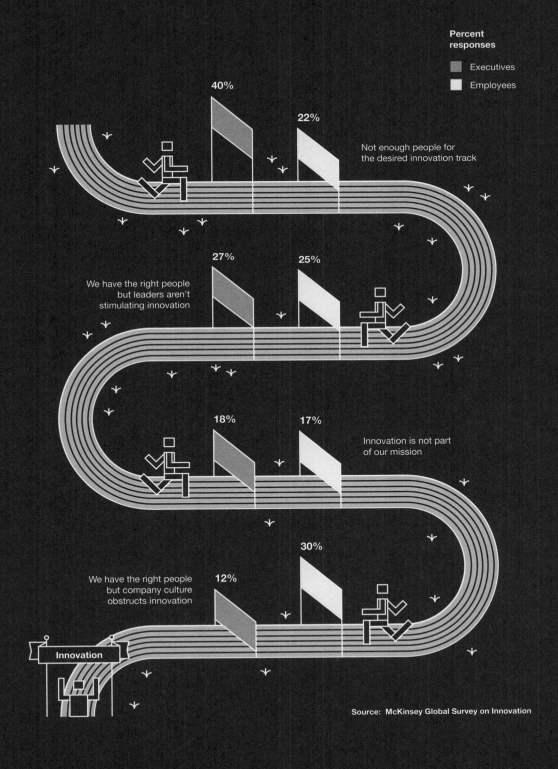

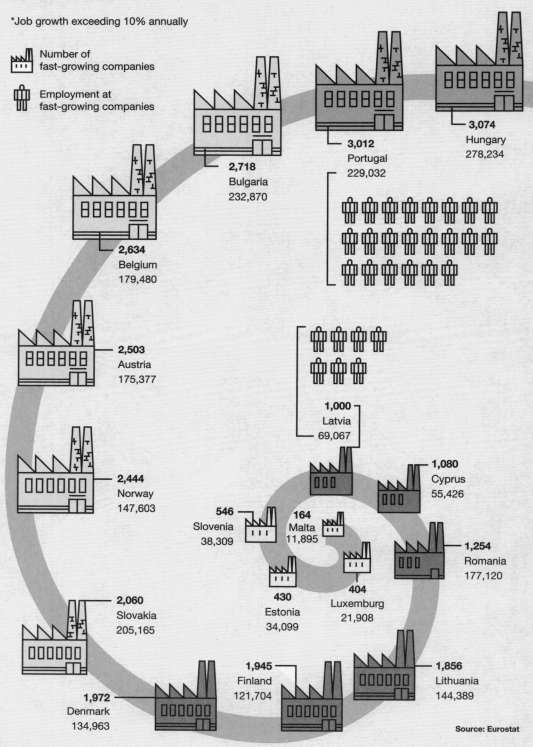

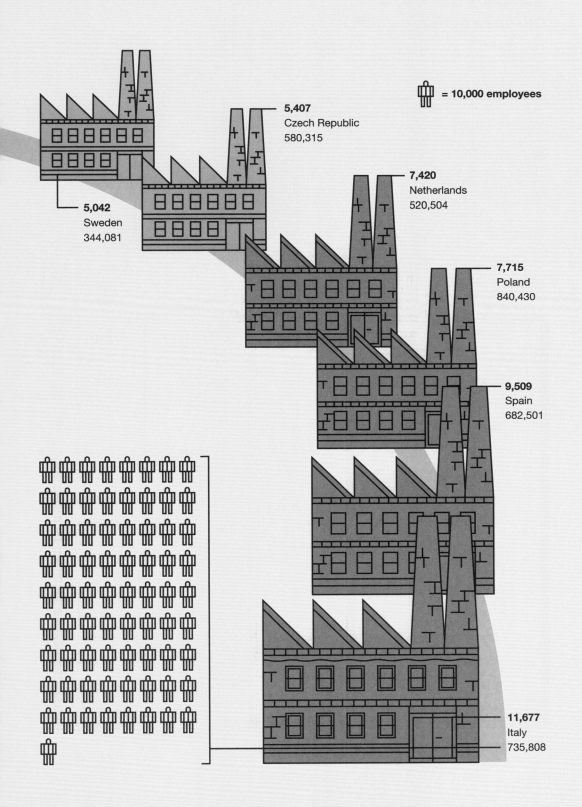

Company Startups and Closures in Europe (2011)

Number of companies
- Startup
- Closure

Percent of total companies in operation in the country
- Startup
- Closure

				
11.02%	328,117	France	193,351	6.49%
6.67%	264,671	Italy	304,187	7.66%
8.66%	258,661	Germany	246,552	8.26%
7.98%	243,800	Spain	288,547	9.44%
12.39%	104,996	Portugal	204,239	24.10%
10.55%	104,479	Czech Republic	83,589	8.44%
11.01%	101,519	Netherlands	65,957	7.16%
9.98%	55,676	Hungary	67,981	12.19%
10.84%	43,988	Romania	35,433	8.73%
10.96%	35,061	Bulgaria	39,183	12.25%
23.71%	31,299	Lithuania	67,902	51.45%
5.25%	28,601	Belgium	18,111	3.32%
12.09%	26,365	Denmark	25,592	11.74%
6.17%	20,952	Austria	21,602	6.36%
19.19%	16,880	Latvia	15,543	17.67%
10.16%	12,746	Slovenia	8,800	7.02%
6.27%	11,847	Ireland	12,611	6.67%

Source: Eurostat

Distribution by Sector of the 100 Most Valuable Brands (2013)

1. Technology
2. Automobiles
3. Financial services
4. Packaged consumer goods
5. Beverages
6. Luxury items
7. Retail trade
8. Diversify businesses
9. Restaurants
10. Telecommunications
11. Media
12. Textiles
13. Alcoholic beverages
14. Leisure
15. Tobacco products
16. Transportation
17. Heavy equipment
18. Oil and gas
19. Business services
20. Aerospace

Number of companies: 19

Business value (billions of US dollars): 488

Sector	Business value (billions US$)	Number of companies
1. Technology	488	19
2. Automobiles	154	11
3. Financial services	124	14
4. Packaged consumer goods	122	12
5. Beverages	98	4
6. Luxury items	87	8
7. Retail trade	69	5
8. Diversify businesses	55	3
9. Restaurants	52	3
10. Telecommunications	44	2
11. Media	38	4
12. Textiles	33	3
13. Alcoholic beverages	28	2
14. Leisure	23	1
15. Tobacco products	17	1
16. Transportation	16	2
17. Heavy equipment	15	2
18. Oil and gas	14	2
19. Business services	10	1
20. Aerospace	6	1

Source: Forbes

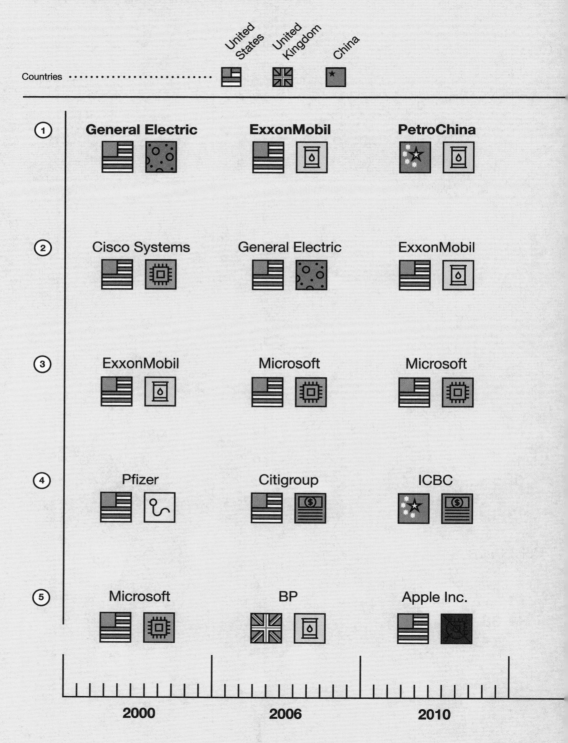

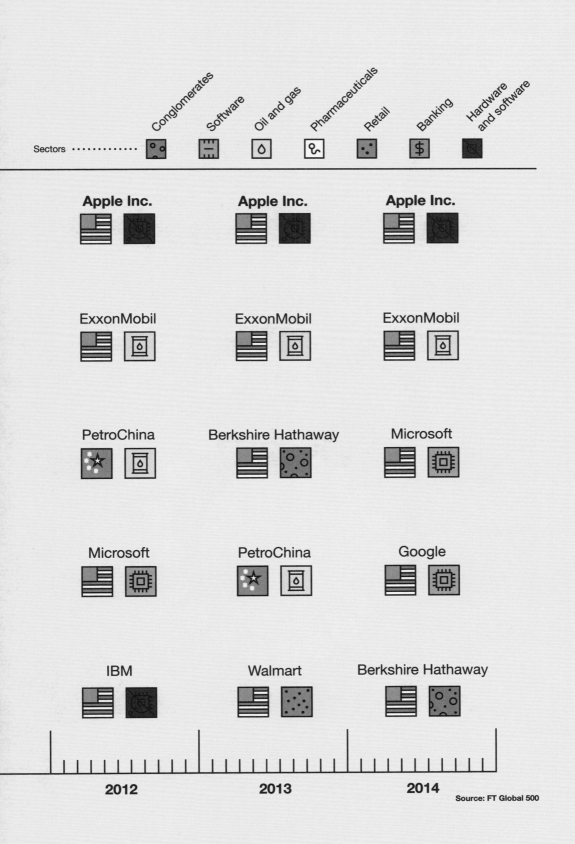

Market Value of the World's Largest Tech Companies (2013)

Global ranking:

1	Apple	13	Oracle	63	Nintendo
2	Microsoft	21	SAP	72	Nokia
4	IBM	31	Hewlett-Packard	80	Sony
5	Google	33	Amazon	84	Dell
8	Intel	36	Facebook	90	Ericsson
9	Samsung	57	Canon		
12	Cisco	59	eBay		

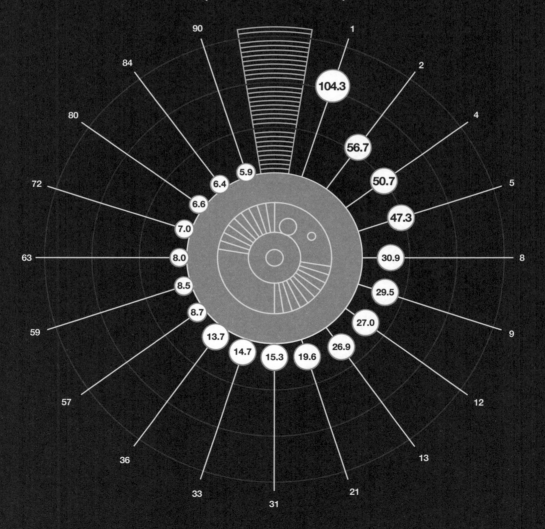

Company value (billions of US dollars)

Rank	Value
1	104.3
2	56.7
4	50.7
5	47.3
8	30.9
9	29.5
12	27.0
13	26.9
21	19.6
31	15.3
33	14.7
36	13.7
57	8.7
59	8.5
63	8.0
72	7.0
80	6.6
84	6.4
90	5.9

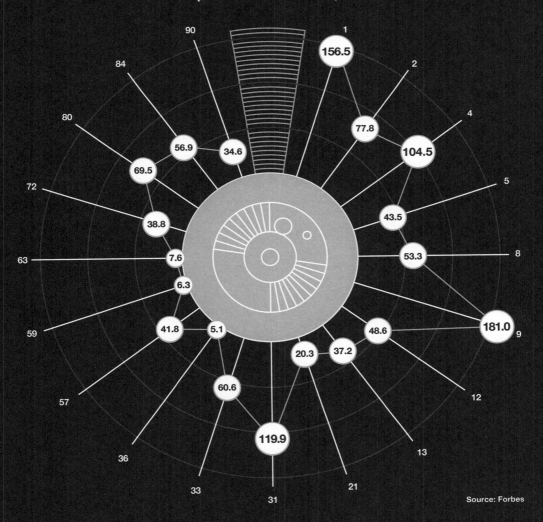

Governance and Managing Change in the Company of the 21st Century

William M. Klepper

Professor Klepper presents various case studies of companies in the context of their corporate governance and the management of change while confronted with a downturn in their business cycle, when their CEOs were coming under pressure to lead the change.

Klepper's core argument is that the CEO's style needs to be matched to the business at each point in its cycle and that the board needs to intervene actively to help the CEO close any gaps between his/her capabilities/style and the requirement of the company.

Because of the changing nature of the business cycle, he states that it is imperative for boards to constantly evaluate their leadership and their strategy. This helps boards and businesses at every stage of the business cycle and can help regulate the relationship between the board and its CEO. Klepper maintains both progress and change are essential for the company of the twenty-first century. To achieve both, the board and CEO must form their social contract of shared values, commitment to stakeholders, risk management, and transparency. This then provides a foundation for addressing the challenges to their strategy and alignment of their business system over time. Boards need to match up the CEO's agenda, practices and style with what is required to progress in their business cycle.

William M. Klepper
Columbia Business School

Dr Klepper joined Columbia Business School in 1996 and teaches Executive Leadership in the Executive MBA program. He serves as the Faculty Director of the Columbia partnership with the *Financial Times* (FT)/Outstanding Directors Exchange (ODX). He annually presents a governance case study of a twenty-first-century company at FT-ODX, recently P&G (2013), HP (2012), and BP (2011). His most recent book, *The CEO's Boss: Tough Love in the Boardroom* (Columbia University Press, 2010), was ranked as one of the Top Five Books by *The Wall Street Journal*'s livemint.com in December, 2010.

Key Features for the Company of the Future:

Develop Your Social Contract
A board/CEO partnership cannot be sustained by good intentions alone; it must be defined by an explicit statement of the beliefs and behaviors that are essential for the general will of the organization. Boards should share a set of common commitments with their CEO: commitment to values; commitment to risk assessment; and commitment to coaching for their continuous improvement.

Practice Tough Love
Intentionally address the realities of your CEO's tenure with the appropriate amount of tough love before your company and CEO become dysfunctional. Boards can learn from those who study CEO tenure, company performance, and successful leadership behaviors. Taking this research into account can help the company thrive at every stage in the life cycle of the business. Constantly assess your CEO's leadership agenda, practices, and style. Business cycles are unavoidable and uncertain, and the board needs to face this reality and be prepared to change its leadership if the CEO cannot adjust to the changing conditions.

Achieve Congruence
If you determine the current CEO cannot adjust to the changing business cycle, the board must understand its own strategic context and intent, i.e., its strategy, before it can begin the CEO selection process; determine the company's position and the agenda, practices, and style required of its CEO; and identify key gaps in structure, process, people, and culture, because these gaps will become the CEO's strategic priorities.

Governance and Managing Change in the Company of the 21st Century

Introduction

At Columbia Business School we teach corporate governance within our Individual, Society, and Business curriculum and explore the connections between corporate governance, value based leadership (a foundation for good corporate governance) and corporate social responsibility. In addition, we view corporate governance as a system of checks and balances among the stockholders, the board, and the CEO.[1]

My study of corporate governance and its intersection with executive leadership and corporate responsibility led me to write *The CEO's Boss: Tough Love in the Boardroom*, published by Columbia University Press in 2010.[2] The intent of this book was to help the Board of Directors operate more effectively as the boss of the CEO. The *Corporate Board Member* (First Quarter 2014) stated: "*The CEO's Boss* serves up a wealth of practical, hands-on recommendations to build a productive partnership and a plan of action for a variety of business settings."[3] The core argument was that the CEO's style needs to be matched to the business's point in its cycle, and that the board needs to intervene actively with the CEO to help him or

What Corporate Governance Is: A System of Checks and Balances Among the Stakeholders, the Board and CEO

Keehner and Randall, *Introduction to Corporate Governance*, IBS Curriculum

her close any gaps between their capabilities/style and the requirement of the company to address its current challenges. In addressing its current challenges, the company must manage the change from its present state to its desired future state. During each of the four years since *The CEO's Boss* called for Tough Love in the Boardroom, I have presented case studies of governance in companies of the twenty-first century at the annual conference of the *Financial Times*/Outstanding Directors Exchange (FT-ODX) in New York City.

Case Series

These companies were chosen because they were in the *FT* headlines as facing strategic challenges that required their management of change. The one exception is the Wounded Warrior Project whose case was just completed at the time of this writing, but will be used as a model for governance and managing change in the twenty-first century.

In each of these for-profit corporate case studies, the companies were faced with a significant challenge in their business performance. They were confronted with a downturn in their business cycle and their CEOs were coming under pressure to lead the change. Within the boardroom of

these companies, times got tough. Tough times required tough love as prescribed in *The CEO's Boss*:

Tough love is an expression used when someone treats another person sternly with the intent to help them in the long run

- Know your CEO's behavioral style and leadership practices;
- Know your organization's needs (Strategy, Priorities and Gaps);
- Match the organization's needs with the leadership that is required;
- Look first at your CEO and then the senior team to find the correct match; and
- If you don't find the correct match, look elsewhere[4]

In the most recent case study presentations at FT-ODX were BP (2011), HP (2012) and P&G (2013); each changed its CEO. BP, after its disaster in the Gulf of Mexico, removed its CEO and chose an insider. HP, after three CEOs in seven years, chose a current non-employee director on its board to be CEO. P&G, challenged by an activist investor, changed out its CEO for the former CEO. Let's look at each of these companies of the twenty-first century in the context of their corporate governance and the management of change.

BP (a.k.a. British Petroleum)

In the aftermath of the 2010 Gulf of Mexico oil spill, a case study examining the implications for the management team and board of BP Oil was presented at FT-ODX in 2011 and published by Columbia CaseWorks.[5] The Gulf disaster became the most recent event to raise the question of BP's leadership ability, including the CEO and board of directors, to manage its growth strategy and risk profile.

The Gulf Explosion

On April 20, 2010, the semi-submersible exploratory offshore drilling rig Deepwater Horizon exploded after a blowout; it sank two days later, killing 11 people. This blowout in the Macondo Prospect field in the Gulf of Mexico resulted in a partially capped oil well one mile below the surface of the water. Experts estimate the gusher to be flowing at 35,000 to 60,000 barrels per day (5,600 to 9,500 m/d) of oil. The exact flow rate was uncertain due to the difficulty of installing measurement devices at that depth and is a matter of ongoing debate. The resulting oil slick covered at least 2,500 square miles (6,500 km), fluctuating from day to day depending on weather conditions. It threatened the coasts of Louisiana, Mississippi, Alabama, Texas, and Florida.

Past Incidents

This was not the first accident in which BP people were killed. In March 2005, BP's Texas City, Texas refinery, one of its largest refineries, exploded causing 15 deaths, injuring 180 people and forcing thousands of nearby residents to remain sheltered in their homes. Under scrutiny after the Texas City refinery explosion, two BP-owned refineries in Texas City, Texas, and Toledo, Ohio, were responsible for 97% (829 out of 851) of willful safety violations by oil refiners between June 2007 and February 2010, as determined by inspections by the Occupational Safety and Health Administration. Jordan Barab, Deputy Assistant Secretary of Labor at OSHA, said "The only thing you can conclude is that BP has a serious, systemic safety problem in their company."[6]

The CEOs

Sir John Browne was BP Chairman and CEO at the time of the Texas City refinery blast and resigned in 2007 when he lost the support of the board after a string of setbacks including a blast in 2005. In his memoir, *Beyond Business* (2010), which came out in February before the Gulf blowout, he wrote that BP pursued outsized risk—in acquisitions, foreign adventures, and deep-water drilling—to grow itself out of its status as a "middleweight insular British company."[7]

When Tony Hayward became BP's chief executive in May 2007, he promised to get the company back to basics. A plain-spoken geologist and longtime company man, Hayward said in a speech at Stanford Business School in 2009: "BP makes its money by someone, somewhere, every day putting on boots, coveralls, a hard hat and glasses, and going out and turning valves … And we'd sort of lost track of that." Hayward also pledged to fix the safety problems that contributed to the downfall of his predecessor. Though the company would continue doing the "tough stuff," he declared, it would make safety its "No. 1 priority."[8] Until the April 20 explosion of the Deepwater Horizon oil rig in the Gulf, Hayward repeatedly said he was slaying two dragons at once: safety lapses that led to major accidents, including a deadly 2005 Texas refinery explosion; and bloated costs that left BP lagging behind rivals Royal Dutch Shell plc and Exxon Mobil Corp. A *Wall Street Journal* examination of internal BP documents, legal filings, official investigations and reports by federal inspectors, as well as interviews with regulators, shows a record that doesn't always match Hayward's reports of safety improvements.[9]

Two weeks prior to the Gulf explosion BP admitted that malfunctioning equipment lead to the release of over 530,000 pounds of chemicals into the air of Texas City and surrounding areas from April 6 to May 16, 2010—the same refinery that had exploded killing 11 in 2005, but this time on

Hayward's watch. The leak included 17,000 pounds of benzene (a known carcinogen), 37,000 pounds of nitrogen oxides (which contributes to respiratory problems), and 186,000 pounds of carbon monoxide.[10]

The Board

The BP board had known for years that something was wrong with safety at BP. BP assembled an independent panel, headed by former Secretary of State James Baker, to investigate safety at its US refineries. While the panel worked, a BP pipeline in Alaska leaked more than 200,000 gallons of crude in March 2006. The panel's report, published in January 2007, is brutally direct. While its immediate focus is BP's five US refineries, its findings go far beyond them. Calling for "leadership from the top of the company, starting with the board and going down," the report found that "BP has not provided effective process safety leadership." Corporate-governance authority Robert A.G. Monks, who testified as an expert witness for a Texas City worker, says, "The BP board was on notice that the corporate culture of 'saving over safety' pervaded BP. They were on notice that the mechanisms for informing the board were dysfunctional. The board had an affirmative duty to understand the risks involved in the drilling of this well."[11]

Carl-Henric Svanberg became the non-executive chairman of the board in June 2009, following a career at Ericsson that was marked by aggressive cost-cutting measures taken to return the company to profitability. At the time of Svanberg's appointment to the board, Hayward stated that "He is a businessman of international stature who is recognized for his transformation of Ericsson. Our shared views on many aspects of global business give me great confidence that we will work very effectively together on the next phase of BP's progress."[12]

Leadership for the Future

BP's board replaced Tony Hayward, whose repeated stumbles during the company's three-month oil spill in the Gulf of Mexico alienated federal and state officials as well as residents of the Gulf Coast. Through the nomination committee, the board engaged external advisers who identified an external candidate and existing executive director, Bob Dudley, for the position of

group chief executive. After interviews and detailed consideration it was concluded that Bob Dudley had the strong industry, operational and geo-political experience required for the role and he was appointed as the group chief executive. Dudley, 54, who grew up in Mississippi and spent summers fishing and swimming on the Gulf, had been in charge of BP's response to the spill. Dudley took over on Oct 1, 2010 after a two-month transition period. "We will look at what we have learned from this incident. We will look at our culture and our safety and operations," Dudley said.[13]

Lessons Learned

How might the BP board and its new CEO, Robert Dudley, start their learning journey together? They could return to the 2007 Baker study of the Texas City refinery explosion and answer the four questions of the After Action Review (AAR):

- What was our intent (Recommendations from the Baker report)?
- What happened between 2007 and 2014—safety violations?
- Why did it happen—why do we continue to have safety problems?
- How can we make it better—manage concurrently our growth strategy and risk profile? It would be reasonable to assume that this AAR for post mortem has already occurred.

As is prescribed in *The CEO's Boss*, "a strong partnership between the CEO and the company's directors" is necessary. However, a strong partnership doesn't occur simply by wishing for it. Dudley and the BP board need to form clear, mutually understood expectations for the partnership-- a Social Contract. To paraphrase Rousseau's original work, each must place "his person and authority under the supreme direction of the general will"—the CEO/board partnership. At a minimum, the Social Contract should include:

- Commitment to values
- Commitment to the stakeholders
- Commitment to risk assessment
- Commitment to transparency[14]

The BP CEO/board commitment to values is not meant to substitute for the public statement of what BP stands for:
We care deeply about how we deliver energy to the world. Above everything, that starts with safety and excellence in our operations
or its values:
Safety, Respect, Excellence, Courage, One Team.

It recommends that the CEO and board define the instrumental values to which they collectively subscribe for the good of their working partnership. An example of where this distinction made a difference was at Tyco International during its rise from the failed leadership of its former chairman and CEO Dennis Kozlowski who was sentenced to 8 to 25 years in prison for stealing $600 million from the company. Edward D. Breen was appointed the new chairman and CEO of Tyco in 2002. In August of 2002, with the priority of improving the company's governance, Breen announced the appointment of Jack Krol as lead director. Together they lead the formation of their CEO/board Social Contract–*How we conduct ourselves*:

- **Integrity**

We demand of each other and ourselves the highest standards of individual and corporate integrity with our customers, suppliers, vendors, agents and stakeholders. We vigorously protect company assets and comply with all company policies and laws.

- **Excellence**

We continually challenge each other to improve our products, our processes and ourselves. We strive always to understand our customers' and suppliers' businesses and help them achieve their goals. We are dedicated to diversity, fair treatment, mutual respect and trust of our employees and customers.

- **Teamwork**

We foster an environment that encourages innovation, creativity and results through teamwork and mutual respect. We practice leadership that teaches, inspires and promotes full participation and career development. We encourage open and effective communication and interaction.

- **Accountability**

We will meet the commitments we make and take personal responsibility for all actions and results. We will create an operating discipline of continuous improvement that will be integrated into our culture.[15]

Today, these board Governance Principles have been extended to embrace all the employees of Tyco International and how they interact with its stakeholders and one another.

Reading the annual reports of BP since the Gulf explosion, it is evident that there is a heightened commitment to stakeholders, risk assessment and transparency. One can only recommend that they strengthen their resolve to

their commitments through a renewed CEO/board partnership—a Social Contract of their governance principles.

Hewlett-Packard (HP)

Columbia CaseWorks first examined corporate governance at HP from the period of 1999 to 2005. "In July 1999 Carly Fiorina was lured from rising star status at Lucent Technologies to become CEO and, in time, Chairman of the Board. During her tenure, Fiorina spearheaded several moves to transform and revitalize the company. Most notable was her decision to merge with Compaq Computers, catalyzing a much publicized proxy battle led by Walter Hewlett, son of the company's cofounder, over the direction the company should take. In February 2005, Fiorina was hastily fired, leaving many to speculate on what factors, other than her performance as CEO, might have been at play."[16]

> **HP's board made it clear that all directors, as well as officers and employees, should display the highest standard of ethics, consistent with HP's longstanding values and standards**

In 2012, it was time to look again at HP. At the FT-ODX conference, an updated case study of HP was presented.[17] During the period between 2005 and 2011, HP's board had hired and fired two other CEOs. Mark V. Hurd had been appointed as CEO after he investigated a boardroom scandal involving company spying on board members, employees and journalists. As an outcome of that investigation, the board made it clear that all directors, as well as officers and employees, should display the highest standard of ethics, consistent with HP's longstanding values and standards. HP has and will continue to maintain a code of conduct known as the "Standards of Business Conduct" for its directors, officers and employees. This code is meant to build trust, one day at a time, by making ethical decisions, taking action when misconduct occurs, and avoiding retaliation while cooperating with investigations. In HP's 2005 Annual Report, Hurd asserted that *HP is on its way to building a culture of accountability and execution. We have a strong brand and an increasingly loyal customer base that wants to see HP win. And we will continue to expend every ounce of effort to make sure that we live up to each one of our commitments to our customers, our partners, our employees and our stockholders.* In August 2010, Hurd was fired over the accounting of expenses for entertaining of a female contractor. Michael Holston, HP EVP and general counsel, stated that Hurd's actions "showed a profound lack of judgment."[18]

The board hired as its CEO Leo Apotheker, who had previously served in that same role at SAP. Apotheker had a vision of making HP a Web-oriented and software company. He was fired after eleven months on the job, during which period HP produced poor earnings and made expensive acquisitions. The most notable of these acquisitions was Autonomy, the British software maker, for $11.1 billion. HP wrote down $8.8 billion of its acquisition of Autonomy, an overpayment of 79%.[19]

At the start of his tenure as CEO, Apotheker was successful in bringing in five new directors to the board. Among those five was Meg Whitman, the former head of eBay. On September 4, 2011 she was named as the next HP CEO, its third in seven years. HP's chairman Raymond Lane defended the board's hasty decision to appoint Whitman, saying she was the "best choice" for the job. "Meg is a proven leader of people," he said in an interview with CNBC. Apotheker "has great qualities, but not the qualities that are needed here and now."[20]

In carrying out their duties as corporate leaders, a board and the CEO must be vigilant in looking beyond any short-sighted, short-lived interests to set policies and make decisions that are in the best interest of the company over a longer time horizon. The board has a unique responsibility to "ask questions, think independently, and show tough love when necessary" (*The CEO's Boss*). In the case of HP, the board has accepted that the company is in a turnaround that will take more than a year's tenure of its CEO. Whitman said that HP needs four more years "to have confidence in itself."[21]

Lessons Learned

In the case of Apotheker, it was evident that the company needed to identify and hire a CEO whose talents and approach would take the company in a very different direction from where it had been heading. The board, as the CEO's boss, needs to know specifically, what skills, vision, approach and management style would be required of this new CEO? What criteria would a board use in evaluating candidates and making the best choice for the company and its stakeholders?

The following 4-step process is recommended to determine if a prospective CEO aligns with the needs of the business (CEO Alignment).[22]

- **Step 1**

A board needs to fully understand its own strategic context and intent—collectively, its strategy—before it can hope to engage productively in the process of selecting a CEO. Only then can a board move on to the next step.

- **Step 2**

 Determine, given the company's position, the agenda, practices, and style required of its CEO.

- **Step 3**

 The board must assess the alignment of the levers of its business system (structure, process, people, culture) and identify the gaps, because these gaps will become the CEO's strategic priorities.

- **Step 4**

 Achieve a degree of congruence between the strategy, the CEO, and the business system.

As part of Step 1, it is not uncommon for the board to work with a management consulting firm to clarify its strategic context and revise its overarching corporate strategy. It is essential that the board start the process with this baseline analysis, as it will make apparent the specific strategic needs of the organization over which the new CEO will preside.

In carrying out Step 2, the board must be sensitive to the particular business cycle in which the company finds itself, as some leaders are better equipped to manage, for instance, an early stage of the business cycle, while others are better suited to manage a mature venture. The behavioral style of the CEO also matters a great deal in matching the leader to his or her circumstance. Is the prospective CEO, for instance, driving, expressive, amiable, or analytical—and to what extent does this personal style align with the current needs of the business? Attention to issues of behavior and style may be all the more pressing following a time of crisis.

During Step 3, the board places its focus on aligning the business system. Every CEO candidate will want to know what is broken in the company and what needs fixing. Before speaking with prospective CEOs, the board must determine what is broken—i.e. what levers of the business system are not aligned and, therefore, not supporting the current strategy.

As the board moves toward Step 4, its members must be mindful of the need for the CEO to provide both strategic leadership and strategic management. Strategic leadership requires a specific set of agendas, practices, and behaviors that will result in the "change an organization desires." Strategic management aligns the levers of the business system to achieve that change. Once inserted into the business system, a CEO will serve either as a catalyst or an impediment to a board's desired change.

Gaining congruence between strategy, the CEO, and the business systems is a process of discovery whose effectiveness is determined by asking the right questions. The following questions will be helpful to a board seeking to explore and validate their choice of a new CEO:

CEO Alignment

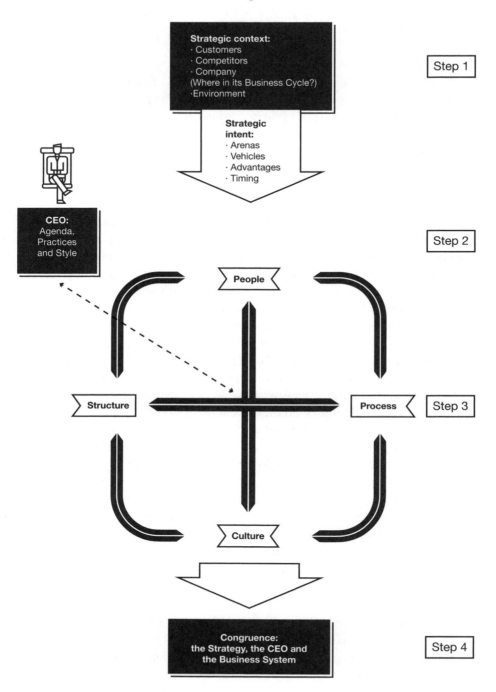

D.C. Hambrick and J.W. Fredrickson, "Are You Sure You Have A Strategy?". *Academy of Management Executive*, 15 (2001), 48–59; M. Tushman and C. O'Reilly, *Managerial Problem Solving: A Congruence Approach* (Harvard Business Publishing, 2007).

– **Structure**

How would you align your activities as CEO to achieve the strategic objectives of the business? Does the current design of our organization provide the structure you would need to support our strategic intent? Are there any systems you feel are not aligned?

– **Process**

How would you improve the work flow throughout the organization? What do you feel is the knowledge, skill, and information needed to improve our work processes? Do you feel our performance measures and indicators are aligned?

– **People**

Do you feel our employees possess the required competencies? Do you envision any changes? If so, how are they aligned with our employees' expectations and motivations?

– **Culture**

How should we be doing things around here in support of our strategic intent? Are the norms and values aligned with yours, and if so, how?

The HP annual reports that have followed the appointment of Meg Whitman acknowledge the current turnaround strategy and leadership challenge to align its business system to this change. The board recently announced that its interim chairman Ralph Whitworth, who two months earlier assumed the chairmanship when its non-executive chairman Raymond J. Lane stepped down, had departed for personal reasons and that Meg Whitman would become CEO and Board Chair. HP had separated the CEO and Chair responsibilities after terminating Carly Fiorina in her CEO and Chair position in 2005. The elimination of the non-executive chair is not without controversy.[23] Meg Whitman in her combined role of CEO and Chair will need to achieve congruence on two fronts: CEO alignment with the strategy/business system as well as congruence in the alignment of the CEO/board partnership which raises the preceding recommendation to BP to renew their Social Contract, its governance principles.

Procter and Gamble (P&G)

At the 2013 meeting of the FT-ODX conference, the case of P&G board's handling of its CEO's strategy and activists was discussed. That case study then became the material for a Columbia Caseworks publication: "Procter & Gamble in 2013:

A Board Adrift?"[24] The reason for raising this question lies in the board's response to the confrontation with its activist investor William Ackman, who called for the firing of P&G's CEO Bob McDonald due to the company's poor financial performance over his tenure. In May 2013 the board replaced McDonald, who had been appointed CEO in July 2009, with his predecessor, A.G. Lafley. This was not the first time that the P&G board had replaced its CEO in the face of poor financial performance. In July 2000 P&G stock hit bottom, dropping 50% in the space of several months. Lafley had replaced Durk I. Jager, who had been CEO for only 17 months. In the nine years that followed under Lafley's leadership, annual organic sales grew—on average— 5%, core earnings-per-share grew 12% and free cash flow productivity increased 111%.[25]

McDonald's accession to the top job at P&G had been the product of a careful, years-long succession planning process. As Lafley put it, "We benchmarked internal candidates against strong external CEOs that our directors knew. We concluded that an outside option wasn't needed and wouldn't be as good a fit for P&G."[26] McDonald, in many ways, was Lafley's handpicked successor. He and Lafley had spent most of their professional careers at P&G and had developed together its growth strategy of moving into emerging markets around the globe. Now under McDonald's tenure, P&G was underperforming against the competition (Colgate-Palmolive, Clorox and Unilever) from 2009 to 2012; and Unilever had been well established in the emerging markets space from which Lafley and McDonald believed its revenue growth would come.

"Procter & Gamble in 2013: A Board Adrift?". The reason for this question lies in the board's response to its activist investor Ackman, who called for the firing of P&G's CEO due to the company's poor financial performance

McDonald's push into emerging markets was accompanied by cost-cutting at home, and he laid out his goals in P&G's 2012 annual letter to shareholders: "Earlier this year, we announced our objective of delivering $10 billion in cost savings by the end of fiscal year 2016. This program includes $6 billion of savings in cost of goods sold, $1 billion from marketing efficiencies, and $3 billion from non-manufacturing overhead." Despite McDonald's efforts, P&G struggled, with net earnings down and the stock largely flat, even as P&G's competitors were outperforming it in the crucial emerging markets space. Yet this statement from the 2012 Annual Report indicated the board's ongoing commitment to McDonald's strategy: "We see significant remaining growth opportunities as our business in developing markets is still smaller as a percentage of sales than the developing markets businesses of some of our

competitors, and we will continue to focus on growing our business in the largest and most important of these markets."[27]

Activist Investor

In 2012 William Ackman revealed that Pershing Square Capital Management held roughly 1% of P&G's shares, making him one of P&G's largest shareholders. He immediately began pushing for change at the consumer products giant. He was respectful of the board in his public statements, but was critical of McDonald. He felt that he lacked focus and didn't have the ability to execute the emerging market strategy while at the same time cutting cost.[28] Analysts also began criticizing the company along the lines Ackman had laid out.

In September 2012 Ackman met with two of P&G's directors—Kenneth Chenault, the CEO of American Express, and W. James McNerney Jr., the chairman and CEO of The Boeing Company. Later that month *BloombergBusinessWeek* reported that P&G's board reiterated its confidence in McDonald. McNerney acknowledged in a public statement that P&G's directors were monitoring McDonald's strategy and added, "The board also wholeheartedly supports Bob McDonald as he leads its implementation."[29]

McDonald intensified his efforts to get P&G back on track and, potentially, blunt Ackman's attempt to oust him. In November 2012, P&G announced an aggressive $4 to $6 billion stock buyback program for 2013, something that McDonald had strenuously argued against earlier in the year. The announcement came a month after P&G reported that its fiscal 2013 first-quarter profit had declined 6.9% and sales were off 3.7%.[30]

McDonald also took this opportunity to reiterate P&G's cost-cutting goals, including plans to lay off between 2% and 4% of the company's workforce, and reaffirm the "40-20-10" strategy he articulated in P&G's 2012 annual report. In short, McDonald had charted a course to growth by pledging to refocus the company on its 40 most profitable products, its 20 largest innovations, and the 10 developing markets with the highest growth potential.[31]

For his part, Ackman remained undeterred, responding, "We're delighted to see the company's made some progress, but P&G deserves to be led by one of the best CEOs in the world. We don't think Bob McDonald meets that standard."[32]

The Board Acquiesces

On Thursday evening, May 23, 2013, P&G issued a press release announcing that McDonald would officially step down on May 30 and that Lafley would come out of retirement and return to his former role as CEO and chairman of the board.[33]

Under unrelenting pressure from Ackman and another disappointing quarter at P&G, McDonald had finally resigned, and Lafley was brought back in to take his place. Publically, McDonald's exit was described as a resignation of his choosing, rather than an ouster by the board.

Lessons Learned

Whether or not the board chose to remove McDonald or was simply reacting to Ackman's aggressive overtures, it did most decidedly choose Lafley as McDonald's successor, giving him days of notice—rather than weeks or months.[34] Was Lafley the best choice for the role? Some industry insiders, including Jason Tauber, a research analyst with the Large Cap Disciplined Growth team at Neuberger Berman Group (which then held 8.7 million P&G shares), suggested that bringing back Lafley "highlights poor succession planning by the board."[35]

The CEO's Boss stresses that there is a hierarchy of needs in every organization that is typically expressed in its strategy, priorities, and the performance and opportunity gaps—the measurable difference between the current and desired future state. If there is a mismatch between the current needs of the organization and the leadership practices of the CEO, then that is the point where the board must intervene, either with guidance (tough love) or action, such as removing the CEO. As in the case of HP, a process is offered in *The CEO's Boss* for determining whether a prospective CEO aligns with the needs of a business.[36]

It is expected that Lafley will lead a successful second turnaround of P&G during his second term as CEO. He definitely left at the end of his first term as a hero, but at the end of the first year of his second term he has yet to significantly move the needle on the P&G stock price from where McDonald left it–around $80 per share. In the future, it is recommended that the P&G board look both inside and outside the company for the best match of a CEO for its needs. BP was under similar pressure to change out its leadership and took the time to engage a professional search firm to test their inside choice. At least one outside candidate was considered with leadership agenda, practices and style that matched up with their needs.

In *The CEO's Boss*, an integrated leadership model is offered as a means to match the CEO's agenda, practices and style with the company's business cycle requirements.

The core argument is that the CEO's style needs to be matched to the business at each point in its cycle and that the board needs to intervene actively to help the CEO close any gaps between his/her capabilities/style and the requirement of the company. Although attention to leadership styles and a commitment to tough love all make sense on paper, implementing these strategies in the midst of the business cycle is sometimes difficult.

Integrated Leadership Model
CEO Agenda, practices and style

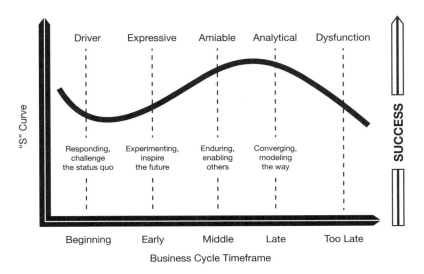

Klepper, 2010 (adapted from Hambrick and Fukutomi, 1991; Kouzes and Posner, 1987; Merrill and Reid, 1981)

During a downturn, attention is often on immediate solutions rather than on overall strategies, and during an upturn it can feel irrelevant to examine a system or partnership that seems to be working. However, because of the changing nature of the business cycle, it is imperative that boards constantly evaluate their leadership and their strategy. This method can help boards and businesses at every stage of the business cycle and can help regulate one of the most important relationships in the company: the relationship between the board and its CEO.[37]

The Wounded Warrior Project (WWP)

In addition to the BP, HP and P&G case studies of twenty-first-century corporations in the for-profit world, there are lessons to be learned from organizations in the not-for-profit arena. One of those organizations, the Wounded Warrior Project, was founded in the fall of 2003 and marked its tenth anniversary in 2013 as a mission-driven organization existing to honor and empower Wounded Warriors, specifically those who suffered a

physical or mental injury during the Afghanistan and Iraq wars that ensued after the September 11, 2001 terrorist attack on the New York City World Trade Center. The vision of this organization was simple: to focus on those newly injured and "foster the most successful, well-adjusted generation of wounded service members in our nation's history."[38] The Columbia CaseWorks case study, "Wounded Warrior Project: Leading from the Front," examines the governance and management of change of the WWP leadership over its ten year history and offers best practices for all organizations, for-profit and not-for profit, to emulate.[39]

> **The CEO's style needs to be matched to the business at each point in its cycle and the board needs to intervene actively to help the CEO**

WWP could look back on many successes over its ten year history. By September 2012 WWP was serving 27,492 veterans; one year later this number rose to 38,954. Revenues to fund programs were over $224 million for FY 2013 (year ending in September) and were being directed to a range of programs and services, with costs closely monitored relative to program effectiveness. Yet for all the organization's successes, CEO Steve Nardizzi and his team believed that it was facing a significant inflection point. The scale and scope of the WWP had grown exponentially in terms of the organization's size, funding, and programs and were pushing at the boundaries of the team's managerial and business leadership capabilities. Importantly, with the end of the US presence in the conflict zones, awareness of veterans, their sacrifices, and ongoing needs would likely fade from top of mind and the result would be a decline in funding to groups like WWP. But the mental and physical needs of the veterans would not fade.

As Nardizzi reflected on earlier discussions that the WWP leadership team had with Professor William Klepper of Columbia Business School, he was more and more convinced that Klepper's advice was on target. WWP needed to consider the required capabilities of leadership in the future and also ensure that it had a board in place capable of defining and directing the organization. If WWP was to achieve its vision of fostering "the most successful, well-adjusted generation of wounded service members" in US history, change was needed. Nardizzi summarized:

> Discussions with Klepper really opened our eyes. Since our founding we were an organization and a board on the 'inside looking out.' We have had the same board since we were the tiniest of charities. At that time, we needed an operational board who understood warriors, warrior programs, the role of government, and, most importantly, because we had little resources

for staff we needed board members willing to roll up their sleeves. Today, we have a staff to run the organization so our needs are more strategic. For the future, we need a board able to be on the 'outside looking in.' We still need a board to provide operating oversight but importantly, we need a diverse board that can see the broader landscape, the next big issue coming our way, and get WWP out in front of it.[40]

Klepper, drawn to Nardizzi's passion for his organization's value and mission, listened and suggested that WWP work with Korn Ferry International, a consultancy firm with specialized knowledge in the area of corporate governance. Within months, three broad areas had been identified for consideration: succession planning, the size of the board, and the composition of the board in light of future needs. The governance committee needed to make a recommendation to the board within a few short weeks. As the committee considered its options, it weighed several factors: that WWP was devoted to its mission, that either by serendipity or design WWP had so far managed to do everything right, and that the future loomed large.

Leadership, People, and Governance

In 2013, two of WWP's founding fathers continued to lead the organization. Nardizzi was the chief executive / CEO responsible for the oversight of all aspects of the organization. Prior to taking on the role in 2009, Nardizzi had been deputy executive. Albion (Al) Giordano now acted as the deputy executive/COO. Giordano was himself a disabled veteran of the US Marine Corps. WWP's board of directors was composed of 12 men and women, with all but two having military experience.

WWP used its core values of fun, integrity, loyalty, innovation, and service (FILIS) as the basis for its leadership. FILIS and teamwork drove action in the organization and guided decision-making aligned with the mission of fostering the most successful, well-adjusted generation of wounded warriors in US history. As Giordano noted, "It really is our people who identify the need, who develop the strategy, who implement the strategy, who figure out where the next great opportunity is programmatically. So if they're all aligned and they're all working together as a team, they have the same value set, passion about our mission, they're going to figure it out and create the next great success."

By the end of 2013 the number of WWP offices had grown to 17 with 342 employees providing programs for alumni. In an annual survey of alumni, about 45% indicated that they were meeting their individual goals, about 26% indicated they were making progress, while the remaining 29% indicated they were not making progress toward their goals.

The leadership team and the board were responsible for oversight and setting the direction for the future. Anthony Principi, vice president of the WWP board and former Secretary of Veterans Affairs, addressed some of the challenges facing WWP:

> Today the Department of Veterans Affairs faces numerous challenges, including allegations of misconduct at several VA medical centers; returning troops with severe battlefield wounds, a burgeoning backlog of claims for disability compensation, and rapidly changing demographics in a declining military and veteran population. As a former Secretary of Veterans Affairs I appreciate the enormity of these challenges and the need for strong and decisive leadership to chart a new course for the VA in the 21st century. The Wounded Warrior Project will play an important role in the VA's transition, helping to develop innovative programs to meet the needs of today's wounded warriors. The leadership and staff have propelled WWP to become the finest veterans' service organization in the country. The future success of WWP in carrying out its mission 'to care for him who shall have borne the battle, and for his widow, and his orphan' [President Abraham Lincoln] will rest on the shoulders of today and tomorrow's leaders. WWP's board of directors has the important responsibility of ensuring that the men and women who bring WWP to life fulfill Lincoln's charge to care for all who have sacrificed.[41]

Governing for the Future

If WWP were to continue its progress in fostering "the most successful, well-adjusted generation of wounded service members" in US history, change would be needed. As the team considered the changes, it was clear that change would need to come from the top—in leadership and direction setting. Notably, it would fall to WWP leadership—specifically the Board—to create an environment that would continue to support the organization and its mission. What was less clear was whether the existing Board and leadership had the skills needed to achieve the strategic goals. A strategy had been defined but questions remained. Did the organization have the resources to successfully execute the strategy? Did the leadership have the capabilities necessary to successfully execute the strategy? And was the Board sufficiently diverse to examine the internal and external context of the organization—a skill set that would be increasingly important for the future success of WWP?

Working with Korn Ferry International and Professor Klepper, the WWP team highlighted broad areas for consideration:

- **Succession Planning**

Nardizzi and Giordano were two of the founding fathers of the WWP. Would their successors have the skills and competencies to lead the organization forward to the next level? Was there sufficient bench strength to take on an enterprise-wide leadership role? What were the skills and competencies needed to lead the WWP into the next decade?

- **The Board**

In 2013 WWP's board had 14 seats (with two currently unfilled) while most groups with decision-making responsibility functioned optimally with 7-10 members. Should WWP seek to downsize the board? If it needed to change, what should be the criteria? How should board members be evaluated? Did the current board have the core competencies to provide the oversight to get the best possible results? Did board members have the strategic competencies needed to help the WWP face the challenges of the future? Were they thinking ahead to potential successors?

As the WWP entered its second decade, its governance policies and practices would ensure its continued success. In addition, its CEO and board leadership share a common commitment to the WWP mission and its core values. They proactively addressed the changes required in their governance system and executive leadership over the next decade to serve wounded warriors. WWP is a model organization of good governance and leadership practices from which for-profits can profit.

Recommendations for Governing and Managing Change in the Company of the 21st Century

BP, HP and P&G are companies of the twenty-first century and each one has been challenged by a change in its current state that has put in jeopardy its desired future state. Each continues to confront these challenges and each needs a strong partnership between its CEO and board in order to endure. In examining the case studies and the lessons learned from each of these companies, recommendations were offered. By way of summary, the prescription for a prosperous partnership and future includes the following:

Develop your Social Contract

A Board/CEO partnership cannot be sustained by good intentions alone; it must be defined by an explicit statement of the beliefs and behaviors that are

essential for the general will of the organization. Boards should share a set of common commitments with their CEO:

– Commitment to values: a leadership credo that answers the question "What do we stand for as an organization?"
– Commitment to the stakeholders—customers, employees, shareholders, and community
– Commitment to risk assessment— a willingness to manage the company's risk profile
– Commitment to transparency— complete honesty in financial and non-financial matter
– Commitment to coaching for their continuous improvement

Practice Tough Love

Intentionally address the realities of your CEO's tenure with the appropriate amount of tough love before your company and CEO become dysfunctional. Boards can learn from those who study CEO tenure, company performance, and successful leadership behaviors. Taking this research into account can help the company thrive at every stage in the life cycle of the business.

Constantly Assess Your CEO's Leadership Agenda, Practices, and Style

Business cycles are unavoidable and uncertain, and the board needs to face this reality and be prepared to change its leadership if the CEO cannot adjust to the changing conditions.

Achieve Congruence

If you determine the current CEO cannot adjust to the changing business cycle, the Board must:

– Understand its own strategic context and intent, i.e., its strategy, before it can begin the CEO selection process;
– Determine the company's position and the agenda, practices, and style required of its CEO; and
– Identify key gaps in structure, process, people, and culture, because these gaps will become the CEO's strategic priorities.

Closing

Mark Twain once stated, "You know, I'm all for progress. It's change I object to." Unfortunately, both progress and change are required of the company of the twenty-first century. To achieve both, the board and CEO must form their Social Contract of shared values, commitment to stakeholders, risk management and transparency. This then provides a foundation for addressing the challenges to their strategy and alignment of their business system over time. Boards need to be the CEO's boss, exercise the Tough Love in the Boardroom and match up the CEO's agenda, practices, and style with what is required to progress in their business cycle. This chapter is offered as a succinct means by which organizations can both manage change and progress in the twenty-first century. A more comprehensive reading of this chapter's content can be obtained from Columbia CaseWorks (BP, HP, P&G and WWP) and Columbia University Press (*The CEO's Boss: Tough Love in the Boardroom*).

Columbia CaseWorks <http://www4.gsb.columbia.edu/caseworks>
Columbia University Press <http://cup.columbia.edu/book/978-0-231-14988-4/droom>

Notes

1 Keehner and Randall, "Introduction to Corporate Governance," IBS Curriculum, Columbia Business School, 2008.

2 W. M. Klepper, *The CEO's Boss: Tough Love in the Boardroom* (New York: Columbia University Press, 2010).

3 D. Scally, "The CEO's Boss: Tough Love in the Boardroom," Corporate Board Member, First Quarter 2014.

4 W.M. Klepper, *The CEO's Boss*, Chapter 2.

5 W.M. Klepper, "BP: A Company in Peril?," Columbia CaseWorks, April 12, 2012.

6 J. Morris and M.B. Pell, "Renegade Refiner: OSHA Says BP Has 'Systemic Safety Problem'," The Center for Public Integrity, May 17, 2010.

7 D. Fisher, "Memoirs of BP's Browne Foreshadow Blowout," *Forbes*, August 12, 2010.

8 S. Lyall, "In BP's Record, a History of Boldness and Costly Blunders," *The New York Times*, July 12, 2010.

9 G. Chazan, B. Faucon, and B. Casselman, "As CEO Hayward Remade BP, Safety, Cost Drives Clashed," *The Wall Street Journal*, June 29, 2010.

10 R. Knutson, "BP Texas Refinery Had Huge Toxic Release Just Before Gulf Blowout," *ProPublica*, July 2, 2010.

11 G. Colvin, "Who's to Blame at BP? The Board," *Fortune*, July 28, 2010.

12 J. Werdigier, "BP Taps the Telecommunications Industry for its Chairman," *The New York Times*, June 25, 2009.

13 The BP 2011 Annual Report, March 2, 2011.

14 W.M. Klepper, *The CEO's Boss*, The Social Contract, Chapter 1.

15 Tyco International Ltd., Board Governance Principles, amended, December 6, 2007.

16 D. Beim, R. Biggadike, F. Edwards, and D. Sorid, "Corporate Governance at Hewlett-Packard 1995-2005," Columbia CaseWorks, March 18, 2010.

17 W.M. Klepper, "Hewlett-Packard: Its Board, Its CEOs, Its Business," FT-ODX, New York City, October 12, 2012.

18 A. Vance, "HP Ousts Chief for Hiding Payments to Friend," *New York Times*, August 6, 2010.

19 Q. Hardy, "H.P. Takes $8 Billion Charge on E.D.S. Acquisition," *The New York Times*, August 8, 2012.

20 J. Menn and R. Waters, "HP Defends Whitman as 'Best Choice'," *Financial Times*, September 24, 2011.

21 Q. Hardy, "Meg Whitman's Toughest Campaign: Retooling H.P.," *The New York Times*, September 29, 2012.

22 W.M. Klepper, *The CEO's Boss*, The Social Contract, Chapter 6.

23 Governance Insight Alert, GMI Ratings, July 21, 2014.

24 W.M. Klepper, "Procter & Gamble in 2013: A Board Adrift?", Columbia CaseWorks, February 17, 2014.

25 "Purpose, Values and Principles," Procter & Gamble <http://www.pg.com/en_US/company/purpose_people/executive_team/a_g_lafley.shtml> [accessed July 27, 2014].

26
A.G. Lafley, "The Art and Science of Finding the Right CEO," Harvard Business Review, October 2011.

27
Procter & Gamble, 2012 Annual Report, 2012.

28
M. Farrell, "Ackman: P&G CEO May Need to Go," CNNMoney, May 8, 2013.

29
L. Coleman-Lochner, "P&G Confirms Meeting With Ackman," Bloomberg News, September 27, 2012.

30
Melodie Warner, "Procter & Gamble Hikes Stock Buyback Estimate," MarketWatch, November 15, 2012 <http://www.marketwatch.com/story/procter-gamble-hikes-stock-buyback-estimate-2012-11-15>

31
P&G, 2012 Annual Report.

32
J. Reingold, "Can Procter & Gamble CEO Bob McDonald Hang On?" Fortune, February 8, 2013 <http://management.fortune.cnn.com/2013/02/08/procter-gamble-mcdonald>

33
"A. G. Lafley Rejoins Procter & Gamble as Chairman, President and Chief Executive Officer," Procter & Gamble press release, May 23, 2013, on P&G website <http://news.pg.com/press-release/pg-corporate-announcements/ag-lafley-rejoins-procter-gamble-chairman-president-and-chi>

34
R. Kerber, N. Damouni, and J. Wohl, "Analysis: P&G All-Star Board's Oversight Questioned as CEO Departs," Reuters, May 29, 2013 <http://www.reuters.com/article/2013/05/29/us-proctergamble-ceo-board-analysis-idUSBRE94S05U20130529>

35
Kerber, Damouni, and Wohl, "Analysis."

36
W.M. Klepper, The CEO's Boss, Chapter 2.

37
W.M. Klepper, The CEO's Boss, The Right Partnership Matters, Chapter 3.

38
Wounded Warrior Project, Mission Statement <http://www.woundedwarriorproject.org/mission.aspx>

39
W.M. Klepper, "Wounded Warrior Project: Leading from the Front," Columbia CaseWorks, July 24, 2014.

40
Steven Nardizzi, interview by casewriter, Sawgrass, Florida, March 8, 2014. Applies to this and all other Nardizzi statements, unless otherwise noted.

41
Anthony Principi, email message to casewriter, May 20, 2014.

The Organization of the Future: A New Model for a Faster-Moving World

John P. Kotter

It is a truism to state that on every important business index, the world is forging ahead at an unpredicted pace, and John P. Kotter sees the risks involved with this singularity—be they financial, social, environmental or political—rising in a similar exponential way.

Professor Kotter sees the major challenge for business leaders today is staying competitive and growing profitably amid increasing turbulence and disruption. He argues that the fundamental problem is that any company that has made it past the start-up stage is optimized much more for efficiency than for strategic agility—the ability to capitalize on opportunities and dodge threats with speed and assurance—and today any company that isn't rethinking its direction at least every few years (as well as constantly adjusting to changing contexts) and then quickly making necessary operational changes is putting itself at risk. The demands between what it takes to stay ahead of increasingly fierce competition, on the one hand, and needing to deliver this year's results, on the other, are daunting. Kotter says the key to managing this complex situation is properly balancing the daily demands of running a company with identifying the most important hazards or opportunities early enough, formulating innovative strategic initiatives nimbly enough, and especially executing those initiatives fast enough.

John P. Kotter
Harvard University

Regarded by many as the authority on leadership and change, Dr John P. Kotter is a *New York Times* best-selling author, award-winning business and management thought leader, business entrepreneur, inspirational speaker, and Harvard professor. He has authored nineteen books to date—twelve of them best sellers. Arguably his most popular book, *Our Iceberg is Melting*, introduced a broad audience to the eight-step philosophy behind Kotter International. Other widely read books include *A Sense of Urgency*, *The Heart of Change*, and *Leading Change*, which *Time* magazine selected in 2011 as one of the 25 most influential business management books ever written.

Key Features for the Company of the Future:

Think Differently About Strategy
Today's notion of strategy as having two basic components–creation and implementation–needs to be revised. Creation and implementation will start to blur in the future, and in agile organizations, strategy is already being viewed as a dynamic force, not one directed by a strategic planning department and put into a yearly planning cycle. Future organizations will need a high level of "strategic fitness," which will be improved the more the organization exercises its strategy skills, becomes adept at dealing with a hyper-competitive environment and incorporates those skills into its DNA or culture.

Add a Network System —And Add it Correctly!
Clarify your Big Opportunity, create a sense of urgency around it and tap into leaders throughout your organization. There is a distinct first-mover advantage to implementing the dual organizational structure because it takes time to put in place and to get right. Those organizations that move quickly will be the first to realize the potential of the system, and to capture the strategic advantages it can create for their organization.

Change Your Leadership Routines
To run an organization with a dual operating system requires changing the routines leaders follow and challenging the view of management as a practice. Organizations driven by powerful forces from the inside, by an extremely agile network-like-structure that operates in concert with the hierarchy, necessitate different leadership. Organizational theorists have been integrating insights from network theory, complexity research and positive psychology into new thinking about organizations, which is the first step down the path.

The Organization of the Future: A New Model for a Faster-Moving World

On almost every important business index, the world is racing ahead. The stakes—the financial, social, environmental, and political consequences—are rising in a similar exponential way.

In this new world, the big question facing business leaders everywhere is how to stay competitive and grow profitably amid this increasing turbulence and disruption. The most fundamental problem is that any company that has made it past the start-up stage is optimized much more for efficiency than for strategic agility—the ability to capitalize on opportunities and dodge threats with speed and assurance. I could give you a hundred examples of companies that, like Borders and Research in Motion (RIM), recognized the need for a big strategic move but couldn't pull themselves together fast enough to make it and ended up sitting on the sidelines as nimbler competitors beat them, badly.

Companies used to reconsider their basic strategies only rarely, when they were forced to do so by big shifts in their environments. Today any company that isn't rethinking its direction at least every few years (as well as constantly adjusting to changing contexts) and then quickly making necessary operational changes is putting itself at risk. That's what faster

change is doing to us. But as any business leader can attest, the tension between what it takes to stay ahead of increasingly fierce competition, on the one hand, and needing to deliver this year's results, on the other, can be overwhelming.

We cannot discount the daily demands of running a company, which traditional hierarchies and managerial processes can still do very well. What they do *not* do well is identify the most important hazards or opportunities early enough, formulate innovative strategic initiatives nimbly enough, and (especially) execute those initiatives fast enough.

Traditional Management-Driven Hierarchies

Virtually all successful organizations on earth go through a very similar life cycle. They begin with a network-like structure, sort of like a solar system with a sun, planets, moons, and even satellites. Founders are at the center. Others are at various nodes working on different initiatives. Action is opportunity seeking and risk taking, all guided by a vision that people buy into. Energized individuals move quickly and with agility.

Over time, a successful organization evolves through a series of stages into an enterprise that is structured as a hierarchy and is driven by well-known managerial processes: planning, budgeting, job defining, staffing, measuring, problem solving. With a well-structured hierarchy and with managerial processes that are driven with skill, this more mature organization can produce incredibly reliable and efficient results on a weekly, quarterly, and annual basis.

The management-driven hierarchies that good organizations use and we take for granted are one of the most amazing innovations of the twentieth century

A well-designed hierarchy allows us to sort work into departments, product divisions, and regions, where strong expertise is developed and nurtured, time-tested procedures are invented and used, and there are clear reporting relationships and accountability. Couple this with managerial processes that can guide and coordinate the actions of employees—even thousands of employees located around the globe—and you have an operating system that lets people do what they know how to do exceptionally well.

There are those who deride all of this as a bureaucratic leftover from the past, not fit to handle twenty-first-century needs. Get rid of it. Smash it. Start over. Organize as a spider web. Eliminate middle management and let the staff manage themselves. But the truth is that the management-driven

hierarchies that good organizations use and we take for granted are one of the most amazing innovations of the twentieth century. And they are still absolutely necessary to make organizations work.

One part of what makes them amazing is that they can be enhanced to deal with change, going beyond mere repetition—at least up to a point. We have learned how to launch initiatives within a hierarchical system to take on new tasks and improve performance on old ones. We know how to identify new problems, find and analyze data in a dynamic marketplace, and build business cases for changing what we make, how we make it, how we sell it, and where we sell it. We've learned how to execute these changes by adding task forces, tiger teams, project management departments, and executive sponsors for new initiatives. We can do this while still taking care of the day-to-day work of the organization because this strategic change methodology is easily accommodated by a hierarchical structure and basic managerial processes. And that is precisely what leaders everywhere have been doing, and to a greater degree, each year.

> Executives are launching more strategic initiatives than ever. Skilled leaders have always tried to improve productivity, but now they are trying to innovate more and faster

Every relevant survey of executives I have seen for a decade now reports that they are launching more strategic initiatives than ever. Skilled leaders have always tried to improve productivity, but now they are trying to innovate more and faster. When historical organizational cultures—formed over many years or decades—have slowed action, impatient leaders have tried to change those cultures. The goal of all this, of course, is to accelerate profitable growth to keep up or get ahead of the competition.

But those same surveys show that success across these initiatives is often illusive. A recent reboot at JCPenney, for example, looked exceptionally promising—for a few months. And then all the various strategic projects began to fall apart. Even well-run organizations, unless they are very small and new, are having great difficulty moving with the speed and agility required in a faster-moving world. Japanese firms that once were the envy of everyone are now being left in the dust by rivals in Korea and California.

Across industries and sectors, and around the world, everywhere you look it seems clear that the current way in which we run our organizations—even when we enhance them with more and more sophisticated strategic planning departments or interdepartmental task forces—may not be able to do the job.

The Limits of Hierarchies

The frustrations of this reality are well known.

You find yourself going back again and again to the same small number of trusted people to lead key initiatives. That puts obvious limits on what can be done and at what speed. You find that communication across silos does not happen with sufficient speed and effectiveness. You find that policies, rules, and procedures, even sensible ones, become barriers to strategic speed. These inevitably grow over time, implemented as solutions to real problems of cost, quality, or compliance. But in a faster-moving world they become, at a minimum, bumps in the road—if not outright cement barriers.

Going back again and again to the same small number of trusted people to lead key initiatives puts limits on what can be done and at what speed

Part of the problem is political and social: people are often loath to take chances without permission from their superiors. Part of it is simply related to human nature: people cling to their habits and fear loss of power and stature.

Complacency and insufficient buy-in, a typical product of past success, complicate matters further. With even a little complacency, people don't believe anything much new is needed and begin to resist change. With insufficient buy-in, they might believe something new is needed, but not the strategic initiatives being launched from the top. Both attitudes stall acceleration.

It can be tempting to simply blame the problems on people but the reality is that the problem is *systemic* and directly related to the limitations of hierarchy and basic managerial processes.

Silos are an inherent part of hierarchical operating systems. They can be made with thinner walls and leaders can try to make them less parochial, but they cannot be eliminated. So too with rules and procedures: we can reduce their number, but we will always need some of them. The list of similar issues goes on and on. You can reduce but not eliminate levels. You can tell people not to ignore the long term but you cannot eliminate quarterly budgets. These and other factors are an inherent part of the system and, predictably, eventually become anchors on efforts to accelerate strategic agility and strategy execution in a faster-moving world.

Good leaders know all these things, if sometimes only intuitively, and try to make up for the problems with those speed-it-up enhancements. They create all sorts of project-management organizations to handle special projects. They use interdepartmental task forces to cut across silos. They bring in strategy

consultants or build strategic planning departments to focus on longer-term issues. In a similar way, they add strategic planning to the yearly operational planning exercise. They build in change-management capabilities to overcome complacency, lower resistance, and increase buy-in. When done well, these and other enhancements can reduce the problems with stalling and increase speed and agility— *but only up to a point.*

Consider typical approaches to change management. Such methods—using diagnostic assessments and analyses, innovative communication techniques, training modules—can be invaluable in helping with episodic problems that have relatively straightforward solutions, such as implementing a well-tested financial reporting system. These approaches are effective when it is reasonably clear that you need to move from point A to point B; when the distance between the two points is not galactic; and when pushback from employees will not be Herculean. Change-management processes supplement the system we know. They can slide easily into a project management organization. They can be made stronger or faster by adding more resources, more sophisticated versions of the same old methods, or more talent to drive the process—but, again, they have their limits.

When it is not 100% clear where point B is because of continuous change, when the jump into the future needs to be a big one because the world is moving so fast, and when the potential pushback is likely to be formidable because of the size of the necessary strategic changes and the potential implications for people, then using a conventional change-management approach may create confusion, resistance, fatigue, and higher costs.

What we need today is a powerful new element to address the challenges posed by mounting complexity and rapid change. The solution, which I have seen work astonishingly well, is a second system that is organized as a network—more like a start-up's solar system than a mature organization's Giza pyramid—that can create agility and speed. It powerfully complements rather than overburdens a more mature organization's hierarchy, thus freeing the latter to do what it's optimized to do. It makes an enterprise easier to run while accelerating strategic change. This is not a question of "either/or." It's "both/and": two systems that operate in concert. A dual operating system.

The Structure of a Dual System

It seems like new management tools are proposed every week for finding a competitive advantage or dealing with twenty-first-century demands. How is a dual operating system any different? The answer is twofold. First, a dual system is more about *leading* strategic initiatives to capitalize on Big

Opportunities or dodge big threats than it is about management. Second, although the dual system is a new idea, it is a manner of operating that has been hiding in plain sight for years. All successful organizations operate more or less as I describe during the most dynamic growth period in their life cycle. They just don't understand this while it is happening or sustain it as they mature.

The basic structure is self-explanatory: hierarchy on one side and network on the other. The network side mimics successful enterprises in their entrepreneurial phase, before there were organization charts showing reporting relationships, before there were formal job descriptions and status levels. That structure looks roughly like a constantly evolving solar system, with a guiding mechanism as the sun, strategic initiatives as planets, and sub-initiatives as moons or satellites.

This structure is dynamic: initiatives and sub-initiatives coalesce and disband as needed. Although a typical hierarchy tends not to change much from year to year, this type of network typically morphs all the time and with ease. Since it contains no bureaucratic layers, command-and-control prohibitions, or Six Sigma processes, the network permits a level of individualism, creativity, and innovation that even the least bureaucratic hierarchy, run by the most talented executives, simply cannot provide. Populated with a diagonal slice of employees from all across the organization and up and down its ranks, the network liberates information from silos and hierarchical layers and enables it to flow with far greater freedom and at accelerated speed.

The hierarchy part of the dual operating system differs from almost every other hierarchy today in one very important way. Much of the work ordinarily assigned to it that demands innovation, agility, difficult change, and big strategic initiatives executed quickly— challenges dumped on work streams, tiger teams, or strategy departments—has been shifted over to the network part. That leaves the hierarchy less encumbered and better able to perform what it is designed for: doing today's job well, making incremental changes to further improve efficiency, and handling those strategic initiatives that help a company deal with predictable adjustments, such as routine IT upgrades.

The hierarchy part of the dual operating system differs from other hierarchies in that much of the work ordinarily assigned to it has been shifted over to the network part

In a truly reliable, efficient, agile, and *fast* enterprise, the network meshes with the more traditional structure; it is not some sort of "super task force" that reports to some level in the hierarchy. It is seamlessly connected to and coordinated with the hierarchy in a number of ways, chiefly through the people who populate both systems. Still, the organization's top management plays a

The Dual System

John P. Kotter

Evolution of the Company: From Network to Hierarchy

The Organization of the Future: A New Model for a Faster-Moving World

crucial role in starting and maintaining the network. The C-suite or executive committee must launch it, explicitly bless it, support it, and ensure that it and the hierarchy stay aligned. The hierarchy's leadership team must serve as role models for their subordinates in interacting with the network. I have found that none of this requires much C-suite time. But these actions by senior executives clearly signal that the network is not in any way a rogue operation. It is not an informal organization. It is not just a small engagement exercise which makes those who participate feel good. It is part of a system designed for competing and winning.

I am not describing a purely theoretical idea. Every successful organization goes through a phase, usually very early in its history, in which it actually operates with this dual structure. This is true whether you are Panasonic in Osaka, Morgan Stanley in New York, or a nonprofit in London. The problem is that the network side of a dual system in the normal life cycle of organizations is informal and invisible to most people, so it rarely sustains itself. As they mature, organizations evolve naturally toward a single system—a hierarchical organization—at the expense of the entrepreneurial network. The lack of insight and effort to formalize and sustain an organization that was both highly reliable and efficient on the one hand and fast and agile on the other did not cost us much in a slower-moving past. That situation has changed forever—for Panasonic, Morgan Stanley, and thousands of others—or it will soon.

Characteristics of the Dual Operating System

On close observation, it's clear that a well-functioning dual operating system is guided by a few basic principles:

- Many people driving important change, and from everywhere, not just the usual few appointees. It all starts here. For speed and agility, you need a fundamentally different way to gather information, make decisions, and implement decisions that have some strategic significance. You need more eyes to see, more brains to think, and more legs to act in order to accelerate. You need additional people with their own particular windows on the world and with their additional good working relationships with others, in order to truly innovate. More people need to be able to have the latitude to initiate—not just carry out someone else's directives. But this must be done with proven processes that do not risk chaos, create destructive conflict, duplicate efforts, or waste money. And it must be done with insiders. Two hundred consultants, no matter how smart or dynamic, cannot do the job.

- A "get-to" mindset, not a "have-to" one. Every great leader throughout history has demonstrated that it is possible to find many change agents, and from every corner of society—but only if people are given a choice and feel they truly have permission to step forward and act. The desire to work with others for an important and exciting shared purpose, and the realistic possibility of doing so, are key. They always have been. And people who feel they have the privilege of being involved in an important activity have also shown, throughout history, that they will volunteer to do so in addition to their normal activities. You don't have to hire a new crew at great expense. Existing people provide the energy.

- Action that is head and heart driven, not just head driven. Most people won't want to help if you appeal only to logic, with numbers and business cases. You must also appeal to how people feel. As have all the great leaders throughout history, you must speak to the genuine and fundamental human desire to contribute to some bigger cause, to take a community or an organization into a better future. If you can provide a vehicle that can give greater meaning and purpose to their efforts, amazing things are possible.

- Much more leadership, not just more management. To achieve any significant though routine task—as well as the uncountable number of repetitive tasks in an organization of even modest size—competent management from significant numbers of people is essential. Yes, you need leadership too, but the guts of the engine are managerial processes. Yet in order to capitalize on unpredictable windows of opportunity which might open and close quickly, and to somehow spot and avoid unpredictable threats, the name of the game is leadership, and not from one larger-than-life executive. The game is about vision, opportunity, agility, inspired action, passion, innovation, and celebration—not just project management, budget reviews, reporting relationships, compensation, and accountability to a plan. Both sets of actions are crucial, but the latter alone will not guarantee success in a turbulent world.

- An inseparable partnership between the hierarchy and the network, not just an enhanced hierarchy. The two systems, network and hierarchy, work as one, with a constant flow of information and activity between them—an approach that succeeds in part because the people essentially volunteering to work in the network already have jobs within the hierarchy. The dual operating system cannot be, and does not have to be, two super-silos, staffed by two different groups of full-time people, like the

old Xerox PARC (an amazing strategic innovation machine) and Xerox corporate itself (which pretty much ignored PARC, or at least could never execute on the fantastic commercial opportunities it uncovered). And, ultimately, the meshing of the two parts succeeds as does anything new that at first seems awkward, wrong, or threatening: through education, role modeling from the top of the hierarchy, demonstrated success, and finally sinking into the very DNA of the organization, so it comes to feel just like, well, "the way we do things here."

These principles point to something very different than the default way of operating within a hierarchy: to drive change through a limited number of appointed people who are given a business case for a particular set of goals and who project-manage the process of achieving the goals in the case. That default process can work just fine when the pace needed is not bullet-like, the potential pushback from people is not ferocious, and the clarity of what is needed is high (and innovation requirements are therefore low). But, increasingly, that is not the world in which we are living.

Based on these principles, the action on the network side of a dual system is different from that on the hierarchy side. Both are systematic. They are just very different. It's not a matter of one side being hard and metrically driven while the other is fluffy or soft. We know less today about network processes like "creating short-term wins" than we do about hierarchical processes like operational planning or creating relevant metrics. But, just as action within a well-run hierarchy is far from control-oriented people doing whatever comes into their heads, action within a well-run network is very different from enthusiastic volunteers doing whatever they want.

Because action within networks accelerates activity, especially strategically relevant activity, I call its basic processes the Accelerators.

The Eight Accelerators

The network's processes resemble the activity you usually find in successful, entrepreneurial contexts. They are much like my eight steps for leading change, only this time with top management launching a dynamic that creates many more active change drivers, a network structure integrated with the hierarchy, and processes that, once started, never stop.

These are the eight Accelerators:

- **Create a Sense of Urgency Around a Big Opportunity**
 The first Accelerator is all about creating and maintaining a strong sense of urgency, among as many people as possible, around a Big Opportunity

an organization is facing. Building a dual system starts here. This is, in many ways, the secret sauce which allows behavior to happen that many who have grown up in mature organizations would think impossible.

Urgency, in the sense used here, is not just about this week's problems but about the strategic threats and possibilities flying at you faster and faster. With Accelerator 1 working well, large groups of people, not just a few executives, rise each day thinking about how they might be able to help you pursue a Big Opportunity.

- **Build and Evolve a Guiding Coalition**

 The second Accelerator leverages off a greatly heightened and aligned sense of urgency to build the core of the network structure, then later to help it evolve into a stronger and more sophisticated form. This guiding coalition of people from across the organization feels the urgency deeply. These are individuals from all silos and levels who want to help you take on strategic challenges, deal with hyper-competitiveness, and win the Big Opportunity. They are people who want to lead, to be change agents, and to help others do the same. This core group has the drive, the intellectual and emotional commitment, the connections, the skills, and the information to be an effective sun in your dynamic new solar system. These are people who can, and do, learn how to work together effectively as a large team.

 With a sufficient sense of urgency, finding good people who want to participate in a guiding coalition is surprisingly easy. Getting individuals from different levels and silos to work well together requires effort. Just throw them into a room and they are likely to recreate what they know: a management-centric hierarchy. But under the right conditions—with urgency around a Big Opportunity as a crucial component—they will learn how to work together in a totally new way. And with help, both the guiding coalition and the organization's executive committee will learn how to work together in a way that allows for the hierarchy side and the network side to stay strategically aligned, to maintain high levels of reliability and efficiency, and to develop a whole new capacity for speed and agility.

- **Form a Change Vision and Strategic Initiatives**

 The third Accelerator has the guiding coalition clarify a vision that fits a big strategic opportunity and select strategic initiatives that can move you with speed and agility toward the vision. When you first form a dual system, much of this, especially the initiatives, may already exist, created by the hierarchy's leadership team. But the initiatives the nascent network side attacks first will be those that individuals

in the guiding coalition have great passion to work on. These will always be activities that the organization's executive committee agrees make great sense. But these will be initiatives which a management-driven hierarchy is ill-equipped to handle well enough or fast enough by itself.

- **Enlist a Volunteer Army**
 In the fourth Accelerator, the guiding coalition, and others who wish to help, communicate information about the strategic vision and the strategic change initiatives to the organization in ways that lead large numbers of people to buy into the whole flow of action. Done well, this process results in many individuals wanting to help, either with some specific initiative or just in general. This Accelerator starts to pull, as if by gravity, the planets and moons into the new network system.

- **Enable Action by Removing Barriers**
 In the fifth Accelerator, everyone helping on the network side (the "right side" in the illustrations) works swiftly to achieve initiatives and find new ones that are strategically relevant. People talk, think, invent, and test, all in the spirit of an agile and swift entrepreneurial start-up. Much of the action here has to do with identifying and removing barriers which slow or stop strategically important activity. Within a dual system, and unlike in a start-up, this process guides people to pay close attention to their hierarchy: to what is being done there (to avoid overlap of effort), to what has been done there (to avoid plowing old ground), and to the hierarchy's operational goals and incremental strategic initiatives (to maintain alignment). Smart actions, based on good information from all silos and levels, are taken with heightened speed.

- **Generate (and Celebrate) Short-Term Wins**
 The sixth Accelerator is about everyone on the network side helping to create an ongoing flow of strategically relevant wins, both big and very small. Action here also ensures that the wins are as visible as possible to the entire organization and that they are celebrated, even if only in small ways. These wins, and their celebration, can carry great psychological power and play a crucial role in building and sustaining a dual system. They give credibility to the new structure. This credibility in turn promotes more and more cooperation within the overall organization. These wins draw out respect, understanding, and eventually complete cooperation from the most control-oriented managers, who themselves have no desire to be network-side volunteers.

- **Sustain Acceleration**
Accelerator 7 keeps the entire system moving despite a general human tendency to let up after a win or two. It is built on the recognition that so many wins come from sub-initiatives which, by themselves, may be neither substantial nor particularly useful in a strategic sense. Larger initiatives will lose steam and support unless related sub-initiatives are also completed successfully. Here, with relentless energy focused forward on new opportunities and challenges, we find a motor which helps all the others. Accelerators keep going, as needed, like spark plugs and cylinders in a car's engine. It is the opposite of a one-and-done approach and mindset.

- **Institute Change**
Accelerator 8 helps institutionalize wins, integrating them into the hierarchy's processes, systems, procedures, and behavior— in effect, helping to infuse the changes into the culture of the organization. When this happens with more and more changes, there is a cumulative effect. After a few years, such institutionalizations of action drive the whole dual operating system approach into an organization's very DNA.

When these Accelerators are all functioning well, they naturally solve the challenges inherent in building a new and different kind of organization. They provide the energy, the volunteers, the coordination,

the integration of hierarchy and network, and the needed cooperation. As they capitalize on opportunities and work around threats, the whole system grows and accelerates. Eventually it becomes the way you do business in a rapidly changing world. You move ahead of tough competition or achieve fiercely ambitious goals. And, done right, all this happens without adding expensive staff, disrupting daily operations, or missing earnings targets.

The Volunteer Army

The people who drive these processes and populate the Accelerator network also help make the daily business of the organization hum. They're not a separate group of consultants, new hires, or task force appointees.

We have found that a guiding coalition of 5–10% of the managerial and employee population in a hierarchy is typically an appropriate size. A team of this size is generally large enough to make the dual system work, for two reasons. First, because they work in the hierarchy, these 5–10% have crucial organizational knowledge, relationships, credibility, and influence. They are often the first to see threats or opportunities—and they have the zeal to deal with them if put into a structure where that is possible. Second, they add no new (perhaps impossibly large) budget item.

> **A guiding coalition of 5–10% of the managerial and employee population in a hierarchy is typically an appropriate size. A team of this size is generally large enough to make the dual system work**

If the sense of urgency around the Big Opportunity is high enough, a guiding coalition of this size will have a large enough reach into the organization to recruit their colleagues to volunteer on initiatives and subinitiatives, thereby growing the network. In a fully functioning dual operating system, it is not unusual to see more than half of an organization volunteering in some capacity to drive transformational change. Modest but aligned actions, taken by many passionate people who bring with them insight from all levels and all silos, imbue the network with the power it needs to undertake smart, strategic action.

People who have never seen this sort of dual operating system work often worry, quite logically, that a bunch of enthusiastic volunteers might create more problems than they solve—by running off and making ill-conceived

The Role of the Guiding Coalition

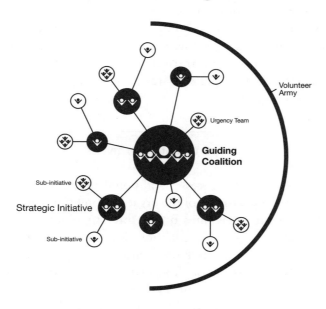

decisions and disrupting daily operations. Here is where the network structure, the underlying principles, and the accelerating processes all come into play. They create conditions under which people generate not just ideas, but ideas backed by good data from all silos and levels in a hierarchy. They create conditions under which people do not just develop initiatives, but understand that it is their job to implement them. They create conditions which guide people not just to keep daily operations running smoothly, but also to improve day-to-day processes to make the work of the organization easier, more efficient, less costly, and more effective.

In organizations where a dual system has really taken hold, individuals have told me that the rewards from working in the network can be tremendous—though they are rarely monetary. They talk about the fulfillment they get from pursuing a broader, enterprise-wide mission they believe in. They appreciate the chance to collaborate with a broader array of people than they ever could have worked with in their regular jobs within the hierarchy. A number of them say that their strategy work has led to increased visibility across the organization and to better positions in the hierarchy. And their managers often come to appreciate how the volunteers develop professionally. Consider this email I received from a client in Europe: "I can't believe how quickly this second operating system gives growth to real talents within the organization. Once people feel 'Yes, I can do it!' they also start faster growth in their regular jobs in the hierarchy, which helps make today's operations more effective."

Growing and Building Momentum Organically

A dual operating system doesn't start fully formed and doesn't require a sweeping overhaul of the organization—hence there is much less risk than one might think. It evolves, growing organically over time, accelerating action to deal with a hyper-competitive world, and taking on a life that seems to differ in the details from company to company. It can start with small steps. Version 1.0 of a right-side, strategy-accelerator network may arise in only one part of an enterprise—say, the supply chain system or the European group. After it becomes a powerful force there, it can expand into other parts of the organization.

Version 1.0 may also play no role in strategy formulation or adjustment, but concentrate only on agile and innovative implementation. It may feel at first more like a big employee-engagement exercise hat, indeed, produces a much bigger payoff without increasing the payroll. But the network and the Accelerators evolve, and momentum comes faster than you might expect. As long as the executive committee understands the new system and plays its role, and as long as the new organization does indeed help with competitive challenges, the whole dual system model will eventually seep into the culture as "the way we do things here."

In a fully functioning dual operating system, it is not unusual to see more than half of an organization volunteering in some capacity to drive transformational change

Not surprisingly, there are challenges. Over the past seven years, my team has aided any number of pioneers—in the private and public sectors, functional departments, product divisions, or at corporate headquarters—in building dual operating systems. The challenges are fairly predictable, and not insignificant. One is ensuring that the two parts of the system learn to work together well. Here it is essential that the core of the network (the guiding coalition) and the executive committee learn to develop and maintain the right relationship. Another is building momentum: the most important step here is to create and communicate wins from the very start.

Probably the biggest challenge is how to make people who are accustomed to control-oriented hierarchies believe that a dual system is even possible. Education can help. The right attitude from the top of the hierarchy helps greatly. But again, this is why a rational and compelling sense of urgency around a big strategic opportunity is so important. Once it has been sparked, mobilizing the guiding coalition and putting the remaining Accelerators in motion can happen almost organically. It doesn't jolt an enterprise the way

sudden dramatic organizational change does. It doesn't require you to build something gigantic and then flick a switch to get it going (while praying that it works). And in a world where capital is constrained in so many organizations, the incremental cost of this approach is, incredibly, almost nothing. Think of it as a vast, inexpensive, purposeful, and structured expansion—in scale, scope, and power—of the smaller, informal networks that accomplish important tasks faster and cheaper than hierarchies can.

Conclusion

The inevitable failures of single operating systems hurt us now. I believe they are going to kill us in the future. The twenty-first century will force us all to evolve toward a fundamentally new form of organization. The good news is that this can allow us to do much more than simply hang onto what we have achieved in the twentieth century. If we successfully implement a new way of running organizations we can take advantage of the strategic challenges in a rapidly changing world. We can actually make better products and services, enlarge wealth, and create more and better jobs, all more quickly than we have done in the past. That is, while the consequences of an increasingly changing world do have a downside, they also have a potentially huge upside.

We still have much to learn. Nevertheless, the companies that get there first, because they are willing to pioneer action now, will see immediate and long-term success—for shareholders, customers, employees, and themselves. I am convinced that those who lag will suffer greatly—if they survive at all.

Reprinted by permission of Harvard Business Review Press. Adapted from John P. Kotter, *Accelerate: Building Strategic Agility for a Faster-Moving World* (Boston: Harvard Business Review Press, 2014). All rights reserved.

Open Innovation: Striving for Innovation Success in the 21st Century

Henry Chesbrough

Longstanding expert and pioneer in the field Professor Chesbrough feels there is much confusion surrounding what open innovation is exactly, and he goes on to define it as "the use of purposive inflows and outflows of knowledge to accelerate internal innovation and expand the markets for external use of innovation." He continues by explaining and giving examples of "outside-in and inside-out" open innovation models. Chesbrough sees open innovation expanding well beyond simple collaboration between two firms and he believes designing and managing innovation communities will become increasingly important for the development of open innovation. In this way open innovation's effectiveness is not restricted to a few select corporations; it makes more effective use of internal and external knowledge in every single type of organization.

Henry Chesbrough
Haas School of Business, University of California at Berkeley

Henry Chesbrough is Faculty Director of the Garwood Center for Corporate Innovation at UC Berkeley's Haas School of Business. He also holds a position at Esade Business School in Ramon Llull University in Spain. He is a scholar of managing technology and innovation, and best known as the father of Open Innovation. Previously he was an assistant professor at Harvard Business School, and before that a product manager and later Vice President of Marketing at Quantum Corporation, a manufacturer of hard disk drives. He holds a BA from Yale University, an MBA from Stanford University, and a PhD from the University of California-Berkeley.

Key Features for the Company of the Future:

Be Open
Not all of the smart people work for your company. It will be paramount for your smart people to find and collaborate with the other smart people working elsewhere in the world, in order for your company to be successful in innovation.

Embrace Failure
Innovation cannot occur without risk, and no company is able to innovate effectively unless they learn how to manage this risk. If you have never failed, this means that you have not attempted anything very important! Creating a culture in the company that can celebrate useful failure, and also learns from it, is essential to succeeding with innovation later on.

Innovate the Business Model, Not Just the Technology
A better business model often beats a better technology. Companies that are successful often become trapped by their business model. Learn how to improve or even change your business model, so that you can continue to thrive even after your business model becomes obsolete.

Open Innovation: Striving for Innovation Success in the 21st Century

Introduction

In this article, I will take the opportunity to reflect upon the activities in an area where I have been privileged to play an important role in both defining and developing the field: open innovation.

My 2003 book titled *Open Innovation* outlined a new model for industrial innovation. Since that time, the concept has been cited by thousands of academic articles and adopted by the majority of large firms in the US and Europe. Open innovation has changed the management of innovation, as witnessed by the plethora of managers with "open innovation" in their job titles. In this short article, I want to go back to the beginning of the concept, and then use that review to project forward into a possible future for open innovation, and the management of innovation more generally, for a company striving to succeed in the twenty-first century.

When I wrote *Open Innovation* in 2003, I did a Google search on the term "open innovation," and I got about 200 links that said "company X opened its innovation office at location Y." The two words together really had no meaning. When I conducted a search on that same term last week, I found 483 million

links, most of which were about this new model of innovation. There have been hundreds of academic articles written on the open innovation approach, along with a number of industry conferences on the topic, and there is even an annual PhD conference that trains dozens of new scholars each year, all of whom are writing dissertations on aspects of open innovation.

However, the words "open innovation" are defined differently by different people, making it more challenging for people outside academia to apply its concepts effectively in practice. Just as Eskimos have dozens of words for "snow," the term "open innovation" has acquired multiple meanings.

In my own view, the open innovation paradigm can be understood as the antithesis of the traditional vertical integration model in which internal innovation activities lead to internally developed products and services that are then distributed by the firm. The vertically integrated model is what I term a closed innovation model. Put into a single sentence, open innovation is "the use of purposive inflows and outflows of knowledge to accelerate internal innovation and expand the markets for external use of innovation."[2]

Open innovation assumes that firms can and should use external ideas as well as internal ideas, and internal and external paths to market, as they look to advance their innovations. Open innovation processes combine internal and external ideas together into platforms, architectures, and systems. Open innovation processes utilize business models to define the requirements for these architectures and systems. These business models access both external and internal ideas to create value while defining internal mechanisms to claim some portion of that value.

There are two important pathways for ideas to flow in open innovation: outside-in and inside-out. The outside-in part of open innovation involves opening up a company's innovation processes to many kinds of external inputs and contributions. It is this aspect of open innovation that has received the greatest attention, both in academic research and in industry practice. Inside-out open innovation requires organizations to allow unused and underutilized ideas to go outside the organization for others to use in their businesses and business models. In contrast to the outside-in branch, this portion of the model is less explored and hence less well understood, both in academic research and also in industry practice.

A Schism in Open Innovation Definitions

There is another definition of open innovation out there, one that builds on the concept of open-source software. This approach ignores the business model and takes no account of the concept of false negative projects (or the inside-out half of the open innovation model I present below). The work of Eric von Hippel, for example, analyzes "open and distributed innovation,"

using the example of open-source software as the motivating example for his analysis.[3] While I have taken care to clarify that open innovation is not synonymous with the model of open-source software, this distinction is elided in the work of von Hippel (who does not cite my work in his analysis) and that of his colleagues. One can infer from this omission that they are philosophically opposed to the idea of a business model, and think that there should be little or no IP protection for innovation either.

Open innovation is "the use of purposive inflows and outflows of knowledge to accelerate internal innovation and expand the markets for its external use"

There is an irony in this, because of a schism that has arisen in open-source software itself, the very phenomenon von Hippel studies. Within that community, there is a strong disagreement between the "free software" people and the "open software" people. The free software people, people like Richard Stallman and others, think that "software should be free." Projects like the GNU operating system were constructed using a "copy-left" approach, meaning that any use of the GNU code must itself be shared with the rest of the GNU development community.

This is very much akin to von Hippel's insistence that intellectual property protection is unnecessary and indeed, unhelpful to innovation. In the von Hippel conception of open innovation, users are expected to share their knowledge freely within the community because as users they benefit directly from innovation. Business models have no role to play in his conception. The capital that organizations may require to scale their innovations (and how they may earn a return to justify that capital) is not a question of interest. In my own judgment, von Hippel is correct in observing the critical role that users play in the earliest stages of innovation. However, there are important roles played in investment capital, intellectual property, and business models in later stages of innovation that he does not consider in his analysis.

On the other hand, a separate branch of the open-source software community uses the term "open software," meaning that the companies that use open code can make additions to that code without being obligated to share those additions with the community. Linux is organized along these lines. Companies such as Google, which makes extensive use of Linux, have developed a variety of extensions to the core code that have been kept private and are not shared back with the Linux community. Open software enables companies to build upon open or shared code, investing in proprietary extensions. Both branches of the open-source movement agree on the value of a commons from which programmers can draw useful reference designs and source code, and helpful tools for coding and testing software. But they part company when it comes time to go to market.

Linus Torvalds, the creator of Linux, is squarely in the "open" camp (rather than the "free" camp). In fact, he is rather dismissive of Richard Stallman's evangelism for "free software":

> He's too inflexible, too religious ... I certainly am of the opinion that *open source started working a lot better once it got away from the Free Software Foundation politics and values,* and more people started thinking about it as a tool than a religion. I'm definitely a pragmatist [*emphasis added*].[4]

Torvalds' pragmatic approach to open source is akin to my definition of open innovation, in which a company utilizes a business model to support investment in a project and allows the project to scale over time. IP is not only allowed in my view of open innovation, it actually enables companies to collaborate and coordinate, confident in the knowledge that they will be able to enjoy some protection from direct imitation by others in the community. This is a pragmatic view of innovation, which harnesses the contributions of users, yes, but also other important actors like investors, IP owners, and marketing and business development people.

Both views of open innovation share the insight that being open is a powerful generative mechanism to stimulate a lot of innovation. Von Hippel rightly notes that users are a powerful source of innovation in the early stages of a new product. The differences between "free" and "open" become apparent only after the initial stage of a new product ends and the innovation begins to gain traction in the market. At this point, hobbyists give way to companies that come into the market to commercialize these innovations, business models are created to seek profits, and capital investments are required to create growth. The real social impact of an innovation only arrives after it is commercialized and scaled in the market. While Linux was created by Linus Torvalds and a small community of volunteers, it is sustained today by companies like IBM that have built business models around Linux and driven its usage in the enterprise.

To summarize the difference in brief, open innovation folks like me think you can and should have legal regimes and business models to enable the open process, whereas the free (or "open and distributed innovation") people don't.

The Open Innovation Model

My 2003 book *Open Innovation* is credited by Wikipedia[5] and other observers as the first sustained analysis of this new approach to innovation. That book describes a paradigm shift from a closed to an open model of innovation.

Based on close observation of a small number of companies, the book documents a number of practices associated with this new paradigm.

Under the closed model of innovation, research projects are launched from the science and technology base of the firm (Figure 1). They progress through the development process, and some projects are stopped while others are selected for further work. A few successful projects are chosen to go through to the market. AT&T's Bell Laboratories stands as an exemplar of this model, with many notable research achievements but a notoriously inwardly focused culture. Other celebrated twentieth-century examples of this model include IBM's TJ Watson Research Center, Xerox PARC, GE's Schenectady laboratories, Merck, and Microsoft Research. (It is worth noting that each of these storied institutions has greatly altered its innovation model in the past decade since my book was published.) In other countries, such as Japan, the closed model remains quite popular to this day.

This traditional innovation process is closed because projects can only enter it in one way, at the beginning from the company's internal base, and can only exit in one way, by going into the market.

**Figure 1. The Current Paradigm:
A Closed Innovation System**

Figure 2. The Open Innovation Paradigm

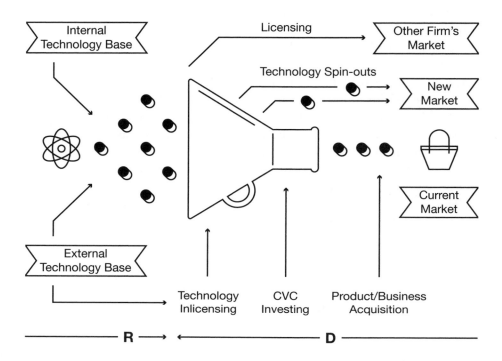

In the open innovation model, by contrast, projects may enter or exit at various points and in various ways (see Figure 2). Here, projects can be launched from either internal or external technology sources, and new technology can enter into the process at various stages—the outside-in portion of the model. In addition, projects can make their way to market in many ways as well, such as through outlicensing or via a spin-off venture company, in addition to going through the company's own marketing and sales channels. This is the inside-out part of the model. I labelled this model "open" because there are many ways for ideas to flow into the process, and many ways for them to flow out into the market. IBM, Intel, Philips, Unilever, and Procter & Gamble all exemplify aspects of this open innovation model.

The growing acceptance of the model is due to its ability to explain unusual anomalies that the closed model could not. For instance, open innovation explains the surprising ability of Cisco to keep up with Lucent and its Bell Labs in the 1990s:

Though they were direct competitors in a very technologically complex industry, Lucent and Cisco were not innovating in the same manner. Lucent devoted enormous resources to exploring the world of new materials and state of the art components and systems, to come up with fundamental discoveries that could fuel future generations of products and services. Cisco, meanwhile, did practically no internal research of this type.

Instead, Cisco deployed a rather different weapon in the battle for innovation leadership. It scanned the world of startup companies that were springing up all around it, which were commercializing new products and services. Some of these startups, in turn, were founded by veterans of Lucent, or AT&T, or Nortel, who took the ideas they worked on at these companies, and attempted to build companies around them. Sometimes, Cisco would invest in these startups. Other times, it simply partnered with them. And more than occasionally, it would later acquire them. In this way, Cisco kept up with the R&D output of perhaps the finest industrial research organization in the world, without doing much internal research of its own.[6]

My conception of open innovation began from close observation of what companies were actually doing and then trying to reflect on what they were doing in relation to what I'd read as a PhD student and then as a professor. Michael Porter's work on business and corporate strategy was very powerful and influential in the 1980s and 1990s, and remains so to this day. It is really a model of closed innovation, where you figure out what your key strategic assets are and you either go for low cost or go for differentiation or you find a niche. You're constantly looking for ways to compete against the other guy. As I saw what was going on in the industry labs, it was clear that a lot of that was happening, but there was a lot of other stuff going on that Porter's model didn't really explain very well at all. These anomalies attracted my interest, and informed my subsequent research.

As part of my research, I spent a significant amount of time at Xerox and its Palo Alto Research Center, popularly known by its acronym, PARC. I tracked 35 projects that started inside of Xerox's labs and got to a certain level of development, when internal funding was stopped. I was curious about what happened to these projects subsequently, because in many cases Xerox encouraged the employees working on them to leave and take them to the external market. Once these people left the lab, budget was freed up for something that was more strategic and promising for the company's core business.

One of the things I discovered was that most of the 35 projects subsequently failed. But a few of them succeeded and actually became publicly traded

companies; the combined market value of those publicly traded spin-off entities substantially exceeded Xerox's own market value. That discovery really made me think about how to better understand what was happening here and how it would work both in a large corporation like Xerox and in a small corporation. How could we think about a system that was more open? At Xerox, their core business models were doing a good job of commercializing certain technical projects that fit well with its business model. But other projects that didn't fit with the core found different business models that made them much more attractive as standalone entities.

Open innovation treats spillovers as a consequence of the company's business model —and sees them not just as a cost, but also as an opportunity

I have come to think of these misfit projects as "false negatives," projects that lacked value in the context of the company's current business model but might have significantly more value if they could be commercialized through a different business model. Innovation researchers have long recognized these "false negatives," characterizing them as spillovers from industrial R&D. In the closed paradigm, these spillovers were regarded as a cost of doing business. Open innovation treats spillovers as a consequence of the company's business model—and sees them not just as a cost, but also as an opportunity to expand the business model or spin off a technology outside the firm to a different business model. Managing these spillovers lies at the heart of the inside-out part of the open innovation model.

The open innovation model also offers a second set of insights around the treatment of intellectual property. In the closed model, companies historically accumulated intellectual property to provide design freedom to their internal staff. The primary objectives were to obtain freedom to operate and to avoid costly litigation. As a result, most patents were actually worth very little to these companies, and the vast majority were never used by the business that held them. Lemley[7] (pp.11–12) cites studies that report a large fraction of patents are neither used nor licensed by firms. Davis and Harrison[8] report that more than half of Dow's patents were unutilized, and Sakkab[9] states that less than 10% of Procter & Gamble's patents were utilized by any of P&G's businesses. My experience in Europe is that the patent utilization ratio is as low, or perhaps even lower, than it is in the US.

In open innovation, by contrast, intellectual property represents a new class of assets that can deliver additional revenues to the current business model and also point the way toward new businesses and new business

models. Open innovation implies that companies should be both active sellers of IP (when it does not fit their own business model) and active buyers of IP (when external IP does fit their business model).

To assess the value of this insight, consider your own organization and evaluate its patent utilization rate. Think of all the patents that your company owns. Then ask yourself, what percentage of these patents is actually used in at least one of your businesses? Often people don't even know the answer, because no one has ever asked the question. In cases where companies have taken the trouble to find out, the percentage is often quite low, between 10 and 30%. This means that 70–90% of a company's patents are not used. In most companies, these unused patents are not offered outside for licensing either. In an open innovation model, IP does not languish; it creates value, either directly or via licensing or other inside-out mechanisms.

Innovating the Business Model

As the Xerox PARC analysis and the IP discussion show, the business model plays a critical role in the innovation process. As I reflected further upon this point, I realized that it warranted an entire book in its own right. This became the motivation for my second book, *Open Business Models*, published in 2006. Instead of treating the business model as fixed, as I did in the first book, I examined the implications of being able to innovate the business model itself.

Making business models more adaptive, I reasoned, might allow companies to obtain more value from innovation, from those anomalous, false negative projects. Had Xerox, for example, been willing to experiment with other business models, some of the value built by 3Com, Adobe, VLSI Technology, and other spinoffs might have accrued directly to Xerox.

The book also presented a maturity model for business models, from commodity-type business models (offering undifferentiated products) to the highest, most valuable kind of business model, a platform model. Platform models are more open, because they entice third parties to innovate on your architecture, your system, your platform. And they often enable others to license unused technologies from you to place into other business models. This makes continued investment in R&D more sustainable and can even confer competitive advantage. P&G, for example, is best known for its embrace of outside-in open innovation via its Connect+Develop initiative. But P&G also opens up its business model to license out technologies for others to use. This isn't as weird as it might seem, because P&G is strategic about how, when, and on what terms it licenses those technologies. As Jeff Weedman of P&G put it to me:

The original view [of competitive advantage] was: I have got it, and you don't. Then there is the view, that I have got it, you have got it, but I have it cheaper. Then there is I have got it, you have got it, but I got it first. Then there is I have got it, you have got it from me, so I make money when I sell it, and I make money when you sell it.[10]

While *Open Business Models* received substantial recognition, it has not had the impact of the first book. However, business model innovation is becoming a growing area of interest for many authors.[11] While my book was among the first to link innovation results to the innovation's fit with the prevailing business model, this is an area that is developing rapidly. However, most organizations still treat R&D activities separately from the design and improvement of business models. This has likely held back progress in this area. Linking these areas more tightly is important for advancing innovation in the future.

Open Innovation for Services

A more recent development is the consideration of how innovation occurs in services businesses. Most of the top forty economies in the OECD get half or more of their GDP from services. And many companies are witnessing a shift to services as well. Xerox now gets more than 25% of its revenues from services. IBM is another classic case, along with GE and Honeywell.

In some cases, what's really happening is the business model is shifting, which can turn a product business into a service business. For example, a GE aircraft engine can be sold for tens of millions of dollars to an airframe manufacturer. That same engine can also be leased to that airframe manufacturer through the company's Power by the Hour program. In the first case, it's a product transaction. In the second case, it becomes a service. What benefits GE in the service transaction is the aftermarket sales and service, spare parts, and other ongoing costs that accrue over the thirty-year operating life of the engine. When it sells its engines as a product, it must compete with many third parties to service the engine. With a Power by the Hour offering, all of that value comes back to GE.

More generally for services, innovation must negotiate a tension between standardization and customization. Standardization allows activities to be repeated many times with great efficiency, spreading the fixed costs of those activities over many transactions. Customization allows each customer to get what he or she wants, for high personal satisfaction. The problem is that standardization denies customers much of what they want, while customization undermines the efficiencies available from standardization.

The resolution to this dichotomy is to construct service platforms. These platforms invite others to build on top of your own offering (the platform), allowing for economies emerging from the standardization of the platform along with customization created by the additions of many others to the platform. A fundamental premise of open innovation is "not all the smart people work for you." That means that there's more value in creating the architecture that connects technologies together in useful ways to solve real problems than there is in creating yet another technological building block. System architecture, the system integration skill to combine pieces in useful ways, becomes even more valuable in a world where there are so many building blocks that can be brought together for any particular purpose.

> A successful platform requires a business model that can inspire and motivate customers and developers and others to join the platform

Platform leadership to me is the business-model side of systems integration. A successful platform requires a business model that can inspire and motivate customers and developers and others to join the platform. The model must be designed to allow those third parties to create business models that work for them, even while the business model works for the platform creator. In that way, their activities increase the value of the core business—their investment makes the platform business more valuable. These ideas are explored in greater length in my book, *Open Services Innovation*.[12]

The Way Forward

While open innovation has had a strong reception since its initial launch more than a decade ago, there is certainly more work to be done. Open innovation was first understood and implemented as a series of collaborations between two organizations to open up the internal innovation process. Today, though, we see many instances in which the concept is being used to orchestrate a significant number of players across multiple roles in the innovation process. Put simply, open innovation is going to expand well beyond collaboration between two firms. Designing and managing innovation communities is going to become increasingly important to the future of open innovation.

Let me illustrate this point with two distinct examples of different kinds of community-level open innovation across a broad spectrum of activities. My first example comes from Taiwan Semiconductor Manufacturing Corporation (TSMC), a foundry operating in the semiconductor industry. TSMC provides manufacturing services from its manufacturing facilities (foundries) to its

clients, who design new semiconductor chips. The customers take these chip designs to TSMC, and TSMC fabricates the designs onto silicon wafers and gives these back to its customers. The customers then package them into individual chips and sell them. This saves TSMC's customers from having to invest in expensive manufacturing plants to manufacture chips. Instead, they rely on companies like TSMC to do the fabrication work for them.

Designing chips requires customers to use a variety of tools, such as reference designs and process recipes. With the growth of TSMC's business ecosystem, many of the third-party companies who make these tools began to take steps to assure their customers that their offerings would run on TSMC's processes. This expansion in third-party tool offerings creates more design options for TSMC's customers—a clear benefit for both TSMC and for the customer. However, these new offerings also increase the complexity TSMC's customers must manage, and this complexity might cause new chips to require redesigns or other expensive modifications to be manufactured correctly—a clear risk.

Designing and managing innovation communities is going to become increasingly important to the future of open innovation

TSMC has addressed this risk with its Open Innovation Platform (their term, not mine!). The Open Innovation Platform starts by combining TSMC's many design and manufacturing services with those provided by many third-party companies and then testing these all together. TSMC then certifies to customers of those third-party offerings that these tools can be used with confidence that the chip will turn out properly the first time through the process. In this way, the Open Innovation Platform helps TSMC's customers get their designs manufactured on the first pass. This avoids very expensive "turns" of the chip design, in which the chip must be redesigned in order to be manufactured properly in volume. The result is faster time to market for TSMC's customers, at a lower cost of design. So TSMC uses open innovation to manage a complex ecosystem of internal and external design sources, simplifying the design process for customers by guaranteeing compatibility, provided they stick to validated resources when designing their chips.

My second example comes from GE and its recent ecomagination challenge. While GE has a very large energy business of its own, with revenues of nearly $40 billion annually, the company has noticed a great deal of venture capital and startup activity in green and renewable energy technologies. Recognizing its own limits, GE sought to establish a process to tap into the ideas out there that had the potential to become promising new ventures in renewable energy and green technology.

But GE did this in an open way. Instead of doing all the work themselves, they enlisted four active venture capital firms who already had experience investing in this space. Together, the four venture capitalists and GE pledged a total of $200 million to invest in attractive startup ventures. The ecomagination challenge was born. In July of 2010, the challenge was launched to the world, and everyone was invited to submit potential project ideas for consideration for investment. More than 3,800 venture proposals were submitted. As of this writing, 23 ventures have been funded, with five other projects receiving other awards; a people's choice award has been given as well. While the ventures are quite young, the venture capital firms and GE are all enthusiastic about the experience. GE's level of enthusiasm has led them to adapt the model to the healthcare space (a Healthymagination challenge was launched in 2011) and also to China's growing market (a challenge was successfully launched there as well).

Open innovation has also moved into the public sector. My colleague Esteve Almirall of Esade Business School is leading some fascinating research within Europe into Open Cities. In Open Cities, local government agencies place their data into a public repository that can be examined and utilized by others who don't work for the local government. Of particular interest are application developers, who create services that employ government data to provide new information to local citizens. The ecosystem of app developers becomes an important resource for an Open City, and brings the activities of a local government closer to its citizens through the click of an Android phone or an iPhone.

And one need not be a large organization to open up the innovation process to the community. A small firm in Florida, Ocean Optics, has instituted a community innovation challenge on a much smaller scale. They received dozens of responses, and ended up funding twenty different researchers on projects that might be of great value to them in the future. The organizer of these challenges, Jason Eichenholz, subsequently spun out a new startup company, Open Photonics, to sell these services to customers beyond Ocean Options. So this is a game that organizations of many sizes can play, if they have the vision and determination to do so.

> Open innovation's effectiveness is not restricted to a few select corporations. It is a process that makes more effective use of internal and external knowledge in every organization

And that is where we're going. Open innovation's effectiveness is not restricted to a few select corporations. It is a process that makes more effective use of internal and external knowledge in every organization, whether old or young, large or small, public or private. More than ten years after the first publication of the book, we can be confident that open innovation is going to be a part of the future for all of us.

Notes

1
This article builds upon and updates an earlier paper published by the author in *Research-Technology Management* in 2012, under the title "Open Innovation: Where We've Been and Where We Are Going."

2
H. Chesbrough, "Open Innovation: A New Paradigm for Understanding Industrial Innovation," in *Open Innovation: Researching a New Paradigm*, ed. by H. Chesbrough, W. Vanhaverbeke, and J. West (New York: Oxford University Press, 2006), 1.

3
E. von Hippel, *Democratizing Innovation* (Cambridge, MA: MIT Press, 2005).

4
S. Lohr, *Go To: The Story of the Math Majors, Bridge Players, Engineers, Chess Wizards, Maverick Scientists and Iconoclasts—The Programmers Who Created the Software Revolution* (New York: Perseus-Basic Books, 2001), 215.

5
Wikipedia, 2014. Open innovation <http://en.wikipedia.org/wiki/Open_innovation> [accessed March 25, 2014].

6
H. Chesbrough, *Open Innovation: The New Imperative for Creating and Profiting from Technology* (Cambridge, MA: Harvard Business School Press, 2003), XVIII.

7
M.A. Lemley, "Rational Ignorance at the Patent Office," *Northwestern University Law Review* 95 (2001), 1495.

8
J.L. Davis and S.S. Harrison, *Edison in the Boardroom: How Leading Companies Realize Value from Their Intellectual Assets* (New York: Wiley, 2001).

9
N. Sakkab, "Connect & Develop Complements Research and Develop at P&G," *Research-Technology Management* 45.2 (2002), 38–45.

10
H. Chesbrough, *Open Business Models* (Cambridge, MA: Harvard Business School Press, 2006), 201.

11
See, for instance: B.D. Baden-Fuller, X. Lecoq, and I. MacMillan (eds.), "Business models," Special Issue, *Long Range Planning* 43 (2010), pp. 2–3; M. Johnson, *Seizing the White Space: Business Model Innovation for Growth and Renewal* (Cambridge, MA: Harvard Business Press, 2010); A. Osterwalder and Y. Pigneur, *Business Model Generation: A Handbook for Visionaries, Game Changers, and Challengers* (Hoboken, NJ: Wiley, 2010).

12
H. Chesbrough, *Open Services Innovation: Rethinking Your Business to Grow and Compete in a New Era* (New York: Jossey Bass, 2011).

Sustainability and the Company of the Future

Carol A. Adams

In her article Professor Adams examines how the company of the future will do business differently while understanding the value of its relationships and the resources and services provided by the natural environment. She sees that the globalization of business which has occurred over the last few decades has made some companies more powerful than some national governments, and has made it easier for some companies to exploit cheap labor, plunder natural resources, and cause serious consequences for the natural environment, human health and biodiversity through pollution.

In the increasingly complex world in which business has to evolve, she considers the need for integrated thinking and what that means for organizational structures and cultures; the traits of leaders of tomorrow's companies; the connected company; new ways of thinking about value; and the role of transparency and accountability in the new business order.

Carol A. Adams
Monash University

Carol A. Adams is an internationally renowned author in corporate reporting and integrating sustainability into business. She is a part-time professor at Monash University and a visiting professor at the University of Glasgow. She is a Non-Executive Director and consults through Integrated Horizons. Carol has led the development of international award-winning management and governance processes and sustainability reports and has been involved in the GRI, AA1000 Standards, UN Global Compact and integrated reporting initiatives. Carol has a financial audit background, is a Chartered Accountant and holds an MSc from the London School of Economics and a PhD from the University of Glasgow.

Key Features for the Company of the Future:

Diversify Your Leadership Team
Your leadership team should include women and an appropriate mix of backgrounds, aptitudes and skills to facilitate dynamic responses to a changing and increasingly complex external environment. Organizational cultures should encourage innovation and risk taking. Focus on fostering collaborative leadership and building partnerships and relationships to support strategy.

Think More Broadly About What Value is and for Whom It Is Created
Making money is no longer considered the only way of creating value for shareholders. Indeed, much of what is of value to an organization is not included on its balance sheet. Creating value for shareholders increasingly requires having strong relationships with stakeholders based on mutual trust and "win-win" outcomes. Being socially and environmentally responsible is essential to earning this trust. Recognize that success is intertwined with and dependent on the well-being of society and the environment.

Think Longer Term
Chief Financial Officers, other senior executives and boards of the future will place more emphasis on long-term success. They will understand the importance of identifying and addressing sustainability risks and taking advantage of sustainability opportunities to achieve strategy. Be prepared for the ongoing risks and opportunities presented by the social and environmental sustainability megaforces of our times.

Sustainability and the Company of the Future

Introducing the Company of the Future

The company of the future will do business differently, understanding the value of its relationships and the resources and services provided by the natural environment. It will be very different from the company of today.

Above all, it will face a high level of complexity and its people will have a broad knowledge and skill set to equip them to look at problems from different perspectives and to work collaboratively with colleagues from different disciplines. Whilst there will, of course, still be some specialists, overall the staffing profile will be more generalist. Leadership teams will be more diverse to ensure that the mix of aptitudes, attitudes, and skills facilitates dynamic responses to a changing external environment. Organizational cultures will encourage innovation and risk-taking.

The globalization of business which has occurred over the last few decades has made some companies more powerful than some national governments. Globalization made it easier for companies to exploit cheap labor, plunder natural resources and cause serious consequences for the natural environment, human health and biodiversity through pollution. And they did—and still do. But that is changing.

Companies which may have got away with environmental destruction and conditions causing death up to the 1980s have increasingly found the world more informed and less tolerant since the advent of the internet and social media. Cutting costs through the exploitation of labor and pollution of the environment, rather than leading to financial success has led to difficulties for corporate giants such as BP, Exxon Mobil, James Hardie, Nestlé, Nike, Shell, and more. They have been forced to change in order to survive. Those forces for change will increase as the world is faced with climate change, water scarcity, food security issues, greater inequality in wealth distribution, and many more challenges.

> **Cutting costs through the exploitation of labor and pollution of the environment, rather than leading to financial success has led to difficulties for corporate giants**

Milton Friedman, an economist, famously said: "... a corporate executive is an employee of the owners of the business. He [sic] has direct responsibility to his [sic] employers. That responsibility is to conduct the business in accordance with their desires, which generally will be to *make as much money as possible* while conforming to the *basic rules of the society* ..." [*emphasis added*].[1]

But what are the "basic rules of society?" Whilst globalization means that these "rules" are converging across geographical boundaries, they will continue to change over time. Taking the "rules of society" regarding the position of women in the workplace as an example, fifty years ago women in banking in the UK were expected to leave work upon marriage and were not employed for management roles. An examination of annual reports in the UK banking and retail sector going back to before the Second World War[2] reveals not only the circumstances of women's employment, but also acceptance and encouragement of unequal opportunities on the part of companies. In the quote below, for example, women were excluded from consideration of opportunities:

> It is not always realised what a variety of opportunities this firm can offer to *young men*... there are attractive careers in selling ... and in such fields as Publicity, Buying and general business administration... For... candidates who show promise of reaching senior rank, we have organised a training course, candidates for which are chosen irrespective of their *background*...[*emphasis added*] (Boots' corporate annual report, 1955)

It is clear that "background" does not include gender, and this public statement indicates that this view was considered perfectly reasonable at the time by (male) corporate leaders and politicians alike. But the "basic rules of society" regarding women's employment have changed to the extent that many employers

now make considerable effort to attract and retain women staff and publicly disclose these efforts. It has become good for business and essential to reputation management. Not only have the rules of the game changed, but making money is no longer considered the only way of creating value for shareholders. Indeed, much of what is of value to an organization, is not included on its balance sheet. Creating value for shareholders increasingly requires having strong relationships with stakeholders based on mutual trust and "win-win" outcomes.

Stakeholders have changed the "rules of society" by which business operates and they continue to do so.[3] The company of the future will know that its success depends on its relationship with society and the environment.

> The company of tomorrow will operate in a different capital market imperative where rewards are in terms of a responsible business which creates value for itself and for its stakeholders in the long term. These rewards feature in the share price of a company that has this responsible approach as the 'catch 22' cycle has been turned on its head, with sustainable business and a sustainable planet/society being intrinsically connected." (Paul Druckman, CEO International Integrated Reporting Council)

Economists and scholars have speculated about what Adam Smith, a professor at the University of Glasgow in the eighteenth century, would have said about the role of business today. Adam Smith is often referred to as the "father of capitalism," an advocate of market forces, an enemy of government regulation and a believer in something referred to as the "invisible hand." Yet in his book, the *Wealth of Nations* (1776),[4] wealth is equated to well-being of people. Indeed much of Adam Smith's thinking was based on morality, justice, and doing good. He advocated action when the rights of individuals are violated because action is called for and necessitated by justice. Smith's central tenet that a person's rights according to law must be protected through a system of justice is an arguably moral stance. We might consider, for example, poor working conditions and unfair pay as a violation of rights (worker rights).[5]

There are some controversial and incomplete interpretations of Adam Smith's work used to shore up different arguments about the role of business in society.[6] In any case, Adam Smith did not witness globalization on the scale that we have, nor the challenges, even atrocities, and opportunities which globalization has brought. Smith was in favour of small businesses and opposed forms of economic concentration that distort the market's natural ability to establish a price that provides a fair return on land, labor, and capital.[7]

The company of the future will know that its success depends on its relationship with society and the environment

This contribution considers: the increasing complexity facing business and the changing world in which it operates; the need for integrated thinking and what that means for organizational structures and cultures; the traits of leaders of tomorrow's company; the connected company; new ways of thinking about value; and the role of transparency and accountability in the new business order.

Increasing Complexity and a Changing World

Corporate leaders face increasing complexity and ambiguity. They will need a clear vision and a powerful moral compass to guide the company through it. This will be tested like never before. Some will shine and many others will flounder. It will be harder to get by without vision and a keen sense of right and wrong.

Corporate leaders are grappling with a range of issues which are changing the way business is done. For many companies, climate change is the most significant issue,[8] bringing with it a range of other concerns including scarcity of natural resources, food security and poverty. They are frustrated by policy uncertainty.[9] Rather than use this policy uncertainty as a reason for inaction and buck passing they need to take responsibility and be guided by a long-term vision of what is possible and what needs to happen.

Corporations have played a major role in exacerbating inequality of wealth distribution. They have earned profits from their operations in Lesser Developed Countries (LDCs) and paid them to their owners in wealthier home countries. Some are now seeing that it is in their interests to work to fix wealth inequality. For example, Unilever works to improve the livelihoods of smallholders through training because it recognizes the benefits in terms of better-quality products and increased stability of supply.[10] As the middle class increases globally, large companies will not have the benefits of cheap labor that globalization has brought them to date.

Corporate leaders face increasing complexity and ambiguity. They will need a clear vision and a powerful moral compass to guide the company through it. This will be tested like never before

Many of the irresponsible business practices and disasters we have seen have been driven by short-termism, the desire for instant gratification, and the lure of rewards for short-term performance. For example, deferred maintenance and slack management have been blamed for leaks from the Union Carbide India Ltd pesticide plant in Bhopal in 1984. Estimates put deaths from the gas release in the thousands and injuries at over half a million. Union Carbide Corporation's payout

for litigation made in 1989 was the equivalent of almost one billion US dollars in today's terms. In 2010 eight ex-employees including the former chairman of Union Carbide India Ltd were convicted of causing death by negligence, and the seven surviving were put behind bars.[11] Consultants repeatedly stress the risk implications of the consequences of short-termism.

To counter this short-termism the International <IR> Framework (International Integrated Reporting Council, 2013), backed by accounting professional bodies around the globe, strongly emphasizes the need to focus on long-term performance. Chief Financial Officers of the future, currently major stumbling blocks in taking advantage of sustainability opportunities and addressing its challenges, will think more about long-term success. They will understand the importance of identifying and addressing sustainability risks to achieve strategy.

The ability of social media to build and damage trust and reputation is another issue concerning corporate leaders today. It's not worth cutting corners, telling lies or covering up. Everyone can find out everything, and quickly. The media is quick to pick up on cover-ups, half-truths and poor corporate behavior.[12] The company of the future will set an ethical culture from the top. It will strive for transparency and accountability.

KPMG's "Expecting the Unexpected" report (2011)[13] summarized a number of scientific predictions concerning "sustainability mega forces" to which today's companies will have to adapt if they are to be around in the future. Many of the issues are connected to climate change and cannot be resolved by any one part of our society. Regulation, government agencies, business leaders, and NGOs will achieve little on their own. If we are to achieve the required reduction in CO_2 emissions to save the people of this planet, we need to work together. Business must engage with regulators, both must engage with communities, and NGOs must engage with all of these parties. We must all be prepared to change. That way we'll find workable solutions. The goals of climate change adaptation and sustainability cannot be achieved without a range of stakeholders taking action and becoming engaged.

Connected issues include: population growth; a growth in the global middle class; ecosystems decline; water scarcity; food security; material resource security; higher global energy demand; changes in the geographical pattern of energy consumption; energy supply and production uncertainties; and increasing regulatory interventions related to climate change.

Global population growth, climate change and the increasing middle classes, particularly in China, will put pressure on ecosystems, the supply of natural resources such as food, water, energy and materials. Businesses will face disruption in supply of materials and resources, and price volatility. Companies will need to develop substitute materials and recover materials from waste.

More companies are realizing how dependent their operations are on the critical services that ecosystems provide. In 2011 Puma valued its impact resulting from land use, air pollution and waste along the value chain at €51 million, added to previously announced €94 million for GHG emissions and water consumption.[14]

Businesses will be vulnerable to water shortages, declines in water quality, water price volatility, and reputational challenges. Growth could be compromised and conflicts over water supplies may create a security risk to business operations. Coca Cola had to close a plant in India this year because farmers said it was using too much water.[15]

More companies will do what Nike has done in its 2013 Sustainability Report,[16] identifying global trends which impact their business. Nike's list includes: increasing energy consumption; water inadequacy; changing climate; income divides and bridges; obesity spreading; the coming of age in the southern hemisphere; women in a New Light; and easy access to information.

Issues which Nike has identified as having the potential to pose challenges or opportunities for Nike in the future include: radical transparency/traceability; new emphasis on the genetically modified debate; impacts of counterfeit waste; from fast fashion to fast e-waste; growing attention to stranded assets; divestment as a new form of climate advocacy; raising the bar for women farmers; China's green future; Brazil's environmental push; and greater focus on product end of life. Similarly, Unilever's Annual Report and Accounts 2013[17] considers risks associated with not managing: sustainability; customer relationships; people; the supply chain; and systems and information.

Integrated Thinking

The extreme challenges of the next two decades will clearly differentiate exceptional leaders. A few bold leaders will become known for forging a new and rewarding path for business, one that is aligned to the well-being of society and the environment.

The company of the future will not only recognize that to survive and thrive it needs to adapt, but will also take steps to change both the way it does business and its notion of what constitutes success. A number of business leaders are rising to the challenge.

Paul Polman, Unilever's CEO, has made a clear connection between long-term business success and tackling social and environmental issues:

> … the biggest challenge is the continuing threat to 'planetary boundaries'; resulting in extreme weather patterns and growing resource constraints. These have increasing impact on our business… We remain convinced that businesses that both address the concerns of citizens

and the needs of the environment will prosper over the long term...
As... [the Unilever Sustainable Living Plan] becomes embedded, there
is growing evidence that it is also accelerating our growth.
(Annual Report and Accounts 2012, p.4)[18]

Similarly, in a Foreword jointly signed by the chairman and chief executive, the Royal Bank of Scotland Group's RBS Sustainability Review 2013[19] begins with the words: "In 2013, we were the least trusted company in the least trusted sector of the economy. That must change."

Unilever recognize that the growth of their business is dependent on reducing their environmental footprint and improving their contribution to society. Indeed, Unilever's vision is to double the size of its business while reducing its environmental footprint and increasing its positive social impact. Their 2013 Annual Report[20] succinctly captures the moral and business imperative for integrated thinking: "Business needs to be a regenerative force in the system that gives it life" (p.8).

> The company of the future will take steps to change both the way it does business and its notion of what constitutes success

Banks come up against scrutiny with regard to the nature of the projects they fund. And they are generally mistrusted by many. Demonstrating a contribution to creating value for the societies they depend on and diligence with regard to the environmental impacts of the projects they fund is therefore critical for their long-term success. The Standard Bank Group (SBG)[21] appears to do this better than many. The real proof, of course, comes in information provided publicly about the nature of loans made. The RBS Sustainability Review 2013 performance highlights includes both financial and non-financial performance measures, including £6.4 billion new lending to small and medium-sized enterprises (SMEs), 65% of energy project finance committed to wind and solar, and 6.2% reduction from 2012 in scope 1 and 2 emissions. These are the things which will increasingly matter to bank stakeholders. The RBS sustainability review sets out in some detail how the bank manages environmental, social, and ethical (ESE) risk. 2% of cases assessed against the bank's ESE policies were prohibited and a further 12% were escalated to the reputation risk committee.

The reader of SBG's 2013 Annual Integrated Report is also left with the feeling that the bank sees its success as inextricably linked with its relationship to society. For example, socioeconomic development and provision of sustainable and responsible financial services are identified as material issues. The report includes information on stakeholder engagement processes and explains its approach to environmental and social risk screening. Sustainability risk is explicitly mentioned alongside other operational risks (p.90).

These changes have occurred and will continue to do so because stakeholders, on whom the company depends, have demanded it and (social) media has ensured that these demands have been heard. In the company of the future responsibility for sustainable development will rest with the board (as it does already in some forward-thinking companies such as the Standard Bank Group and the Royal Bank of Scotland Group). The board will recognize that opportunities and challenges around responsibility and sustainability need to be reflected in strategy and that most well-considered strategic initiatives of value to a business are not developed in silos. Rather, they involve a range of inputs from around the company. The board of the company of the future will recognize that getting senior executives around a table to think about how the different parts of the organization work together in itself adds value. Working out what it is about people, relationships, and environmental measures that add value to a business is important for long-term success. Understanding how environmental impacts can affect reputation and financial risk makes good business sense. This is integrated thinking.[22]

The company of the future is less likely to have clear functional boundaries and hierarchical structures, but rather a more dynamic, flat structure that facilitates the desirable degree of cross-functional and informal communication channels needed to make sustainability change work. Job descriptions and performance review practices will increasingly incorporate sustainability activities and measures as well as the skills required to achieve them, such as ability to work collaboratively in teams, critical thinking, and showing initiative. Finance, communications, marketing, public affairs and environmental people will work together to get sustainability into strategy, develop the business case for sustainability initiatives, get agreement on sustainability Key Performance Indicators and targets and getting sustainability incorporated into plans, ensure that sustainability messages are consistent, prioritized, accurate and above all, not greenwash, and to develop stakeholder engagement processes to identify material issues and risk.

Leaders of the Company of the Future

I claim above that integrating sustainability will be essential for the survival of the company of the future. Achieving it depends on leadership,[23] and the company of the future will have: a CEO who has the foresight and courage to see that doing the right thing is good for business; board members who understand the relevance of sustainability to strategy and risk; and senior executives with the expertise and skills to make it happen and, crucially, the ability to collaborate and work across functions.

The CEO's moral conviction will be strong enough to convince others to follow. (Most employees will want to follow a sustainable path if that is where they are led. Being part of a team which is taking a sustainable path will be a source of great satisfaction to many.) The CEO will ensure that the management structures and governance processes to integrate responsibility and sustainability are in place and that the executive team have collaborative leadership styles. Territorial leaders who build silo empires will be a thing of the past.

In setting the strategic direction of the company, the board will recognize the importance of staff, customers, communities, and the risks associated with the limitations of natural resources and the impact of pollution. The board will understand the critical impact of these issues on the business model, long-term success, and ability to deliver on strategy. They will understand that identifying sustainability risks requires stakeholder engagement and having governance processes which expect the unexpected. The board's Remuneration Committee will obtain sustainability performance data to inform its deliberations. Corporate boards of the future will also ensure that climate change and sustainability issues are incorporated into strategic and operational planning and risk assessment.

> **Being part of a team which is taking a sustainable path will be a source of great satisfaction to many employees**

> A business enterprise of the future would have a leader and leaders down the line with a wide bandwidth to appreciate the true potential of people, their aspirations and enhance well-being, along with deep love for nature and its enhancement. People must feel from their experience and stories such leadership culture enhanced life and nature!
>
> The business will have an enterprise model that recognises excellence and innovation - to generate moderate profits or revenues, after giving back suppliers and dealer-chains fair rates and on time; employees given fair compensation, social security, development and work satisfaction with care and so on. People connected in every way should say - may this Company grow forever! The Ownership structure and Governance processes reflect a *consensus* based activity.
>
> The Business of the future is one which clearly demonstrates that Relationships are above all forms of transactions and performance. So, more than what is called 'shared value', the focus is on convincing oneself and all other stakeholders that *sustainable value is co-created*, never created by one or the few. (Anant Nadkarni, retired Vice President CSR and Sustainability, Tata)

Boardrooms of the future will no longer be dominated by white men. The proportion of female board members will have substantially increased, in part due to recognition that this ensures a social and environmental sustainability focus along with the profit imperative[24] and an understanding of the relevance of sustainability performance to overall performance.

Committed and proactive executives will collaborate to react to changes in the external environment and work together to make necessary organizational change happen. These leaders will be knowledgeable about sustainability issues, processes, performance management, and communication. These change leaders will have the ear of the CEO. Moral authority and leadership skills are important, but not enough for the scale of change required.[25]

Solving the challenges and taking the opportunities they present requires corporate leaders who are guided by a sense of what is right. Tomorrow's senior executives will be a self-aware diverse group with collaborative leadership styles working in a culture which allows for critical reflection. They will have the courage to "do the right thing" and to create a collaborative culture where dissenters are heard.

The Connected Company

The strength of relationships with stakeholders, including customers, suppliers, employees, investors, civil society groups, and NGOs will be increasingly critical to the success of the company of the future. Some companies will follow Nike in learning the importance of this the hard way.

Nike contracted with factories throughout Asia (which became known as Nike sweatshops) which were found out for using child labor, poor working conditions, and excessive overtime, and for sexually harassing female workers and paying below the minimum wage. This was widely publicized by CorpWatch (a US-based research group), Naomi Klein in her book *No Logo* (1999),[26] Michael Moore and the BBC in documentaries, and various anti-globalization and anti-sweatshop groups. Universities started to boycott Nike products, leading to a global boycott campaign in the 1990s. Nike's original denial of claims[27] and its view that what happened in supplier factories wasn't its concern, only served to increase the campaign against it. Nike has been forced to change its position, now taking transparency, accountability, and corporate responsibility very seriously.

The company of the future will encourage its pension fund to realize the benefits of socially responsible investment

The Ethical Consumer website[28] provides information about current boycotts, how to start one and successful boycotts. Nestlé is included on the successful

boycott list. It has been much criticized for its aggressive and deceptive sales of baby milk formula in countries with limited access to clean water.[29] In 2010 Greenpeace launched a campaign[30] against Nestlé, resulting in Nestlé's adoption of a comprehensive zero deforestation policy in its palm oil supply chain.

The company of the future will encourage its pension fund to realize the benefits of socially responsible investment. Unilever did this[31] and is set to increase responsible investment following good results.[32] This will be an increasing trend by pension funds which itself will be a powerful force in shaping the company of the future. The desire to get into, and stay in, socially responsible investment funds will influence corporate strategies and encourage longer-term, responsible thinking.

Dramatic changes in China and other parts of Asia will have a global impact. The rise in the middle classes means Chinese companies will no longer be able to compete with cheap labor alone. They are addressing this by being the best in other areas—including sustainability. Huawei's Sustainability Report 2013,[33] for example, details extensive and world-leading practices to integrate sustainability into its supply chain.

Creating Value

As discussed earlier, Milton Friedman saw the *purpose* of business to simply be to make as much money as possible for the owners of the business. The power of big business today is such that it is expected by many to serve a broader purpose, sometimes reflected in different forms of ownership, such as customer, community or employee owned businesses. The purpose of business includes providing jobs, educating customers about the social and environmental impact of products, advocating for government policies to reduce the impact of climate change, and so on.

The company of the future, as part of an increasingly globalized and complex world, will be a connected and dynamic part of the fabric of society. Not only will the boundaries around its constituent departments/divisions/functions be increasingly blurred as companies recognize the need to take a multi-functional and multi-disciplinary approach to solving complex and interconnected problems, but also the boundaries around the organization will be increasingly fuzzy as companies recognize that their success depends on their taking responsibility for the environment, employees, suppliers, customers, and other stakeholders.

The changing view of the relationship between businesses, society and the environment is to some extent reflected in, and perhaps to a greater extent further catalyzed by, the work of the International Integrated Reporting Council (IIRC). It encourages companies to consider the role of a range of "capitals" in their business model. Whilst traditionally companies have thought about their business model in terms of flows of money or "financial capital," the IIRC

encourages businesses to explain their business model with respect to a number of capitals including, for example, human capital, natural capital, social and relationship capital and intellectual capital. Extending this line of thinking we can consider value as being created (and depleted) across all capitals through relationships with a broad range of stakeholders:

"Value is not created by or within an organization alone" (IIRC Framework, para 2.2)

Tomorrow's company will have contributed to redefining how we consider and measure value, a process which itself will have contributed to changing the nature of business

Over the last century a mass of rules has developed to measure financial capital. These rules now capture an ever decreasing component of the worth or value of a company. Tomorrow's company will have contributed to redefining how we consider and measure value, a process which itself will have contributed to changing the nature of business. The company of the future will explain how it defines value and the relevance of multiple capitals and stakeholder views to their concept of value. It will go on to explain what steps they have taken to maximize value creation according to its definition.

The shift from Milton Friedman's way of thinking in the case of Unilever is clear from this statement:

> Our purpose: to make sustainable living commonplace ... Our first priority is to our consumers—then customers, employees, suppliers and communities. When we fulfil our responsibilities to them, we believe that our shareholders will be rewarded. (Unilever Annual Report and Accounts 2012, inside front cover)[34]

Similarly Sasol outlines how stakeholders create value for the company:

> ... Communities ... understanding of ... issues and ... potential challenges which may need to be addressed ... Unions ... Through ... discussion ... we develop and build relationships and grow trust ... (Sasol Annual Integrated Report 2013, pp.38-9)[35]

The company of the future will not only listen to its stakeholders and define value broadly in terms of all six capitals, but will also recognize its duty of transparency and accountability over a broad range of activities and impacts in which stakeholders have an interest.

Transparency and Accountability

As the power and impact of the world's largest companies have increased, so have demands for increased transparency and accountability. Many a corporate reputation has been damaged by misinformation, not disclosing negative issues or impacts (which are instead revealed by the media or NGOs), and by not accepting a responsibility of accountability to stakeholders over corporate impacts on them. By the same token transparency and accountability have been useful to restore public trust. Shell was the subject of public outrage in the late 1990s over its plan for Brent Spar, a decommissioned floating oil storage facility, and was also accused of complicity in the murder of Ken Saro Wiwa and eight other activists against Shell's treatment of the Ogoni people in Nigeria.[36] A very public, high-profile and global campaign led by Greenpeace about plans to dump Brent Spar in the North Sea got a lot of support. There was a widespread boycott of Shell service stations across Northern Europe. Shell abandoned its plans to sink Brent Spar, parked it in a Norwegian fjord and later reused much of its structure. Subsequently Shell went on to win the ACCA social reporting awards,[37] complying with globally recognized sustainability reporting frameworks and including negative comment from stakeholders in their report. They were keen to show they had listened to stakeholders and learned their lesson, and to win back public trust.

A more recent example of recognition of the importance of accountability is provided by the Royal Bank of Scotland Group in its Sustainability Review 2013. The Chairman and Chief Executive Foreword begins with the words, "In 2013, we were the least trusted company in the least trusted sector of the economy. That must change." The report increases the focus on impacts of banking which are of public concern, such as lending policies, new lending to small and medium-sized enterprises and first-time mortgages, diversity and equality at work, and cultural change towards enhanced ethical behavior.

> **Transparency and accountability have been useful to restore public trust in the world's leading companies**

Key Performance Indicators include the percentage of energy project finance committed to wind and solar, and the chief executive acknowledges the link between financial and non-financial performance, and value creation for investors and society: "The success of a bank depends on a strong financial position, and a reputation for great customer service based on a deep connectivity with the society the bank supports, and is in turn supported by." (p.7). In 2013 a wider range of stakeholders was consulted and the board level Group Sustainability

Committee met with 26 advocacy groups during the year. Overall this type of engagement by board level committees and consideration of sustainability and social responsibility issues is low, but will be commonplace in the company of the future.

Aside from avoiding the negative consequences of a lack of transparency and accountability there are clear benefits of being accountable. Not only does accountability avoid the consequences of reputational risk; it also strengthens relationships with stakeholders. The trust that it allows to develop builds a bank of goodwill which can be relied upon to see an organization through difficult times. A company that has worked to build trust will more readily survive an incident which brings it into question. This is extremely valuable.

Accountability also significantly improves internal decision-making. The imperative of making information publicly available means that information and data have to be collected and verified. Very often the decision to make information available externally is reached the first time the information is gathered, making it available for the first time to inform internal decisions. Not only does this improve the quality of internal decisions, but it also ensures that performance on the matter being reported is monitored. Monitoring performance, of course, is key to improving it.

A hundred, even fifty years ago, corporate reporting consisted of little more than a profit and loss account and balance sheet. Whilst these financial statements are still an important feature of the corporate reporting package, non-financial performance measures and information on management and governance processes get as much, if not more attention, by some readers. Companies are increasingly disclosing their strategy and information on the context, both opportunities and risks, in which they are working to achieve it. This is something investors will increasingly want to know about. According to KPMG (2013)[38] only 5% of the G250 currently include information on the financial value at stake through social and environmental risks. Quality reporting on social and environmental sustainability impacts should disclose the process of engaging with stakeholders, determining material issues and managing sustainability in the supply chain. It should also have time-bound targets. Many companies still fall short of this.

Looking ahead, companies will disclose what value means to them and what steps they are taking to maximize value according to their definition. They will seek to convey the value that is created through their relationships with society and the environment and the value of the natural resources they consume. This will further shift corporate thinking away from a narrow short-term profit motive to a more holistic way of thinking about what constitutes success in a new world order.

Closing Word: The Company of the Future

In summary, the company of the future will be one which has excelled at:

- addressing climate change risks;
- expecting the unexpected;
- building partnerships and relationships to support strategy;
- fostering collaborative leadership;
- focusing on the short, medium *and* long term.

The company of the future needs to be more deeply integrated with civil society, rather than one standing to one side with a somewhat detached focus on its profit objective. That integration needs to be both physical (i.e. with the natural world and nature's balance) and ethical (i.e. where societal values happen to be). In that way it will be both less vulnerable to change in factors beyond its control, and more attractive and trustworthy to both talent and customers. (Mark Joiner, former Finance Director, National Australia Bank)

The company of the future will also be one that responds to the increasing tendency of consumers, employees, and other stakeholders to look for:

- a corporate vision and goals which recognize the importance of the company's relationship with society and the environment and a leader with a sound moral compass;
- diversity in the senior leadership team;
- a collaborative culture allowing for innovation and responsiveness;
- flexible work patterns and a variety of work opportunities;
- quantified social/environmental targets;
- transparency and accountability.

Notes

1 M. Friedman, "The Social Responsibility of Business is to Increase its Profits," in *Ethical Theory and Business*, ed. by T.L. Beauchamp and N.E. Bowie, 5th edn (Englewood Cliffs, NJ: Prentice-Hall, 1997), 56–7 (first publ. in *The New York Times* magazine, September 13, 1970).

2 C.A. Adams and G.F. Harte, "The Changing Portrayal of the Employment of Women in British Banks' and Retail Companies' Corporate Annual Reports," *Accounting, Organizations and Society*, 23, no. 8 (1998), 781–812.

3 For an explanation of this process see C.A. Adams and G. Whelan, "Conceptualising Future Change in Corporate Sustainability Reporting," *Accounting, Auditing and Accountability Journal*, 22.1 (2009), 118–43.

4 A. Smith, *An Inquiry into the Nature and Causes of the Wealth of Nations* (London: W. Strahan & T. Cadell, 1776).

5 J.A. Brown and W.R. Forster, "CSR and Stakeholder Theory: A Tale of Adam Smith," *Journal of Business Ethics*, 112.2 (2013), 301-12 <doi: 10.1007/s10551-012-1251-4>

6 See, for example: Brown and Forster, 2012; S. Cooney, "Adam Smith, Milton Friedman and the Social Responsibility of Business," *TriplePundit*, August 20, 2012 <http://www.triplepundit.com/2012/08/adam-smith-milton-friedman-social-responsibility-of-business>; and D.C. Korten, *When Corporations Run the World* (Bloomfield, CT & San Francisco: Kumarian Press & Berrett-Koehler, 1995).

7 Korten, 1995.

8 See KPMG 2011 report "Expecting the Unexpected: Building Business Value in a Changing World" <http://www.kpmg.com/Global/en/IssuesAndInsights/ArticlesPublications/Documents/building-business-value.pdf>; and UN Global Compact/Accenture 2013 study "The UN Global Compact-Accenture CEO Study on Sustainability 2013: Architects of a Better World" <http://www.accenture.com/SiteCollectionDocuments/PDF/Accenture-UN-Global-Compact-Acn-CEO-Study-Sustainability-2013.pdf>

9 See UN Global Compact/Accenture 2013 study.

10 Unilever, "Sustainable Living Plan: Progress Report 2012" <http://www.unilever.co.uk/Images/USLP-Progress-Report-2012-FI_tcm28-352007.pdf>

11 E. Broughton, "The Bhopal Disaster and its Aftermath: A Review," *Environmental Health*, 4.6 (2005); A. Cherukupally, "Union Carbide and the Bhopal Disaster," *Global Research*, October 19, 2011 <http://www.globalresearch.ca/union-carbide-and-the-bhopal-disaster/27161>

12 As demonstrated in C.A. Adams, "The Ethical, Social and Environmental Reporting—Performance Portrayal Gap," *Accounting, Auditing and Accountability Journal*, 17.5 (2004), 731–57.

13
KPMG, "Expecting the Unexpected: Building Business Value in a Changing World", 2011 <http://www.kpmg.com/Global/en/IssuesAndInsights/ArticlesPublications/Documents/building-business-value.pdf>

14
For more information see <http://about.puma.com/puma-completes-first-environmental-profit-and-loss-account-which-values-impacts-at-e-145-million>

15
A. Chilkoti, "Water Shortage Shuts Coca-Cola Plant in India," *Financial Times*, June 19, 2014 <http://www.ft.com/cms/s/0/16d888d4-f790-11e3-b2cf-00144feabdc0.html#axzz3COXGeybu>; J. Tapper, "Coke May Have Won the World Cup, But It's Losing in India," CNBC, June 24, 2014 <http://www.cnbc.com/id/101784471>

16
<http://www.nikeresponsibility.com/report/uploads/files/FY12-13_NIKE_Inc_CR_Report.pdf>

17
<http://www.unilever.com/investorrelations/annual_reports/AnnualReportandAccounts2013>

18
<http://www.unilever.co.uk/Images/ir_Unilever_AR12_tcm28-348646.pdf>

19
<http://www.rbs.com/content/dam/rbs/Documents/Sustainability/RBS_Sustainability_Report_2013.pdf>

20
<http://www.unilever.com/investorrelations/annual_reports/AnnualReportandAccounts2013>

21
<http://www.standardbank.com>

22
The International Integrated Reporting Council (2013: 12) defines integrated thinking as "the active consideration by an organization of the relationships between its various operating and functional units and the capitals that the organization uses or affects. Integrated thinking leads to integrated decision-making and actions that consider the creation of value over the short, medium and long term."

23
C.A. Adams, "The Role of Leadership and Governance in Transformational Change Towards Sustainability," *Global Responsibility*, Issue 9, September 2013 <http://www.grli.org/index.php/resources/grli-magazine-/311-the-grli-partner-magazine-september-2013>

24
See, for example, K.A. McElhaney and S. Mobasseri, "Women Create a Sustainable Future," UC Berkeley Haas School of Business, October 2012 <http://responsiblebusiness.haas.berkeley.edu/Women_Create_Sustainable_Value_FINAL_10_2012.pdf>

25
C.A. Adams, M.G. Heijltjes, G. Jack, T. Marjoribanks, and M. Powell, "The Development of Leaders Able to Respond to Climate Change and Sustainability Challenges: The Role of Business Schools," *Sustainability Accounting, Management and Policy Journal*, 2.1 (2011), 165–71.

26
N. Klein, *No Logo: Taking Aim at the Brand Bullies* (New York: Picador, 1999).

27
See R. Locke, "The Promise and Perils of Globalization: The Case of Nike," in *Management: Inventing and Delivering its Future*, ed. by T.A. Kochan and R.L. Schmalensee (Cambridge, Mass. & London: MIT Press, 2003).

28
<http://www.ethicalconsumer.org>

29
M. Muller, "The Baby Killer: A War on Want Investigation into the Promotion and Sale of Powdered Baby Milks in the Third World," War on Want, March 1974 <http://archive.babymilkaction.org/pdfs/babykiller.pdf>

30
<http://www.greenpeace.org/international/en/campaigns/climate-change/kitkat>

31
E. Simon, "Do Sustainable Companies Offer Sustainable Pensions?" *Guardian Sustainable Business*, September 19, 2013 <http://www.theguardian.com/sustainable-business/do-sustainable-companies-offer-sustainable-pensions>

32
L. Preesman, "Unilever Pension Fund to Increase ESG on Back of Strong Returns," *Investment & Pensions Europe*, May 13, 2014 <http://www.ipe.com/unilever-pension-fund-to-increase-esg-on-back-of-strong-returns/10001825.fullarticle>

33
<http://www.huawei.com/en/about-huawei/sustainability/sustainability-report>

34
<http://www.unilever.com.sg/Images/ir_Unilever_AR12_tcm205-348376.pdf>

35
<http://www.sasol.com/sites/default/files/publications/integrated_reports/downloads/Sasol%20IR%202013lores.pdf>

36
C.A. Adams, "Help Firms Open Up," *Times Higher Education*, November 3, 2000 <http://www.timeshighereducation.co.uk/news/help-firms-to-open-up/154822.article>

37
C.A. Adams and A. Zutshi, "Corporate Social Responsibility: Why Business Should Act Responsibly and be Accountable," *Australian Accounting Review*, 14.3 (2004), 31–39.

38
KPMG, "The KPMG Survey of Corporate Responsibility Reporting 2013" <http://www.kpmg.com/global/en/topics/climate-change-sustainability-services/pages/default.aspx>

Transforming an Analog Company into a Digital Company: The Case of BBVA

Francisco González

Banks must urgently undertake a far-reaching technological and cultural transformation. The industry is swiftly advancing towards a new ecosystem. The emerging new competitors—mostly spilling over from the internet—are unburdened by cost legacies and closely aligned with the needs and characteristics of new "digital" customers. To survive and thrive in that environment, banks must leverage their key competitive edge, namely, the information they already have about their customers, turning it into knowledge to deliver a better customer experience.

 BBVA began its transformation towards knowledge-driven banking seven years ago. This paper reviews the main elements of that process: the construction of a sophisticated technology platform which is already in operation today, and an in-depth cultural shift. Recently, with the creation of the Digital Banking Area, BBVA has addressed radical organizational change to drive forward a renewal of corporate culture and speed up the transition from being a highly effective "analog" bank— as BBVA used to be—to achieving its goal of being the first knowledge-based service provider of the digital age.

Francisco González
Chairman & CEO BBVA

An economics graduate of the Universidad Complutense de Madrid, Francisco González has been the executive president of BBVA since 2000. During his term of office he has undertaken an ambitious plan to transform the Group in three key respects—principles, people and innovation. As a member of numerous international forums, he works towards adapting the banking industry to technological progress and societal change.

Before the merger of Banco Bilbao Vizcaya with Argentaria, he was the CEO of Argentaria, where he led the successful integration, transformation and privatization of a widely diverse group of state-controlled banks. Having started his career in 1964 as a programmer at a computing firm, he has ever since sought to transform twenty-first-century banking with the support of new technologies.

Key Features for the Company of the Future:

Technology
Sophisticated technological infrastructure is a necessary, but by no means the only condition of competing effectively in the digital realm. Banks' fiduciary duty means that data security is of special importance. At the same time, data is the banks' main competitive advantage. So while outsourcing may be a good option for many functions it is essential to have in place a technology platform that protects the core of the business.

Culture
The digital environment requires a corporate culture that is radically different from conventional banking practice. This new culture must look to improve customer experience and encourage collaborative work as a means to explore collective intelligence and knowledge. Shunning rigid hierarchies and creating flexibility and openness, the new culture should support agile decision-making, nurture employees' entrepreneurial spirit and drive innovation.

Leadership
Technological renewal and, even more so, cultural change are complex propositions that should be addressed decisively while the organization remains operational in terms of revenue and earnings. Success hinges on strong, determined and inspiring leadership which provides a role model for the new attitudes and practices that change requires, and promotes increasing awareness and the ongoing spread of the right signals of recognition.

Transforming an Analog Company into a Digital Company: The Case of BBVA

Banking: a Change-Averse Industry

In the past few years we have witnessed the far-reaching effects of the ongoing technological revolution on the ways we do business. Individual industries and whole sectors have been transformed; companies seemingly conjured from thin air swiftly rise to the top of their fields, joining the ranks of the world's most valuable businesses. Conversely, long-established industry names fall into decay or disappear altogether.

This book provides a glimpse of the severe shocks that today's companies are called on to withstand. Technology has changed, shifting the boundaries of production and distribution possibilities. Customers have changed, as have their requirements and the ways in which we reach them. Employees have changed, and their skills and motivation are now different. Change also takes place in organizational structures, decision-making models and forms of leadership, to meet the challenges of today and face those of tomorrow: technological progress and social development never stop, creating new uncertainties on the horizon of the business world.

These processes of transformation are all the more far-reaching, swift and radical in information-rich domains, such as the media, culture, and

entertainment. Banking has changed, too. But despite being an information-rich activity—the "raw materials" of financial services are money and information—banking has changed a lot less than other industries. Money is readily digitized: when it takes the form of electronic book entries, it becomes information that can be processed and transferred in an instant.

Various reasons have been suggested to explain why banking has changed relatively little. First, the industry is subject to heavy regulation and government intervention. This discourages potential new entrants, so incumbent banks feel less pressure to change. Another factor often pointed to is average user age, which is higher than that seen in other industries—such as music. What's more, most people take a conservative approach to their finances. And it may well be that the rapid growth and high earnings of the financial services industry in the years leading up to the downturn nurtured complacency and inefficiencies which in other sectors would have proved fatal.

Technology has changed, shifting the boundaries of production and distribution possibilities. Customers have changed, as have their requirements and the ways in which we reach them. Employees have changed, and their skills and motivation are now different

But all this is changing. In fact, it already has changed. After the downturn, the financial services industry finds itself in an entirely new landscape. Laws and regulations are a lot tougher in the fields of consumer protection, good practice requirements, control, and capital ratios. This means thinner margins, higher costs, and lower earnings. In addition, users are now more demanding—they want improved transparency, cheaper prices and higher service quality.

Only a major effort of transformation will enable banks to return to profit figures capable of assuring medium- and long-term survival, and, by offering a wider, improved range of services at competitive prices, to restore their tarnished reputations in the eyes of customers and society at large.

This transformation is increasingly urgent for two powerful reasons. First, customers are changing swiftly; secondly, new competitors are stepping onto the stage.

A whole generation of customers have grown up with the internet—they make intensive use of social media and live in a "digital mode." The "millennial" generation—also known as Generation Y—are now aged 25 to 40. They are approaching the peak of their professional development and making major financial decisions. By 2020, "millennials" will account for a third of the population of the United States and 75% of the workforce. 90% of

them deal with their banks exclusively online, and half of them do so using their smartphones.

Over 70% of millennials say they would be happy to pay for banking products and services provided by non-banking companies—for example, telecommunications operators, technology and internet providers, online retailers. These percentages exceed 50% even among earlier generations—aged up to 55 years.[1]

What this means is that banks are losing their monopoly over people's financial trust. And later generations—like "Generation Z," born in or after the 1990s—will no doubt bring still greater developments which are yet to be discovered.

The United States is in most respects at the forefront of these changes, but the trend is global. It is not only in developed countries where we can see this shift. In developing countries, too, the more affluent customers are following the same pattern. What's more, technology is making it possible to offer financial products and services to a poorer, more scattered population which conventional banks are unable to cater for at affordable prices. This potential market encompasses up to two billion new customers.

Change is opening up opportunities that foster the rise of a new league of competitors—mostly but not exclusively spilling over from the digital world. These new entrants can be far more efficient and agile than banks, because they are not burdened with inefficient, rigid and largely obsolete technologies or expensive brick-and-mortar distribution networks.

From Analog to Digital: Towards Knowledge-Driven Banking

Today banks must face a tough climate: tighter margins; overcapacity; tarnished reputations; and the pressure of new high-tech competitors who can move flexibly, unburdened by cost legacies.

But banks do enjoy a key competitive advantage: the huge mass of information they already have about their customers. The challenge is to turn that information into knowledge, and use the knowledge to give customers what they want.

It need hardly be said that the first thing customers want is better, quicker service on transparent terms and at an affordable price, in keeping with their own individual needs.

One of the implications is that customers should be able to interact fully with their bank, at any time and at any place, using their mobile devices. Today, there are 5 billion mobile phones in the world but only 1.2 billion bank customers. And mobile devices support an ever-increasing range of functionalities. Mobile data traffic now stands at more than 2.5 exabytes per month, and will almost treble every two years.[2]

This means on the one hand that the role of bank branches has radically changed; on the other, the potential scope of the banking market has widened immensely.

In the years to come the mobile phone will win a far greater share of interactions with banks. Technological progress—APIs, cloud computing—and increased investment in mobile banking development (now standing at about $2 billion a year in terms of venture capital alone, plus the heavy internal investment of banks themselves) will lead to a powerful rise in the operational features of mobile devices and in the range and complexity of financial transactions they will support.

Nevertheless, many people still want to deal with their bank by other means: branch offices, ATMs, computers, conventional telephones, and an increasing number of "smart" devices. So banks need to offer their customers a genuinely "omnichannel" experience. The same value proposal, the same service, must be available at any time by any channel, and you should be able to switch from one channel to another instantly and seamlessly.

Facing new competitors who can move flexibly, unburdened by cost legacies, banks do enjoy a key competitive advantage: the huge mass of information they already have about their customers

And of course customers will increasingly want their bank to offer content carrying higher value-added—products and services that fit their needs more closely.

To meet these demands, banks must develop a new knowledge-based business model for the digital world.

According to Peter Weill[3] the new digital model has three mainstays: first, content, the things being sold; secondly, customer experience—how the product or service is presented and used; and, thirdly, the technology platform, which shapes production and distribution.

I like to explain the construction of this new model by analogy to building a house. The technology platform is the foundation, while internal processes, organizational structures, and corporate culture are the various floors, including the installations (insulation, electricity, heating, plumbing, etc). Finally, the channels by which customers interact with the bank are the roof of the house. All these elements together make the house comfortable and safe. They let us offer the customer a good product and a satisfying experience.

For many banks, the technology platform is a limiting factor and a nearly insurmountable challenge. Most bank platforms were designed and built in the 1960s and 70s. Professor Weill calls them "spaghetti platforms," because of the complexity of the connections resulting from several decades of add-ons, tweaks, and repairs.

This is why so many banks have tried to meet the digital challenge by building their "house" from the roof down, that is, starting with the channels. But

that's a stopgap solution. Without strong foundations, the increased volume and sophistication of online banking will overburden the obsolete platforms and the house will ultimately collapse.

This is because the improvement of content and customer experience to the standards customers want will call for systematic use of a vast volume of data.

The issue is not limited to handling an increasing volume of transactions and customer interactions. It crucially hinges on the huge amount of data collected in the course of customer contact, combined with the immense and rapidly increasing volume of information available on the internet, largely supplied by people's social media activity and devices within the "Internet of Things." We must capture, store and accurately process all that information to generate the knowledge to offer customers the best possible experience, even anticipating their needs and supporting them throughout their decision-making process. This is what I call "knowledge-driven banking," which is far superior to what we now refer to as "customer-focused banking"—which in its time was a very meaningful improvement on conventional "product-based banking."

Banks must take the lead in Big Data techniques if they are to make use of the competitive edge granted by their incumbent status. This can only be done with huge data-processing capabilities and a technological structure that fully and seamlessly integrates the knowledge thus generated with every customer channel and every point of contact.

Such capabilities are still beyond the grasp of conventional banking platforms. Cloud computing, however, has created the possibility of enhancing them flexibly and efficiently. Many of the new entrants to the banking field will use cloud computing, and it can be an immensely useful tool for incumbent banks as well. But security concerns and regulatory and compliance requirements call for a very careful decision as to which data, transactions, and capabilities ought to remain on the bank's proprietary systems. The bank, what's more, must coordinate and integrate all cloud-based services. This highly complex task will be powerfully aided by a flexible and modern technology platform.

> **Banks must take the lead in Big Data techniques if they are to make use of the competitive edge granted by their incumbent status**

Having said all this, the upgrading of technology, however necessary, is not the toughest challenge to which banks must rise. To succeed in the new digital world conventional banks must completely revamp their business model. We need to reinvent operations and processes, redefine organizational structures, undertake a revolution in approaches to work, and rethink the skills and talent we need our people to display. In short, we need a transformation in corporate culture, a complete reinvention of the business itself.

Transforming a conventional "analog" bank into a new "digital" provider of knowledge-driven services can only be a protracted and complex process. We must keep up an ongoing tension of testing and reassessing what we have, trial and error, an unending search. That is to say, we can never stop innovating. Our approach to work must accordingly be far more agile and flexible, less hierarchical, rich in communication across divisions, more open and more collaborative. The new culture we are called on to develop must be compatible with keeping up, to its full extent, the operational pace of our present business, our relationship with our customers and all our stakeholders. The process might be compared to changing the tires of a truck while still in motion.

Very few banks in the world have put themselves to the task with the necessary determination and depth. But our very survival is at stake. A new competitive landscape is taking shape in the financial services industry. A new ecosystem to which we must adapt.

We are witnessing the emergence of start-ups that focus on single segments of the value chain. These new entrants use the latest technology and lean, flexible structures to offer highly specific products. They can do so at cheap prices and offering a great customer experience by dint of speed, agility, and intensive use of Big Data technologies.

Any number of these projects focus on transactions—payments, transfers, financial asset sales—such as PayPal, Dwolla, Square, M-Pesa, Billtrust, Kantox, Traxpay, etc. Adjoining this field we find companies that offer alternative currencies, such as Bitcoin, Bitstamp, Xapo, BitPay, etc.

Moving beyond the field of payments, initiatives are under way in other segments formerly monopolized by conventional banks: product and service selection advice (Bankrate, MoneySuperMarket, LendingTree, Credit Karma); personal finance management (Fintonic, Moven, MINT, etc.); investment and wealth management and advice (Betterment, Wealthfront, SigFig, Personal Capital, Nutmeg); crowdfunding capital and debt financing (Lending Club, Kickstarter, Crowdfunder, AngelList, etc.). Lending to individuals—so far thought of as the segment most resistant to disintermediation—is being addressed by the preapproved loans industry (Lending Club, Prosper, Kreditech, Lenddo and many others).

Some companies are even trying to extract value from banking transaction data itself by providing customers with APIs to access their data, or directly supplying the tools for any business to manage its financial transactions on its own or for a bank to develop its digital offering (Bancbox, Open Bank Project, Plaid, etc.).

The major online players (Google, Facebook, Amazon and Apple), leading telecoms companies and big retailers are taking a real interest in offering financial products to supplement their existing goods and services. There are several reasons for this. First, it enables them to offer their customers a fully rounded experience. Secondly, a financial relationship potentially entails

multiple and recurring customer interactions through which a wealth of information can be extracted.

These players can supply a broader range of financial products and services and, eventually, create a fully fledged banking offer. At the very least they can create "packages" that combine their own products and services with financial products and services. These are packages that conventional banks will be hard-pressed to replicate.

Transforming a conventional "analog" bank into a new "digital" provider of knowledge-driven services can only be a protracted and complex process. We must keep up an ongoing tension of testing and reassessing what we have, trial and error, an unending search. We can never stop innovating

We are witnessing the disaggregation of the financial services industry, with a multitude of highly specialized competitors operating in different segments. What's more, major players are likely to enter the market with wider product ranges. So the banking industry—clearly burdened by overcapacity and in need of a far-reaching process of consolidation—will see an influx of competitors who will put still more pressure on incumbent banks' growth potential and bottom line.

Those banks that let the challenge of transformation go unmet, or fail in the attempt, are doomed to disappear. This won't happen straight away. The regulatory framework is still a formidable barrier to some areas of banking, and many customers remain attached to established practice.

But these barriers will undergo an inexorable decline. Disintermediation in an ever-widening portion of the value chain will drive out the incumbent banks, leaving them with the heavily regulated areas only. Elsewhere they will be relegated to providing back-end tasks and mere infrastructure, at a distance from the end-customer.

Yet those banks that successfully achieve transformation will leverage their knowledge of their customers to remain as the main point of contact, offering a wider and better range of services, whether sourced internally or through platforms where various specialist providers and customers themselves can interact. Only the platform owner will be able to integrate all the knowledge generated about end-customers to enhance their experience and widen and improve the available product range (whether produced by the owner itself or other suppliers which the owner admits to the platform).

None of this is "economic fiction"—this ecosystem model is already a reality in the digital world. It is yet to reach the domain of banking in anything more than embryonic form,[4] but its emergence is inevitable. At some point in the course of this process there will arise a competitive face-off between

"digital" banks and the leading internet-based providers. The banks, using the financial information available to them supplemented by public sources, will seek to offer a wider and better range of financial and non-financial products. Their rivals will use their information about their users to offer financial services among others.

Against a background of swift technological progress and the rise of all kinds of new competitors, it will be hard to tell who is making the right decisions and implementing them tenaciously and imaginatively. Customer behavior will ultimately cast its light on the landscape. Those perceived as leaders in digital transformation will earn better prospects of growth and profit, which in turn will win them the technical and financial capabilities to make best use of the process of consolidation: they will attract the best talent, bolster their reputation facing customers and suppliers, and capture a larger, wider and truly global market share.

The Transformation of BBVA

At BBVA we soon became aware of the depth and reach of the change faced by the banking industry when many still thought our field would be perpetually shielded by regulations and user conservatism.

Seven years ago we undertook the task of rebuilding our technology platform from scratch. We entirely transformed our technology function so that we could at one and the same time keep existing systems in full operation and develop new systems in line with the latest technological advances. We doubled our systems investment from €1.2 billion in 2006 to €2.4 billion in 2013. A substantial change took place in the proportion of funds spent to keep systems operational ("run") to funds invested in new development ("change"), moving from the industry standard of 80%/20% to a new standard of 60%/40%.

After seven years of work, at BBVA we have achieved a state-of-the-art technology platform.[5] As a result, while we processed 90 million transactions a day in 2006, we were able to process 250 million transactions a day by 2013. We estimate we will reach 1.2 to 1.4 billion transactions by 2020. At the same time, the new platform enables us to meet increasing security requirements. From 2006 to 2013, the number of attempted attacks on BBVA multiplied by a factor of 60. However, technology-driven fraud in 2013 was less than half what it was in 2010.

In short, our technology platform is able to satisfy the requirements of data capture, storage and management, which are growing exponentially in step with our progress into the digital age. We are aware that this task can never be achieved completely. There will always be new and more complex demands. But we also believe we are ahead of our peers, and able to compete successfully with new digital entrants.

Technology, though essential, is only a tool in the hands of our people to help them build a better experience for customers.

What is needed here is a revolution in operations, processes, and organizational structures; a major shift in approaches to work and in the required skills and talent. This must signify a radical transformation of our corporate culture or, following our earlier analogy, the way in which we build the "floors" of our digital "house."

From the outset we identified a number of essential cultural traits that we had to encourage: agility, flexibility, the primacy of collaborative work, an entrepreneurial spirit, and support for innovation. Given this, it fell to us to advocate open innovation models as a way to overcome the limitations to which organizations are typically subject, and place the development of value proposals in the hands of the best talent—whether it be found in employees, customers, outside partners or any other of the company's stakeholders.

The cultural transformation is undoubtedly even harder to achieve than the technological one, because we lack any obvious model or benchmark. We have to work with the infinite complexities of people, social relations and pre-existing cultures.

Over the past few years, at BBVA we have comprehensively re-engineered our processes in step with our technological overhaul. And we have promoted a change of culture. To spread the new culture and help it gradually permeate the entire organization, three approaches proved particularly useful to us.

First, leadership and top-down role models. At every public or internal presentation, the senior management of the Group stressed the need to embrace change, encourage innovation, and engage in collaborative work. We had to lose our fear of failure—which can be a rich source of learning and a driver of creativity. This approach was coupled with a major effort of internal and external communication on the bank's developments in the digital domain. We set up models to be followed by raising awareness of our strategies and forward steps in this field, and of the people undertaking them.

After seven years of work, at BBVA we have achieved a state-of-the-art technology platform. As a result, while we processed 90 million transactions a day in 2006, we were able to process 250 million transactions a day by 2013

Secondly, we leveraged our selection and training policies. We have invested more than €40 million a year in this area. The bank's training division operates physical venues that serve as a powerful point of reference for all our employees and stakeholders, and enable us to share experiences and knowledge. Our training centers teach the key subjects involved in addressing change at BBVA (strategy, marketing, finance, technology, leadership) in

partnership with external institutions that are at the forefront of their respective fields: e.g., London Business School, IBM, Center for Creative Leadership, Wharton, Harvard, IESE, IE, Boston College.

Our greatest effort, however, was to build one of the most innovative e-learning platforms in the world. This system enables us to provide over 3 million hours of online education and training, involving more than 175,000 course-takers (i.e., an average of 1.7 courses were taken annually by each Group employee).

New technologies (e-learning platform, use of mobile devices) and new learning approaches (newsletters, on-the-job learning, MOOCs) are becoming an increasingly important way of providing a range of flexible training options that everyone can access.

In the field of selection our goal is to be present wherever the talent and knowledge we need is likely to emerge. We have relationships in place with the leading, cutting-edge business schools, such as those referred to earlier and others. Our key "brand" as an employer is aligned with the goal of being "the best—and first—digital bank in the world." We are leveraging intensive use of social media (LinkedIn, Facebook, Twitter) to achieve global positioning in keeping with our requirements and expectations.

Finally, we regard the new corporate buildings now under construction as powerful instruments to accelerate change. In the countries where we have a significant presence we are bringing together BBVA employees at new headquarters. Though originally driven by financial and efficiency-related criteria, this effort is now a lever in the service of achieving our transformation.

In this book the article produced by the BBVA New Headquarters Team[6] provides a detailed account of how this project was implemented and what it was intended to achieve. Here I shall do no more than stress the point that our aim is to create a new work experience for the digital era. The design of this experience must be both global and focused on people, meeting their functional and emotional needs. Under the new approaches to work we aim to put in place the key vector is collaborative work as a way to bring forth collective intelligence and stimulate

Over the past few years, at BBVA we have comprehensively re-engineered our processes in step with our technological overhaul. And we have promoted a change of culture

innovation. This requires simultaneous action in three distinct but interrelated realms: physical space, technology, and culture (behaviors). Given the interrelatedness of the three settings, the new headquarters are proving to be powerful drivers of behavioral change.

Over these years BBVA's transformation drive has already garnered meaningful results. The Group's active digital customers in December 2011 numbered 5 million; by mid-2014, that figure had climbed to 8.4 million. Active customers using mobile technologies grew from 0.3 million to 3.6 million (i.e., they multiplied twelvefold). We have reconfigured our branch network, too. On the one hand, we created small "convenience" branches focusing on customer self-service; on the other, we operate larger branch offices where financial specialists can provide customers with personalized advice and higher value-added. These developments and the introduction of a system supporting remote personalized advice have enabled BBVA to raise the average office time spent on sales efforts from 38% to 45%, while the proportion of sales staff to total Group employees has risen from 28% to 38%, coupled with significant growth in our cross-selling success rate.

We regard the new corporate buildings now under construction as powerful instruments to accelerate change

We have also set in motion a highly ambitious Big Data project. After a period of getting things ready and attracting the right talent, the initiative is enjoying real success as to customer segmentation, improved credit risk scoring, and fraud reduction, among other areas.

We have taken steps to encourage the emergence of an open innovation platform and community. Developers come together to present, critique and improve their ideas, and help one another develop new concepts and prototypes in a process of co-creation.

BBVA is already launching new products designed and produced specially for the digital world, such as BBVA Wallet and Wizzo. The new products are a good "test bench" and have proved a powerful way of building teams and helping them learn. They are also doing very well in the market.

While building our own capabilities and talent, we also keep an eye on outside talent. BBVA Ventures is a San Francisco-based venture capital firm with a global reach that invests in start-ups that develop innovative financial services.

BBVA Ventures helps us stay on top of what is happening in the realm of digital banking. It also enables us to form alliances involving promising teams and initiatives, and may open the door to acquiring talent, technologies or business models with a disruptive potential in the industry. Specifically, this was the case with our recent acquisition of Simple, a pioneering start-up that focuses squarely on the user experience in mobile banking. Our active presence in the domain of digital start-ups and our bid to support open platforms have led to another first of its kind deal: the recent agreement between BBVA Compass with Dwolla, a payment system start-up. Bank customers can now use Dwolla's real-time payment network to make their money transfers.

These are all meaningful forward steps that carry the organization and its people onward to a new corporate culture. In fact, at BBVA we are confident of having gained a competitive edge over competing conventional banks both technologically and in terms of revamping processes, organizational structures, and corporate culture.

But the pace of change in the digital realm and the ongoing acceleration of the innovation cycle prompted us to speed up our transformation and turn around our organizational structure in radical ways to place the digital world at the center of our vision for the future. It was for this reason that in 2014 we created the Digital Banking Area.

BBVA Digital Banking: a Radical Organizational Change to Accelerate Transformation

The main purpose of this new business Area is to speed up the Group's transformation into a digital bank. The Area is directly responsible for developing existing distribution channels, adapting internal processes and designing a new range of digital products and services capable of delivering the best possible customer experience.

The guiding idea is that the Area will, in addition to enhancing BBVA's digital business and presence, work as a catalyst to transform the entire Group. In step with the digitization of the business, the Digital Banking Area will spread throughout every unit of the organization the relevant procedures, work methods, and culture. BBVA Digital Banking is the "BBVA version" of what John Kotter—in his paper collected in this book—has called the "dual model" for driving change forward.

The new Digital Banking Area's mission has four key angles: a new, enhanced customer experience; knowledge-driven personalization using the best data analysis technologies; communication in clear, concise language; and access to products and services at any time and from any place.

This mission specification calls for a new set of behaviors. First, the customer must be the focal point of every decision. Secondly, we must be able to experiment and react quickly, launch initiatives and end them promptly if unsuccessful, and use the iteration method to improve. Thirdly, we must target what's truly important for customers and the business—do fewer but more relevant things, and do them better. Fourthly, we must be accountable: we should set specific, quantifiable objectives, constantly measure our forward and backward steps, take any necessary corrective action promptly, and quickly take stock of any failures.

BBVA Digital Banking brings together all digital ventures and initiatives throughout the Group and, in light of the above principles, drives forward an

ambitious project for change, which has two branches: transformation in project management and transformation in human resource management.

In project management we have opted for the Agile methodology. In a nutshell, this involves forming time-limited multidisciplinary teams specifically tailored to the requirements of the given project; team members make intensive use of online tools to work collaboratively. To allow them the widest flexibility in their approach teams are given full decision-making independence—although they are of course accountable for their decisions—and use iterative trial and error to test, improve, or reject the initial concept.

This new project management model entails a new human resource management model. The Digital Banking Area has been granted full authority to make its own hiring decisions. But we also want to encourage the entire Group to develop, search for, and recognize talent both within the organization and outside. We need our people to have the right know-how but also, and more importantly, we need them to have the cultural features that fit in with this new model—flexible, non-hierarchical, highly mobile, and subject to very quick project progress assessment cycles.

The Area is sub-divided into several functional units: Marketing, Customer Experience and Business Intelligence, Omni Channel, Technology, Strategy and Planning, and Talent and Culture. These units provide support for six business divisions. Four of those divisions are geographical, corresponding to the Group's main regions: Spain and Portugal, United States, Mexico, and South America. The other two divisions are global: Forms of Payment and New Digital Businesses.

BBVA Digital Banking brings together all digital ventures and initiatives throughout the Group and drives forward an ambitious project for change, which has two branches: transformation in project management and in human resource management

This organizational structure reflects the Digital Banking Area's goal of transforming BBVA's existing activity and finding new, knowledge-driven lines of business in the digital realm.

In the business units, objectives—and, accordingly, decisions and priorities—are shaped by the features of each market, particularly the extent of its digitization and the specific opportunities available.

So in the more developed markets, such as Spain and the United States, the Digital Banking Area's scope of action extends to digital transformation of the entire franchise and the development of a new business model. This means the Digital Banking Area is directly responsible for the entire market offering, the distribution model, and process design. As a result, the Area takes on joint responsibility with the local business unit for the income statement as a whole.

In Mexico and South America, the focus lies on developing the digital offering, whether at the request of the local unit or on the Area's own initiative. In addition the Area manages all digital functions—product development, channels, marketing, processes, technology, etc. These efforts are aimed at the existing "digitized" population, but also seek to develop low-cost models capable of rolling out a profitable financial product range targeting low-income segments (financial inclusiveness). In these regions, the Digital Banking Area is co-responsible, in conjunction with the local business unit, for the "digital" income statement.

The Digital Banking Area is still at an early stage of development. It is attracting and integrating talent, building teams, specifying projects, and creating ties, agreements, and operational schemes with other business and support areas within the Group

In the field of New Digital Businesses the aim is to develop new business models and value proposals beyond the scope of conventional banking. This unit—which is 100% digital in its organizational structure and culture—is entirely independent from the bank and operates as a global business line with its own income statement. It takes its projects forward internally or in partnership with others with a view to maximize the return on BBVA capabilities and assets and external talent. New Digital Businesses is accordingly in charge of the BBVA Group's interactions with the digital ecosystem. One of the entities reporting to it is BBVA Ventures. It is also in charge of executing BBVA's mergers and acquisitions in the digital sector.

The Digital Banking Area is still at an early stage of development. It is attracting and integrating talent, building teams, specifying projects, and creating ties, agreements, and operational schemes with other business and support areas within the Group.

But even at this incipient phase results are coming through. The Area has already launched almost fifty Agile-driven projects across all business areas involving close to 500 people. One key concern is to initiate and accelerate new projects; another highly significant consideration is to continue projects scheduled or started previously. Highly ambitious targets have been set for 2015 which involve a very significant portion of Group human and technological resources.

Leaving this aside, however, I believe that the Area's most meaningful impact is that its principles and work approaches are permeating the organization as a whole—through its ties with other areas, its visibility in internal communications, and the backing it finds in the organization's leadership.

This is why I think that the creation of BBVA Digital Banking was a bold and insightful decision in aid of speeding up the Group's digital transformation. And I also believe we will shortly see the tangible results of the projects now being set in motion and of the Area's role as a catalyst for change in the organization's working approaches and culture.

Final Thoughts: Change Requires Leadership

It was some time ago that BBVA perceived the risks and opportunities inherent in technological change, and for several years we have worked towards reinventing ourselves and moving on from analog banking—however efficient and profitable it might have been by the standards of the twentieth century—into a knowledge-driven digital business of the twenty-first century.

This article focuses on two of the milestones in this process. First, the construction over the past seven years of an entirely new technology platform capable of supporting the data capture, storage and processing requirements of digital banking, which are far more demanding than those seen in conventional banking. Our platform now places us clearly ahead of our peers.

Secondly, in the domain of cultural transformation we have worked hard on several fronts and undertaken many significant projects. Our overarching goal has been to shape an organization that nurtures change and innovation—not as ends in themselves, but as a means to deliver the best possible customer experience. Very recently, the launch of the Digital Banking Area has marked a turning-point in the transformation of our processes, structures, approaches to work, capabilities and mindset, in alignment with the demands of the digital world.

We have come far, and are now in a position to lead the process of transformation of the banking industry and so become the first—and best—knowledge-based bank, fully in alignment with the digital ecosystem.

But we are aware that there is still a long road ahead. Our transformation, as we now envision it, is in progress and far from complete. Far more importantly, technological change continues apace, and society is changing with it. We are witnessing the dawn of Big Data technology. The Internet of Things is only just taking off, but is set to grow exponentially. In these realms, as in so many others—some of which we can as yet barely imagine—"more is different," in the words of Kenneth Cukier in his article for this book, "Big Data and the Future of Business."

So we are running a race which, for as long as the present stage of scientific and technological progress accelerates, has no discernible finish line. If we are not to lose our way, if we are not to become complacent or resign ourselves to being second-best, we must modify people's attitude to change—we must not merely

accept, but embrace and promote change. This calls for strong and cohesive leadership throughout the organization. Our leaders must advocate change, encourage change by example, recognize those who support change, and take steps to remove the practices and structures that stand in the way of change.

This is surely the key to BBVA's successful transformation so far. And this is the kind of leadership we need in future if we are to achieve our goal that BBVA should become the foremost figure in transforming the best of analog banking into the best of knowledge-based banking for the twenty-first century.

Notes

1
Accenture, "The Digital Disruption in Banking," 2014 North America Consumer Digital Banking Survey.

2
Cisco, "Cisco Visual Networking Index. Global Mobile Data for 2013–2018".

3
P. Weill and M. Vitale, *Place to Space: Migrating to Ebusiness Models* (Boston: Harvard Business School Papers, 2001); P. Weill and J.W. Ross, *IT Savvy: What Top Executives Must Know to Go from Pain to Gain* (Boston: Harvard University Press, 2009).

4
The recent agreement between BBVA Compass with Dwolla (discussed elsewhere in this article) is a pioneering example of this kind of partnership, which will become widespread in future.

5
For a detailed account see F. González, "Knowledge Banking for a Hyperconnected Society", in *Change* (Madrid: BBVA, 2013).

6
"New Workplaces for BBVA: Promoting Collaborative Work".

Publisher
BBVA

Project direction and coordination
Chairman's Advisory, BBVA

Texts
Carol A. Adams, Celia de Anca, Salvador Aragón, The BBVA New Headquarters Team (Iván Argüelles Carralero, Gloria Lamas Rull, Beatriz Lara Bartolomé, Susana López Arias, Belén Piserra de Castro, Alfonso Zulaica Alfonso), Henry Chesbrough, Kenneth Cukier, George S. Day, Philip Evans, Stewart D. Friedman, Esteban García-Canal, Francisco González, Mauro F. Guillén, Herzog & de Meuron, Alison Maitland, Haim Mendelson, Geoffrey Moore, William M. Klepper, John P. Kotter, Joan E. Ricart, Peter Thomson, Chris Warhurst, and Sally Wright

Edition and production
Turner

Publishing coordination
Nuria Martínez Deaño

Graphic design
David Cano

Layout
comando g

Infographics
relajaelcoco
Andrés Tacsir (Contents)

Translation
Mike Escárzaga

Copyediting
Tessa Milne

Images
Album/AKG images: 272 (left); Iwan Baan: 268–69, 273, 277, 283, 285, 286–87, 290–91; BBVA: 294, 298, 304, 327, and 332; Carlos Benítez–Donoso González: 303, 308–09, 311, 312, and 314–15; Herzog & de Meuron: 270, 271, 276, 278, 279, 280–81, and 284; TAFYR: 266, and 274–75

Printing
Artes Gráficas Palermo

Binding
Ramos

© of the publication, BBVA, 2014
© of the texts, their respective authors, 2014

ISBN: 978-84-16142-92-7
DL: M-32793-2014
Printed in Spain